Design & Emotion Moves

Design & Emotion Moves

Edited by

Pieter M.A. Desmet, Jeroen van Erp and MariAnne Karlsson

Cambridge Scholars Publishing

Design and Emotion Moves, Edited by Pieter M.A. Desmet, Jeroen van Erp and MariAnne Karlsson

This book first published 2008

Cambridge Scholars Publishing

12 Back Chapman Street, Newcastle upon Tyne, NE6 2XX, UK

British Library Cataloguing in Publication Data
A catalogue record for this book is available from the British Library

ISBN (10): 1-4438-0016-3, ISBN (13): 978-1-4438-0016-7

TABLE OF CONTENTS

LIST OF ILLUSTRATIONS

LIST OF TABLES

DESIGN & EMOTION MOVES

PIETER M.A. DESMET, JEROEN VAN ERP AND MARIANNE KARLSSON

1. Introduction

Eighteen authors who presented their research at the 5th international Design & Emotion conference were invited to write a chapter that shares their research approaches to and insights into the domain of design & emotion. The result is this book, an attempt to present a cross section of current developments in design & emotion research activities. Please do not let the word "emotion" mislead you. Strictly speaking, the concept of emotion refers to a particular and specific affective phenomenon: a relatively brief episode of coordinated brain, autonomic, and behavioural changes that facilitate a response to an external or internal event of significance for the organism (see Scherer et al. 2001). Readers will find, however, that many chapters do not actually discuss emotions. This is because in this book –as in the design (research) discipline in general– the word emotion is used to represent a perspective that is much wider than the formal definition would strictly allow for. What all the chapters do have in common is that their focus always includes some kind of affective aspect involved in the user-product relationship. Emotion is an affective phenomenon, but so are moods, feelings, experiences, and general pleasure. Although all of these phenomena are represented by design & emotion research, the term emotion is used because it clearly expresses, without requiring lengthy explanations, the affective basis of the research domain. This justifies the suggestion to characterise design & emotion as a research domain rather than a research topic, emphasizing its multifaceted and multidisciplinary nature. In spite of the wide variety of themes, angles and approaches, all research activities in this domain share the basic proposition that in order to understand users (or consumers) and the users' behaviour, one must understand the affective responses that are involved in the processes of buying, using, and owning products. This proposition represents the backbone of this book. Consequently, all the chapters report and discuss (the development) of methods, theories, or tools that can assist

those who want to understand the affective impact of design, and those who want to explore the use of structured approaches to design for emotion activities.

2. Structure of the book

The book is not structured in sections; all the chapters are simply placed in alphabetical order according to the names of the first author. This pragmatic decision was made because we found that all our attempts to formulate unambiguous sections failed to be satisfactory. As all the chapters touch upon several themes, a categorisation into specific themes would not do justice to their conceptual richness. As an alternative, we produced an informal composition, as shown in the graphical overviews at the end of this introduction, which should be of some assistance in finding chapters that meet your particular interests. These are loosely defined compositions; one according to approach-based categories, and the other according to thematic categories. Although most chapters do not fit in only one particular category, the categories cover all the chapters. The themes were derived from the chapters (as opposed to being pre-defined) and represent current directions and challenges for the D&E research agenda.

Dynamic interaction

The famous Wii game console of Nintendo, which has sold over 9.5 million units since its introduction in November 2006, is as innovative as it is successful. The console was specifically designed to engage users with the active physical and social interactions that are required to play the game. A distinguishing feature is the wireless controller, the Wii Remote, which can be used as a handheld pointing device and which detects movement in three dimensions. The excitement of the game is generated by the dynamic interaction with the Wii Remote, as well as by the social interaction involved in gaming together (Figure 0-1).

Products are not static but dynamic stimuli. Product usage and ownership involves emotional episodes that may include a variety of both pleasant and unpleasant experiences. The majority of techniques to measure emotions have difficulties with this dynamic nature. We are still a long way from being able to model, or even understand the emotional episodes involved in the interaction between user and product in the actual context of usage.

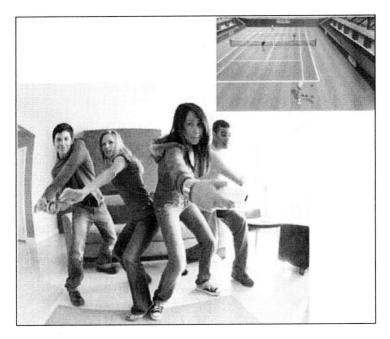

Figure 0-1. People at play with the Wii game console.

Several of the chapters describe studies that have, in different ways, undertaken the challenge to understand the multidimensional and dynamic nature of design as an emotional stimulus. Gomez, Popovic, and Bucolo studied emotions involved in the driving experience. More specifically, they studied emotions during interaction between driver and vehicle interface in a natural driving situation. Their aim was to identify aspects that affected the driving experience, and the effect of emotions experienced while driving on the overall emotional experience. Adank and Warell present and discuss techniques that can be used to assess sensory product experience in user-product interactions. Schrammel, Geven, Leitner, and Tscheligi studied how people organize their experiences and which factors are relevant for evoking positive and negative experiences in their encounters and interaction with technology and artefacts. On the basis of an exploration of the mechanisms of magic, De Groot and Hughes introduce a framework that can help designers navigate the various elements that constitute a magical engagement with products or services. This challenge also involves the relationship between the emotional

episodes and behaviour and attitudes. Porat and Tractinsky studied the effect on attitude of emotions experienced while visiting an e-store, in relation to dimensions such as usability and aesthetics. Chapman discusses the relationships between users and their products in the context of adapting and evolving consumer behaviour, and the emergent paradigm of "emotionally durable design". Finally, Lee, Davidoff, Zimmerman, and Dey explored the roles that a smart home can play in enabling families to regain control of their lives.

Sources / stimuli

One of the musical instruments used by Icelandic singer Björk on her recent world tour was the "Reactable", an innovative collaborative multi-touch interfaced synthesizer. The instrument, which was developed by scientists at the Universitat Pompeu Fabra Barcelona (Spain), enables several performers to simultaneously share control by moving and rotating physical objects on a luminous round table surface. In doing so, users can create complex and dynamic sonic topologies. In addition, a projector draws dynamic animations on its surface, providing a visual feedback of the state, the activity and the main characteristics of the sounds produced by the audio synthesizer. Musicians are animated by the multi-experiential nature of the instrument, involving dynamic, visual, auditory, tactual, and social sensations (Figure 0-2).

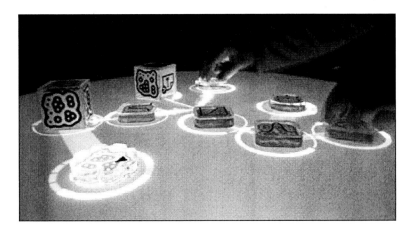

Figure 0-2. The Reactable music instrument.

One part of the challenge in understanding how products elicit emotions is to understand in what ways products can act as emotional stimuli. There is a wide variety of emotional stimuli; some direct, and some indirect and more associative. In design experience, the object of our experience is not necessarily the design itself, but it can also be an associated person, company, event, activity, idea, or memory. Moreover, the object of experience may vary within one and the same interaction.

Fisher and Nordli investigated the specific influence of product shape on emotional responses. Porter, Chhibber, and Porter studied the influence of various types of potential sources of pleasure, functionality, and usability, of different population demographics. Demir and Erbuğ investigated product-related determinants of satisfaction, and found that product groups differ in terms of the sources of the overall satisfaction response. Karana and van Kesteren focused on the experience of materials, for which they proposed a framework that includes several main components: physical characteristics, sensorial properties, meanings and emotions. Zwartkruis-Pelgrim, Hoonhout, Lashina, de Kort, and IJsselsteijn studied the effects of ambient scent and coloured light on atmosphere experience.

Sensorial experience

Readers may recognise the memory of the biscuit tin kept stored by our parents on the top shelf of the kitchen cabinet, teasing us with its unreachable presence. For Alessi, Stefano Giovanni designed the "Mary Biscuit" cookie box that teases us in an even more sophisticated way: by rousing our senses. The plastic box is brightly coloured and semi-transparent. To avoid any doubt about the function of the box, the lid has the shape of a Mary Biscuit, and even smells like vanilla. The translucent material reveals shades of the seductive biscuits inside. What is even more teasing is the fact that the lid is much smaller than the box. The consequence of this design is that you may find yourself wriggling your hand into the box to grope around for the last cookie (Figure 0-3).

When it comes to the senses, design activities are often dominated by the visual appearance. Visual appearance is easy to communicate (drawings) and we have a language for discussing appearance (size, shape, colour, etcetera). Obviously, design for experience requires a more complete focus on all human senses. One of the challenges in this area is the necessity to simulate and test sensorial experiences during design processes. We can make a drawing to simulate a visual appearance, but how do we simulate,

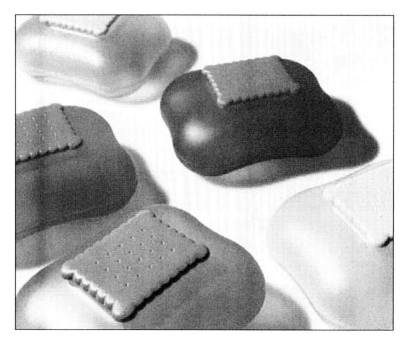

Figure 0-3. The Mary Biscuit cookie box.

for instance, tactile experiences? There is a need for instruments that can effectively measure sensorial experience, and means for communicating experiential aspects that are understood by the various disciplines involved in new product development processes. Furthermore, there is a need for theory that can help us to explain how experiences are connected to the senses, and how sensations interact with product experiences.

Hughes and Tillotson focused on scent, and present some design proposals that demonstrate how designers are able to envision new modes of interaction with scent-producing devices. Adank and Warell introduce techniques that connect sensory responses to product features and characteristics. Martin-Juchat and Marynower adopted a multi-sensorial approach in their analysis of the experience of a car park design.

Pleasant emotions

In a joint project, the design agency KVD (based in Amsterdam, The Netherlands) and the Department of Industrial Design Engineering of Delft

University developed a series of in-flight meals for economy class intercontinental flights of KLM Air France. The aim was to introduce meals that elicit more pleasant emotions than those that are traditionally served during flights. Research indicated that the nature of the emotions that passengers want to experience differs according to the type of meal. An experiential character was defined for each type of meal. For instance, for the main breakfast meal the metaphor 'the charger, like a morning walk in the park' was used to express a character of being invigorating, engaging and dedicated (Figure 0-4).

The interest in emotion emerged from the experience that an understanding of qualities like functionality, usability, and safety, is not always sufficient for developing products that people actually enjoy using or owning. Acknowledging a need for theory and methods, researchers started to adopt the topic of subjective product pleasure as a necessary object of study. Nowadays, pleasure, a basic dimension involved in all affective responses in the human-product relationship, is an indisputably relevant phenomenon in design research. At the same time it is only a basic and therefore general dimension of affect, ignoring the enormous diversity of pleasant experiences involved in using products. An emerging theme focuses on this diversity and explores possibilities to differentiate between types of pleasure, or types of positive experiences.

Three chapters focus on specific pleasant emotions: Desmet explored the similarities and differences in the eliciting conditions for the two emotions of desire and inspiration, Demir and Erbuğ studied product related

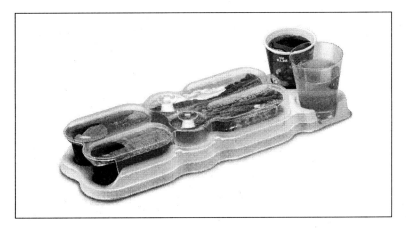

Figure 0-4. Morning Tapas airline breakfast for KLM.

determinants involved in the specific emotion of satisfaction, and Grimaldi explored the possibilities to design for the specific emotion of surprise.

Identity / branding

Internet Protocol Television (IPTV) is a system which involves delivery of a digital television service using the Internet protocol over a network infrastructure. Instead of being delivered through traditional broadcast and cable formats, content is received through the technologies used for computer networks. In 2007, the communication and design agency Fabrique (based in Delft, The Netherlands) was invited to design a set-top box for the IPTV service to be launched by KPN, a Dutch telecom company. The design, which resembles a small dog, was primarily based on the key experiential brand experience of KPN, which is characterised as a combined experience of reliability and innovativeness. Although when first confronted with the product, most people did not know what the product was, at the same time they experienced it as somehow friendly and familiar. In that way the design communicates the novelty of the product and service in a non-alienating fashion (Figure 0-5).

Over the years, many approaches, methods, and tools have been developed that can assist in emotion-focused design activities. Measurement instruments have been developed that can be used to determine specific emotion profiles, and approaches have been developed that link subjective

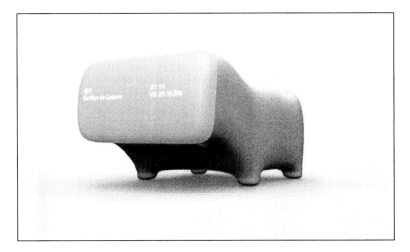

Figure 0-5. Internet Protocol Television set-top box for KPN Telecom.

sensorial experiences to objective product properties. The possibilities created by these methods and tools also introduce a new challenge. The ability to design for emotion requires a strong vision on what kind of experience one wants to design for. Companies often find it difficult to formulate their 'emotional intention,' which, on the one hand should reflect the needs of the user, and on the other should also reflect the identity of the company or brand. Given their stimulus-independent character (one can, for example, be inspired by a shape, an idea, a company, a service, a brand, an activity, etcetera), emotions are particularly useful for formulating experiences that generate coherence between brand identity and product design. An important research theme is therefore the relationship between emotion and (brand) identity.

In a case study, Martin-Juchat and Marynower explored the relationship between emotion, design and communication, using sociosemiotics to interpret the success of the Lyon Auto car park. Abbott, Shackleton, Holland, Guest, and Jenkins studied brand categorisation and the identification of influencing product attributes, diagnosing the "Bentleyness" of automotive design properties.

3. Gothenburg Design & Emotion conference

The International Conference on Design & Emotion is a forum where practitioners, researchers and industry meet and exchange knowledge and insights concerning the cross-disciplinary field of design & emotion. The first conference was hosted by Delft University in 1999. Since then conferences have been organised every two years in close co-operation with a new hosting organization. Conferences with a variety of sub-themes have been held in Potsdam, Germany (2000), in Loughborough, UK (2002), and in Ankara, Turkey (2004). The fifth and most recent edition took place in September 2006 in the wonderful city of Gothenburg, Sweden. The event was organised in cooperation with Chalmers University of Technology and hosted more than 200 delegates, representing more than 30 nationalities. More than 300 abstracts were submitted, and almost 100 papers were presented, addressing a wide variety of topics, discussing the practical, theoretical, societal, and methodological issues relevant to the domain of design & emotion. The programme included four key-note speakers.

Simonetta Carbonaro from Domus Academy, Milan and Borås University, argued that if consumption cannot be reduced to simply functional expectations (form follows function), a next step is considering

the merely emotional and multi-sensorial benefits of what is referred to as "experience marketing". However, this assumption neglects the significance of consumption as a gesture which also seeks an existential, subjective and collective "sense". There is a latent consumer need hiding in most of the consumption gestures that management and marketing disciplines have not sufficiently explored and grasped yet: the search for "sense", or the return to "meaning" after an extended period of purposeful ephemeral merriment. The presentation by Fleming Hansen from the Copenhagen School of Business Administration and Economics was concerned with the measurement of emotions and the study of the role of emotions in consumer choice. Contemporary neurological findings suggest that emotions may play a role in their own right, quite differently from the way in which they have been considered in traditional consumer behaviour theory. Young-Ill Kim, from Hyundai and Kia Motors, spoke on differences between east and west. He argued that East and West differ in

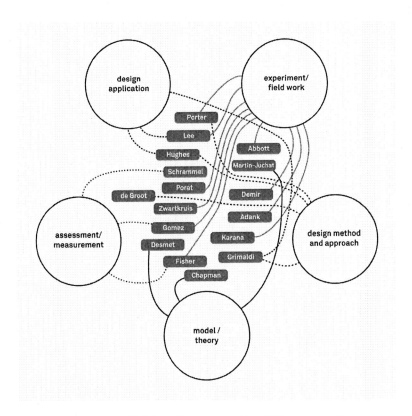

culture, differences which have been created by differences in, for instance, climate, nature, food and the way of life throughout numerous years. These differences can also be traced in the design of environments and artefacts. Marije Volgelzang, with a background from the Design Academy at Eindhoven, told a tale of food design and different ways of approaching food and design. Her talk illustrated what one can accomplish using food as a design material and how emotions can be triggered by different food designs.

Befitting the emotional atmosphere, we enjoyed our conference dinner surrounded by living–and swimming–sharks! This inspiring event contributed directly to the main goal of the Design & Emotion society: to facilitate dialogue between designers, researchers and industry. With a record number of delegates, the Gothenburg conference illustrated the vibrancy of the design & emotion research domain, and that the interest in

experience has outlived the suggestion that this may be a passing academic fashion, soon to be replaced by a newly launched research trend.

Design & Emotion Society

The Design & Emotion society raises issues and facilitates dialogue among practitioners, researchers and industry, in order to integrate salient themes of emotional experience into the design profession. The society, which was established in 1999, is a network organization that is used to exchange insights, research, methods and tools that support design for emotion activities. Although the initiative originated from the discipline of product design and design research, through the years practitioners from other design disciplines such as interaction design and branding design, have contributed to and benefited from the network and activities. Since its establishment, various sub-movements have arisen, and critical reflections on experience-driven design have emerged. The society acclaims this lively direction and willingly accepts the challenge to guide and stimulate the ongoing dialogue. Over the years, the network has expanded and the number of members has grown to over 3000. More importantly, after these successful conferences, a worldwide acknowledgement of the significance of the area of design & emotion was observed. In 2008, the Hong Kong Polytechnic University will host the sixth edition of the D&E conference.

Works Cited

Scherer, K.R. & Peper, M. (2001). Psychological theories of emotion and neuropsychological research. In Boller, F. and Grafman, J. (Eds.), *Handbook of Neuropsychology. Vol. 5* (Emotional behavior and its disorders, ed. G. Gainotti, pp. 17-48). Amsterdam: Elsevier.

CHAPTER ONE

ENGINEERING EMOTIONAL PRODUCT
IDENTITIES IN HIGH-LUXURY VEHICLES

MARCUS ABBOTT, JOHN P. SHACKLETON,
RAY HOLLAND, PETER GUEST
AND MELINDA-JUNE JENKINS

1. Automotive product uniformity

Product uniformity is a contemporary concept pervading many areas of consumerism in the developed world. It is, therefore, reflected widely in the literature (Hekkert et al. 2003; Karjalainen 2005; Snelders et al. 1999; Karjalainen et al. 2005); Simonetta Carbonaro and Christain Votava describe it as *"a vicious cycle of innovation pressure, information food and shorter product life cycles"* (Carbonaro et al. 2005) which inevitably impacts upon the product development - product consumption relationship. It is especially significant in the automotive marketplace, where the differentiation between the product offerings of different vehicle manufacturers has been narrowing for a number of decades as industry consolidation and production technologies have matured and globalised. Product performance (for example; power, acceleration, ride, handling, braking), quality levels, reliability, durability and safety levels, are no longer a competitive influence exclusive to the more expensive and luxurious marques. They have reached a level of "technical parity", converging to become a minimum requirement of the now experienced and knowledgeable consumer visiting any showroom (Accenture 2005; Antlitz et al. 2004; Cornet et al. 2005; Di Riso et al. 2005; Gruntegs et al. 2005; Jacoby 2006).

When evaluating this trend, it can be deduced that that which the consumer expects from a product could be defined in terms of product quality, being on the one hand objective; *"expressed by a state of physical*

fulfilment" (for example, the product meets its targets; is functional) or on the other, subjective; "*expressed by user satisfaction*" (for example, the way the product meets its targets; is delightful or appealing) (Kano et al. 1984). Kano's model for quality has been adapted more recently (e.g., Schutte 2005) to give an insight into the natural cycle of technology diffusion experienced by automotive consumers and those participating in many other mature product segments (de Chernatony et al. 2003). Many objective benefits were once attractive to automotive consumers when

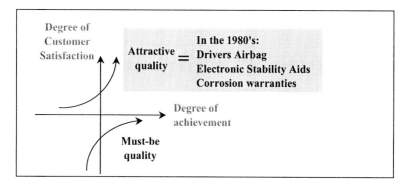

Figure 1-1. Kano Model (Kano et al. 1984) with examples of "attractive qualities" in automotive products in the 1980's.

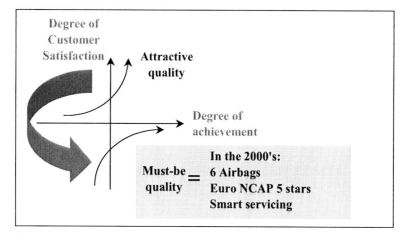

Figure 1-2. Kano Model (following the adaptation by Schutte 2005) with examples of "must-be qualities" in automotive products, 2000 onwards.

they were unexpected against normal performance and were rarely obtainable (Figure 1-1). During the past 25 years, however, they have become somewhat ubiquitous, obtainable and therefore largely expected, moving them from attractive to must-be qualities in consumers expectations (Figure 1-2).

2. The rise of the brand

The question can be posed, therefore; what are the new attractive product qualities for today's consumer in the automotive marketplace? There is significant evidence to suggest one answer may be the brand and brand-design. Branding is a cognitive concept (Franzen et al. 2001), made within the minds of the consumer (de Chernatony et al. 2003), with some physical manifestations (like a logo (e.g., the Nike "tick"), or sound (e.g., the Windows start-up tune) (Lindstrom 2005)) that promotes and motivates, for example, evocative cognitive associations that may include emotional thoughts and responses and narrative strings of "code" creating, in the most successful brands, rich streams of meaning (Alexander 1996; Karjalainen 2005; MacFarquhar 1994; Valentine et al. 1993) and the further expression of self-beliefs and values. Within the automotive marketplace, leveraging the brand's values through the design of the product, is one of the new product differentiation strategies and the battle-ground upon which commercial advantage is now being fought (Figure 1-3)

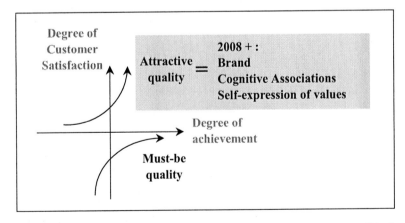

Figure 1-3. Kano Model (Kano et al. 1984) with examples of "attractive qualities" and "must-be qualities" for automotive products, 2008 onwards.

(Barroff 2006; Di Riso et al. 2005; Gonzalez 2006; Gruntegs et al. 2005; Simms et al. 2006).

Profitability, and even survival, appears to increasingly depend on the potency of the company's brand image and the distinguishability of its branded products (Carbon et al. 2005). Companies with strong brands have found that competitive advantage *and* competitive protection can be earned by carefully aligning key product qualities to their brand values (Aaker 1991; Rowland et al. 1994). Automakers focusing on the once attractive qualities of safety, for example, in their attribute based marketing campaigns, have found their market share correspondingly decline (Cornet et al. 2005) whilst the top product properties consistently held now by "high-involvement" products include attributes (the emotions, values and thoughts which we *attribute* to a product) that stimulate positive cognitive/associational links (of people, places, or life-styles), uniqueness (or novelty), nostalgic value and sensory appeal (Martin 1998). Consumer research and other commentary, therefore, support the proposition that a new preference exists for emotionally stimulating, brand related properties as the new attractive qualities of products in the automotive marketplace (e.g., Zhang et al. 1999). Stefan Jacoby, Executive Vice President for Marketing, Volkswagen Group, appropriately reflects; "*We produce cars, but sell emotions*" (Jacoby 2006).

In response to the rise of the brand, companies have shifted their focus from a singular approach to brand development (typically advertising communications) to broader and more diverse brand focused design, development, manufacturing, and product extension and marketing strategies. Brand strength has subsequently turned into a key business health-check (Haug et al. 2006; Phillips 2005; Reynolds et al. 2005; Valentine et al. 2000) whilst in many businesses every employee is being promoted as a brand ambassador (Heaton et al. 2005), and in automotive R&D divisions, developing products that embody attributes that enhance the brand are at the heart of many design and engineering attribute-management processes.

3. High-luxury and "pinnacle" brands

The high-luxury automotive segment, (cars selling for over €150,000), and "pinnacle" automotive segment (cars selling for over €220,000) are markets where the importance of the brand is distinct and marked. For

global conglomerates, luxury brands are important flagships, hearts of core competences and a precious resource (Dannenberg et al. 2004);

> For a manufacturer, possession of evocative brands is now an asset more valuable than ownership of industrial real estate or even access to technology" (Bayley 2005, describing Aston Martin).

Here, luxury is framed more in the traditional sense, of exclusive, conspicuous, physical products like cars, clothing, furniture etcetera, and less so in the emerging "new-luxury" described by Bayley, Müller-Pietralla and others of rare, non-physical, qualities like time, exploration and authenticity (Pearlfisher 2005; Müller-Pietralla 2005; Ellison 2007). Nevertheless, both are inexorably linked for those participating in the high-luxury automotive segments, mirroring a general observation of culture within many evolving luxury product markets;

> Customers are no longer "consumers" [they are] no longer impressed by something as simple as superlatives... Rather, they are much more seeking intuitively understood reference points, which are in harmony with their own value system and their individual life themes (Carbonaro et al. 2005).

In other words, many consumers *"are looking for a brand that suggests the universe to which they aspire"* (Dejean 2006); utilising the artefact as an extension of their self-image (Belk 1988). The transport needs of high-net-worth individuals, therefore, have become a reflection of personal self-expressions and values rather than providing just the utility of getting from "A to B" (Taylor 2003). Most will outlay the highest percentage of their discretionary spend in "investments of passion", like cars. Many will also own a collection, of varying types for specific occasions, and when considering another will exercise their facility to opt between, maybe, another car, a boat, a painting or new holiday home (Hallmark, in Autoweb 2002).

Within these segments, there is a select group of established brands that operate exclusively within it; for example Aston Martin, Ferrari, Lamborghini, Rolls-Royce, Bentley, and more recently, the re-launch of Bugatti. Common to these marques are rich and clearly recognisable brand identities built on decades of luxury and sporting heritage. Automakers attempting to break into these segments can quickly hit consumer-acceptance barriers if they do not possess established, recognisable and congruent brand identities to support their proposition (Eisenstein 2004; Shulinder 2005; Taylor 2003). Bentley's recent accomplishment in this arena is, in part, based on new product introduction programmes focused

on products that embody attributes that support the brand's five values or "pillars"; Racing, Driving, Power, Design and Craftsmanship (Feast 2004; McCormick 2005). These values have long-established foundations stretching from five LeMans wins in the 1930's (and more recently a sixth in 2003) through propositions of the romance of touring, torque (more salient, perhaps, than power) and style, to luxury and bespoke coachwork for British Royalty. As far back as 1933, Autocar described how influential the character of the Bentley brand is in the product experience. The passage is worth including here in its entirety because of its insight and remarkable suitability to the current topic;

> One of the most interesting and at the same time most curious things in connection with motoring is the way in which certain cars acquire what can only be termed a personality, odd though the term may seem in connection with machinery. Once achieve this point and a firm has every prospect of success, since the owners of the car in question hold stoutly the opinion that there is no better machine to be had, and take, as it were, a personal pride in any success the marque may attain. So it is with the Bentley (Autocar, October 6th 1933).

Authentic, emotionally founded, brand-values personified in and experienced through the branded product are therefore a significant component to success in the high-luxury automotive marketplace, whilst in a wider context, these themes are also increasingly areas of discourse for contemporary product and brand theorists and practitioners concerned with evolving mass affluence and luxury cultures within many other product markets (Carbonaro et al. 2005; Muller-Pietralla 2005; Pearlfisher 2005; Karjalainen et al. 2005).

4. Brand and product categorisation

It is common to the established brands in the high-luxury and "pinnacle" automotive segments that their appeal is based upon the cognitive associations that follow from their distinct brand identities and values that have developed over time, and have become interwoven into each product representation. Consider, for example, one Bentley customers' recent comments about "performance feel" in the Continental GT;

> It was good. It just pulls like a steam train. It feels very much like a Bentley engine; that's good. It feels like a Bentley engine, that's important to say (personal communication).

For automakers striving to understand how to promote these emotional associations in consumers' minds, it is important to have an understanding of how cognitive concepts, like a brand, are perceived through the receipt of *specific* multi-sensory stimuli. Cognitive science proposes the process is one where the stimulating properties are passed though our senses, categorised, understood and sometimes combined to create further cognitive concepts corresponding to other beliefs, that, in turn, lead to physical outputs; allowing *"meaning to cause and be caused"* (Pinker 1997) (Barsalou 1983; Eco 1976; Fodor 1998; Hampton 2006; Kenny 1994; Margolis et al. 1999; Martindale 1990; Pinker 1997; Rey 1999; Rosch 1999; Simon 1996). This phenomenon can be clearly demonstrated within the current topic; significant research has been published into the stimuli, categorisation and associative meanings of brands and their subsequent power to mould consumer satisfaction (Aaker 1991; de Chernatony et al. 2003; Czellar 2003; Keller 1993; Lindstrom 2005) through a spectrum of derived congruent rational or emotional benefits like affordances, recognition, delight or self-esteem (Kreuzbauer et al. 2005; Romaniuk et al. 2004).

"Authenticity" of the product to expected brand-values is an important example of such a cognitive association mechanism. As discussed earlier, historical, or "lineages" of associations are particularly salient for automotive brands, like Volvo or Mini, that aim to evoke perceptions of authenticity, heredity and therefore credibility against certain product properties (Karjalainen 2005; Simms et al. 2006). Lindstrom, more widely, suggests;

> Your primary objective… should be to ensure that all the historical links and associations connected to your brand are supported, [they are] the strongest competitive advantage of [the] brand" (Lindstrom 2005),

where "support" means the presence of appropriate multi-sensory stimuli that motivates accurate brand-categorisation effects. Lindstrom further encourages brand custodians and product creators to deconstruct this relationship (calling out; *"Smash your brand!"*) to examine the lineage of the concept's associative links from the constituent units that stimulated it, emulating the brief for the designer of the "Coke" bottle; *"create a design which could be instantly recognised from a single piece if it were smashed on the floor"*.

5. Brand as category

The dominant hypotheses within cognitive science, marketing and product management postulates that "brand" is one property, or a collection of properties of a product, and that product is subject to cognitive categorisation and prototype effects within a product category (like Mobile Phones); for example, Romaniuk et al. (2000), cited in de Chernatony et al. (2003), identified that the properties of prototypical brands within a product category enabled consumers to predict the performance of unknown brands based on property commonality. They accompany others, where discussions explore the influences of brand properties in product category segmentation (for example, Henderson et al. 1998; Kreuzbauer et al. 2005; Meyvis et al. 2002; Warlop et al. 2006; Karjalainen et al. 2005; Warell 2006), or the reciprocal influence of the product category on the character of the brand (e.g., Batra et al. 2006).

Whilst this is the popular view, recent emerging hypotheses also suggest that *some* brands are *taxonomic* categories in themselves; their constituent members being the products of the brand category (Abbott et al. 2007; Boush 1993; Joiner et al. 1998; Loken et al. 2002). When brands are considered as cognitive categories, laws of prototypicality and "family resemblances" (Kenny 1994) emphasise the saliency of brand related product properties rather than common functional product properties or objective benefits embodied across and within multiple brands. However, limited evidence to support this view exists in the literature, as acknowledged by Boush. To add to the knowledge, Abbott et al. (2007) demonstrated recently that branded concepts like the Apple iPod behave as "natural" categories as well as being constituent members of an alternative category, the product category "MP3 player".

The cognitive processing mechanisms of concept property reception that lead to the identification of an example, or set of examples, as the best example(s), or "prototype(s)", within a given cognitive category are important here. This is because evidence suggests that, to some degree, consumer satisfaction is based on constructs of category prototypicality within the high-luxury auto segment and that it aids brand identification accuracy and "fitness for purpose" (or in this case, "fitness for brand") (Franzen et al. 2001). Consequently, for brand managers and product creators, focus needs to be placed on *which* product properties are most salient in consumers' identification of a product being typical of, for example, a Bentley, and how that understanding can be expressed

empirically, so that future product proposals can be assessed for typicality during the development phase and appropriately modified.

6. Selective Modification Model

To help inform this process, a lead can be taken from Smith et al. (1988) who proposed the Selective Modification Model as a method which has become common within the literature, for typicality measurement within concept categories based upon cognitive judgements of similarity/dissimilarity of examples to a prototype set. The model identifies concept property "diagnosticity values" (the usefulness of the property in discriminating the concept) and property saliency (the strength of the property in discriminating the concept) and is *"...among the only theories... to offer quantitative predictions about typicality"* (Smith et al. 1988). Hampton (2006) observes that the Selective Modification Model can be successful in identifying typicality but should not be taken as a model for categorisation, despite both assessments being subject to the constructs of similarity. Categorisation is determined by the presence of some absolute content which when above a certain threshold triggers category membership. The Selective Modification Model, however, does not define thresholds, but *relative* values of similarity. Interest in these methods in this paper is in the potential *identification* of prototypical property diagnosticity and salience values for the brand-concept BENTLEY rather than exploring, at this time, example typicality. It is proposed, therefore, to follow an exploration of that element alone, although an eye is kept on its logical development into typicality assessments at a later date.

7. Heritage study

The value of closely managing established brand properties within and through the branded product is clearly recognised. Further, it is widely observed that concept recognition and cognitive categorisation is based upon attained and experiential knowledge of the concept (e.g., Fodor 1998; Simon 1996). Therefore, in the analysis of branded product "typicality", or in this case "Bentleyness", it appears appropriate to draw reference to a lineage of products familiar to the viewer. At Bentley Motors a study to identify product properties and features that are typical to the brand was conducted, and according to the guiding principles above, included examples from the company's past product portfolio as test stimuli. In the analysis of results from this first study, the complex brand-concept BENTLEY was further segmented to facilitate calculations and to align a

focus area of the vehicle to parallel research. Consequently, the detail following describes the characteristics of the brand-concept BENTLEY INTERIOR.

8. Hypothesis

The background research lead to an expectation that some product properties are more or less important in the stimulation of the identification of the concept BENTLEY INTERIOR, and that "prototype effects" may be evident. Also, it was expected that *if* certain properties were more or less important in that stimulation, they would be *differently* important (scaled) for different product properties. As discussed above, such conclusions would be advantageous to product and brand development generally; through understanding these concepts it may be possible to inform and subsequently influence the forward projection of new branded products and therefore also, consumer satisfaction relative to anticipated associative thoughts, beliefs, values and emotions.

9. Study method

A group of 160 associates of the company, both male and female, but with a design and engineering bias, was randomly selected to review, in groups of 40, a collection of five vehicles and over 400 photographs categorised by discrete features, that included, for example, "Exterior and Interior Lighting", "Glazing", "Exterior and Interior Handles", "Colours", "Veneers" and "Seat Styles" (Figure 1-4). The photographs were pre-selected by the first, fourth and fifth authors, from a database of over 3000 feature examples taken from products made by the company between the early 1920's and 2002 and grouped into 36 feature categories with 12 different examples of the feature in each category (see Figure 1-5 for two examples from the categories "Airvents" and "Instruments"). The collection of vehicles was also sourced by the first, fourth and fifth authors from the Bentley Lineage collection, with examples from the 1930's through to the 1990's, including four previous production cars and one bespoke Royal vehicle. Reviews were limited to a 1-hour duration and discussion between the participants was not restricted. Participants were also encouraged to assess features through visual cues, in the case of the photographs, or other sensory stimuli, in the case of the vehicles, which could be sat in, but not driven, thereby limiting stimuli to non-dynamic properties. Participants were then asked to identify their top ten feature examples, in no specific order, which to them most represented the higher-

level concept BENTLEY, seven from the photographic collection and three from the vehicle collection and which of the five vehicles was most typical

Figure 1-4. Bentley Heritage Study layout.

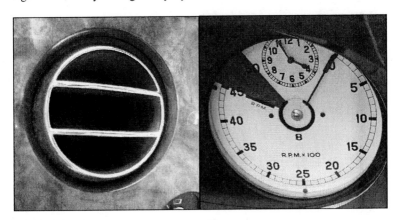

Figure 1-5. "Bulls-eye" Airvent and Tachometer with clock; feature examples from the Bentley Heritage Study photographic collection.

overall. In asking for an explanatory note about each of the chosen examples, significant quantities of free-form elaborative descriptions were also collected, consisting predominantly of adjectives or nouns with adjectival relationships (for example; "jewellery" > "jewelled").

10. Analysis and results

Analysis of the data collected took two forms; firstly a sum of votes for specific features and secondly, a detailed analysis of descriptors with diagnosticity calculations according to the Selective Modification Model, focused on the vehicle interior alone. The aim of conducting the first analysis was to identify which feature categories, or properties, were exemplars of the concept BENTLEY INTERIOR and which, if any, category members could be identified as having perceptions of prototypicality. The aim of the second analysis was to identify how attributed descriptions of the properties were most salient in stimulating the identification of typicality for different interior vehicle features.

By summing individual feature scores, the results of the analysis of photographic feature categories identified that there were distinct groups

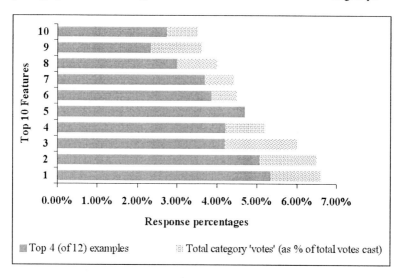

Figure 1-6. Percentage of total responses received allocated to the Top 10 feature categories. Responses attributed to the top 4 of the 12 possible examples within each category shown hatched.

of highly popular features; those appearing more frequently in participants' identifications of examples that most represented the concept BENTLEY INTERIOR; supporting the hypothesis that certain features are more or less important in the identification of this brand-concept. The top ten scoring feature categories, of the 36 possible, represented 49% of the total 1275 responses (Figure 1-6). These categories included features such as "Luxury items" (including, for example, companion mirrors and drinks cabinets) "Veneer" and "Brightware" (for example, the application of chromed metal details to audio speaker surrounds and gauge bezels). All the features are not named here to protect commercial confidentiality.

Also, within those feature categories, there were limited and discrete exemplars present. For example, the top feature category ([1], Figure 1-6.) attracted 85 responses, with 81% of these given to four features from the 12 available. It is proposed, therefore, based upon likeliness of selection and cognitive efficiency principles (e.g., Pinker 1977), that those four examples are more prototypical of the feature reviewed than other examples present. Note also, in Figure 1-6, how some feature categories examined on this basis included exemplars with stronger or weaker prototypicality effects; category five had all of its responses determined by four of the 12 possible examples, thereby suggesting distinct prototypicality and supporting the hypothesis that features which are more or less important in the identification of the brand-concept do so by varying amounts. A similar analysis of the vehicle collection showed that the examples were also distinctly ranked, with the most popular example receiving 10% more responses than the next highest, suggesting that prototype effects exist within both the photographic and physical exhibits reviewed.

The first analysis also performed the function of ranking the prototypical features in preparation for the second stage; 81% of all descriptors collected being allocated to the top 12 feature categories. Remaining categories contained statistically insufficient numbers of descriptors to analyse and were subsequently eliminated. The feature categories were further reduced to nine to include only those influencing the specific area of interest, the interior of the vehicle (feature a, b,...i., Table 1-1). Following Selective Modification Model principles, the participants free-form explanations of the nine features identified as being typical of the concept BENTLEY INTERIOR were analysed by the first author for elaborative descriptors. For example, adjectives *"detailed"*, *"intricate"* and *"hand-crafted"* were extracted and listed from individual response

forms. Many of these were emotionally based reactions attributed to the features encountered (for example; "*beautiful*"; "*stylish*"), some were more rational (for example; "*clean*"; "*metallic*"). To enable diagnosticity calculations for each feature category, each descriptor extracted from the responses was allocated a "vote" towards a defining construct; a higher-order synonym-type concept. For example, the feature "Tool Kits" (feature [d], Table 1-1) included descriptors "ordered", "simplicity", "clean" and "precise", which were collapsed into the construct "Precision" with the aid of Wordnet 2.1 (http://wordnet.princeton.edu), a linguistics tool that identifies synonyms ranked by likeliness of instantiation within common dialogue. Descriptors with total votes below 5 were further collected into sub-constructs to make them statistically significant, or were eliminated from the analysis if synonym relationships could not be identified.

Property diagnosticity is the measure of discrimination of concept properties verses other concept properties and was derived in this study, following Smith et al. (1988), through an n by x table, whereby n is the number of attributed descriptors ($n=39$) and x the number of features assessed ($x=9$). Diagnosticity values (v) are then calculated through the formula;

$$v=(x^2/N \min (A\text{-}1), (B\text{-}1)) \ 1/2$$

where x^2 equals chi square, N the total number of constructs, A the number of rows and B the number of columns. The chi square tests were conducted using software available at http://graphpad.com/quickcalcs.

Table 1-1 shows the diagnosticity values resulting for the 9 interior feature categories derived from this study. Of these, "Precision", "Hand-crafted", "Refined" and "Comfort" produced statistically significant chi square values of less than 0.05 ($p<0.0001$; 0.0214; 0.0362 and 0.0285 respectively). Diagnosticity values identified according to the Selective Modification Model also demonstrate that individual descriptors are not equally important when diagnosing typicality for the concept BENTLEY INTERIOR, thus supporting Smith et al.'s (1988) general findings, and the hypothesis in this application; constructs such as "Ordered" and "Quality" are more salient (have higher value) when assessing prototypical Bentley Tool Kits, for example than "Detail" or "Bespoke". Overall, the construct "Precision" concluded with a significantly higher diagnosticity value than other constructs due to the influence of its component descriptor "simplicity", which tended to be used by reviewers to describe degrees of

restraint and lack of complication involved in the exact execution of the features assessed.

The analysis also identified some interesting construct effects; the construct "Potency", for Tool Kits, has a high diagnosticity value for the feature. This suggested two potential phenomena evolving; firstly, that such elaborative constructs, which express capabilities beyond some basic

	Property				Feature	a	b	c	d	e	f	g	h	I
Diagnosticity value	Construct	Construct total Observed	Descriptor Observed	Descriptor										
9.298	Precision	61	14	ordered		1	1	2	8			2		
			32	simplicity		1	7	3	1	4	5	3	5	3
			6	clean				2	1	1				2
			9	precise						4			4	1
2.681	Hand crafted	44	22	like furniture	21									1
			15	craftsmanship	9	1	2	1	1					1
			7	care	4				2					1
2.315	Refined	59	11	beautiful	3		1	1	1	2	3			
			21	elegant	4	4	4		3	2	2			2
			27	stylish		4	13		4	2	1	1		2
1.673	Comfort	30	21	comfortable		20				1				
			9	armchair		9								
1.046	Character	25	5	expressive		1	2		2					
			10	sporty		3	4				2			1
			5	potency				5						
			5	character	2	1	1			1				
0.743	Quality	23	15	quality			2	8	1			2	2	
			8	appealing	6		1		1					
0.697	Luxurious	19	9	luxury	3	4			2					
			6	rich	1	1		1			1	2		
			4	jewellery	1			1		1		1		
0.398	Structure	14	5	solid	2		1			1		1		
			9	strong	1	1				3		2	2	
0.385	Form	39	11	size	7	2			2					
			7	form	7									
			11	flowing	6					1	3		1	
			10	graphic	2					2	3	1	2	
0.188	Practicality	26	9	functional		4	2			2		1		
			7	practical			3	1		2	1			
			10	utility					5			1	4	
0.175	Bespoke	28	9	branding	2		2	4	1					
			11	individual	3		2	3	1	1			1	
			8	distinct	1	1		1	2	1	1	1		
0.165	Lineage	19	11	class		1	4			2	1		3	
			8	pedigree		4	3				1			
0.044	Sensory	16	6	soft		1	2		1		1	1		
			5	tactile		1			1		1			
			5	metallic							4	1		
0.010	Detailing	33	17	detailed				7	4	2		1	3	
			16	intricate	14	2								
					101	71	55	54	35	34	30	28	28	

Table 1-1. Analysis of adjectival descriptors collected for interior feature categories and the calculation of diagnosticity values.

requirements, or "must-be" qualities, of the modern automotive product, maybe significant when assessing some feature examples for typicality to the concept BENTLEY and are potentially one of the "attractive qualities" of the brand. Or, secondly, that some fondly-thought-of features that were once important were being artificially elevated through nostalgic cognitive judgements. Further research into the retrospective review method employed in this study verses contemporary cognitive judgements of past products and their properties are necessary to understand these effects fully, and to enrich this discourse.

11. Further applications

Following the principles proposed by Smith et al. (1988) with the Selective Modification Model and Tversky's related Contrast Principle (in Margolis et al. 1999), similarity to the category prototype can be assessed using the diagnostic values identified; those studies were successful in identifying similarity scores for a number of "basic" concepts including BIRD and APPLE. For more complex brand-concepts like BENTLEY, or the lower-order concept BENTLEY INTERIOR, little research has been conducted into the measurement of typicality to a prototype or prototype set with a brand-category. Therefore, further research would also benefit from similar review and analytical processes to that described and available elsewhere. To do this with current and/or future branded product concepts may help to define and refine the application and enable the assessment of consumer satisfaction through understanding and measuring the cognitive constructs that evoke an "authenticity" perception. However, as discussed, concerns do arise when diagnosing salient properties for a concept that has evolved over extended periods. The perceptions and the elaborative, emotive descriptions attributed through the study of example features created from as far back as 1923, may be biased by contemporary reference points arising within today's technological, social or cultural context. Nevertheless, this makes values obtained by the current work no less valid, as the brands current diagnosticity, with all its evolutionary "moulding" in the consumers mind, over extended periods, is the basis upon which *they* assess typicality for current and future product offerings.

It is also apparent that the brand-concept is elaborated through emotive, rich and complex defining properties that have varying degrees of saliency in the stimulation of the brand-categorisation effect. Some properties maybe interwoven with those defining alternative brands within the product category, some are likely to be unique. In order that brand

managers and product creators are able to profit from this analysis by it informing the product development process, understanding the distribution of the constructs across multiple product examples within the brand-category "semantic space" would be useful. To make it more valuable still an application together with assessments of alternative brands and their product examples against those constructs should be considered. This may then help facilitate the development of products that further enhance their brands distinguishability against alternative brands and sharpen prototypicality assessments that are constructed through consumers cognitive processing of specific property stimuli and their emotive reactions to it. This theme is further explored in Abbott et al. (2008a).

12. Conclusions

This paper discusses the prevalent differentiating product properties of vehicles in the high-luxury and "pinnacle" market segments and observes that, over time, "attractive (product) qualities" have become brand-based and associated with the expression of personal beliefs, values and emotions. Following cognitive science theories and methods, the processes that allow these attributes to be attached to a brand-concept through its prototypical product examples that have developed and evolved over extended periods have been explored and finally measured.

Building on the appropriate and available research foundations, it is proposed that to design and engineer successful product evolutions, which satisfy these prevalent attractive product qualities, an understanding of the cognitive diagnosis of typicality to a prototype would be helpful in order that it may inform and guide the product development process. In conducting a focus group study of heritage properties at Bentley Motors Limited, supporting evidence was gathered through quantitative and qualitative data recording that confirmed the exemplars of the concept BENTLEY INTERIOR and judgements of prototypicality for features around the interior of the car. Using the Selective Modification Model, feature properties that stimulated perceived best-fit between the brand and the product were found to follow principles identified in research elsewhere and the expected results in the hypothesis; they are both variable (different) between features and weighted (have a measurable scaled importance).

Values identified for the "diagnosticity" of the concept BENTLEY INTERIOR, by feature, could be used to further extend this research to assess both typicality and potential "authenticity" of new product examples to the brand-category, for example, through the application of

the second stage of Tyversky's Contrast Principle (in Margolis et al. 1999). This methodology could be further combined with other quantitative and qualitative analysis tools from cognitive science and marketing disciplines as an informative guide or modification process in the management of brands and in the engineering of emotional product identities in high-luxury vehicles.

Works Cited

Aaker, D.A. (1991). *Managing Brand Equity; Capitalizing on the Value of a Brand Name*. NY, USA: The Free Press.

Abbott, M., Shackleton, J.P. and Holland, R. (2007). "Brand" as Category; An Analysis of Categorisation and Branded Product Concepts. *Proceedings from The International Associations of Design Research 2007,* Hong Kong, 12⁻15ᵗʰ. November 2007.

Abbott, M., Shackleton, J.P. and Holland, R. (2008a). Measuring the Brand Category through Semantic Differentiation. *Journal of Product and Brand Management.* In press.

Accenture (2005). *High Performance in the Automotive Industry.* URL: www.autoassembly.mckinsey.com edn. McKinsey and Company.

Alexander, M. (1996). *The Myth at the Heart of the Brand.* URL: www.semioticsolutions.com; ESOMAR Seminar; The Big Brand Challenge, October 1996.

Antlitz, A., Dr. et al. (2004). *Hands on the Wheel; What Customers Really Want From the Automotive Industry.* URL: www.autoassembly.mckinsey.com edn. McKinsey and Company.

Autoweb (2002). *Bentley GT Coupe; The Marketing Story.* URL: www.autoweb.com.au

Barroff, R. (2006). Editorial. *Interior Motives,* Jan/Feb 2006.

Barsalou, L.W. (1983). Ad-hoc Categories. *Memory & Cognition,* **11**(3), 211-227.

Batra, R., Lenk, P. and Wedel, M. (2006). *Separating Brand from Category Personality.* University of Michigan. Unpublished. URL: www.umich.edu.

Bayley, S. (2005). Aston Martin V8 Vantage. *Car Magazine,* October 2005, pp. 120.

Belk, R.W. (1988). Possessions and the Extended Self. *Journal of Consumer Research,* **15**(2), 139-168.

Boush, D.M. (1993). Brands as Categories. In Aaker, D.A. and Biel, A.L. (Eds.), *Brand Equity and Advertising: Advertising's role in Building Strong Brands.* NJ, USA: Lawrence Erlbaum Associates.

Carbon, C. and Leder, H. (2005). The Repeated Evaluation Technique (RET). A Method to Capture Dynamic Effects of Innovativeness and Attractiveness. *Applied Cognitive Psychology,* 19, 587-601.

Carbonaro, S. and Votavo, C. (2005). Paths to a New Prosperity. *Presentation, 5th International Conference on Design & Emotion.* Gothenburg, Sweden 2006.

Cornet, A. and Krieger, A. (2005). Customer-Driven Innovation Management. URL: www.autoassembly.mckinsey.com edn. McKinsey and Company.

Czellar, S. (2003). Consumer Attitude Toward Brand Extensions: An Integrative Model and Research Propositions. *International Journal of Research in Marketing,* 20, 97-115.

Dannenberg, J. and Kleinhans, C. (2004). The Coming Age of Collaboration in the Automotive Industry. *Mercer Management Journal,* June 2004.

De Chernatony, L. and McDonald, M. (2003). Creating Powerful Brands. 3th edn. Oxford, UK: Elsevier Butterworth Heinemann.

DeJean, J. (2005). The Essence of Style. URL: www.luxuryculture.com. November 2005.

Di Riso, G., Ghislanzoni, G. and Scalabrini, G. (2005). Selling the Sizzle-"Super Car" Marketing in Europe. URL: www.autoassembly.mckinsey.com edn. McKinsey and Company.

Eco, U. (1976). *A Theory of Semiotics.* 1 edn. Ontario, Canada: Indiana University Press.

Eisenstein, P.A. (2004). *Maybach Learning Some Costly Lessons.* URL: www.TheCarConnection.com. March 2004.

Ellison, H. (2007). The Quest for Authenticity. *LuxeAsia, Supplement of The International Herald Tribune,* September 2007, 16-17.

Feast, R. (2004). The DNA of Bentley–Rich Heritage. *Challenging Future.* 1 edn. St. Paul, USA: Motorbooks International.

Fodor, J.A. (1998). *Concepts: Where Cognitive Sciences Went Wrong.* Oxford, UK: Oxford University Press.

Franzen, G. and Bouwman, M. (2001). *The Mental World of Brands–Mind, Memory and Brand Success.* Oxford, UK: World Advertising Research Centre.

Gonzalez, R.W. (2006). *Brand Strategy and Design; The Accelerating Importance of Design in Creating Compelling Appeal and Differentiation.* Amicus Group Whitepapers, No.14. URL: www.amicusgroup.com.

Gruntegs, V., Grupen, C., Hoelscher, A., Mitchke, M. and Wunram, J. (2005). *Customer Driven; How to Achieve Sales and Marketing*

Excellence. URL: www.autoassembly.mckinsey.com edn. McKinsey and Company.

Hampton, J. (2006). *Conceptual Combination.* URL: www.staff.city.ac.uk/hampton/combination, July, 2006.

Haug, K., Malorny, C., Mercer, G. and Zielke, A. (2006). *Nissan Outperforms Again.* URL: www.autoassembly.mckinsey.com edn. McKinsey and Company.

Heaton, C. and Gizzo, R. (2005). *Delivering on the Brand Promise; Making Every Employee a Brand Manager.* URL: www.autoassembly.mckinsey.com edn. McKinsey and Company.

Hekkert, P., Snelders, D. and van Wieringen, P.C.W. (2003). "Most Advanced Yet Acceptable": Typicality and Novelty as Joint Predictors of Aesthetic Preference in Industrial Design. *British Journal of Psychology,* 94, 111-124.

Henderson, G.R., Iacobucci, D. and Calder, B.J. (1998). Brand Diagnostics: Mapping Branding Effects Using Consumer Associative Networks. *European Journal of Operational Research,* 111, 306-327.

Jacoby, S. (2006). Living the Brand: The Potential of Marketing Innovation, *Volkswagen 3rd. World Marketing Conference,* Wolfsburg, Germany, 28-29th June 2006.

Joiner, C. and Loken, B. (1998). The Inclusion Effect and Category-Based Induction: Theory and Application to Brand Categories. *Journal of Consumer Psychology,* 7(2), 101-129.

Kano, N., Seraku, N., Takahashi, F. and Tsuji, S. (1984). Attractive Quality and Must-Be Quality. *Translation from "Hinshitsu" (Quality, The Journal of the Japanese Society for Quality Control),* 14(2).

Karjalainen, T. (2005). Safe Shoulders and Personal Faces: Transforming Brand Strategy to Product Design. *Proceedings of the 12th International Product Development Management Confernece,* Copenhagen, Denmark, 12-14th June 2005.

Karjalainen, T. and Warell, A. (2005). Do You Recognise This Tea Flask ? Transformation of Brand-specific Product Identity Through Visual Design Cues. *Proceedings of the Internaional Design Congress 2005,* Taiwan, 1-4th. November 2005.

Keller, K.L. (1993). Conceptualizing, Measuring, and Managing Customer-Based Brand Equity. *Journal of Marketing, 57(*1), 1-22.

Kenny, A. (ed. 1994). *The Wittgenstein Reader.* Blackwell Publishing.

Kreuzbauer, R. and Malter, A.J. (2005). Embodied Cognition and New Product Design: Changing Product Form to Influence Brand Categorisation. *Journal of Product Innovation Management,* 22, 165-176.

Lindstrom, M. (2005). *Brand Sense; How to Build Powerful Brands Through Touch, Taste, Smell, Sight and Sound.* London, UK: Kogan Page.

Loken, B., Joiner, C. and Peck, J. (2002). Category Attitude Measures: Exemplars as Inputs. *Journal of Consumer Psychology,* **12**(2), 149-161.

MacFarquhar, L. (1994). This Semiotician Went To Market. *Lingua Franca,* September/October 1994, 59-79.

Margolis, E. and Lawrence, S. (ed. 1999). *Concepts–Core Readings.* Cambridge, Massachusetts, USA: MIT Press.

Martin, C.L. (1998). Relationship Marketing: a High-involvement Product Attribute Approach. *Journal of Product & Brand Management,* **7**(1), p6.

Martindale, C. (1990). *The Clockwork Muse; The Predictability of Artistic Change.* USA: Basic Books.

McCormick, J. (2005). Bentley Finds the Super-Luxury Sweet Spot. *Detroit News,* July 2005.

Meyvis, T. and Janiszewski, C. (2002). *When Are Broader Brands Stronger Brands? An Accessibility Perspective on the Formation of Brand Equity.* URL: www.cba.ufl.edu. July, 2006.

Muller-Pietralla, W. (2005). *Desire, Exclusivness, Future of Luxury.* Unpublished. Personal communication.

Pearlfisher, (2005). *Lifemodes.* Unpublished. Personal communication.

Phillips, C. (2005). *Branding From the Inside Out: How to Approach Brand Strategy, Brand Measurement and the Management of Brands as Assets.* URL: www.brandamplitude.com. December 2005.

Pinker, S. (1997). *How the Mind Works.* Penguin.

Rey, G. (1999). Concepts and Stereotypes. In Margolis, E. and Lawrence, S. (Eds.), *Concepts–Core Readings.* Massachusetts, USA: MIT Press.

Reynolds, T.J. and Phillips, C.B. (2005). In Search of True Brand Equity Metrics: All Market Share Ain't Created Equal. *Journal of Advertising Research,* June 2005.

Romaniuk, J. and Sharp, B. (2004). Conceptualizing and Measuring Brand Salience. *Marketing Theory,* **4**(4), 327-342.

Rosch, E. (1999). Principles of Categorisation. In Margolis, E. and Lawrence, S. (Eds.), *Concepts–Core Readings.* Massachusetts, USA: MIT Press.

Rowland, G. and Evans, M. (1994). Topographers of the Galactic Frontier. *Co-design,* **3**(1), p84.

Schutte, S. (2005). *Engineering Emotional Values in Product Design.* Linkopings University.

Shuldiner, H. (2005). Cars for Connoisseurs. *Chief Executive.* URL: www.chiefexecutive.net, May 2005, (208).

Simms, C.D. and Trott, P. (2006). The Perceptions of the BMW Mini Brand: The Importance of Historical Associations and the Development of a Model. *Journal of Product and Brand Management,* **15**(4), 228-238.

Simon, H.A. (1996). *Sciences of the Artificial.* 3rd edn. Cambridge, Massachusetts: MIT Press.

Smith, E.E., Osherson, D.N., Rips, L.J. and Keane, M. (1988). Combining Prototypes: A Selective Modification Model. *Cognitive Science,* 12, 485-527.

Snelders, D. and Hekkert, P. (1999). Association Measures as Predictors of Product Originality. *Advances in Consumer Research,* 26, 588-592.

Taylor, A., III (2003). Luxury Cars–Got $300,000?; These Cars Are For You. *Fortune,* January 2003.

Valentine, V. and Evans, M. (1993). The Dark Side of the Onion; Rethinking "Rational" and "Emotional" Responses. *Journal of the Market Research Society,* **35**(2), 125.

Valentine, V. and Gordon, W. (2000). The 21st. Century Consumer–A New Model of Thinking. *MRS Annual Conference,* 2000.

Warell, A. (2006). Identity Recognition in Product Design: An Approach for Design Management. *13th International Product Development Management Conference,* 11-13th. June 2006, European Institute for Advanced Studies in Management (EIASM).

Warlop, L., Ratneshwar, S. and van Osselaer, S.M.J. (2006). *On the Role of Distinctive Brand Cues in Learning Product Quality from Consumption Experience.* URL: www.econ.kuleuven.ac.be November, 2006.

Zhang, L. and Shen, W. (1999). *Sensory Evaluation of Commercial Truck Interiors,* SAE. 1999-01-1267.

CHAPTER TWO

"FIVE SENSES TESTING"–
ASSESSING AND PREDICTING SENSORY
EXPERIENCE OF PRODUCT DESIGN

RODNEY ADANK AND ANDERS WARELL

1. Introduction

Sensory perception is a basic mode of experiencing products and product use and is the basis of a pleasurable interaction with products. Our senses, commonly classified as vision, hearing, touch, balance, taste/smell (Mather 2006), are the first point of contact with the physical product, and should be a valuable source of information in the development and design of products.

Goldstein (2002) writes: "*One purpose of perception is to inform us about properties of the environment that are important for our survival*". For the purposes of design, we may go so far as to say that the role of sensory perception is to guide us to engage with products that look and feel safe, friendly or useful. Perception and pleasure attained from sensorial stimuli is not the same for all; it is highly subjective, and it is linked to the shifting aspects of individual, cultural and social variables. The process of perception involves responding to external stimuli from the sensory system: synthesizing, merging, combining and selectively accepting/rejecting sensory information along with other internal sources of information that make up the variable factors and shifting aspects of the individual (Berlyne 1971). Moreover, it is dependent on sensory modalities governed by different individual perceptive characteristics, which, in all, makes every sensory experience a highly individual affair (Bonapace 2000). Psychophysical research has shown that the inherent variability in our perceptual interpretations means that the same event

viewed by different individuals generates different perceptual responses (Mather 2006).

Bonapace (2000) discusses the world around us as *"a supplier of stimuli that reach people through sensory channels which triggers the stimulus and response mechanisms"*. These response mechanisms include: input–sensorial stimuli from the environment; perception–what the individual receives after stimuli pass through psycho-sensorial filters; cognition–the consequent elaboration and decision-making; action–the result of the decision; output–the result of the action.

The senses are the source of our aesthetic experience of the product–in fact, the original Greek word *aisthetikos* refers to *"sense perception"* (Merriam-Webster 2006). Through the work of Baumgarten in the mid-eighteenth century, the meaning of the term changed into *"philosophy of the beautiful"* (Burnham 2006) or *"sensuous delight"* (Goldman 2001), a generally accepted use of the term "aesthetics" today. In fact, Hekkert (2006) proposed a definition of aesthetics that equates it with pleasure attained from sensory perception.

Sensory perception as part of the total product experience leads to a range of effects originating in products, including aesthetic, emotional and pleasurable responses. According to Hekkert (2006), product experience can be seen as

> the entire set of effects that is elicited by the interaction between a user and a product, including the degree to which all our senses are gratified (aesthetic experience), the meanings we attach to the product (experience of meaning), and the feelings and emotions that are elicited (emotional experience).

In fact, Berlyne (1971) notes that *"all stimuli that are registered by the nervous system have motivational effects, including the physiological indices of emotional impact"*. More recently, other authors have discussed the senses in relation to other parts of the product experience, especially parts related to feelings and emotions. The *"pleasurable products"* (Jordan 2000) and *"emotional design"* movements (Desmet 2002; Norman 2004) are based on the understanding of hedonic and emotional benefits arising from the aesthetic and sensory experience of products.

Jordan (2002) describes pleasure as *"the emotional, hedonic and practical benefits associated with products and services."* He

differentiates the types of pleasures into four categories: physio-pleasure; socio-pleasure; psycho-pleasure; and ideo-pleasure. The senses directly inform physiological-pleasure, which includes pleasures connected with vision, touch, hearing, taste, smell, and the kinaesthetic; our awareness of the body in space (Bonapace 2000).

Desmet (2002) states that emotions are a result of our assessment or appraisal of the product in light of our experience and concerns related to it. Sensory impressions give rise to emotions and indirectly also inform psycho-pleasure, relating to cognitive demands and emotional reactions related to sensory perception. For example, an MP3 player that allows quick and easy selection of music files through its interface provides a higher degree of psychological pleasure than one that is difficult to navigate or likely to give errors. Understanding the sensory experience of products is a critical factor in being able to understand the subsequent appraisals that lead to emotions, and subsequently, to types of pleasurable response.

The need for approaches that inform designers in making design decisions that are not only based on intuitive judgements and "educated guesses" is often addressed (see, for example, Liu 2003). Overbeeke et al. (2002) state that it is the designer's task to

> ...make the product's function accessible to the user whilst allowing for interaction with the product in a beautiful way. Aesthetics of interaction is his goal."

They emphasise the importance of the designer focusing on designing the interaction and staying tuned to the experiential. Accordingly, it is important to understand the senses as the starting point for the experiential interaction with products.

2. Sensory experience in product design and development

Sensory assessment of product interaction provides us with insights into immensely rich and varied experiences. The condition of the sensory receptors alters over time, and in some instances may not be present at all due to accidents, disease, or abnormalities. This provides a challenge for designers seeking to make design inclusive. A strategy that relies on only one sensory stimulus to inform the product experience automatically reduces the attractiveness and relevance of the product to those with a reduced functioning in the relevant sensory receptor. In situations where

health or safety issues are critical, such as a railroad crossing, a multi-modal sensory design approach is adopted to ensure a universal communication of the danger.

The sensitivity and condition of the major sensory receptors can be assessed through objective measures. The environmental conditions needed for the perception of sensory information can be specified with objective measures that identify "comfort-to-tolerance" ranges within which sensory receptors can perform (Dreyfuss 1967). These objective measures of sensory performance, along with anthropometric data, have for many decades provided information that designers and ergonomists can apply to "Task Analysis" aiding the development of safety, functionality and usability. One example is provided by Dreyfuss' (1967) use of schematic diagrams that describe the physical anthropometrics of person-product interaction in a variety of use contexts.

Sensory experience also comes loaded with subjective assessments that lead to aesthetic interpretation, the elicitation of emotions, and (depending on that emotion), pleasure. Better understanding of the subjective sensory product experience develops better understanding of the development of emotions, and allows designers to raise their understanding of user needs beyond usability to achieve a pleasurable interaction with the product (e.g., Jordan 2000).

Before discussing some of the techniques that can be used to gain information about the sensory experience of products, it is useful to briefly review some characteristics of the information that the senses–vision, hearing, touch, balance, taste/smell–can contribute to pleasurable and meaningful product interaction.

2.1 Vision

Vision is usually the first sense that engages when we experience a product. Vision can provide the first experience of a product, because one characteristic of vision is that we can see an object before our other senses can detect it. The eye transmits a vast amount of information: processing of visual stimuli alone consumes over half of the neurons in the brain's cerebral cortex (Mather 2006). Vision both communicates the descriptive characteristics of a product and also allows us to assess the aesthetic qualities of what we see. Vision is the base for assumptions as to the other product qualities we are observing. This forms the basis of the study of

design semantics. MacDonald (2002) writes: *"Visual features embody codes, manifest as styles, which act as shorthand for sets of social or cultural values"*. The quality of vision can alter during the lifespan, for example, as we age reading may require stronger light or larger print; colour perception can change with age.

2.2 Hearing

The sense of hearing allows us to sense sound, unlike vision, in all directions and through opaque occluded objects (Mather 2006). The tone, speed and pitch of what we hear are all factors that are open to interpretations that can relate directly to the quality of product interaction. Sounds can be perceived as weak or authorative, annoying or pleasurable, alarming or relaxing. Product semantics can generate expectations of what the product will sound like, and evaluation of a product can include whether there is dissonance with these expectations.

2.3 Touch

Mather (2006) writes, *"Touch mediates our most intimate contact with the external world"*. Through touch we sense texture, temperature, pressure, pain and vibration. Touch allows us to make qualitative judgements related to the affective qualities of the surface we are in contact with. Product experience that interacts with the fingertips or lips contacts our most sensitive touch receptors. Touch requires tangible access to the product. A wool blanket on a cold night may make us feel warm and also comforted by its softness.

2.4 Balance

Balance lets us orientate ourselves and move through the external environment: walking, turning, running, upright and without falling, and while doing so, being able to maintain a focus on a independently moving object (Mather 2006). Balance dictates how we physically manage the product with which we interact. With smaller products such as mobile phones, the distribution of mass within the product itself is critical to the handling of the product and to the development of usability, utility and playfulness. With larger products where physical effort is required to manage the mass of the product such as chainsaws and construction tools, balance and handling have an additional effect on the fatigue of the user.

Balance is a factor that should be considered in designing for objects for an aging population, where disturbances in balance are a safety issue.

2.5 Taste and smell

Taste and smell are generally not considered in the hard product sphere of product design, although they may be considered in the overlapping areas of packaging design for fast-moving consumer goods. Technologies now exist that allow the incorporation of taste and smell into the design of products in which this sense has not been represented. In view of the range of products that purposely or inadvertently end up in our mouths, such as drink bottles, whistles, children's toys, torches, keys, and mobile phones, further consideration of this sensory source of information may be warranted.

Smell is an immensely affective sense. Smell fires strong associations with past experiences, memory, places, situations, and emotions. This is a result of its unique sensory pathway that travels directly to the primitive part of the brain (the limbic system), achieving effects before perception of the smell stimulus (which occurs in the neocortex) is achieved (Jacobs 2002). The perception of the intensity of smell is temporary, and declines with continuous exposure (Mather 2006). The perfume industry is an example of the value we place on smell. Perfume is an intensely intimate and emotive product that offers an intense affective experience, for which consumers pay a premium. Taste is less sensitive than smell. Jacobs (2002) tells us that what most people think of as taste, is in fact flavour. The perception of flavour is informed by smell receptors, and to a lesser degree, vision and touch (texture), experience, and by culture.

2.6 Experiences with traditional techniques

Experience with undergraduate design and graduate ergonomic students involved in product design projects revealed that traditional techniques used to develop the usability of products, such as task analysis and observation, mood boards and product personality assignment, did not meet all our needs in providing information about the sensory qualities of products. We briefly review these techniques before discussing three new techniques that we have explored in our work with undergraduate and graduate design students and design professionals.

Task analysis (Dreyfuss 1967) is appropriate for developing the usable, utilitarian and functional aspects of product interaction. It does this by using objective measures and specifying comfort-tolerance zones, in order to avoid a painful or hazardous interaction. The outcome of task analysis tends to be satisfactory comfort and fit, with subjective sensory assessment of the product interaction alluded to as a consequence. Observation studies provide a mixture of objective information and subjective interpretation of the person-product interaction. We noted that students found it difficult to remain focused on sensation and rapidly drifted into task assessments and objective observation.

Techniques such as mood boards (McDonagh et al. 2002) and product personality assignment (Jordan 2002) were found to be more readily accessible in developing an understanding of the affective nature of product interaction. Mood boards are used to represent the intangible, emotive and aspirational aspects of design intent or the design brief in order to make them accessible to the design team. The process of developing mood boards involves the design team or end user in collaging or graphically laying out images, selecting colour combinations, textures, and other materials that may relate to a variety of product characteristics, such as style, character, or context of use. Mood boards are particularly useful in the early stages of the design process.

One advantage of mood boards is that they can communicate emotions and attitudes to the designers before concrete product concepts are entrenched (McDonagh et al. 2002). Visual, tactile and olfactory stimuli can be readily presented using image board or collage techniques, but other senses such as balance are more difficult to capture. Image-boarding techniques are straightforward and efficient to apply in design and development processes; but the interpretation of presented stimuli is largely left to the viewer. This subjectivity is problematic if intentions are not made explicit. Collages of images or other sensory stimuli can create a lack of clarity since the objective may only be clear to the creator of the image boards. A characteristic of mood boards is that they tend to address more long-term affective states (moods). These are not necessarily the result of an emotion brought about through sensory stimulus.

The process of product personality assignment (PPA) (Jordan 2002) involves establishing a product's personality profile by using subjective assessment to assign personality traits, such as kind/unkind, extrovert/introvert, excessive/moderate, to the product. The objective is to

identify the link between the aesthetic qualities of the product and its perceived personality. In our experience with undergraduate students we found that PPA provided a rich source of design discussion that moved away from objective measures and into the realm of subjective perception and semantics. The ability to shift from a focus on product function and usability into affordance and pleasure is desirable when dealing with sensory experience and affective design. A limitation of PPA is that there is no direct way of mapping product features to personality traits.

Of the four techniques–task analysis, observation, mood boards and product personality assignment–the last two develop our ability to communicate intangible aspects of affective design through abstract representations or through assignment of personality traits. Understanding how the product affects the sensory aspect of the person-product experience will further advance our ability to design for affective sensory experience.

3. Characteristics of the sensory experience

In this work, we propose that three central characteristics of the sensory experience need to be considered in the design of techniques to support designing for the senses: the *intimacy*, *subjectiveness* and *temporality* of sensation. In the following, we will discuss relevant aspects of the three characteristics of sensory experience that arise from person-product interaction.

3.1 The intimacy of sensation

A typical product interaction engages a variety of senses in a range of different ways. Factors such as the type of product, the nature of the interaction, and the stimulus or set of stimuli provided determine which senses, or sets of senses, are engaged. As a general rule, the more distant (distal) the experience of the product, the fewer the senses engaged. For example, only the visual sense is engaged when seeing something, such as a typical traffic light, from afar. As the product experience moves closer in proximity (proximal), other sensory organs participate as they are stimulated, informing the sensory experience. A complex personal product like a mobile phone engages us in a much more intimate experience than a traffic light. Here the visual, tactile, auditory, balance senses are engaged, providing a richer sensory experience.

Sensory information provided through vision in *distal product interaction* leads to subjective assessments of the product aesthetic. Distal perception (a largely subjective assessment of product aesthetics) generates expectations in the end user of what the actual proximal experience (which would be more objective, thus informing usability) would be like. Sensory information provided in *proximal product interaction* is informed by a broader range of senses (including hearing, touch, balance, taste/smell and vision) and leads directly to assessments of the product's properties, qualities, and usability characteristics. The development of these aesthetic and usability attributes in product design is generally treated separately, and by differing professions, and this schism can lead to situations where a beautiful product aesthetic subsequently frustrates us during interaction (Overbeeke et al. 2002).

The classic example of this is the VHS recorder (latterly the DVD recorder). The perception of the product's aesthetic design, material quality and operating controls build expectations as to the usability of the product and the ensuing pleasurable interaction. We anticipate, sometimes eagerly, watching favourite movies, recording interesting documentaries, and catching sporting events. These expectations of usability may not be realised when it comes to interacting with the programming functions through the remote control, which is seldom displayed or demonstrated with the product when purchased. The dissonance between our expectation and the real interaction can result in an intensely unpleasurable use experience–a result of the product semantics being disconnected from the usability aspects of the product.

As the product interaction experience moves from distal to proximal our sensory experience gains immersion as different stimuli come into play, engaging a greater range of senses. With this increasing sensory immersion a more comprehensive and intimate assessment of the person-product interaction may be made.

3.2 The subjectiveness of sensation

Sensory perceptions give rise to subjective and individually different experiences. The physiological functioning of the senses is principally the same for all humans, recognising that some individuals may have reduced or missing sensory function for some or all senses, and that perception exhibits different characteristics dependent on e.g., age, sex, and culture (Mather 2006). With so many variables, individual perceptive characteristics

differ, and consequently the same sensory stimulus can give rise to differing perceptive assessments from one individual to another. For some individuals the fragrance of a particular perfume will evoke vivid memories of past events, people and places, for others it may just be a pleasant smell.

In person-product interactions where assessments of taste are the issue, the subjective perception of sensation may be very strong, as it is not mediated by an objective measure. When couples are selecting kitchen products for their redesigned kitchen the subjective sensory experience of the product can be a significant factor in their selection (and often in ensuing arguments). The feel of the oven handle as it moves through its arc to open; the sound of the chimes that tell you the dishwasher is finished; the colour; the proportions; the overall product aesthetic, all add to the subjective experience. Our personal preferences for a product are related to perception mediated by internal factors such as culture, past experience, and peer group.

3.3 The temporality of sensation

Imagine seeing a new car in a showroom – the first point of contact is the distal visual experience, which is of pivotal importance for our decision to further engage in interaction with the product. If our visual judgment is favourable, we may proceed to more proximal interaction, involving opening the door, sitting down, feeling the textures, sensing the smells, the tactility of controls and knobs, and assessing the comfort of the seat. The modality of the sensory experience changes, the importance of certain senses changes, all adding to a more complete "picture" of the product and our experience of it. Over time, our initial assessment may have been modified by subsequent sets of sensory experiences; we may not notice the same stimuli but have grown used to the product's characteristics.

Jordan (2000) acknowledges the importance of considering the emotional experience of a product over time. Such experiences are informed by the senses; e.g. a portable stereo system is, over time, likely to be perceived (and assessed) through its performance and aesthetics (visual and haptic sense), quality of sound (hearing), and possibly later the tactility of knobs and controls in operation. It is important to understand senses and perceptions over time, as initial impressions of a product are

likely to influence a person's decision to purchase the product (Jordan 2000).

4. Towards Five Senses Testing

In this section we present and discuss three techniques–Sensory Experience Assessment, the Sensory Snapshot, and Experience Continuum Sampling–of an approach that we collectively describe as *"Five Senses Testing"*.

Relating to the three characteristics described previously, the techniques of Five Senses Testing were developed in an effort to (1) focus the design team on sensory experience and interaction through consideration of the *intimacy* of sensation (Sensory Experience Assessment); (2) to collect and assess sensory information from product experience through consideration of the *subjectivity* of sensation (Sensory Snapshot); and (3) to gain a deeper understanding of sensory experience through consideration of the *temporality* of sensation (Experience Continuum Sampling).

The techniques were developed in our work with undergraduate and graduate design and ergonomics students, and with design professionals employed in small to medium sized industry in New Zealand, with the aim of allowing the consideration of affective factors to occur earlier in the design process. The three techniques are described, with examples to illustrate how the techniques work, and reference to the applications of the techniques, including their benefits and limitations.

4.1 Technique 1: Sensory Experience Assessment

The purpose of this technique is to provide an immersion experience for members of a development team: designers, engineers, ergonomists and marketers, in order to focus attention on the intimacy of sensory experience through different subjective proximal product interaction with an existing product. This needs to be understood because it will provide the designer, with

> …a feel for the experiential world of the user. The designer must then maintain a state of attention to it, and focus on designing the interaction. The designer needs to experience and stayed tuned to the experiential (Overbeeke et al. 2002).

The Sensory Experience Assessment technique consists of a pre-use assessment (product examination prior to use); an in-use assessment (product examination during use); an analysis of the outcomes, followed by idea generation. The procedure is as follows:

1. Feedback documents are prepared prior to undertaking the investigation.
2. For pre-use and in-use assessment, clear-cut images that present the product in its visual entirety are placed centrally on a page allowing space around the images for feedback. At the top right of the document, a list of the five senses (vision, hearing, touch, balance, taste & smell) focuses feedback.
3. For in-use assessment only, five pages per group are supplied, each labelled with one of the five senses to prompt focused design activity.
4. Participants are instructed on the procedure. The first step is for small groups (two to three) to take the selected product, examine it through observation without actually using it, and verbalise their sensory responses to the product, documenting these on the first (pre-use) feedback document .
5. The next step is to use the product in context, then document their sensory responses as in the first step.
6. Then participants discuss how to improve the product in a manner that would enhance the "five senses experience". Using the second in-use feedback document, participants produce annotated sketches and short statements linked to individual senses.
7. The feedback documents are then reviewed and analysed to compare the sensory modalities used in pre-use and in-use assessment. These are the stimuli for idea generation.

The sensory experience assessment technique offers some benefits:
- It is a quick and easy way to get directly into sensory experience in product interaction.
- It separates sensory information into pre-use and in-use, and makes apparent what sensory modes are in use.
- It provides the opportunity for reflection and active engagement.
- It forces consideration of all the senses.

The limitations of the technique are:
- It only applies to an existing product or well-developed product concept; this can limit how idea generation is supported.

- Because the investigators are considering a representation of a product, the technique may tend to support incremental improvements rather than radical innovations.
- The subjective nature of the information gleaned can be problematic. However, analysis of the collected information can provide some level of objectivity.

Application example: Sensory Experience Assessment

Sensory Experience Assessment was trialled with 15 participants (5 female and 10 male) as part of their undergraduate studies into affective product design at Massey University. Participants' ages ranged from 20-22.

The application described in the following illustrates how the technique of Sensory Experience Assessment works. In this scenario, undergraduate industrial design students ostensibly were evaluating a real, physical product with a view to a redesign. The deeper purpose of the exercise was to let the students experience how the sensory modalities change with the intimacy of the interaction.

Students selected from a range of objects provided for assessment, including a telephone; a 2-stroke garden line trimmer; an electric garden line trimmer and a wind-up radio. The domestic garden vacuum/blower had been included in the options as well, as an example of a product with considerable dissonance between its innocuous appearance and the obnoxious qualities revealed in use.

In the first stage the students were not allowed to use the product. Initially they could handle the blower, but not turn it on. This is often the situation

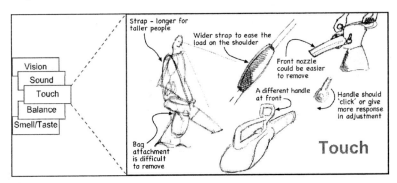

Figure 2-1. Example of Sensory Experience Assessment of product during use.

when consumers purchase a product. In the second stage students went into the campus gardens and used the product in context obtaining a full sensory immersion in the product use. Figure 2-1 illustrates the outcome of students' use of the technique to generate ideas for design improvements.

4.2 Technique 2: Sensory Snapshot

The Sensory Snapshot technique involves a survey of sensory interaction with a product. The purpose of the technique is to obtain a quick insight into the subjective experience of the end user. Furthermore, the Sensory Snapshot allows us to understand the subjective nature of a particular sensory experience and to present it in a graphic way that is easily understood by a designer. The technique yields a graphic representation of the subjective information that is represented in a way that can provide an objective target for improving the sensory experience of the product.

The Sensory Snapshot technique involves the preparation of response sheets; undertaking specified interactions with products; rating sensory experience; and analysing the subjective data generated. The procedure is as follows:

1. A five-axis radar diagram is generated, with one of the five senses on each axis (Figure 2-2). Each axis is graded into five sections, numbered 1-5 from the centre. On this scale, 1 represents a "highly negative" while 5 represents a "highly positive" experience.
2. The diagram is transferred onto a reporting sheet, with one sheet distributed to each respondent.
3. The participants are instructed on the procedure, which is to assess their sensory experience of the product interaction under investigation, and allocate it a mark on each sensory axis.
4. The investigator connects the five dots to generate an individual sensory experience map. The result is a collection of subjective radar maps. The investigator can average the individual scores to generate a combined sensory assessment map that describes the collective subjective experience of all respondents.

The Sensory Snapshot technique offers the following benefits:
- Investigators can identify any sensory modality that is not performing well and design to enhance this.
- It can be used to identify areas where targeted design activity will yield the most benefit.

- The technique is very fast: it rapidly yields large quantities of information. The outcomes are readily presented in a graphic format that is very easily understood. This makes the analysis stage similarly fast and simple.
- Because the focus is on the sensory information rather than the product form, idea generation is not constrained.
- Sensory snapshots can be incorporated into a range of other activities such as focus groups and user trials, offering a valuable tool to stimulate user interaction.

The limitations of the technique:
- The Sensory Snapshot applies best to an existing product or to well-developed product concepts but it can be used with low grade models.
- Because only one measure for each sense is recorded, distinctive sensory experiences, such as the sensation of simultaneously holding and writing with a pen, cannot be represented very well.
- Similarly, with interactions of longer duration the information yielded is less sensitive.
- Higher quality information can be obtained by focusing on a small interaction or a partial experience, as the technique is not sufficiently sensitive to measure complex interactions.

Application example: Sensory Snapshot

The Sensory Snapshot technique was trialled with five participants (two female and three male) as part of their postgraduate studies in Ergonomics. Ages ranged from 25-55; all were students at Massey University.

In the application, students used the Sensory Snapshot technique to evaluate the sensory modalities of lunchtime food products available from local restaurants. The diagram is for a sushi roll supplied by a restaurant called Tsunami Sushi. The sushi roll was named the *Ruapehu Roll,* after a local volcano.

The Ruapehu Roll was well presented and scored highly on sight, touch and taste. Unlike many sushi rolls, this product scored for sound as it was a baked product that sizzled, to the delight of the investigation team.

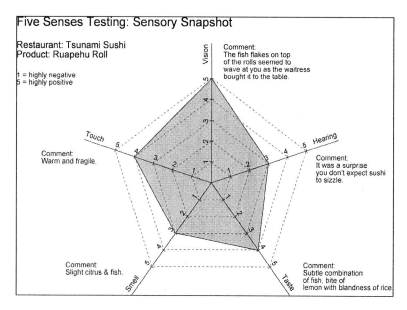

Figure 2-2. Example of Sensory Snapshot.

4.3 Technique 3: Experience Continuum Sampling

The purpose of Experience Continuum Sampling is to provide, through sensory experience, in-depth, specific information related to product features and experiences. This approach can be used by industrial participants to obtain insight into sensory response related to their products. The person-product experience continuum refers to the continuum of product experience from the first to the last interaction with the product. It usually describes a number of distinct stages specific to the product type and the nature of the interaction the product requires in use.

Experience Continuum Sampling involves the following procedures, some of which are illustrated in Figure 2-3:

1. A range of product interactions along the person-product experience continuum is identified, and from this range, a stage that represents a specific activity of interaction is selected for sampling.
2. The investigator prepares a feedback form. This form is more sophisticated than those used in the sensory experience assessment and sensory snapshot (see Figure 2-3 for an example of the form). The form includes the stage on the experience continuum being

sampled; a description of the trial and the respondent; a visual analogue scale to accommodate ratings for each of the five senses; a place holder for the active product feature that will be identified by the sampling; and space for reflective comments. Images of the product and the respondent in context are also desirable for the reference information they provide.

3. Suitable respondents are selected from the target market for the product and the stage of interest is explained to the respondent. If this technique is used at the early stages of design where the product is not well represented, the respondent can be a member of the design team.

4. The field trial, which involves the respondent, in the presence of the investigator, interacting with the product, is conducted.

5. After the trial, the investigator interviews the respondent to assess the quality of the sensory experience for each of the five senses; identifies the active feature of the product that provides that experience; and elicits a reflective comment on the relationship between sensory information and the active feature.

6. The results are reviewed and analysed to identify areas of further design activity. Subjective information from the reflective comment and the sensory assessment is linked directly to the active feature of the product. The performance of the active feature can now be judged in terms of the sensation it provides.

The benefits offered by Experience Continuum Sampling include:
- Sensory modes are linked to the product feature.
- It separates sensory information and makes it apparent what modes are in use.
- It takes the investigator into the environment of the respondent, providing high quality of information and a measure of objectivity.
- The technique forces consideration of all the senses.
- Clear sensory information can be obtained in relation to a specific stage of interaction.
- It can be used at the early stages of design.

The limitations of the technique are:
- It works best with an existing product or well-developed product concept.
- Where the investigators are considering an existing product, the technique may tend to support incremental improvements rather than radical innovations.

- The technique needs to be well thought out and requires forward planning.

Application example: Experience Continuum Sampling

Experience Continuum Sampling was trialled with 15 participants (5 female and 10 male) as part of their undergraduate studies into affective product design at Massey University. Participants' ages ranged from 20-22. Subsequently, the Experience Continuum Sampling technique was trailed in a series of product innovation workshops with industrial participants from product developing and manufacturing companies. Of the 55 participants, 28 were manufacturing professionals from engineering, marketing, management and design. The rest were academic staff, senior students and design researchers from Massey University.

In the application, undergraduate industrial design students evaluated a real product with a view to a redesign. The deeper purpose of the exercise was to let the students experience how the sensory modalities change over the continuum of product experience.

Students selected a 2-stroke garden line trimmer from the same range of objects provided for the sensory experience assessment technique. The 2-stroke garden line trimmer is suitable for this technique because it is a product that presents a range of well-defined stages (preparation, refuelling, loading trim line into cassette, starting machine, trimming,

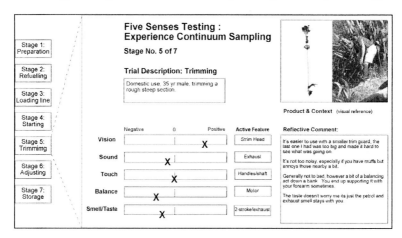

Figure 2-3. An example form of Experience Continuum Sampling technique.

adjusting trim line, storage) along the continuum of product experience.

In the planning stage, the student investigators used the product in order to identify the significant stages along the product experience continuum. This provided an immersive experience and exposure to the probable sensory modalities likely to come into play during their investigation. Experience with the physical product is necessary for the development of the feedback form.

The field trial brought the investigators into contact with respondents and the environments of use. Their response to the outcomes of the technique was very positive. The investigators were able to draw clear connections between the motivations of the respondents and the active features of the product. They noted that the reflective comment, supported by the record of sensory input for each sense let them understand more fully the quality of the sensory interaction. The collection of data from other stages along the continuum provided good qualitative sensory experience information relatively quickly in comparison to other field survey techniques such as product observation in use.

5. Findings

In the following, results from the application trials with respect to the experience of using the techniques are presented and discussed.

5.1 Sensory Experience Assessment

This technique provided direct assessment of the product through participatory experience. The experience for the students assessing the garden vacuum/blower was dramatic. They could not work out how to use the shoulder strap; they had trouble controlling the device to use it properly. Some found the switch hard to use; all were surprised and horrified by the noise produced. The students described the experience with a range of subjective comments, documented through their feedback forms, including; vision: "*Looks cool!*"; hearing: "*Unbelievable! I don't want to go near it*"; touch: "*Hard and slippery*" ; balance: "*Feels awkward? Hard, inflexible*"; taste/smell: "*?*".

Most participants felt they had gained an insight into how products affect users in a manner they had previously not considered. For example, the group working with the 2-stroke line trimmer realised the product created noise and was loud, and concluded that at least two groups would be considered negatively affected by the product: the primary subject–the user needing earmuffs to comfortably and safely use the product, and the secondary group–those in the vicinity of the user, being subjected to the disturbing noise of the product. Generally this is a subjective technique but students rushed to find an objective measure of the noise (measured at 85 decibels) that they perceived as very loud.

Another group using the technique on the garden vacuum/blower identified that the quality of experience when using the major control switch was poor and determined that the product should give a greater sense of control in adjustment.

5.2 Sensory Snapshot

The technique provided direct analysis of the product through participatory experience. Investigators noted that using the radar diagram easily allowed other senses to be added if necessary. For example, for product experiences that involve movement, an axis for balance could be included. Developing a description was found to be difficult without describing feelings associated with sensory experience. The design criteria developed were non-specific and tended to be about product aspiration.

5.3 Experience Continuum Sampling

The technique of Experience Continuum Sampling was developed using student subjects using an existing product (a garden trimmer) as described in the application example previously. It was later applied during three two-day workshops where participants from a range of manufacturing companies used it on concepts, sketch concepts and low grade prototypes. They used the technique to assess the sensory experience across a range of design projects. Themes included systems for intelligent houses, communication products, and temporary shelter design.

Most of the 28 industry participants found the technique had good value, with several noting it provided useful information that enhanced design potential. The vast majority of qualitative feedback from using the technique on the various projects was enthusiastically positive, indicating

the potential of the technique for addressing issues of sensory experience that were deemed useful for design.

Positive responses included comments such as: "*Interesting, brought up ideas of new features for our product*"; "*Good to be able to go outside the square*"; "*Interesting, user centric–encourages use of otherwise ignored feedback from test subjects*"; "*Very tidy–a great way to summarize what we should be doing/and do on a daily basis*"; "*Great. I'm taking this away and using it at work tomorrow*". There were three non-committal or negative comments; "*Not very applicable unless product is at final stage*"; "*It opened up new ways of looking at a product. But I felt it may have missed a few areas*"; "*It's totally impossible to assess sensory information unless you have a finished product*".

Feedback indicated that Experience Continuum Sampling requires a certain amount of imagination and extrapolation in terms of the appearance and the physical properties of the final product when used at the early phases of the design process. One participant thought that sensory evaluation should not supersede functional elements.

5.4 Discussion

Technique 1: Sensory Experience Assessment is an immersion technique. When used at the start of a product investigation it provides a sensory experience of person-product interaction for the investigator through exposure to different levels of sensory stimuli that mimic the pre-purchase and post-experience user scenario. This informs the investigator as to specific sensory encounters that may be useful to investigate further. The technique is limited by the fact that existing products have to be used and, thus, can limit the investigator's subsequent creative efforts producing incremental improvements rather than total innovations. However, the use of the technique could feed valuable insights into new product development. The challenge for this technique is that it needs to deliver a dramatic experience for the investigator in order to keep the investigator motivated and tuned to developing sensory experience in product interaction.

Technique 2: Sensory Snapshot is a survey technique that documents the subjective nature of sensory encounter and can be used from the early stages of establishing user needs to the later stages of design development. Sensory Snapshot provides quick graphic representations of sensory

experience that may be used to speed the identification of specific stages of sensory experience requiring further investigation. The technique is limited by the amount of sensory information that can be fed back to the investigators. The multi-modal nature of sensory experience means that the origins of the stimulus for each sense may be open to interpretation. The challenge for this technique is to make the duration of the sensory experience relatively short in order to avoid the homogenising effect of time on perception.

Technique 3: Experience Continuum Sampling is principally a field technique involving both the investigator and respondent. It is designed to develop the linkage between sensory experience and product attributes. It can be used in the early consumer research stages of a product development exercise and with trained investigators in early stages of the design development. Experience Continuum Sampling is an in-depth investigation of specific stages of sensory person-product interaction, linking sensation to product feature. This technique is limited by the time required to plan and implement a trial, and the response form, which may constrain the manner in which the user responds. The challenge for the technique is to make it more accessible for earlier stages in the design process.

6. General discussion

The challenge during product design development is to assess and predict the effect of the emerging product on the senses and to design products in an informed manner with respect to sensory experiences. By understanding the relationship between sensory input and the correlating aspects of our experience, we can better understand factors that affect the end-user's product experience. This leads to clearer insight into the nature of the sensorial qualities of product experience. It is then possible to intentionally develop these qualities to attain specified levels of affective and pleasurable experience.

The challenge of the "incomplete product" is similar to distal product experience, where we rely principally on one sensual mode to inform us. Through our perception of that sensation we then build expectations as to the proximal experience of that product, its texture, balance, softness. When sensory techniques such as Experience Continuum Sampling are used by the design team on early representation of product concepts be they sketches or prototypes, the perception of the design team and their

aspiration of sensory experience can aid the building of a cohesive sensory strategy in development.

"Five Senses Testing" uses a range of techniques to inform and advance the development of sensory qualities in product design. Feedback from students and professional industrial users indicated that the method is useful for informing an ongoing design process, as well as for bringing attention to previously unconsidered aspects of product perception. All products may not incorporate all senses/perceptual modes, but the method can successfully be used to highlight opportunities and bring attention to modes other than the apparent visual properties of product appearance. Consequently this method provides application beyond design, providing value to other fields involved in product innovation and development.

The development of tools and techniques that usefully informs the design process about sensory experiences provides benefits to the design development of products, moving them from visual aesthetics and usability to building cohesive sensory experiences achieving a rich aesthetic of interaction.

Acknowledgements

The authors wish to acknowledge Affect, The Centre of Affective Design Research at Massey University, for the support provided for the research.

Works Cited

Berlyne, D.E. (1971). *Aesthetics and Psychobiology.* New York: Appleton-Century-Crofts.

Bonapace, L. (2000). Pleasure-based human factors and the SEQUAM: sensorial quality assessment method. In *Proceedings of Design+Research*, 261-271. Milan.

Borkan, G.A., Hults, D.E. and Mayer, P.J. (1982). Physical Anthropological Approaches to Aging. In *Yearbook of Physical Anthropology*, 25:181-202.

Burnham, H.D. (2006). Immanuel Kant (1724-1804): Theory of Aesthetics and Teleology (The Critique of Judgment). In *The Internet Encyclopaedia of Philosophy*, URL: http://www.iep.utm.edu/, April 2006.

Desmet, P.M.A. (2002). *Designing Emotions*. Delft: Delft University of Technology.

Dreyfuss, H. (1967). *Designing for People*. New York: Paragraphic Books.

Goldman, A. (2001). The Aesthetic. In Gaut, B. and McIver Lopes, D. (Eds.), *The Routledge Companion to Aesthetics,* 181-192. London: Routledge.

Goldstein, E.B. (2002). *Sensation and Perception*. 6th Edition. Pacific Grove, CA: Wadsworth.

Gordon, I.E. (2004). *Theories of visual perception*. Hove: Psychology Press.

Hekkert, P. (2006). *Design aesthetics: Principles of pleasure in product design*. Psychology Science, **48**(2), 157-172.

Jacobs, T.J.C. (2002). In Roberts, D. (Ed.), *Signals and Perception: The Fundamentals of Human Sensation,* 304. Basingstoke, U.K.: Palgrave Macmillan.

Jordan, P. (2000). *Designing Pleasurable Products*. London: Taylor & Francis.

Jordan, P.W. (2002). *How to Make Brilliant Stuff That People Love & Make Big Money Out of It*. Chichester: John Wiley and Sons Ltd.

Liu, Y. (2003). Engineering aesthetics and aesthetic ergonomics: Theoretical foundations and a dual-process methodology. *Ergonomics*, **46**(13/14), 1273-1292.

MacDonald, A.S. (2002). The Scenario of Sensory Encounter: Cultural Factors in Sensory-Aesthetic Experience. In Green, W.S. and Jordan, P.W. (Eds.), *Pleasure with Products: Beyond Usability*. London: Taylor & Francis.

Mather, G. (2006). *Foundations of Perception*. Hove: Psychology Press.

McDonagh, D., Bruseberg, A. and Haslam, C. (2002). Visual product evaluation: exploring users' emotional relationship with products. In *Applied Ergonomics*, **33**(3): 231-240.

Merriam-Webster (2006). *Merriam-Webster Online Dictionary*. Merriam-Webster, Inc. URL: http://www.m-w.com/, April 2006.

Norman, D.A. (2004). *Emotional Design: Why We Love (or Hate) Everyday Things*. New York: Basic Books.

Overbeeke, K., Djadjadiningrat, T., Hummels, C. and Wensveen, S. (2002). Beauty in Usability: Forget about Ease of Use! In Green, W.S. and Jordan, P.W. (Eds.), *Pleasure with Products: Beyond Usability,* London: Taylor & Francis.

CHAPTER THREE

SUSTAINING RELATIONSHIPS
BETWEEN PEOPLE AND THINGS

JONATHAN CHAPMAN

1. Desire and destruction

Since Bernard London (1932) introduced of the term "planned obsolescence" (London 1932), made popular by Vance Packard in his monograph *The Waste Makers* (Packard 1963), interest in the lifespans of manufactured objects has steadily become a crucial constituent of contemporary design discourse (Cooper 2002). Indeed, as a consumer populous, we disposes of considerable, and increasing, volumes of products each year–the majority of which still perform their tasks perfectly, in a utilitarian sense. In an emotive sense, however, these unwanted products bear an immaterial form of defect manifest within the relational space occupied by both subject and object (user and product). In this way, it is clear that the *design for durability* paradigm has important implications beyond its conventional interpretation, in which product longevity is considered solely in terms of an object's physical endurance–whether cherished or discarded. In this sense, it can be seen that durability is just as much about desire, love and attachment, as it is fractured polymers, worn gaskets or blown circuitry. It therefore appears clear that there is little point designing physical durability into consumer goods, if consumers lack the desire to keep them.

In the case of most products, longer lifespans are environmentally beneficial, as the majority of energy consumed occurs pre-use, during the resource extraction and manufacturing phases. This is particularly true of digital products–such as mobile phones, PDA's, digital cameras and MP3 players–that require low levels of energy to operate (largely due to their frictionless action, achieved through a lack of moving parts), but actually require relatively high levels of energy to produce, ship and distribute. Of

course there are exceptions to this rule. Products that consume substantial amounts of energy during the use phase, when more energy efficient alternatives are commercially available, may well become counterproductive over extended periods of time; products that typify this classification include white goods such as washing machines and fridge freezers.

2. Defining the self

The need to consume tends to occur when a perceived discrepancy exists between an *actual* and a *desired* state of being. Despite the broad range of conflicting and contradictory theories that abound, the principle endeavour of consumer motivation (as a field of knowledge) is to develop understanding of the *manifest*–known to the person–and *latent*–unknown to the person–motivational drivers that make people do the things they do, buy the things they buy and discard the things they discard. To date, knowledge emerging from this field has almost exclusively served to bolster economic sustainability. Yet, it is surely a shallow philosophy that would make human welfare synonymous with the indiscriminate production and consumption of material goods (Macpherson 1978). Until recently, environmental and social sustainability have scarcely featured within the interests of this commercially oriented field–as such, the efficacy of conventional capitalism must be questioned; more lucrative models exist than the blind nurturing of endless sequences of desire and destruction.

Ask a developed world human to stop consuming and you might as well ask a vampire not to suck blood (Chapman 2005a). Consumption is not just a way of life, it is life; providing an invaluable vehicle for the ever evolving self to process and interact within a world that is both unstable, and ever changing. Searles describes the consumer's existential journey as an unceasing struggle to differentiate himself increasingly fully, not only from his human, but also from his nonhuman environment (Searles 1960). The drive to consume is natural, and may be described as *symptomatic* of a characteristically stimulus-hungry species existing within an over-streamlined world in which the experience of everyday life comes with the problems already solved, and the decisions already made.

In this oversaturated world of people and things, durable attachments with objects are seldom witnessed. Most products deliver a predictable diatribe of information, which quickly transforms wonder into drudgery; serial disappointments are delivered through nothing more than a products

failure to maintain currency with the evolving values and needs of their user. The volume of waste produced by this cyclic pattern of short-term desire and disappointment is a major problem, not just in terms of space and where to put it, but, perhaps more notably, for its toxic corruption of the biosphere.

Corporate futurologists force-feed us a happy-ever-after portrayal of life where technology is the solution to every problem. There is no room for doubt or complexity in their techno-utopian visions. Everyone is a stereotype, and social and cultural roles remain unchanged. Despite the fact that technology is evolving, the imagined products that feature in their fantasies reassure us that nothing essential will change, everything will stay the same (Dunne et al. 2001).

The individualistic process of consumption is motivated by complex emotional drivers, and is about far more than just the purchasing of new and shinier things (Chapman 2005a); it is a journey towards the ideal or desired self, that through cyclic patterns of desire and disappointment, becomes a seemingly endless process of serial destruction. Material artefacts are indicative of an individual's aspirations, and serve to outline their desired life direction. At the most superficial level, an object can be seen by the user to resonate with and be symbolic of the self. Thus, perceiving oneself as rich and powerful might lead to conspicuous consumption, such as owning a luxurious car or wearing designer apparel. At a more profound psychodynamic level, having and utilizing an object can compensate for an unconsciously felt inadequacy (Cupchik 1999).

Manufactured products serve to illustrate our aspirations, whilst defining us existentially; as Douglas and Isherwood state, products are not merely functional, but provide important signals in human relationships (Douglas et al. 1979). As such, possessions are used as symbols of what we are, what we have been, and what we are attempting to become (Schultz et al. 1989), whilst providing an archaic means of possession by enabling the consumer to *incorporate* (Fromm 1979) an object's meaning– in other words, the material you possess signifies the destiny you chase. As a result of this, consumers are drawn to objects in possession of that which they subconsciously yearn to become. A study by Jääskö, Mattelmäki, and Ylirisku, found that although meaning is always sought, this meaning is not always associated with the objects themselves, often manifesting as a result of the services that they render. For example products that support self-expression and social interaction as cellular

phones may become meaningful to the owner because of the saved messages or names and contact information of the loved ones (Jääsko et al, 2003a).

3. Meaning and consumption

Though it may be possible to design objects that elicit broadly authored emotional responses, the specific character of these responses are largely beyond the designer's capabilities due to idiosyncrasies of each individual user. In this way, designers cannot craft an experience, but only the conditions or levers that might create an intended experience (Forlizzi et al. 2000). What those required conditions are however, is still unclear to design. People can differentially attend to the sensory qualities of the design object and attach diverse personal meanings onto it because they see it used in various contexts. Their reactive emotions will therefore reflect personal associations and meanings, which are projected onto the object (Cupchik 1999). Therefore, recognizing that users consider products as part of themselves is key to understanding the meaning of objects (Belk 1988).

Indeed, conventional reality consists of a deeply abstracted culture of signs, or simulations (Baudrillard 1993), which motivate consumers more than the physical products themselves. This self-actualising mode of subject-object relations (Thompson 2005) provides a mirror that mediates momentary reflections of individual existence. However, the continual evolution of the self-actualising user poses a significant challenge to old or outmoded possessions that are no longer representative of the self; transient and unstable cycles of consumption and waste are born. Studies by Csikszentmihalyi and Rochberg-Halton (1981), Schultz, Kleine and Kernan (1989), Wallendorf and Arnould (1988), Ball and Tasaki (1992) and Dittmar (1992) are conclusive in their relating of attachment behaviours toward individualistic concept of self.

In a paper entitled *Meaningful product relationships*, Batterbee and Mattelmäki describe a survey where stories are collected about possessions with which users have meaningful associations. Their proposition is that meanings, experiences and meaningful relationships with products are developed over a time span and they are often related to life situations (Batterbee et al. 2004). From this research, 3 categories of objects were defined, that facilitate the understanding of different kinds of subject object attachment; these categories are; Meaningful Tool where the

activity an objects enables, rather than the object itself, is the thing of meaning; Meaningful Association, in which a product is considered significant as it carries cultural and/or individual meaning and Living Object (Jordan 2000) wherein an emotional bond is created between an individual and a product. Indeed, issues of design and meaning are highly complex, and more tacit and hidden aspects such as product meaning or personal motivation have influence in the user experience but are not that easily recognized or communicated to design, or even directly affected by design (Jääskö et al. 2003b).

4. Meaning and waste

Until the middle of the 20th century consumer durables were generally viewed as investments and, within reasonable cost boundaries, were designed to last as long as possible. Doggedly pursuing the dream of a technologically enhanced and physically durable world has enabled us to fabricate a plateau of material immunity. Durable metals, polymers and composite materials have enabled us to construct this synthetic futurescape; immune to the glare of biological decay, these materials grossly outlive our desire for them and so the illusion of control bares its first predicament: waste.

Since then, however, planned obsolescence, the deliberate curtailment of a product's life span, has become commonplace, driven by, for example, a need for cost reductions in order to meet price points, the convenience of disposability, and the appeal of fashion (Cooper 2004). We are currently experiencing a societal shift that is steering us away from deep communal values toward a contemporary mode of individuality fragmented over countless relationships with objects and the experiences they mediate. This has cast us in an abstract version of reality in which relationships are sought from toasters, mobile phones and other fabricated experiences. Indeed, during recent years, there has been a move away from interpersonal relationships toward a newer and faster mode of relations (Brunner 1996). Today, empathy is encountered not so much with each other but through fleeting embraces with manufactured, and evermore technologically advanced artefacts. We do amazing things with technology, and we are filling the world with amazing systems and devices, but we find it hard to explain what this new stuff is for, or what value it adds to our lives. When it comes to innovation, we are looking down the wrong end of the telescope: away from people, toward technology. Industry suffers from a kind of global autism–a psychological disorder that is

characterized by detachment from other human beings (Thackara 2001). The Design Transformation Group argues that this shift, away from immateriality and anonymous experience towards reflexive encounters, is seemingly only the crest of a larger cultural wave which is rapidly imparting greater understanding into the way we perceive, condition and create the world in which we live (de Groot 1997).

To have seen through and therefore know is to deflower the entity (Sartre 1969). The uptake of products is largely motivated by this notion; we consume the unknown in order to demystify and make it familiar. Waste therefore appears to be as much a part of the consumption experience as are purchase and use–it is evolution made tangible. French librarian and writer, Georges Bataille reinforces this notion through stating the general movement of exudation of waste of living matter impels him, and he cannot stop it; moreover, being at the summit, his sovereignty in the living world identifies him with this movement; it destines him, in a privileged way, to that glorious operation, to useless consumption (Botting et al. 1997). Consuming has ambiguous qualities: it relieves anxiety, because what one has cannot be taken away; but it also requires one to consume ever more, because previous consumption soon loses its satisfactory character (Fromm 1979).

In a sense we outgrow what was once great, feeling we no longer need these outdated objects or, perhaps, could now do better. We become familiar with their greatness and as a direct consequence, our expectation of *greatness itself* subsequently increases; adoration rapidly mutates into a resentment of a past that is now outdated and obsolete. This common phenomenon of individual evolution and the out-growing of a *static* product by its *constantly changing* user, yield intensely destructive implications for the sustainability of consumerism. So why do we chortle to ourselves at the fake walnut veneered TV-set lying face down in a ditch, or the recently ejected avocado bathroom suite, still standing earnestly to attention? Is it triumph perhaps? Affirmation of our transcendence beyond those aesthetic *faux pas* that we as consumers, sitting frigidly poised on the *style-islands*, have fought so hard to assemble, but which now sink beneath the smoggy swath of ecological decay we brewed in the making? If you were to mine a landfill site, you would see thick, choked geological strata of *style* descend before you, punctuated by zeitgeist objects whose archaeological discovery would serve to punctuate a design era more poignantly than any carbon-dating methodology ever could (Chapman 2007).

5. Sustainable design is symptom-focussed

With the exception of texts from a handful of researchers–namely, van Der Ryn and Cowans' *Ecological Design* (1997), McDonough and Braungarts' *Cradle to Cradle* (2002), Papanek's *Green Imperative* (1995), Chapman & Gants' *Designers, Visionaries and Other Stories* (2007), Manzini and Jegous' *Sustainable Everyday* (2003) and Walker's *Sustainable by Design* (2006)–sustainable design methodologies have a tendency to adopt a symptom-focussed persona; addressing the after-effects rather than the causes of the inefficient model of design, production and consumption we face today. This is particularly evident when one looks outside of academia and design research circles, where practicing designers do not always have the time to engage in theoretical debates about the future of design–instead they require workable, time-efficient strategies that can be put into practice, today; this lack of accessible, ready information forces designers into a minority position, of limited power and influence.

In response, sustainable design practice has a tendency toward end of pipe methodologies such as recycling, disassembly and biodegradability. Indeed, if the so-called green design approach (better known in the United States as "design for the environment") has a limitation, it is that it intervenes at the end-of-pipe. It modifies individual products or services, but does not transform the industrial process as a whole (Thackara 2005). For example, increased recycling does not reduce the flow of material and energy through the economy but it does reduce resource depletion and waste volumes (Stahel 1986). In overlooking deeper strategic possibilities, sustainable design fails to engage with deeper, and potentially, more effective strategies. It is imperative therefore, that in addition to engaging with essential end-of-pipe methodologies, sustainable design also explore the deeper motivational origins of our wasteful engagement with products; developing credible new strategic opportunities, that build upon current perceptions of environmentally responsible design, to signpost and develop new directions for positive change.

Despite growth as a specialist approach to design, sustainable design remains unresolved (Treanor 2005). Since it was formally established in the 1960s, sustainable design has continued to adopt the subservient role of industry's cleaner. Furthermore, the word sustainable has been slapped onto everything from sustainable forestry to sustainable agriculture, sustainable economic growth, sustainable development, sustainable

communities and sustainable energy production. The widespread use of the term indicates that many people conclude that the dominant, industrial models of production are unsustainable (Duvall 2004). Through this whitewash, it may be argued that the impact of a well-intentioned term has been lost.

New approaches to sustainable design are needed. The urgency of this need, is reinforced by *The Stern Review* (2006), which states that if no action is taken to reduce emissions, the concentration of greenhouse gases in the atmosphere could reach double its pre-industrial level as early as 2035, virtually committing us to a global average temperature rise of over 2°C. In the longer term, there would be more than a 50% chance that the temperature rise would exceed 5°C. This rise would be very dangerous indeed; it is equivalent to the change in average temperatures from the last ice age to today. Such a radical change in the physical geography of the world must lead to major changes in the human geography–where people live and how they live their lives (Stern 2006). In 2007, the environmental audit for the United Nations (UN), involving 1400 scientists, concluded that the speed at which mankind has used resources over the past 20 years has put humanity's very survival at risk (United Nations Environment Programme 2007). Following the publication of their findings, the UN Environment Programme made an urgent call for action, stating that the point of no return is fast approaching. A comparative survey by Global Environmental Output, also in 2007, shows that the world's population has grown by 34% to 6.7 billion in 20 years; 73,000km^2 of forest is lost across the world each year (3.5 times the size of Wales); populations of freshwater fish have declined by 50% in 20 years and more than half of all cities throughout the world exceed World Health Organisation (WHO) pollution guidelines (Global Environmental Output 2007).

It is critical therefore, that the methodologies through which we address sustainable design, and more specifically design for durability, are questioned to enable the development of new strategic working methods, which address the unprecedented ecological crisis we currently face. Yet, amidst the industry-wide movement to achieve compliance with environmental legislation (such as the EU WEEE Directive), the root causes of the ecological crisis we face are all too frequently overlooked; meanwhile the inefficient consumer machine surges wastefully forth, but now it does so with recycled materials instead of virgin ones. By neglecting to better understand the motivational drivers underpinning the consumption and waste of products, design resigns itself to an end-of-pipe

problem-solving agency, rather than the central pioneer of positive social, economic and environmental change that it potentially could be.

Passive consumer attitudes to the ecological crisis we face are enforced further by the misguided preconception that comfort must be sacrificed in order to make positive change, and the changes in living that would be required are so drastic that people prefer the future catastrophe to the sacrifice they would have to make now (Fromm 1979). Warped notions of ascetic lifestyles abounding with non-enjoyment invade the consumer psyche, rendering the prospect of a greener existence an undesirable alternative and thus, the inefficient consumer machine continues to thrust wastefully forth. Feel good after measures such as recycling bare grave similarity to someone who quits smoking on his deathbed (Palahniuk 1999).

We lead a resource hungry existence, taking out a great deal more from the Earth than we put back. Even bearing in mind a very loose definition of development, the anthropocentric bias of the statement springs to mind; it is not the preservation of nature's dignity, which is on the international agenda, but to extend human-centred utilitarianism to posterity (Sessions 1995). Resources–as we like to call matter that we have a commercial use for–are being transformed at a speed far beyond the natural self-renewing rate of the biosphere. Consequently, reserves of useful matter are running low and many will soon have vanished. The human race was fortunate enough to inherit a 3.8 billion-year old reserve of natural capital (Hawken et al. 1999). At present rates of consumption it is unlikely that there will be much of it left by the end of this century. In addition, since the mid-eighteenth century more of nature has been destroyed than in all prior history (Hawken et al. 1999)–in the past fifty years alone the human race has stripped the world of a fourth of its topsoil and a third of its forest cover. In total one third of all the planets resources have been consumed within the past four decades (Burnie 1999).

The colossal throughput of materials and energy that have become so characteristic of modern life are a contemporary legacy, emerging from the short-sighted merging of excessive material durability with short-lived product use careers, or "career plans" (van Hinte 1997). It therefore must be said that in their current guise, sustainable design methodologies lack genuine depth–recyclable "waste", biodegradable "waste", disassemble-able "waste" etcetera–and as such, adopt a symptom-focussed approach

comparable in ethos to Western Medicine; in consequence, deeper strategic possibilities are overlooked (Chapman 2006).

Form has a vital role to play in achieving the function of sustainability. Function has a more ethereal quality than is commonly recognised–it could be said that function exists on a linear scale, in which at one end you have *task-oriented* function where objects perform and fulfil their tasks well (which is a sustainable characteristic), and at the other end of the scale, you have a more *sociological/existential* function where objects are effective in mediating the particular values and beliefs of the individual user. Both modes of functionality are largely dependent on the designer, and are central to the success or failure of an object in social, economic and environmental terms, as when objects succeed within both modes of functionality through design, replacement motives are quelled, and things generally, are valued, cherished and kept.

Sustainable design methodologies seldom engage with the more fundamental questions such as the meaning and place of products in our lives, and the contribution of materials goods to what might be broadly termed the human endeavour (Walker 2006). In consequence, the consumer machine continues to rage forth practically unchanged, leaving designers to attend the periphery, healing mere symptoms of what is, in essence, a fundamentally flawed system.

6. Relationships between people and things

Though strategic approaches to product life extension are fairly commonplace, in most instances, durability is characterized simply by specifying resilient materials, fixable technologies and the application of advanced design engineering methodologies that reduce the likelihood of blown circuits, stress fractures and other physical failures; engineers therefore celebrate in triumph as fully functioning vacuum cleaners emerge from a five-year landfill hiatus. It must be questioned as to whether this is durable product design, or simply the designing of durable waste (Chapman 2005b)? Once emotional attachments weaken and these products are eventually discarded, this objective model of durability has a particularly destructive impact on the biosphere. Therefore, designing physical durability into products is pointless, if users lack the desire to keep them. Interacting with this technocratic and de-personalized environment fuels a reactionary mind set that hankers after meaningful content, mystery and emotion (de Groot 1997). According to Dunne and

Raby, this is because both the scope and power of emotional experiences delivered via objects born of this ideology are incredibly limited, and offer very little to users–even though industrial design plays a part in the design of extreme pain (e.g., weapons) and pleasure (e.g., sex aids), the range of emotions offered through most electronic products is pathetically narrow (Dunne et al. 2001). As a result, industrial design has increasingly become nothing more than a subordinate packager of technology–housing hardware within intelligible skins that enable thoughtless, and effortless, subject object interaction. Indeed, the computational and communicative devices that now assist almost every transaction in our daily lives are designed as dull and servile boxes that respond to our commands in a state of neutrality; stress and techno-phobia are the result (de Groot 2002).

Schopenhauer claims that our existence has no foundation on which to rest except the transient present, and thus, its form is essentially unceasing motion, without any possibility of that repose which we continually strive after (Schopenhauer 1970). Furthermore, because everything moves so fast, and we cannot stop it, we have to create some *islands of slowness*. Design, in all its history, but especially in more recent years, has been an agent of acceleration. Is it possible to conceive of solutions combining real-time interactions with the possibility of taking time for thinking and contemplation (Manzini 2002)? Current consumption operates within a linear production-consumption system that takes resources, makes them into products, then discards or wastes them–slowing consumption offers a direct response to unsustainable consumption. By slowing the mass flows in the linear production-consumption economy a level of sustainability could be achieved (Park 2004). Yet it must also be noted that such consumption beyond minimal and basic needs is not necessarily an unnatural, or bad thing in and of itself, as throughout history we have always sought to find ways to make our lives a bit easier to live (Shah 2003).

Emotionally durable products dodge the deflowering gaze (Sartre 1969) of waste by possessing interlaced layers of meaning that grow and adapt with the user, to ensure that the subject and the object co-evolve, rather than the one-sided development that usually takes place, where the user outgrows the static product in a handful of weeks, or days. What can be understood from these success stories, and how can this inform the design of more emotionally durable products? After all, what people basically want is a well functioning and up to date product that meets their altering

needs; the dynamic nature of this desire requires a similar approach–the development of dynamic and flexible products (van Nes et al. 2005).

Most consumer products are like stories with an incredible opening line, but which just continue repeating it throughout–their narrative capabilities are pathetically limited (Chapman 2005a). Yet, as everyday life in the 21st century becomes evermore programmed, the need for fiction, rich evolving narrative experiences, complexity and dialogue increases correspondingly–instead of thinking about appearance, user-friendliness or corporate identity, industrial designers could develop design proposals that challenge conventional values–new strategies need to be developed that are both critical and optimistic, that engage with and challenge industry's technological agenda (Dunne et al. 2001).

7. WEEE and emotion

The European Union (EU) Waste and Electrical and Electronic Equipment (WEEE) Directive calls on members of the EU to implement the legal framework to ensure that producers take responsibility for their electric and electronic products at end of life–representing the fastest growing waste sector in the EU, WEEE is a significant piece of legislation–particularly so, in the context of product longevity (Chapman 2006). Manufacturers of electrical and electronic products must satisfy the legislative demands of WEEE by assuming a whole-life responsibility for their products. In Britain for example, the average consumer generates an average of 16 kg of household WEEE each year; that is 1.1 million tonnes of household WEEE every 12 months in the UK alone–5 million television sets are estimated to join this waste stream annually. During the last decade alone, consumption of household goods and services in the UK has risen by 67%, and household energy consumption by 7%–consumption is not only growing in magnitude, but the throughput of manufactured goods is speeding up. The pattern of consumption with many types of consumer goods is shortening functional lives as goods are predestined as waste (Ginn 2004).

The industry response to the WEEE Directive is gathering pace with Nokia, Bosch Siemens and Canon funding major new initiatives that address the costly take-back and recovery of end of life products. For Nokia's UK market where handsets are replaced on average once every 18-months end of life legislation is of particular relevance. 15-million mobile phones are discarded in the UK each year; fortunately for Nokia,

their products are sufficiently portable that they may be dropped-off at the nearest high street store. However, manufacturers of bulkier goods such as washing machines and refrigerators are not so fortunate. As Europe's leading household appliance manufacturer, Bosch Siemens in 2004 forecasted annual costs running to some 60-million (BSH Bosch 2004) euros, just to remain in compliance with the forthcoming legislative demands of the WEEE Directive (Chapman 2006). According to Uwe Hennack, CEO of Bosch Siemens Homes Appliances Ltd., the challenge is to design products that last longer, are lower cost to recycle, affordable to the consumer, use less waste energy and are produced in an environment that is environmentally friendly (BSH Bosch 2004). Though it is not always easy for consumers to identify products designed for long life spans (Christer et al. 2004). The threat of litigation for non-compliance will force many to re-appraise their product portfolios. As a consequence, such legislative instruments might establish frameworks and drivers for a more formalised design response to unsustainable consumption (Park 2004). Today however, products designed for take-back are still geared toward disassembly and recycling and/or reuse. This is because eco-design usually functions at an operational level and is unlikely to hold much potential for radical change because it works within the same thinking that caused the problems in the first place (Lofthouse 2004). As Feyerabend states, no theory ever agrees with all the facts in its domain, yet it is not always the theory that is to blame. Facts are constituted by older ideologies, and a clash between facts and theories may be proof of progress (Feyerabend 1993).

8. A 6-point experiential framework for emotionally durable design

The emergent paradigm of *emotionally durable design* is located within three converging fields of knowledge–sustainable product design, emotional and user-centred design, and consumer motivation. Though the need for longer lasting products is widely recognised and supported, practical working methods, design frameworks and tools that enable the commercial implementation of such emotionally durable artefacts, are scarce. This may be described as a consequence of the apparently intangible, ethereal nature of considerations pertaining to psychological function, which cause confusion for the practicing designer tasked with the design and development of greater emotional longevity in products. As a result, the positive impact(s) of academic studies in this area has thus far failed to penetrate the working practices and methodologies of design–

arguably, the one place where new models of sustainable design knowledge and understanding are most urgently needed. It is essential therefore that practical methodological information is generated, that enables product designers to engage more effectively with complex issues of emotional durability through design; presenting a more expansive, holistic approach to design for durability, and more broadly, the lived-experience of sustainability.

Results from an empirical study (Chapman 2006), which examined the attachment behaviours of 2154 respondents with their DEPs, enabled the development and distillation of a *6-point experiential framework*; providing product designers with distinct conceptual pathways through which to initiate engagement with salient issues of emotional durability and design. These pathways are essential to the practitioner, enabling them to begin framing and articulating specific points of intervention; enabling a more structured, focussed model of exploration into issues emotional durability and design. Furthermore, as a collection of terms, an original territory of enquiry is delineated and defined. Furthermore, the terms themselves begin to construct a vocabulary for clearer articulation of immaterial phenomenon. The 6-point experiential framework (and supporting annotations) is as follows:

1. **Narrative**: users share a unique personal history with the product; this often relates to when, how and from whom the object was acquired.
2. **Detachment**: feel no emotional connection to the product, have low expectations and thus perceive it in a favourable way due to a lack of emotional demand or expectation (this also suggests that attachment may actually be counterproductive, as it elevates the level of expectation within the user to a point that is often unattainable).
3. **Surface**: the product is physically ageing well, and developing a tangible character through time, use and sometimes misuse.
4. **Attachment**: feel a strong emotional connection to the product, due to the service it provides, the information it contains and the meaning it conveys.
5. **Fiction**: are delighted or even enchanted by the product as it is not yet fully understood or know by the user; these are often recently purchased products that are still being explored and discovered by the user.

6. **Consciousness**: the product is perceived as autonomous and in possession of its own free will; it is quirky, often temperamental and interaction is an acquired skill that can be fully acquired only with practice.

By designing and developing products that consumers wish to keep for longer, these products are transformed into conversation pieces–linking consumers to producers, though an ongoing and sustained dialogue of service, upgrade and repair. If appropriately managed, it may be argued that fostering and maintaining such relationships with customers, presents a significant part of the solution to issues of sustainability and design; enabling business to continue generating revenue whilst reducing the frequency of need for further costly manufacturing, resource extraction, energy consumption, atmospheric pollution and waste.

9. Conclusions

Commercial interest in the lifespans of manufactured objects can be traced back to Bernard London's introduced of the term *planned obsolescence* (London 1932). Almost 80 years later, the design of longer lasting products has become widely recognized as a viable approach to sustainable design, yet despite this recognition, practical design tools and methodologies that enable designers to effectively address these issues have yet to be developed. Indeed, though the historical discourse is familiar, a tangible and accessible vocabulary is lacking within the dualistic contexts of emotion and design for durability. This lack has contributed to a current state of inertia within both academic and industrial domains, in which an absence of accessible, practical methodological information has served to freeze progress. The 6-point experiential framework presented here, aims to begin addressing this by generating new theoretical architecture that enables designers to more effectively engage with complex issues of emotional durability through design.

Even today, in the era of environmental awareness, ethical consumption and sustainable design, a sense of instability continues to encircle the design, production and consumption of electronic products. Perhaps due to the normalcy of innovation, an expendable and sacrificial persona renders most products transient and replaceable orphans of circumstance. In response to this, commercially viable strategies for emotionally durable products must be developed, that slowly penetrate the user psyche over longer and more rewarding periods of time–new and

alternative genres of objects that reduce the consumption and waste of resources by increasing the resilience of relationships established between consumers and their products; empowering the user to transcend the superficial urgencies of conventional consumerism, to forge deep emotive connections with their possessions. These new and provocative creative strategies will provide the cornerstones to positive social, economic and environmental progress, at a time of looming ecological crisis, increasing legislation and questionable levels of sustainable design progress.

Works Cited

Ball, A.D. and Tasaki, L.H. (1992). The Role and Measurement of Attachment in Consumer Behaviour. *Journal of Consumer Psychology*, **1**(2), 155-172.

Batterbee, K. and Mattelmaki, T. (2004). Meaningful product relationships. In McDonnaugh, D., Hekkert, P., Van Erp, J., and Gyi, D., (Eds.), *Design and Emotion*, Taylor and Francis, London, 337-341.

Baudrillard, J. (1993). *Symbolic Exchange and Death*. Sage Publications, London, UK.

Belk, R.W. (1988). Possessions and the Extended Self. *Journal of Consumer Research*, 15 (September), 139-168.

Botting, F. and Wilson, S. (1997). *The Bataille Reader*. Blackwell, Oxford

Brunner, F.M. (1996). *Consumerism and Relationships: The Psychology of Extropersonal Relationships*. URL: www.hooked.net/~brunner, November.

BSH Bosch und Siemens Hausgeräte Gmbh (2004). *Environmental and Corporate Responsibility Report*.

Burnie, D. (1999). *Get A Grip On Ecology*. The Ivy Press, Lewes.

Chapman, J. and Gant, N. (2007). *Designers, Visionaries and Other Stories: A collection of sustainable design essays*. Earthscan, London.

Chapman, J. (2007). Desire, Disappointment and Domestic Waste. In *Pavillion Commissions Programme 2007*, Pavillion [ISBN 978-0-9544775-4-7], Leeds, 2007, 4-11.

—. (2005a). *Emotionally Durable Design: Objects, Experiences and Empathy*. Earthscan, London

—. (2005b). Emotionally Durable Design. *Waste Management World*, Earthscan, London, Autumn.

—. (2006). Modern Life is Rubbish. *Blueprint*, No. 241, April.

Christer, K. and Cooper, T. (2004). *Marketing durability: A preliminary review of the market potential for life span labels*. Academy of Marketing Conference, Cheltenham, July.

Cooper, T. (2003). Durable consumption: reflections on product life cycles and the throwaway society. In Hertwich, E., (Ed.), *Life-cycle Approaches to Sustainable Consumption* (Workshop Proceedings), Austria, November 2002, 15-27.

—. (2005). Inadequate life? Evidence of consumer attitudes to product obsolescence. *Journal of Consumer Policy*, 27, 421–449.

Csikszentmihalyi, M. and Rochberg-Halton, E. (1981). *The Meaning of Things: Domestic Symbols and the Self.* Cambridge.

Cupchik, G.C. (1999). Emotion and Industrial Design: Reconciling Meanings and Feelings. *1st International Conference on Design and Emotion*, Delft University of Technology, The Netherlands.

de Groot, C.H. (1997). Experiencing the Phenomenological Object. *Closing the Gap Between Subject and Object*. Design Transformation Group, London, 20–21.

—. (2002). *The Consciousness of Objects–Or the Darker Side of Design*. Birmingham Institute of Art and Design, University of Central England, Birmingham, UK.

Dittmar, H. (1992). *The Social Psychology of Material Possessions: To Have Is To Be*. St. Martin's press, New York.

Douglas, M. and Isherwood, B. (1979). *The World of Goods*. Allen Lane, London.

Dunne, A. and Raby, F. (2001). *Design Noir: The Secret Life Of Electronic Objects*. August/Birkhauser, Switzerland/UK.

Duvall, B. (2004). The Unsustainability of Sustainability. *Culture Change* homepage–A project of the Sustainable Energy Institute. URL: www.culturechange.org/issue19/unsustainability.htm, September.

Feyerabend, P. (1993). *Against Method*. Verso, London.

Forlizzi, J. and Ford, S. (2000). The Building Blocks of Experience. DIS2000, 17-19 August. In Boyarski, D. and Kellogg, W. A. (Eds.), *DIS Conference Proceedings*. ACM Publishing, New York, 419-423.

Fromm, E. (1979). *To Have Or To Be*. Abacus, London.

Ginn, F, (2004). *Global Action Plan Consuming Passions: Do we have to shop till we drop 10 years of consumption in the UK Global Action Plan*. London.

Hawken, P., Lovins, A. and Hunter Lovins, L. (1999). *Natural Capitalism: Creating the Next Industrial Revolution*. Little, Brown and Company, USA.

Jääskö, V. and Mattelmäki, T. (2003a). Observing and Probing. *DPPI '03*, June 23-26, Pittsburgh.

Jääskö, V., Mattelmäki, T. and Ylirisku, S. (2003b). The Scene of Experience. *The Good, The Bad and The Irrelevant* (Conference Proceedings), September 3-5, University of Art and Design Helsinki.

Jordan, P.W. (2000). *Designing Pleasurable Products.* Taylor and Francis, London.

Lofthouse, V. (2004). Investigation into the role of core industrial designers in ecodesign projects. *Design Studies*, Vol. 25, No. 2, March 2004.

London, B. (1932). *Ending the Depression Through Planned Obsolescence.* Pamphlet, US.

Macpherson, C.B. (1978). *Property: Mainstream and Critical Positions.* University of Toronto Press, Canada.

Manzini, E. (2002). *Ideas of wellbeing: Beyond the rebound effect.* Sustainable Services and Systems: Transitions towards Sustainability, Amsterdam.

Manzini, E. and Jégou, F. (2001). *Sustainable Everyday: Scenarios of Urban Life.* Milan: Fondazione La Triennale di Milano/Edizioni Ambiente.

McDonough, W. and Braungart, M. (2002). *Cradle to Cradle: Remaking the Way We Make Things.* North Point Press, USA.

Packard, V. (1963). *The Waste Makers.* Penguin, Middlesex.

Palahniuk, C. (1999). *Fight Club.* Henry Holt & Company Inc., USA.

Papanek, V. (1995). *The Green Imperative: Natural Design for the Real World.* Thames & Hudson, London, 1995.

Park, M. (2004). Design for Sustainable Consumption. *Futureground*, Design Research Society, Melbourne, November.

Sartre, J.P. (1969). *Being and Nothingness: A Phenomenological Essay on Ontology.* Routledge, London.

Schopenhauer, A. (1970). *On the Vanity of Existence.* Scholarly Press, Michigan, US.

Schultz, S.E., Kleine, R.E. and Kernan, J.B. (1989). These are a few of my favourite things: Toward an explication of attachment as a consumer behaviour construct. *Advances in Consumer Research*, 16, 359-366.

Searles, H.F. (1960). *The Nonhuman Environment.* International University Press, New York, USA.

Sessions, G. (1995). Deep Ecology for the 21st Century: Readings on the Philosophy and Practice of the New Environmentalism. *Shambhala*, Boston, USA.

Shah, A. (2003). *Behind Consumption and Consumerism.* Quoted on the *Global Issues* web site–URL:
http://www.globalissues.org/TradeRelated/Consumption.asp, May.

Stahel, W.R. (1986). The Functional Economy: Cultural and Organizational Change. In *Hidden innovation. Science & Public Policy*, London, **13**(4), August.

—. (1986). The Functional Economy: Cultural and Organizational Change. In *Hidden innovation. Science & Public Policy*, London, **13**(4), August.

Stern, N. (2006). *The Stern Review on the Economics of Climate Change*. New Economics Foundation, London, October 30.

Thackara, J. (2001). The Design Challenge of Pervasive Computing. *Interactions*, New York, **8**(3), May/June, 46-52.

—. (2005). *In the Bubble: Designing in a Complex World*. MIT Press, Cambridge, MA.

Thompson, J. (2005). More than meets the eye. Exploring opportunities for new products, which may aid us emotionally as well as physically. In McDonagh, D., Hekkert, P., van Erp, J. and Gyi, D. (Eds.), *Design and Emotion*. Taylor and Francis, London, 332-336.

Treanor, P. (2005). *Why Sustainability Is Wrong*. URL: www.web.inter.nl.net/users/Paul.Treanor/sustainability.html, November.

United Nations Environment Programme (2007).

van der Ryn, S. and Cowan, S. (1997). *Ecological Design*. Island Press, USA.

van Hinte, E. (1997). *Eternally Yours: Visions on Product Endurance*. 010 Publishers, Rotterdam, The Netherlands

van Nes, N., and Cramer, J. (2005). Influencing Product Lifetime Through Product Design. *Business Strategy and the Environment*, Wiley Interscience, 14, 286–299.

Walker, S. (2006). Object Lessons: Enduring Artifacts and Sustainable Solutions. *Design Issues*, **22**(1), 20-31.

—. (2006). *Sustainable By Design: Explorations in Theory and Practice*. Earthscan.

Wallendorf, M. and Arnould, E.J. (1988). My Favourite Things: A Cross-Cultural Inquiry into Object Attachment, Possessiveness and Social Linkage. *Journal of Consumer Research*, 14, 531-547.

World Health Organisation (2007).

CHAPTER FOUR

PRODUCT GROUP DEPENDENT DETERMINANTS OF USER SATISFACTION

ERDEM DEMİR AND ÇİĞDEM ERBUĞ

1. Introduction

In the last couple of years, following the rapid advances in technology, companies have continued to offer more and more choices for consumers (Lorenz 1990; Norman 1988; Thackara 1997; Schmid 2001). In relation to this abundance of alternatives, product users have become more demanding. They are now pursuing rich and pleasurable experiences with products (Demirbilek et al. 2003; Jordan 1999).

In an attempt to understand these user demands, designers have started to refer to social and behavioural sciences (Frascara 2002). However, as Lawson (1990) states, social and behavioural sciences remain largely descriptive while design is necessarily prescriptive, so the psychologists and sociologists have gone on researching and the designers designing, and they are yet to re-educate each other into more genuinely collaborative roles. Satisfaction, as it is discussed in consumer research literature (see Giese et al. 2000, for an overview) involves a similar problem.

"Consumer/customer satisfaction" is defined as a consumer's post-consumption response based on his/her expectations and influenced by affect aroused during the consumption experience (Oliver 1993; Spreng et al. 1996; Westbrook et al. 1991). This holistic definition, which acknowledges the role of affect in satisfaction response, fits the current aim of designing for experiences. However, unfortunately, the broad perspective of this domain does not unravel the links between the product itself and the satisfaction response, which implies an information gap between marketing and design domains. This gap in practice hinders the support that satisfaction information can actually provide for the designer.

The user satisfaction information, as an informative resource, can maintain its value for designers if it presents product-related determinants of user experience. Following this argument, this paper focuses on product-related determinants of user satisfaction. It presents the results of an empirical study conducted to investigate the impact of different product-related determinants on user satisfaction for various product groups.

2. Consumer satisfaction

Because of its influence on the post-purchase consumer behaviour (Oliver 1980; Ladhari 2007) and on the success of the brand in the market, consumer satisfaction has been one of the central issues in the consumer behaviour discipline since the early work of Cardozo (1965). The domain has witnessed various definitions and characterizations of the concept since then. Giese and Cote (2000) presented an overview of the definitional treatment of consumer satisfaction, by identifying the definitional dimensions. The first of the dimensions is the type of response. Some authors focused on the cognitive involvement, whereas others focused on the role of affect in the satisfaction response. The second dimension is the focus, i.e. the object, of satisfaction. Several works investigated satisfaction with products and services and some others focused on satisfaction with the decision of purchase, or the salesperson behaviour. The third dimension is the timing of the response. Although the satisfaction response was commonly considered to be a post-consumption phenomenon, some works characterized it as a purchase or choice-related phenomenon. In this paper, following the definition of Oliver (1997), satisfaction is defined as a judgment that a product is providing a pleasurable level of consumption-related fulfilment after actual use. In this definition, satisfaction is referred to as a concept having both cognitive and affective components, having a product focus, and referring to post-consumption period.

Friman (2004) differentiates encounter satisfaction from overall satisfaction: encounter satisfaction is related to the evaluation of the single transactions or encounters with a product or service, whereas overall satisfaction refers to the summary response that is formed over a period of time and shaped by several encounters. Encounter satisfaction can be seen as an emotional reaction because it is an affective response to a change in the environment (Frijda 1986). However, overall satisfaction, as outlined above, has cognitive, affective, and behavioural components, is formed

through a relatively longer period of time and numerous encounters with the product, and is more static instead of dynamic and ephemeral (Oliver 1980). With these properties it resembles an attitude rather than an emotion (Hunt 1977; Mano et al. 1993). The main focus of this study is on the overall satisfaction.

Another important issue is the difference between satisfaction and dissatisfaction. Some studies show that consumers may report a high dissatisfaction (i.e. very dissatisfied) and a neutral satisfaction for the same product in the satisfaction measurement study (Giese et al. 2000), implying the necessity to treat satisfaction and dissatisfaction as separate dimensions rather than two extremes of the same continuum.

2.1 The process of satisfaction response formation

The early models of consumer satisfaction are mainly composed of cognitive constructs and processes. The basic process in the formation of the satisfaction response is expectancy confirmation, which has two interrelated components: (1) formation of expectations about the performance or the quality of the product or the service, and (2) disconfirmation of these expectations (either positively or negatively) after consumption or use (Oliver 1980). According to this model, the higher the formed expectations are and the more positive the disconfirmation is, the more intense the resulting satisfaction response. Cadotte et al. (1987) claim that the main reference point in the performance or quality fulfilment judgments should be norms or standards rather than expectations. Unlike the term of expectation, these constructs imply a desired performance and quality level. In the literature, other cognition-based models are also proposed (for example, the equity theory-based model of Huppertz et al. (1978), and the attribution theory-based model of Folkes 1984). These other models will not be discussed here as the expectancy conformation model had more explanatory power in various product and service contexts (Oliver et al. 1987).

Westbrook (1987) stated that the satisfaction response was not only shaped by the cognitive comparison processes but also by retrieval and integration of relevant product-related affective experiences, which were identified elsewhere as consumption emotions (Richins 1997). Various works found significant influences of both positive and negative affect on the satisfaction response (Oliver 1993; Mano et al. 1993; Ladhari 2007). As expected, pleasant experiences increased the level of satisfaction,

whereas unpleasant experiences had negative effects. Caro and Garcia (2007) identified two different perspectives on the role of affective processes in the formation of satisfaction responses. According to the first, the mediating role, affect resulting from the instrumental evaluations of the products and services influences satisfaction (Mano 2004). The second view considers affective experiences with products and services as an independent variable: affective experiences that are not related to the instrumental aspects of the products can also influence satisfaction. Caro and Garcia (2007) reported empirical evidence for the second view in a public-service context.

2.2 Product attribute bases of satisfaction

Oliver (1993) defined attribute satisfaction as the evaluative judgment about the attribute performance, and referred to attribute satisfaction as one of the main determinants of overall satisfaction. In a previous study, Oliver (1992) provided an attribute-based analysis for automobiles and identified two attribute groups. The first group included attributes with the continuing performance of the product such as acceleration, ride, fuel economy and the second group is comprised of those which are one-time (such as price), infrequently accessed (such as service), and unchanging characteristics (such as safety, quality). Swan and Comb's (1976) instrumental and expressive attribute groups separated the performance-related attributes form the intangible attributes of the products. The authors reported that the expressive group was more important for satisfaction, whereas the instrumental group was more important for dissatisfaction in the case of clothing apparel. However, Maddox (1981) showed that the findings of Swan and Combs were not applicable to some other product groups, such as durables. This finding implies a necessity to approach satisfaction with sensitivity to the type of the product under investigation.

To sum up, consumer behaviour literature explains how the consumer satisfaction response is formed and which cognitive and affective constructs play a role in the formation of the response.

The general consumer satisfaction models point to the importance of attribute evaluation, however none of these models detail the particular attributes for different product groups. In addition, some of the attributes that are included in those models are not under the direct influence of the designer, for example, the price of the product. Other models indicate the significance of emotional consumption experiences, but the product-

related aspects of these experiences remain uninvestigated. In our opinion, the value of the satisfaction information for designers can be increased by identifying the product-related determinants of the satisfaction response with a sensitivity for different product groups.

3. Product-related determinants influencing satisfaction

As summarized in the previous section, consumers' experiences with products have either a direct or an indirect influence in the formation of the satisfaction response, therefore the product aspects that are discussed in the user experience area in the design domain can be treated as product-related determinants of satisfaction. In human-computer interaction and product-design domains, some authors analysed the dimensions of user experience and some others proposed criteria for designing positive experiences. These references, either implicitly or explicitly, pointed to the influence of several product determinants on user experience (see Alben et al. 1996; Huspith 1997; Margolin 1997). The first determinant is a combination of usefulness and performance, which can be termed as functionality. The second is usability, the third is aesthetics, and the fourth is product meaning (in relation to the social and cultural context). Each determinant is discussed in more detail in the following paragraphs.

3.1 Usefulness

In this paper, usefulness is defined as the appropriateness of functions offered by a product with respect to its user's needs. In this context, usefulness resides at the base of the satisfaction response. Design research has put considerable effort into designing for user needs and requirements (see Hasdoğan 1996; Stanton 1998), but unfortunately this effort often did not have a correlation in real life cases. Gültekin (2004), targeting technology-driven products, claimed that the excess functions offered by technologically advanced and highly capable products influence the user's usability evaluation and satisfaction negatively.

3.2 Performance

In the consumer research domain, product performance has been referred to as a user expectation shaping overall satisfaction response (Halstead et al. 1994; Tse et al. 1988). These works regarded the performance as the extent to which the product can perform its aimed function, which is also the definition used in this study.

3.3 Usability

Usability of a product is one of the most important factors influencing not only purchase decisions (Dumas et al 1994) but also product acceptance (Nielsen 1993). The concept was commonly defined with its underlying dimensions: effectiveness, i.e. the extent to which a goal in product usage is achieved, efficiency, i.e. effort required to accomplish a goal, and satisfaction, i.e. comfort of use (ISO 1998). For interactive electronic products, the list of underlying dimensions included ease of learning referring the novices' ability to reach a reasonable level of performance rapidly and retention as the ability to remember the usage (Nielsen 1993; Shneiderman 1992). Han et al. (2001) provided an exclusive list of dimensions of usability. These attributes were classified in three groups: perception/cognition (i.e. related to perceiving and interpreting the interface, such as explicitness, responsiveness, simplicity, etcetera), learning/memorization (i.e. addition to learnability and memorizability, consistency, informativeness, etcetera), and control/action (i.e., accessibility, efficiency, etcetera).

3.4 Aesthetics

Desmet and Hekkert (2008) defined the aesthetic aspect of the product experience as the gratification of the senses. Pleasurable experiences that users have with products can contribute to the satisfaction of response as was discussed in the previous section. In user-experience literature, different modalities have been investigated, visual aesthetics being the most commonly investigated modality. In consumer literature, visual aesthetics have been discussed in terms of their influence on both purchase decisions (Veryzer 1993) and post-purchase evaluations (St. James et al. 2004).

Recently, other modalities have gained significance in the user-experience domain. Van Egmond (2008) investigated the auditory experience in product interaction, in particular perceptual and cognitive processes that relate to pleasure in auditory experience. Sonneveld and Schifferstein (2008) identified the dimensions of tactual experience in order to produce a guideline for designers to design products evoking pleasurable tactual experiences. Schifferstein and Spence (2008) investigated the interaction of different sensory modalities in product experience. Different sensorial modalities giving the same message were found to be more pleasurable by the users, according to Schifferstein and

Spence (2008). These modalities, which were shown by these works to be influential on product experience, can also influence the formation of satisfaction response.

3.5 Meanings of products

Experience of the meaning of a product can be considered as an influential factor on the overall satisfaction response. Literature provides several different types of meanings that a product may carry. Dittmar (1992) asserted that certain material possessions, individually and in combination expressed an individual's identity in society. Two types of meanings associated with material possessions were discussed in this work: categorical and self-expressive meanings. Categorical meanings are related to expression of social status, and connections to a particular social group. Whereas self-expressive meaning communicates individuality, i.e. personal values, attributes, and characteristics, and differentiates the product's owner from others. Govers (2004) pointed to the influence of meaning dimension in consumer preferences: she claimed that consumers preferred products that expressed their personality characteristics.

In addition to meanings having a social focus, products may also carry private meanings (Richins, 1994). The main aspect of the private meaning is the owner's personal history in relation to the object. Csikszentmihalyi and Rochberg-Halton (1981) relate private meanings to repeated interaction with a product and psychic energy invested in that product. According to the authors, these products objectify a person's past, present and future as well as his or her close relationships.

Jordan (1999), with the notion of ideo-pleasure, considers products as bearers of intellectual and ideological meanings. A user can get pleasure from political and ideological inferences made by decoding the signs and symbols embedded in the product. This type of pleasurable experiences can be influential in user satisfaction as well.

4. The empirical study

As was discussed in section 2, users look for different aspects in different product groups, and these aspects play a substantial role in the formation of the satisfaction response. It seems reasonable to argue that the satisfying attributes, features or aspects of a stapler, for instance, would be different from those of a washing machine, as these products are used in different

contexts, serve different functions, involve different levels of complexity, and so on. From this perspective, a study was designed to identify the important satisfaction determinants with a particular sensitivity to product groups. The first step in the study was to identify the product groups. Unfortunately, no design-related product classification was encountered in our attempts to find a product classification. A new product classification was therefore proposed in line with the analysis of product classifications proposed by the World Intellectual Property Organization (WIPO 2003), online catalogues of large retail stores such as Sears (Sears Retail Store, 2005), and prominent design awards such as Good Design Awards (Good Design Awards 2005).

Product Group	Examples
White goods	Refrigerator, range, oven, microwave oven, dishwasher, washing machine, etcetera
Small kitchen appliances	Blender, food processor, kettle, toaster, grill, etcetera
Kitchen utensils	Pan, knife set, bottle opener, can opener, corkscrew, knife holder, dish basin, etcetera
Furniture	Seating unit, table, coffee table, stool, chair, cabinet, wardrobe, etcetera
Home electronics	TV, audio system, cable telephone set, answering machine, etcetera
Small appliances	Vacuum cleaner, iron, hair dryer, etcetera
Computer equipment	Monitor, mouse, keyboard, computer box, etcetera
Stationary-office equipment	Pen, pencil sharpener, desk lamp, CD holder, note holder, punch, stapler, etcetera
Personal products	Wallet, backpack, mechanical watch, handbag, etc.
Personal electronics	Cellular phone, laptop, digital photo camera, etc.

Table 4-1. Product groups and examples.

The list of product groups and example products in these groups are provided in Table 4-1.

The importance of different determinants influencing overall satisfaction responses was investigated for different product groups via semi-structured interviews followed by quantitative analysis. The study was carried out with 10 participants of different age groups. Middle and high socio-economic status participants were selected to reduce the effect of price and to focus on product-related qualities. The sessions started with the explanation of the study carried out and the structure of the interview to the participant. After the introduction phase, the participants were asked to name a product in each of the product groups that they owned and used that provides a feeling of overall satisfaction. They were also asked to name a dissatisfying product for each of these groups. The reasons underlying these responses were investigated via open-ended questions on the basis of comparison of this product to others that they previously owned or that they did not own but had seen or had experienced in other contexts, for example, in a shop or at a friend's place. The interviews were conducted at the homes of the participants to facilitate user reports and to enrich the discussion. A typical session lasted between 45 minutes and 1 hour.

The interviews were then transcribed and the content was analysed by labelling the comments of the participants to previously mentioned determinants via the inter-judge agreement approach. In this phase, the sub-headings of these main determinants were identified. This phase was followed by a quantitative analysis of the importance of each determinant for each of the product groups.

When a participant raised a comment labelled by a particular determinant of satisfaction, this determinant was marked as "raised" for that particular product group. All determinants raised by a participant for a satisfactory product were assumed to have equal importance for that participant. For instance, if a participant raised three determinants, no matter how frequently he/she referred to any one of those, these three determinants were assumed to share an importance of 33% for that participant, while the other determinants were labelled with a 0% importance. The importance indices for each product group were then averaged over all participants. This normalization of individual effect was necessary to standardize the number of comments, as some of the participants raised relatively more comments than the others.

Another way of determining relative importance could have been by using the number of comments instead of checking whether one

determinant was raised or not. The number of possible comments may vary a great deal among the determinants, however. For example, regarding usability of a mobile phone, a participant may comment on several different product aspects such as the comfort of holding the phone; the clarity of the display area; the ease of pushing buttons; the understandability of the menu titles. In contrast, the participant may not state so many aspects regarding the durability of the cellular phone. This determinant is considered to be a binary construct, for example, a mobile pone may be evaluated as durable or not, regarding the functioning problems. Hence, an analysis based on the number of comments could yield a bias for the determinants which have relatively more subheadings.

5. Results

The study showed that the most frequently mentioned satisfaction determinants differ according to product groups. The findings were summarized for each product group, and sub-headings were provided for the determinants. The study revealed that durability and safety, which were not included in the initial list of determinants, should also be considered as satisfaction determinants.

Table 4-2 provides an overview of the results. Three different measures are presented in the table. For each product group, the three rows display (a) the relative importance percentages, (b) the number of positive comments, and (c) the number of participants that raised at least one comment for a determinant, respectively.

		Performance	Usefullness	Usability	Aesthetics	Meaning	Durability	Safety
White goods	a)	25%	27%	18%	7%	-	23%	-
	b)	7	13	5	4	-	5	-
	c)	6/10	7/10	5/10	3/10	-	6/10	-
Small kitchen appliances	a)	20%	23%	14%	17%	17%	7%	2%
	b)	7	9	9	8	6	1	1
	c)	6/10	7/10	5/10	6/10	5/10	1/10	1/10
Kitchen utensils	a)	20%	23%	12%	25%	16%	3%	9%
	b)	3	7	3	7	6	1	2
	c)	3/10	5/10	3/10	7/10	4/10	1/10	2/10
Furniture	a)	-	18%	16%	37%	24%	5%	-
	b)	-	5	7	17	9	1	-
	c)	-	5/10	4/10	9/10	6/10	1/10	-
Home electronics	a)	26%	18%	9%	24%	6%	17%	-
	b)	7	5	4	9	2	4	-
	c)	7/10	5/10	2/10	6/10	1/10	4/10	-
Small appliances	a)	34%	15%	28%	6%	9%	8%	-
	b)	5	4	10	2	3	2	-
	c)	5/10	4/10	6/10	1/10	2/10	2/10	-
Computer equipment	a)	12%	8%	43%	14%	18%	4%	-
	b)	2	1	9	3	3	1	-
	c)	2/10	1/10	6/10	3/10	3/10	1/10	-

Stationary-office equipment	a)	6%	17%	4%	36%	33%	4%	-
	b)	2	4	1	10	10	1	-
	c)	2/10	4/10	1/10	7/10	6/10	1/10	-
Personal products	a)	-	26%	16%	26%	24%	8%	-
	b)	-	7	6	14	12	2	-
	c)	-	7/10	4/10	7/10	7/10	2/10	-
Personal electronics	a)	8%	27%	25%	17%	10%	13%	-
	b)	3	11	12	6	3	3	-
	c)	2/10	7/10	7/10	4/10	3/10	3/10	-

Table 4-2. The measures for the importance of satisfaction determinants for different product groups.

5.1 White goods

For this group, participants mostly referred to hard functionality issues as reasons underlying satisfaction. The three most important determinants were *durability*, *performance* and *usefulness* of the product. For some participants, these determinants were so important that some negative aspects of the product, for example, unpleasant smell of the material of a freezer, could be ignored as long as the product provided the required output. *Usability* and *aesthetics* turned out to be of secondary importance for this group of products. In contrast with the other groups, the meaning aspect of the products was not mentioned by any of the participants.

When asked to report a dissatisfying product, eight out of ten participants could not report a dissatisfying white good product. Three of these participants mentioned some negative aspects about some particular white good products that they used (such as lacking feedback about the status of the wash-cycle for a washing machine), however, they did not report overall dissatisfaction with these products, as the main functions were properly served by the product, which also shows the importance of the hard functionality determinants for these products.

Determinants	Sub-Heading	Example
Performance	Quality of the output Energy requirements	Washing machine washing delicately Energy efficient dishwasher
Usefulness	Useful primary function Useful secondary functions Basic functions Adjustability Physical dimensions	Microwave oven cooking quickly Freezer feature of a refrigerator Dishwasher having only required programs Removable trays of a dishwasher Large refrigerator satisfying the requirements of the user
Usability	Efficiency (add-in function) Efficiency (materials) Sense of control	Refrigerator with water dispenser Refrigerator with transparent shelves Dishwasher with basic functions
Aesthetics	Colour Form Texture (visual)	
Durability	Performing without problems for a long time	

Table 4-3. Determinants and sub-headings for satisfactory white goods.

5.2 Small kitchen appliances

The study indicated that the important determinants for this group are *usefulness*, *performance*, *usability*, *aesthetics*, and *meaning* issues. In general, the comments focused on the cost-benefit evaluation about the usage of the product. For instance, a blender was found to be satisfactory based on the high benefit it provided (i.e. fine mixing of food that can not be achieved manually) with respect to its usage costs (i.e. small footprint on the countertop and easy cleaning). In contrast, a food processor was reported to be dissatisfying because of the low benefit relative to the cost

Determinants	Sub-Heading	Example
Performance	Quality of the output	Juicer that takes the entire juice out
Usefulness	Useful primary function Useful add-in functions Basic functions Physical dimensions	Kettle which boils water quickly Ice crushing blender Hand blender instead of food processor. Large kettle satisfying the requirements of the user
Usability	Comfort of use Ease of use (form) Efficiency (detachable parts) Efficiency (number of steps) Flexibility	Hand Blender fitting hand Easy to clean juicer Toaster that is easy to clean Kettle that can be turned on/off while holding Hand blender that can stand on its own on the countertop
Aesthetics	Form	
Meaning	Ideological-Intellectual Product personality Social interaction	Kettle that gives the feeling of being "designed" Modest hand blender Hand blender that is used to make cocktails for friends
Durability	Performing without problems for a long time	
Safety	Not causing accidents	

Table 4-4. Determinants and sub-headings for satisfactory small kitchen appliances.

of cleaning: "... *if I were to realize many steps and use this product to do something which I can do with my hands, it is meaningless to use it*" (participant 1, female, 26, food processor).

5.3 Kitchen utensils

Aesthetics and *usefulness* raised as important determinants. The respondents also raised meaning-related comments frequently. One particular type of comment was related to the play-like feeling arising from the physical interaction with products such as a corkscrew, can opener, and vegetable peeler. Compared to other product groups, *safety*

Determinants	Sub-Heading	Example
Performance	Quality of the output	Sharpness of a knife
Usefulness	Useful primary function Useful (physical dimensions) Useful (form)	Vegetable peeler Sestet of pans that is suitable for every amount of food Wall-mounted knife holder saving space on countertop
Usability	Comfort of use (form) Comfort of use (mechanism) Error prevention	Service fork Corkscrew not requiring too much exertion Open knife holder not concealing knives
Aesthetics	Form Colour Texture (tactile)	Pleasing material in bottle opener
Meaning	Ideological-Intellectual Personal memories Physical interaction Product personality	Corkscrew representing bohemian life style Knife evoking memories of dinners with loved one Can-opener offering play-like interaction Cute bottle opener
Durability	Performing without problems for a long time	
Safety	Not causing accidents	

Table 4-5. Determinants and sub-headings for satisfactory kitchen utensils.

was raised most frequently. These products are generally operated by hand and they are prone to cause accidents, which generated comments about safety: "*...I like this can opener. My mom cut her hand while trying to open a can with a knife and one of my friends cut hers, while using another mechanical one. This one does not cause any problems, it is safe to use this*" (participant 2, male, 25, can opener).

With regard to dissatisfaction, the focus shifted to *usability*. Among the 15 negative comments raised for the unsatisfactory products, seven were related to *usability*. Most of these comments were related with comfort of use affected negatively by the form, mechanism, weight of the product (for example, opening mechanism of spice jars, general form of the can opener not fitting to hand, weight of the crystal decanter). The importance of *aesthetics* can also be seen for dissatisfaction (five of 15 negative comments for unsatisfactory products).

5.4 Furniture

Aesthetics was the most important determinant. A strong visual appeal was sufficient to produce overall satisfaction despite some problems related to other determinants, such as difficulty in cleaning, discomfort of a couch when used occasionally as a bed. In addition, other determinants such as *usefulness*, *usability*, and *meaning* also have influence on the formation of satisfaction response. There was a variety of comments about the meaning of the products for this group. Respondents' comments included the "*authenticity of the wooden material of a seating group*", the "*uniqueness of a lamp*", the "*Scandinavian'ness of a sofa*", etcetera. Another important sub-heading is social meanings related to the usage of the product in social interactions, for example, a corner-seating unit that provides a warm environment due to seating locations.

Participants experiencing usability problems (such as comfort of use, difficult cleaning) with their furniture tended to mention these products as dissatisfactory ones. Seven of 17 negative comments for unsatisfactory products were related to usability of the product.

Determinants	Sub-Heading	Example
Performance	Quality of the output	Table that can take heavy weights
Usefulness	Useful primary function Useful secondary function	Coffee table which makes the room tidy Large armrests of a sofa that can be used as coffee table
Usability	Comfort of use (dimension) Ease of use (weight) Ease of use (material) Ease of use (detachable parts)	Large seating unit Light-weight easy to move sofa Easy to clean material of sofa Detachable cover of sofa making it easier to clean
Aesthetics	Form Colour Texture (visual) Texture (tactile)	 Pleasing touch feelings related to a sofa
Meaning	Personal memories Product personality Social interaction	Corner seating unit evoking childhood memories Uniqueness of the material of lamp Round table facilitating social interaction
Durability	Performing without problems for a long time	

Table 4-6. Determinants and sub-headings for satisfactory furniture.

5.5 Home electronics

The prevailing determinants of this group were found to be *performance* and *aesthetics*. The quality of the output of audio-visual electronic products such as TV, DVD Player, and CD player were named as the main determinants of the satisfaction response. In addition, *aesthetics* turned out to be an important determinant for satisfaction with these products. *Usefulness* and *durability* related comments were of secondary

Determinants	Sub-Heading	Example
Performance	Quality of the output	Quality of the audio output of a music set
Usefulness	Useful primary function Useful secondary functions	TV set that is usable. TV set that is compatible with DVD player
Usability	Comfort of use (form) Ease of use (navigation) Ease of use (guessability)	Form of a remote control fitting the hand Easy to navigate menu structure for a DVD player Understandable wording in the menu of a DVD player
Aesthetics	Form Colour Texture (visual) Texture (tactile)	Knob of a Hi-fi system
Meaning	Product personality Social interaction	"High-tech" looking product DVD Player allowing movie sessions with friends
Durability	Performing without problems for a long time	

Table 4-7. Determinants and sub-headings for satisfactory home electronics.

importance. *Usability* and *meaning* were rarely mentioned in relation to satisfaction from home electronics.

Although its influence for the satisfaction seems faint, *usability* was the most important determinant for dissatisfaction (5 out of 11 negative comments raised for unsatisfactory products). The problems mentioned were generally related to difficulty of use resulting from low understandability, e.g., "...*I cannot decide how I proceed to find a specific menu item. The menu structure is not logical. I cannot understand the words either. What is "base tuning" for God's sake?*" (Participant 4, female, 25, telephone set), as well as, due to low efficiency and high number of steps to be realized for a task, e.g., "*It is very time-consuming to*

tune the channel, I feel very tired when I try to record something with this video" (participant 3, male, 32, video player).

Determinants	Sub-Heading	Example
Performance	Quality of the output	Motor power of a vacuum cleaner
Usefulness	Useful primary function	Vacuum cleaner
Usability	Comfort of use (weight) Ease of use (detachable parts) Ease of use (dimensions) Ease of use (form)	Little force required to iron Ease of storage due to detachable parts Small vacuum cleaner that is used in narrow corridors Stable vacuum cleaner that does not overturn
Aesthetics	Form Colour	
Meaning	Product personality	Playful hairdryer
Durability	Performing without problems for a long time	

Table 4-8. Determinants and sub-headings for satisfactory small appliances.

5.6 Small appliances

The respondents referred to concrete functionality issues like *performance*, *usability*, and *usefulness*. *Aesthetics* or *meaning* determinants turned out to be less influential on the overall satisfaction response. The major dissatisfaction reason was also the performance of the product according to this sample. Five of the nine negative comments raised for unsatisfactory products relate to performance of the product.

5.7 Computer equipment

The most important determinant of this group was *usability*. The usability subheadings included comfort of use due to form (for example wrist rest of a keyboard, form of mouse), ease of carrying (for example ergonomic handling for a computer chassis, flat monitor carried like a

notebook), efficiency (for example scroll wheel of a mouse, which facilitates scrolling). The other determinants were more or less equally important for the overall satisfaction response. The *usability* determinant was also the most frequently mentioned determinant for dissatisfaction response (4 out of 10 negative remarks for unsatisfactory products.)

Determinants	Sub-Heading	Example
Performance	Quality of the output	Optical mouse that responds properly
Usefulness	Useful primary function	Computer itself allowing communication through internet
Usability	Comfort of use (form) Comfort of use (add-in parts) Ease of use (dimensions) Ease of use (form) Efficiency (short cuts)	Comfortable mouse form Keyboard with ankle rest Flat screen that is easy to carry Handle of a computer box making it easy to carry Mouse with roller
Aesthetics	Form Sound Texture (tactile)	Pleasant sounds of keyboard buttons Smooth feeling of the tactile qualities of a keyboard
Meaning	Ideological-Intellectual Product personality Social interaction	Computer box making fun of "high tech" products "Elegant sophisticated" flat computer monitor Computer allowing communication with relatives
Durability	Performing without problems for a long time	

Table 4-9. Determinants and sub-headings for satisfactory computer equipment.

5.8 Stationary-office equipment

The study yielded *aesthetics* and *meaning* determinants as the most influential ones. For instance, simple design solutions interpreted by participants as "*unimposing*" were found satisfactory, for example, a table-top lamp. At the other extreme, interesting and complex design solutions attracted interest and yielded satisfaction response, for example, pen with a novel clicking mechanism. *Usability* considerations such as comfort of use (stapler), efficiency of use (CD holder), prevailed for the overall dissatisfaction (7 out of 13 negative comments for unsatisfactory products).

Determinants	Sub-Heading	Example
Performance	Quality of the output	Table top lamp which works well
Usefulness	Adjustability Physical dimensions	Movable table lamp Small table lamp not occupying much space
Usability	Comfort of use (form) Comfort of use (weight)	Shallow paperclip bins with easy-to-reach bottom Pen with an appropriate weight
Aesthetics	Form Colour Texture (visual)	
Meaning	Ideological- Intellectual Personal memories Product personality	The creative process behind a novel pen Memories related to old-fashioned pencil sharpener Cuteness of a pen holder
Durability	Performing without problems for a long time	

Table 4-10. Determinants and sub-headings for satisfactory stationary-office equipment.

Determinants	Sub-Heading	Example
Usefulness	Useful add-in functions Useful primary function Useful secondary functions Physical dimensions	Watch informing about date Frequently needed watch Handbag having many sections for specific purposes Key-ring that can carry lots of keys
Usability	Comfort of use (material) Comfort of use (weight) Ease of use Efficiency	Strap of a watch that prevents sweat Light watch Clarity of a watch due to graphical elements Few number of steps to be realized to use key-ring
Aesthetics	Form Colour Texture (visual) Texture (tactile)	 Pleasant feeling of the material used for a purse
Meaning	Ideological-Intellectual Personal memories Product personality	Key holder symbolizing technology and advancement Purse (given as a gift) recalling its giver Sporty wallet
Durability	Performing without problems for a long time	

Table 4-11. Determinants and sub-headings for satisfactory personal products.

5.9 Personal products

Usefulness, *aesthetics*, and *meaning* issues were the most influential determinants for this group of products. The sub-headings of *meaning* issues were mostly related with the personality of the product. The comments raised for this determinant reveal positive emotions, such as appreciation and admiration, in response to product personality. These evaluations include keywords such as "*not kitsch*", "*unimposing*", "*attractive*", "*sportive*", "*natural*", "*informal*", and "*unique*". The image

keywords that were stated in positive comments reflected their self ideals, for example, "...*I am quite satisfied with this watch. It just suits me very well. It has an unimposing style. I am in general an unimposing person*" (participant 1, female, 26, watch).

Although *usability* did not turn out to be a primary determinant for satisfaction, it was one of the prevailing determinants for dissatisfaction. The total number of negative comments regarding unsatisfactory products was insufficient to deduce general arguments. However, the following example of an unsatisfactory product reflects the importance of usability quite clearly: "...*I really liked the appearance of the watch, I still do. At the time of purchase I thought that I could read the time despite the fact that the dial was divided into 10 portions, but I could not. The dial misled me many times*" (participant 4, female, 47, watch).

5.10 Personal electronics

Usefulness and *usability* turned out to be the most important determinants of satisfaction from personal electronics. *Aesthetics*, especially visual aesthetics, played a secondary role in the overall satisfaction. It appeared that the appearance of the hardware of these electronic gadgets might give clues about the software as well: "... *I don't check the menus during the purchase stage; I have the impression that if the exterior is designed well, the interior should also be designed well*" (participant 5, male, 25, mobile phone).

Usability was the most important determinant for dissatisfaction. Seven of the 16 negative statements about the unsatisfactory products were related to *usability*. Three of them were hardware related, for example, uncomfortable form of the headset, and the others were software related, for example, insufficient feedback of a mobile phone.

Determinants	Sub-Heading	Example
Performance	Quality of the output	Laptop working fast
Usefulness	Useful primary function	Digital camera facilitating the photo taking activity
	Useful secondary functions	Digital camera with automatic control features
	Physical dimensions	Large screen of a laptop allowing multiple tasks
	Basic functions	Cellular phone without any excess functions
Usability	Clarity (dimensions)	Large readable icons of a cellular phone
	Comfort of use (dimensions)	Buttons of a cellular phone that are comfortable to press
	Comfort of use (form)	Cellular phone comfortable to hold
	Comfort of use (weight)	Light cellular phone that is easy to carry
	Ease of use (navigation)	4-directioned button of a cellular phone
	Ease of learnability	Menu structure of a cellular phone
	Error prevention	Clear warnings of a cellular phone
Aesthetics	Form Color	
Meaning	Product personality	Modesty of a cellular phone
Durability	Performing without problems for a long time	

Table 4-12. Determinants and sub-headings for satisfactory personal electronics.

5.11 Framework of product-related determinants of satisfaction

The study suggested that the formation of the satisfaction response could be influenced by a variety of different product aspects. The study

Figure 4-1. Framework of product-related determinants of satisfaction.

provided an initial list of product-related determinants for the satisfaction response, as well as the subheadings for those determinants. Figure 4-1 provides a framework covering all those determinants and subheadings.

The study suggested that the importance of these determinants varied between different product groups. For instance, *durability* was among the primary factors for satisfaction with white goods, but this was not the case for other product groups such as kitchen utensils. Some of the determinants were not mentioned among the influential satisfaction determinants for some of the product groups, i.e. *meaning* in the case of white goods. In addition, some of the subheadings were product-group-specific, for example sense of control only for highly "interactive" electronic product groups. In such a context, a general framework of satisfaction determinants may seem elusive. Nevertheless, bringing all the

determinants and subheadings together may help the designer to see the big picture and it may act as a checklist for designing satisfactory products.

6. Discussion

Satisfaction, as discussed in consumer behaviour literature, offers little for the design domain. In consumer behaviour literature, the effect of products on satisfaction response has been analysed mainly in terms of the general attribute groups, such as utilitarian attributes and hedonistic attributes, without giving details of what these attributes are (Mano et al. 1993). The satisfaction models that are built on these general constructs are hardly supportive to reach the goal of designing satisfactory products. In order to improve the value of the satisfaction information for designers, this study provided a more detailed account of the relationship between the product and the satisfaction response. The main contribution of this study is not the identification of these determinants, however, as these have been among the basic design criteria since even the earliest design theories, and designers with genuine respect for their profession have been paying painstaking attention to these issues for years. The real contribution of this study is the method that is proposed for identifying the important satisfaction determinants and the initial results about this issue. Although initial results are insightful, they cannot be seen as generalisable results due to the small sample size used in the study. In future, following the methods summarized in this paper and using larger sample sizes, it will be possible to come up with more robust results about the importance of particular determinants for particular product groups. These results will improve the effectiveness of the support provided by the satisfaction information, by revealing the priorities of satisfactory product design. These priorities can be translated to insightful design briefs that recommend the exploitation of key determinants. For instance, in the study, the usefulness of a refrigerator turned out to be the prevailing determinant for satisfaction. A design brief particularly focusing on designing a more satisfactory refrigerator, can recommend the exploitation of the product's usefulness. A particular issue that was found in this study is that white goods may witness different phases of their users' lives (use when single, after a marriage, after having children, after the children leave home) and they may be used in changing need contexts. A focus on usefulness, and in particular on these changing need contexts, may direct the design through more versatile products that can be adapted to these changing contexts by minor adjustments in terms of technical properties, features and physical dimensions.

Designers may also adopt a perspective to offer something more by focusing on the less important determinants. As the literature review on consumer satisfaction shows, consumers' prior expectations are the main elements that influence the satisfaction response (Oliver 1997). The important determinants, according to the study, can be considered to reflect the current expectations of the participants. That is to say, the determinants that were mentioned as important ones are most probably what the participants will look for in their new purchases. From this perspective, going beyond the expected determinants and offering more by focusing on the less important determinants can provide an edge for the product. To continue with the example of the refrigerator, meaning aspects of the white goods turned out to be of secondary importance for the satisfaction formation, which may mean that the refrigerator users do not expect to get meaningful experiences but mainly functionality and usefulness from their products. Once satisfactory levels of functionality and usefulness are being achieved, meaningful attributes such as expressive qualities may exceed what a user expects from a refrigerator and may result in extreme satisfaction.

Works Cited

Alben, L. (1996). Quality of Experience: Defining the Criteria for Effective Interaction Design. *Interactions,* **3**(3): 11-17.

Cadotte, E.R., Woodruff and Jenkins (1987). Expectations and Norms in Models of Consumer Satisfaction. *Journal of Marketing Research,* 24: 305-314.

Cardozo, R.N. (1965). An Experimental Study of Consumer Effort, Expectation and Satisfaction. *Journal of Marketing Research,* 2: 244-249.

Caro, L.M. and García, J.A.M. (2007). Cognitive–affective model of consumer satisfaction. An exploratory study within the framework of a sporting event. *Journal of Business Research,* **60** (2): 108-114.

Csikzentmihalyi, M. and Rochberg-Halton (1981). *The Meaning of Things: Domestic Symbols and the Self.* Cambridge: Cambridge University Press.

Desmet, P. and Hekkert, P. (2007). Framework of product experience. *International Journal of Design,* **1**(1): 57-66.

Dittmar, H. (1992). *The Social Psychology of Material Possessions: to Have is to Be.* New York: St Martin's Press.

Dumas, J.S. and Redish (1994). *A Practical Guide to Usability Testing.* Norwood, NJ: Ablex.

Folkes, V.S. (1984). Consumer reactions to product failure: an attributional approach. *Journal of Consumer Research,* 10: 398-408.

Frascara, J. (2002) *Design and Social Sciences: Making connections.* London: Taylor & Francis.

Frijda, N.H. (1986) *The emotions.* Cambridge: Cambridge University Press.

Friman, M. (2004). The structure of affective reactions to critical incidents. *Journal of Economic Psychology,* 25: 331-353.

Giese, J.L. and Cote (2000). Defining Consumer Satisfaction. Academy of Marketing Science Review [Online]. URL: www.amsreview.org/articles/giese01-2000.pdf.

Good Design Awards. Winners of Good Design Awards 2005 (Online). URL: http://www.chi-athenae.um.org/gdesign/gdesign0.htm.

Govers, P.C.M. (2004). *Product personality.* Delft: Delft University of Technology.

Gültekin, P. (2004). The Negative Effects of Technology-Driven Product Design on User-Product Interaction and Product Usability. Unpublished MSc. Thesis, METU.

Halstead, D., Hartman and Schmidt (1994). Multisource Effects on the Satisfaction Formation Process. *Journal of the Academy of Marketing Science,* 22: 114-129.

Han, S., Yun, Kwahk and Hong (2001). Usability of Consumer Products. *International Journal of Industrial Ergonomics,* 28: 143-151.

Hasdoğan, G. (1996). The Role of User Models in Product Design for Assessment of User Needs. *Design Studies* 17(1): 19-33.

Hekkert, P.P.M. (2007). Design aesthetics: Principles of pleasure in design. *Psychology Science* 48: 157-172.

Hudspith, S. (1997). Utility, Ceremony and Appeal: A Framework for Considering Whole Product Function and User Experience. *DRS News* 2(11) (1997).

Hunt, H.K. (1977) CS/D–Overview and Future Research Direction. In Hunt, H.K. (Ed.), *Conceptualization and Measurement of Consumer Satisfaction and Dissatisfaction.* Cambridge: Marketing Science Institute.

Huppertz J.W., Arenson and Evans. (1978). An Application of Equity Theory to Buyer-Seller Exchange Situations. *Journal of Marketing Research* 15: 250-260.

ISO 9241-11. *Ergonomic Requirements for Office Work With Visual Display Terminals (VDTs)–Part 11: Guidance on usability.* 1998.

Jordan, P. (1999). Pleasure with Products: Human Factors for Body, Mind and Soul. In Green, W.S. and Jordan (Eds.), *Human Factors in*

Product Design: Current Practice and Future Trends, 206-217. London: Taylor & Francis.

Ladhari, R. (2007). The effect of Pleasure on Effect of Consumption Emotions on Satisfaction and Word-of-Mouth Communications. *Psychology & Marketing* **24**(12): 1085–1108.

Lorenz, C. (1990). *The design dimension: The new competitive weapon for product strategy and global marketing.* Oxford: Basil Blackwell.

Maddox, R.N. (1981). Two-Factor Theory and Consumer Satisfaction: Replication and Extension. *Journal of Consumer Research* 8: 97-102.

Mano, H. (2004). Emotion and Consumption: Perspectives and Issues. *Motivation and Emotion* **28**(1) : 107-120.

Mano, H. and Oliver, R.L. (1993). Assessing the Dimensionality and Structure of the Consumption Experience: Evaluation, Feeling, and Satisfaction. *Journal of Consumer Research* 20: 451-466.

Margolin, V. (1997). Getting to Know the User. *Design Studies* **18**(3): 227-236.

Norman, D.A. (1988). *The psychology of everyday things.* New York: Basic Books.

Nielsen, J. (1993). *Usability Engineering.* Boston: Academic Press Inc.

Oliver, R.L. (1980). A cognitive model of the antecedents and consequences of satisfaction decisions. *Journal of Marketing Research* 27: 460–469.

—. (1992). An Investigation of the Attribute Basis of Emotion and Related Affects in Consumption: Suggestions for a Stage-Specific Satisfaction Framework. *Advances in Consumer Research* 19: 237-244.

—. (1993). Cognitive, Affective, and Attribute Bases of the Satisfaction Response. *Journal of Consumer Research* 20: 418-430.

—. (1997) *Satisfaction: A Behavioral Perspective on the Consumer.* New York: The McGraw-Hill Companies, Inc.

Oliver, R.L. and DeSarbo (1988). Response Determinants in Satisfaction Judgments. *Journal of Consumer Research* 14: 495-507.

Richins, M.L. (1994). Valuing Things: The Public and Private Meanings of Possessions. *Journal of Consumer Research* **21**(3): 504-521.

—. (1997). Measuring emotions in the consumption experience. *Journal of Consumer Research* 24: 127-146.

Schmid, B.F. (2001). What is new about the digital economy? *Electronic Markets*, **11**(1): 44-51.

Sears Retail Store (Online). URL: http://www.sears.com, 2005.

Schifferstein, H.N.J. and Spence (2008). Multisensory product experience. In Schifferstein, H.N.J. and Hekkert, P. (Eds.), *Product Experience*, 133-161. London: Elsevier Science Publishers.

Shneidermann, B. (1992). *Designing the User Interface: Strategies for Effective Human-Computer Interaction.* Reading: Addison-Wesley.

Sonneveld, M.H. and Schifferstein. (2008). The tactual experience of objects. In Schifferstein, H.N.J. and Hekkert, P. (Eds.), *Product Experience*, 41-67. London: Elsevier Science Publishers.

Spreng, R.A., MacKenzie and Olshavsky (1996). A Reexamination of the Determinants of Consumer Satisfaction. *Journal of Marketing* 60: 15-32.

St-James, Y. and Taylor (2004). Delight-as-Magic: Refining the Conceptual Domain of Customer Delight. *Advances in Consumer Research* 31: 753-758.

Stanton, N. (1998). Product Design with People in Mind. In Stanton, N (Ed.), *Human Factors in Product Design*, 1-17. London: Taylor & Francis.

Swan, J.E. and Combs (1976). Product Performance and Consumer Satisfaction: A New Concept. *Journal of Marketing* 40: 25-33.

Thackara, J. (1997). *Winners!: How today's successful companies innovate by design.* Amsterdam: BIS Uitgeverij.

Tse, D.K. and Wilton (1988). Models of Consumer Satisfaction Formation: An Extension. *Journal of Marketing Research* 25: 204-212.

Van Egmond, R. (2008). The experience of product sounds. In Schifferstein, H.N.J. and Hekkert, P. (Eds.), *Product Experience*, 69-89. London: Elsevier Science Publishers.

Westbrook, R.A. (1987). Product/Consumption-Based Affective Responses and Postpurchase Processes. *Journal of Marketing Research* 24: 258-270.

Westbrook, R.A. and Oliver (1991). The Dimensionality of Consumption Emotion Patterns and Consumer Satisfaction. *Journal of Consumer Research* 18: 84-91.

WIPO. *Locarno classification for industrial designs* (Online). URL: http://www.wipo.int/classifications/fulltext/locarno8/enm01.html, 2003.

Veryzer, R.W. (1993). Aesthetic response and the Influence of Design Principles on Product Preferences. *Advances in Consumer Research* 20: 224-228.

CHAPTER FIVE

INSPIRE & DESIRE

PIETER M.A. DESMET

1. Introduction

How can we design for emotion? Over the years, this question has stimulated many designers and researchers to explore and examine the relationship between design and emotional responses. Various studies have been reported that aimed to identify sources of emotion in human-product interaction. In other words: what are the properties, attributes, or qualities of the product that can (or should) be manipulated in order to elicit or influence the emotional experiences of consumers and users? Assuming that the design profession can be supported with structured overviews of these "sources of product emotion", academics have proposed various models and frameworks. Some of the examples often referred to include: a framework based on psychological pleasure theory (Jordan 2000); a framework based on cognitive appraisal theory (Desmet 2008); and a framework based on neurobiological emotion theory (Norman 2004). Although different in their theoretical backgrounds, these frameworks have in common that they illustrate the layered nature of product affect, and that they identify four main aspects of design that elicit emotions. The first aspect is the sensory qualities of products. This could include, for example, someone who enjoys the styling of a new car design. The second is task-related interactions, and an example is someone who is irritated by a DVD recorder that does not properly respond to the remote control. The third is the (social) context of usage. For example, someone with a new outfit may enjoy the praising remarks of friends. The fourth aspect is personal and cultural meanings. An example is someone who is happy with an award that represents a personal achievement.

The main contribution of these kinds of frameworks is that they can make it easier for those involved in the design process to consider the full

spectrum of ways in which product affect can be influenced. These insights are particularly useful in the stage of materialisation, that is, when an intangible concept is materialised into tangible design. Note, however, that for those involved in design for emotion this only represents one side of the coin. With the term "design for emotion" I am referring to those design activities that are driven by a (predefined) emotional intention. In some cases this intention is general (e.g., to generate positive or pleasurable experiences), and in other cases it is more specific. The frameworks mentioned above are helpful in design materialisation processes, but not necessarily sufficient in the conceptual stage because, although they indicate what attributes can be manipulated, they do not show how these should be manipulated in order to generate the intended effect. Emotions differ in terms of the underlying eliciting conditions, and this chapter is based on the belief that an understanding of these conditions can be of use in design for emotion activities.

Appraisal psychologists who study the distinctive nature of emotions aim to identify formulas or recipes for the conditions that underlie emotions that are both universal (independent of culture and stimulus type) and emotion specific (that is, distinct recipes for distinct emotions). In design projects driven by specified emotion profiles, these recipes may help to direct the use of the above-mentioned frameworks. Authors like Lazarus (1991) and Scherer (2001) have proposed recipes for a variety of emotions. Even though these recipes are interesting, one difficulty is that emotion research in psychology is predominantly focused on those emotions that are considered to be negative or *unpleasant*. Typologies of basic emotions typically include only one pleasant emotion to three, four or five unpleasant ones, and the nature of the pleasant emotions included is very general, such as "happiness". For design research, this focus is not satisfying because designers mostly aim to create products that evoke *pleasant* responses. And although it is relevant to have insights into how and when products elicit unpleasant emotions, insights in how products elicit pleasant emotions are especially helpful in design practice.

In line with these considerations, this chapter will be exploring the conditions that underlie two pleasant emotions: inspiration and desire. These two were selected because questionnaire studies indicated that they are often experienced in response to product design (Desmet 2002) and because current appraisal theories do not satisfactorily explain their eliciting conditions. The conditions that underlie these two emotions in the domain of product design were explored by means of a photo journal study.

Participants were instructed to take pictures of products in their daily surroundings that elicit particular emotions. In a little note book they explained why these particular products elicited these emotions. To further explore the study results, a design workshop was organised in which, from a designer's point of view, twelve design students examined the conditions encountered.

The conditions that underlie inspiration and desire are discussed, and example cases drawn from the photo study are quoted, to reflect the diversity of the participants' narrative descriptions. In a general discussion, we reflect on the value of focussing on distinct emotions rather than on generalised pleasant responses (such as pleasure or enjoyment).

2. Photo journal study

Twenty-nine Dutch people, aged between 25 and 36, with various educational backgrounds and professions, participated. All the participants volunteered and were not paid for their contributions. Each participant was provided with a roll of film and a booklet that contained 21 pages. On the first page, a set of ten emotion words was printed. The remaining 20 pages provided space for the participant's rationales (each page for comments on a single photo). The goal and procedure of the task were explained in a written introduction. Participants were instructed to photograph (at least) 10 products, each one of which elicited one of the given emotions. These ten emotions had been randomly picked from a total set of 14 emotions relevant to product experience, which had been assembled in previous wok (Desmet 2002). In the notebook, participants recorded for each case the product, the emotion, and why that emotion was experienced. They were instructed to formulate their explanations in as much detail as possible, and invited to describe whatever they thought was relevant to explain their emotion (e.g., context, product design, and associations). The task was performed in a period of six weeks. Each participant submitted between 10 and 15 cases, resulting in an anecdotal database of 383 cases. Each case includes a picture of a product, a participant number, an emotion, a description of the underlying eliciting conditions (using the structure shown in Figure 5-1). Of these cases only those that refer to inspiration (29 cases) and to desire (31 cases) are discussed in the current chapter. In the next stage of the project, 12 master's design students of Delft University discussed the applicability of these conditions in conceptual design activities.

2.1 Structure for analysis

In organising and analysing the data, we searched for patterns in described events, triggers or context, meaning to the person, and anything else that seemed relevant. A structure for the analysis was drawn from the perspective of functional emotion theorists. The basic idea underlying that perspective is that emotions function to mediate between environmental stimulation and behavioural response (e.g., Arnold 1960; Frijda 1986). Emotions are elicited in circumstances that have special significance for the person's well-being, and once elicited, prepare and motivate the person to cope with the circumstances in an adaptive manner. Significance for the person's well-being is related to human concerns, such as protection, reproduction, connection, and exploration, understanding, growth, etcetera. Figure 5-1 shows a structure of emotion with three components drawn from this perspective. The main proposition that underlies the structure is threefold: all emotions involve (1) a relationship with a particular object, (2) a personal relational meaning of that object, and (3) tendencies to establish or modify the relationship with that object. The left side of the figure shows the composition; the right side shows examples (drawn from Lazarus 1991) for the emotions fear and anger.

Figure 5-1. Three components of the emotion process, and two examples.

2.2 Object of Emotion

Emotions are always about something. We are not just satisfied, attracted, or admiring; but *something* is satisfying, *something* is attractive, and *someone* is admirable. Although subjective in nature, we experience our emotions as if they are qualities of the objects of our emotion. In other words, it is the puppy that is adorable, and the election campaign that is repulsive. The word "object" may be a bit misleading because it is not necessarily a material object, like a product ("*I hate my computer*", "*I adore that painting*"). It can also be an animal, a person, a company, and even an event, an activity, a momentary state, or an idea. When it is a person, it can be oneself ("*I am ashamed of myself*") or someone else. Events are things that happen; for example, it starts raining, or the phone rings. Activities are things someone does; for example, dancing or watching television, and a momentary state is someone's body or mental state; for example a good mood, or being ill.

Products can be the object of our emotion in three basic fashions (see Desmet 2008): the perceived product, the activity of using the product, and events caused or influenced by (using or owning) the product. Besides these three types, the object of emotion can also be some other object that is associated with the product. For instance, "*I dislike this car because I associate it with my neighbour*"; "*I love pancakes because they remind me of my childhood*". Note that the object of emotion may vary within one and the same human-product interaction. When using a music player, emotions may pertain to the player, to the act of using the player, and to the music one listens to.

2.3 Situational meaning of objects

Emotions arise in response to events that are important to the individual's well-being. This means that the person who experiences the emotion has to grasp that importance in some way. Events are not pleasant or unpleasant as such; they are appraised and apprehended that way, and it is the relational meaning of the stimulus that counts, not the stimulus event as such. An example is an event in which a friend makes a derogatory remark about you. Depending on the meaning you attach to this remark you might experience anger (i.e. "*I am being mocked*") or amusement ("*This is an innocent joke*"). The same applies to our relationships with products. Depending on the meaning one attaches to a product or an event in which the product is involved, the product will elicit different emotions.

Think of an event in which the computer suddenly stopped responding. One can experience fear (*"I risk losing my working document"*), anger (*"I have to restart which will cost me time"*), relief (*"Now I have an excuse to take a break"*), or any other emotion depending on the relational meaning of the event. The stimulus event is the same, but the emotional response differs. In line with the proposition that different emotions arise in response to different meanings, Lazarus (1991) proposed the concept of "core relational themes" to differentiate between emotions. For example, sadness is elicited by "an irrevocable personal loss"; anger is elicited by "a demeaning offence against me and mine"; disgust is elicited by "taking in or being too close to an indigestible object".

2.4 Action tendencies

Most emotional behaviour is intentional, in the sense that emotions involve actions that establish, maintain, or modify the relationship between the individual and the object of his or her emotion. An emotion always implies and involves an action tendency: a *"readiness to engage in or disengage from interaction with some goal object in some particular fashion"* (Frijda et al. 1989). Three basic tendencies involved in emotional behaviour are often distinguished: to move *away*, to move *against*, and to move *towards*. Unpleasant emotions are associated with the action tendencies to move against or away; pleasant emotions are associated with the tendency to move towards. These basic tendencies can be seen as categories representing a variety of action tendencies. For example, tendencies that fit with the move-away category include: the tendency to avert, to hide, to disappear from view, to ignore, to reject, to shut off, etcetera. According to Frijda (1986), the felt tendencies form a key element of the emotional experience, and distinct emotions are characterised by distinct and specific action tendencies. Table 5-1 gives an overview of "move towards" tendencies (related to pleasant emotions) that have been proposed by Frijda (1986) and by Frijda et al. (1989).

Because the three components in Figure 5-1 differentiate between emotions, they can be used to formulate emotion-specific recipes. Moreover, these components can also be identified in the way we talk about our emotions in our everyday communication. For example, we can imagine someone making the comment *"I was so angry that I almost threw my drink in his face"*. This statement includes an object (him) and tendencies to influence the relationship (throw drink). Or, the comment *"I*

Action tendency	Tendency to:
Accept	Tolerate, receive, or agree with
Approach	Move towards, draw near, or come close to
Attend	Pay attention to what is happening
Be with	Be close by
Broaden	Enlarge range of interactions, or develop
Care for	Be tender, help, comfort, or care for
Identify with	Participate, lose distance, or fuse with
Maintain	Preserve, or continue
Open up	Be receptive, or be approachable
Possess	Possess, or get hold of
Savour	Relish, take in and experience
Surrender	Give in, or part with

Table 5-1. Move towards type action tendencies.

was relieved when I was told that the fever had dropped and that he was no longer in danger". This statement includes an object (he) and a core relational theme (a distressing condition that has changed for the better). This line of thought was used to analyse the cases reported in the study.

3. Inspiration

In ancient inspired creativity, the Muses have been described as whispering, breathing, or singing into the recipient. This view corresponds with the etymological origin for inspiration, the Latin "inspire", which means something like "to breathe into, to inflame". Also in modern literature, inspiration is commonly associated with creative processes (see, for example, Williams 1982) and seen as the moment of discovery that constitutes a breakthrough in the way we have been thinking about a problem (see May 1975). In that line of thought, Arieti (1976) suggested that inspiration occurs at the moment of finding a means to translate a creative idea into form. This traditional view on inspiration can be applied

to any creative process, whether it is an artist creating a composition, a cosmetic surgeon (re)sculpturing a face, or a chef developing a new technique to prepare asparagus. Note that, besides in the realm of creativity, inspiration is also frequently discussed in accounts of mysticism and religion to articulate spiritual awakening or sacred revelation. Though fascinating, none of these accounts seem to acknowledge the role of inspiration in our ordinary day-to-day experiences. Surely, many products associated with inspiration are used in activities that are creative (e.g., paint brushes and musical instruments), religious (e.g., rosaries and the Ka'ba), or spiritual (meditation pillows and talismans), but I prefer to regard these products as representing rather than eliciting inspiration. Although this distinction may be somewhat ambiguous (think, for example, of a person who is inspired by a magical gem because it represents an inspirational value), the current investigation aims to focus on instances in which the product elicits (rather than represents) the experience of inspiration.

3.1 Antecedents of inspiration

Although the collected examples show substantial variation in participants' explanations of why and how products elicit inspiration, the eliciting conditions show two main ingredients: *illumination* and *connection* (see also the discussion of Hart 1998). The first refers to the relational meaning of the stimulus event, involving an experience of a heightened state of awareness. All inspiring products initiate a shift in perspective, an experience of a deeper meaning or clarity, or a grasping of unexpected associations–an *insight*. The second variable refers to the action tendency associated with inspiration. This tendency to connect involves a perceived altering of one's personal boundaries to include some other object. By and large, three objects of inspiration can be observed in the variety of cases, each embodying an object that is represented by or associated with the product: an idea, the self, or the world. In line with these three object types, the cases indicate three manifestations of illumination in the experience of product experience. Figure 5-2 shows these three manifestations of inspiration with example pictures drawn from the data set.

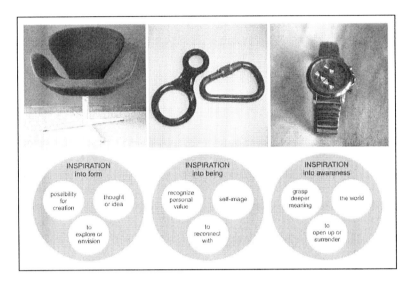

Figure 5-2. Three manifestations of product inspiration.

3.2 Inspiration into form

Inspiration that manifests into form corresponds with the traditional view in which inspiration is conceived as the moment of illumination in a creative process. Fourteen examples report of products that infused participants with new and creative thoughts or ideas. Users report "*ideas start bubbling*", "*my head starts working*", "*I feel creative*", etcetera. One person describes the experience of inspiration when looking at a particular chair (Figure 5-2):

> This chair holds many interesting elements. It has simple yet complex shapes, an interesting inside-outside relationship; it suggests a personally, and it has sensual shapes. This inspires me because it functions as the starting point for my own thoughts and ideas.

These cases can be described as a "light bulb" of an idea popping up. One person was inspired by a book to enrol in a mountain climbing course, and another was inspired by a tablecloth to make her own napkins. In these cases it is not the product as such, but the light bulb (idea or thought) associated with the product that is the object of inspiration. The relational meaning of this light bulb is the sensed opportunity to create or originate,

and the action tendency is to further explore the novel thought or idea, either through analysis or creative action.

3.3 Inspiration into being

Inspiration can also manifest into a (renewed) connection with the self. People can be inspired by products that represent essential values or self-images. One person describes the inspiration elicited by a horse saddle:

> Sometimes life can be very stressful and I tend to forget who I am and what is important to me. Whenever I see a horse saddle, I am inspired because it reminds me of my love for riding: taking time to relax, being in contact with the horse, with nature.

In these ten cases, the illumination manifests as a renewed connection with some part of the self or identity (e.g., hobbies, fields of expertise, skills, passions, or values). One person reported being inspired by a saucepan because it reminds him of his passion for cooking, and another person was inspired by metal objects he keeps on his office desk (Figure 5-2). He keeps these objects in sight because whenever he is in need of some distraction he takes them in his hands, which instantly reconnects him with his love of mountain climbing. In these cases of inspiration, the object of emotion is the self, or self-image that is associated with the product. The relational meaning is not a sensed possibility for creation but the recognition of some important personal value, and the action tendency is to (re)establish the connection between the self and this value.

3.4 Inspiration into awareness

A third manifestation of inspiration is into a general readiness to open up or surrender. Some people report how inspirational products enabled them to see a kind of hidden layer or order in reality. Others explain how products shed new light on some old belief. One person submitted a picture of an electric iron that inspired him because the heat, steam, and danger exhibited the basic elements of energy and he suddenly realised the complexity of seemingly simple processes. Other people give examples of inspiration that is manifested in an experience of extraordinary unity and clarity. One person describes how he is inspired by a watch (Figure 5-2):

> I am inspired by this watch because the mechanism of the device is very complex whereas the output is very simple and straightforward: the time. This tension field between complexity and simplicity represents an ever-returning theme of life.

This inspiration is associated with an awareness of the whole and a general sense of fulfilment. The object of inspiration is the world or life in general, the relational meaning is grasping a deeper meaning, and the action tendency is to open up to and surrender to this awareness.

4. Desire

Apple's introduction of the iPod has been a blessing for many design lecturers because it proved to be the perfect example to illustrate the value of proper design. This modern classic demonstrates that plastic can be beautiful, that smart technology can be intuitive in use, and first and foremost, that mass-produced products can be *desirable*. Desire is generally seen as involuntary and passionate, as something that we do not control but which controls us. In the realm of product design we associate desire with an irrational hunger, yearning, or craving for some object, a suspicious emotion that lures us into buying things we may not be able to afford or may not even have a function for. Given the strong behavioural impact, it makes sense that consumer researchers, in particular, have shown an interest in this emotion. Lynn and Harris (1997), for example, gave an account of the desire for unique consumer products, Ger et al. (1993) discussed the development of consumer desire in developing economies, and Meister (1996) gave an elaborate account of the role of desire in socialism versus capitalism. The focus in consumer research is always on behavioural phenomena associated with desire; either on a personal or on a market scale. The few studies of desire that have been reported in design research have tended to focus on desirable product features or forms (e.g., Chang et al. 2006). The current focus is neither on behavioural consequences of desire nor on product features that elicit desire, but on the underlying conditions or antecedents.

4.1 Antecedents of desire

Belk et al. (1996) explain desire as "*a strong longing, to something for which a person intensively yearns, or to the process of fervently wishing for something*". According to Frijda (1986) an object is appraised as desirable when a person anticipates that possession will facilitate some concern realisation. The reported cases show a wide variety of concerns at stake, for example, the desire for success, for beauty, to entertain a particular lifestyle, to have rich experiences, and for balance in life. The examples also indicate that although there is always an element of anticipated concern realisation, the underlying eliciting conditions come in

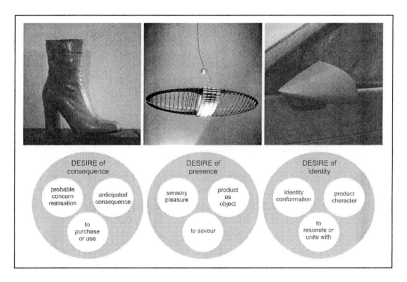

Figure 5-3. Three manifestations of product desire.

different shades. The data indicates, for instance, that the object of product desire is not necessarily the product itself, but it can also be an image, identity or sensation. Three manifestations of product desire have been identified, hereafter referred to as desire of consequence, presence, and identity.

4.2 Desire of consequence

Products are instrumental in the sense that they are bought, owned, and used to serve some purpose in one's life. We can desire for a product because we appraise that the product can serve such a purpose. The concern at stake can be a short-term goal (e.g., "*I want to satisfy my thirst*") and long-term aspirations (e.g., "*I want to have a happy family life*"). The example cases show that the anticipated use or consequences of use can be strong emotional antecedents of desire. Sixteen participants reported cases that fit this appraisal pattern. Reported goals include: "*I want to be sexy*" (garment); "*to have fun*" (kangaroo ball); and "*to be sociable*" (mobile phone). In all these cases, the participants construe the product as *promising* to fulfil that particular goal or need. One participant, for example, reported that she desired a particular ice-cream maker because she anticipated giving her ice-cream loving husband a pleasant surprise. In that case the desire represented the anticipated concern realisation of

making her spouse happy. Or the participant who desired high-heeled shoes (Figure 5-3) because she anticipated that wearing them would give her an attractive feminine look. Another participant reported that:

> I desire this backpack because it has exactly those features that I need; the size, the number of pockets, the material, and even the colours fit my idea of travelling. I can already see myself wearing this backpack next summer vacation.

This case illustrates that possession does not necessarily refer to some anticipated consequence of (using) the product, but can also refer to some anticipated event associated with the product. To summarise: the desire is elicited by an appraised possibility for concern realisation (relational meaning), the object of the desire is the anticipated consequence of using or owning the product, and the action tendency is to purchase or use the product.

4.3 Desire of presence

We saw that for desire of consequence, concern realisation is anticipated but not yet realised. In ten reported examples of desire, the appraised fit seems to be more immediate. For example, one person reported experiencing desire for her appointments diary: "*Whenever I hold my diary I feel desire because of the leather material that is very soft and has a lovely touch*". This desire cannot be explained by an anticipated consequence of the product because the person already owns it. Moreover, she specifically reports that the desire is experienced while holding the diary. Frijda (1986) argues that inherently pleasant stimuli (such as bright colours and sweet tastes) can sometimes elicit desire. This desire "for beauty" is what some researchers would typify as "aesthetic desire" (see, for example, Lazarus 1991). One participant reported an experience of desire for one of the lampshades in his house simply because he could not keep his eyes off its sensuous shape (Figure 5-3). Products can bring us sensory pleasure that is desirable in itself. In those cases, the possession that is called for is independent of anticipated consequences other than the experience of sensory pleasure that was already present before the possession. Following this line of thought, possession of the product is called for because that will ensure continuation of experienced sensory pleasure. In these cases, possession is exhibited by the product's presence. The object of desire is the physical product; the relational meaning is the experienced sensory pleasure, and the action tendency is to savour or to delight in this sensory pleasure.

4.4 Desire of identity

Some examples of desirable products are difficult to explain with the eliciting conditions described above. These are cases that resemble the "social desire" we sometimes experience towards people we admire (or are jealous of). In those cases we do not desire any consequence of "owning" or interacting with that person, but in a sense desire to *be* that person (or to have his or her admirable characteristic). Something similar seems to be the case in five of the reported examples. One person explained his desire for a particular car model (Figure 5-3) as follows:

> This car represents something I strongly desire because it expresses power and gentleness at the same time. When I look at that car I somehow wish I could be just like it.

In this and similar cases, it is not the sensory quality or the anticipated consequences of the product but the product's identity or character that is the object of desire. Apparently the desire for an identity can be elicited by products in a similar way, as we can desire some social identity. Cupchik (1999) proposed that "*an object can be seen by the user to resonate with and be symbolic of self*". This idea matches the research of Belk (1988), who argued that we establish our identity through the products we surround ourselves with. Possession is called for because "we are the sum of what we call ours", and possession is manifested in identification. In these cases, the relational meaning is a confirmation of one's (looked-for) identity, and the action tendency is to unite with, or to resonate with the object of desire.

5. General discussion

We are all familiar with the experience of desire and of inspiration, and therefore there is not a single person who does not know what these two emotions are. The difficulty with emotions, however, is that our implicit understanding swiftly seems to evaporate as soon as we try to make it explicit. The intention of this paper has been to explore some possibilities to provide a meaningful structure for making these emotions more tangible, and therefore discussable. This approach, which can be used for all kinds of emotions, comes with the challenge to explicate general relationships while at the same time representing the subtle and rich nature of the phenomena. The study was explorative in its nature, and is reported here as an ongoing dialogue rather than a definitive statement.

Frijda (1986) explains desire as *"engendered by the thought of, or encounter with, a fit object not in possession, and when such possession seems to call for"*. We saw that products elicit desire when appraised as 'a fit object not in possession, and when possession seems to call for'. The cases showed that although this definition implies that one can only desire products that are not in possession, possession should be seen in a broad way, not only referring to ownership but also to any user-product interaction facilitated by ownership. We can desire to own, use, keep, touch, taste, and even, in a sense, to be a product or something associated with the product. In that sense, there seems to be no conceptual motive for distinguishing product desire from desire we experience in the context of human relationships. With respect to inspiration, we saw that product inspiration always comes with a sense of illumination (an awareness or insight) and a tendency to connect that can manifest in various ways, but somehow always lifts the person to a realm that goes beyond the everyday world of thoughts. Besides their singularities, the eliciting conditions of the two emotions also share similarities. The students in the design workshop experienced that designing for desire appeared to involve considerations that are comparable to those involved in designing for inspiration. They found it difficult to design a product that is desirable yet not inspiring, or the other way around. Although the emotions are different in terms of experience, they both involve motivation and their eliciting conditions involve aspirations and a sense of necessity. In a way, it does not seem too farfetched to suggest that products that inspire us are also those that we desire. However, I prefer not to accentuate this because the differences between these emotions are at least as interesting as their similarities. Although the identified various manifestations of desire and inspiration may only touch on the surface of emotional complexity, acknowledging these differences at least aims to recognize the depths of that complexity.

The differences are evident in action tendencies associated with these two emotions. These tendencies are essential because they characterize experience and differentiate it from mere feelings of pleasantness or unpleasantness; different actions tendencies are what characterize different emotions (see Arnold 1960). The action tendency involved in the experience of desire seems apparent: the tendency of focussed approach, which can be typified as a "pull towards the object of desire". This pull can be observed in all three types of tendencies described above: to purchase or use, to savour, or to resonate with the product. Inspiration seems to come with less palpable action tendencies. From the cases it was observed that inspiration does not require a similar pull to the object as in

product desire. If any tendency can be identified, it is a "push" rather than a "pull": as an uplifting experience inspiration pushes the person to a heightened state of awareness or towards some new (or rediscovered) thought or action. Besides the difference in pull versus push action tendencies, these two, and other pleasant emotions, involve the appraised (possibility) for concern realisation. The concern realisation elicits a pleasant emotion, and the particular appraisal characteristics and associated action tendencies establish what specific emotion is experienced.

There is so much more to learn about positive emotional responses that goes far beyond the general idea of joy or pleasure. In line with this thought, authors have recently started to explore the eliciting conditions of distinct emotions or other affective phenomena. Demir and Erbuğ (this volume) focused on product satisfaction, Ludden et al. (2008) on product surprise, Mugge et al. (2005) on product attachment, Vink et al. (2005) on product comfort, and Russo and Hekkert (2007) on product love. An understanding of the distinctive nature of emotions, and insights into how emotions differ in terms of eliciting conditions, are particularly relevant for design processes that start with a predefined emotion profile. An example was described in Desmet et al. (2007). The aim of this project was to design a mobile phone that specifically elicits the emotions fascination, pleasant surprise, and attraction. What is particularly interesting about this and similar projects that are guided by specified emotion profiles, is that they demonstrate opportunities to use emotional experience as a means for differential advantage. There are many pleasant emotions: pleasant surprise, satisfaction, relief, hope, enthusiasm, inspiration, desire, fascination, admiration, and pride, to name a few. Being selective about what particular emotion(s) to design for, enables the design team to make good use of consumer and marketing insights, strategic considerations, brand identity, and various social and cultural developments that seem important to take into account. In a world where it appears to have become routine to associate all product and service design activities with an undifferentiated focus on pleasure, delight, or joy, this approach may offer some opportunities to revitalise the innovative and pioneering spirit represented by the "design for emotion" movement.

Works Cited

Arieti, S. (1976). *Creativity: the magic synthesis.* New York: Basic Books.
Arnold, M.B. (1960). *Emotions and personality: vol. 1. Psychological aspects.* New York: Colombia University Press.

Belk, R.W. (1988). Possessions and the extended self. *Journal of Consumer Research*, 15, 139-168.

Belk, R.W., Ger, G. and Askegaard, S. (1996). Metaphors of consumer desire. *Advances in Consumer Research*, 23, 368-379.

Chang, H.C., Lai, H.H. and Chang, Y.M. (2006). Expression modes used by consumers in conveying desire for product form: a case study of a car. *International Journal of Industrial Ergnonomics*, 36, 3-10.

Cupchik, G.C. (1999). Emotion and industrial design: reconciling meanings and feelings. In Overbeeke, C.J. and Hekkert, P. (Eds.), *Proceedings of the international conference on design and emotion*. Delft: Delft University of Technology, 75-82.

Desmet, P.M.A. (2008). Product Emotion. In Schifferstein, H.N.J. and Hekkert, P. (Eds), *Product experience*, 379-397. Amsterdam: Elsevier.

—. (2002). *Designing Emotions*. Unpublished doctoral dissertation, Delft University of Technology, Delft, NL.

Desmet P.M.A., Porcelijn, R., and van Dijk, M. (2007). Emotional design; application of a research based design approach. *Journal of Knowledge, Technology & Policy*, **20**(3), 141-155.

Frijda, N.H. (1986). *The emotions*. Cambridge: Cambridge University Press

Frijda, N.H., Kuipers, P. and Schure, E. (1989). Relations among emotion, appraisal, and emotional action readiness. *Journal of Personality and Social Psychology*, 57, 212-228.

Ger, G., Belk, R.W. and Lascu, D.L. (1993). The development of consumer desire in marketizing and developing economies: the cases of Romania and Turkey. *Advances in Consumer Research*, 20, 102-107.

Hart, T. (1998). Inspiration: exploring the experience and its meaning. *Journal of Humanistic Psychology*, **38**(3), 7-35.

Jordan, P.W. (2000). *Designing pleasurable products*. London: Talyor & Francis.

Lazarus, R.S. (1991). *Emotion and Adaptation*. Oxford: Oxford University Press.

Ludden, G.D.S., Schifferstein, H.N.J. and Hekkert, P. (2008). Surprise as a design strategy. *Design Issues* **24**(2), 28-38.

Lynn, M. and Harris, J. (1997). The desire for unique consumer products: a new individual differences scale. *Psychology and Marketing*, **16**(4), 601-616.

May, R. (1975). *The courage to create*. New York: Bantam.

Meister, R. (1996). Beyond satisfaction: desire, consumption, and the future of socialism. *Topoi, 15,* 189-210.

Mugge, R. Schoormans, J.P.L. and Schifferstein, H.N.J. (2005). Design strategies to postpone consumer' product replacement. The value of a strong person-product relationship. *The Design Journal,* **8**(2), 38-48.

Norman, D.A. (2004). *Emotional design.* New York: Basic Books.

Scherer, K.R. (2001). Appraisal considered as a process of multi-level sequential checking. In Scherer, K.R., Schorr, A. and Johnstone, T. (Eds.), *Appraisal process in emotion: theory, methods, research,* 92-120. New York: Oxford University Press.

Russo, B. and Hekkert, P (2007). On the experience of love: the underlying principles. In Koskinen, I. and Keinonen, T. (Eds.), *Proceedings of the 2007 International Conference on Designing Pleasurable Products and Interfaces,* 12-19. New York: ACM Press.

Vink, P., Overbeeke, C.J., and Desmet, P.M.A. (2005). Comfort Experience. In Vink, P. (Ed.), *Comfort and Design,* 1-12. London: CRC Press.

Williams, M.E. (1982). *Inspiration and Milton and Keats.* Totowa, NJ: Barnes and Nobles.

CHAPTER SIX

EMOTIONS AS DISCOURSE–
INTIMATIONS OF A SOCIO-CULTURAL
APPROACH IN A REDUCTIVE METHOD

TOM FISHER AND HILDE NORDLI

1. Introduction

A good deal of work has emerged over the last decade that seeks to understand the affective aspect of consumers' relationship to material (and virtual) objects. Some of this work draws on the range of conceptualisations of emotion that exist to meet objectives that derive from design. Conceptualisations of emotion vary from the scientific perspectives found in psychology to the more humanistic views of emotion that emphasise its cultural aspects. The uses to which they have been put in design are as various and include making products more usable by increasing the likelihood that their users will feel pleasant emotions, even to the extent of joy (Green et al. 2001); to increase products' lifespan by promoting the emotional attachment consumers can develop for objects by acknowledging the feelings of attachment that are evoked in our relationship to consumer products over their lifespan (Van Hinte 1997; Chapman 2005); to differentiate products aimed at small market segments from each other by capturing the emotion element of consumers' appraisal of product elements (Desmet et al. 2001).

Alongside work by McDonagh-Philp and Lebbon (2000), Forlizzi, Disalvo and Hanington (2003), Norman (2004) and others, the design community is likely to be most familiar with Desmet, Hekkert and Jakobs (2000) and Desmet, Overbeeke and Tax's (2001) framework for understanding the role emotion plays in consumers' experience of objects and designers are likely to readily connect with it because their work concentrates on appearance. This approach is thoroughly grounded in the

psychology literature and allows designers to evaluate both the details of objects and the make up of groups of consumers for the likely emotional consequences of their interaction. As well as being attractive to designers because of its concern with appearance, their approach is likely to be especially relevant in the context of new product development. It is reductive, in that it screens out factors other than emotion in consumers' responses to objects, and in common with the approach to emotions found in the psychology literature (e.g., Russell 1980) it reduces emotions to a set that can be positioned spatially in relation to each other and represented visually, combining them with consumers' "concerns". It can integrate the aspect of design decision making that tolerates uncertainty (Rittel 1973; Cross 2001) and it demonstrates that it is viable to attend to the affective potential of the formal details of objects in relative isolation, as does the research described below.

However, this paper argues that such a reductive approach can only capture part of the emotional dimension of human-object relationships, given Dewey's assertion (1980 (1934)) that neither emotions themselves, nor the features of objects that elicit them can be truly understood in isolation. As Dewey puts it:

> Emotion is the moving and cementing force. It selects what is congruous and dyes what is selected with its colour, thereby giving qualitative unity to materials externally disparate and dissimilar (1934).

He warns against "erroneous" views of the nature of acts of expression which derive from the

> ...notion that an emotion is complete in itself within, only when uttered having impact on external material. But, in fact, an emotion is *to* or *from* or *about* something objective, whether in fact or in idea (1934).

This paper suggests that research into human-object relationships which ignores the "to, from and about" of emotion is likely to miss significant aspects of them.

A tendency to the reductive–ignoring the "to, from and about" of emotion–may be a significant methodological challenge for design based emotion research. Deborah Lupton's work confirms the impression that a reductive approach ignores aspects of emotions that are potentially necessary to a full understanding of interactions with objects. She identifies a spectrum of theoretical approaches to emotion that ranges from the "biologic" to the "constructed", the former reducing emotions to

qualities of our physical make-up and the latter asserting that emotions exist entirely in discourse; the former considering emotions as things that "are" in our biology, the latter taking them to be things that we "do" in our embodied social and discursive relationships with others.

Lupton argues convincingly for the importance of the discursive dimension of emotion, and its role in defining "bodily experience" *as* emotion (1998). This suggests that in principle, to fully understand the role of emotions in interactions with objects, design research should be open to their discursive dimension. This could be both a challenge and an opportunity, as by attending to the language associated with the emotional aspect of physical interactions with objects design research can engage with the social/cultural dimensions of those interactions. The discursive aspect of emotions relates strongly to their function in policing our social behaviour. Lupton identifies the role that pride and shame have as social regulators (1998) and illustrates this with reference to the functions of disgust–a relative of shame–that Miller identifies (1997). As he puts it *"Above all, it [disgust] is a moral and social sentiment [...] it ranks people and things in a kind of cosmic ordering"* (1997). Disgust provides the most compelling example of the relationship between physical feelings and what Lupton identifies as "socio-cultural processes", manifested in discourse (1998).

It is notable that this negative emotion does not feature in much of the literature, either that from psychology or in design, despite its clear role in behaviour, including behaviour that relates to designed objects (Fisher 2004; Kubberød 2005). Russell's influential "circumplex" of emotions (1980) for instance includes negative emotional states such as *alarmed, afraid, angry, frustrated, annoyed* and *distressed*, but not *disgusted*. This may be because it is difficult to consider disgust in the abstract–disgust is always disgust *at* something, as Miller stresses, because of its strongly embodied nature. It may be easier to ignore the "referent" of the emotions listed above, though for each of them a referent is also logically necessary. With disgust it is impossible to ignore the "to, from and about" of the emotion.

If studies of the emotional aspect of consumers' reception and evaluation of designs play down the "referents" of emotions, and some seem to, they also may under-value the relational nature of emotions, their embeddedness in and determination by their cultural setting. A tendency to do this may derive from pressures to concentrate on the aspects of emotion

that are likely to bring short term instrumentally applicable benefit—designers and companies want insights that can be applied and that can identify aspects of designs that are likely to elicit appropriate emotions, to make sales.

The following sections of this paper do two things. First they describe a piece of empirical work that assessed whether a packaging design elicited emotions that would align with consumers desire to purchase the product. This was carried out using Kelly's Repertory Grid, which, although it is a somewhat reductive method, does allow some insights into the relationship between participants' responses and the cultural setting in which they are constructed. Second, it reflects on the degree to which this method allows researchers genuinely to rise to the challenge outlined above, noting that this is limited by the lack of discursive richness in the Kelly's Grid method.

2. Empirical work

The authors were briefed to evaluate with consumers a range of novel food can shapes prior to the launch of a can with a "waisted" outline—designed to package a low calorie food (can number 3 in Figure 6-1). The research had a short timescale which ruled out the use of qualitative methods to discover the categories through which consumers were likely to engage with the can shapes and the Kelly's Grid method was selected as it provided a direct and economical way of getting insights into consumers' evaluation of the shapes in terms of categories connected to emotions. Because the product intended for the can was a food product related to weight loss targeted at females, the participants used were twenty women, between the ages of 20 and 45. The client provide twelve differently shaped cans for the research process including a standard can (can 2), the can intended for production (can 3) an alternate design for use in a different geographical region (can 2)[1] and nine "dummy" cans in a variety of shapes.

[1] The client would give permission for only the shapes that are in the public domain to be shown in this paper. The nine "dummy" cans were in shapes that had been developed for other types of product or which had been produced as prototypes to test the capabilities of the production equipment and the latter had a variety of shapes generated without considering their aesthetic effect.

Figure 6-1. Can shapes.

The Kelly's Grid method was developed by George Kelly as part of his psychology of mental constructs and involves the participant choosing a group of three "elements"–a triad which can be words or things–and saying how two of them are the same and one different (Kelly 1955). The participants in this study selected triads from the group of 12 cans, without being told of the intended function for can 3. In this way the process identified the participants "mental constructs" about the shapes. This procedure is broadly phenomenological in that it can elicit mental constructs that are held by the participants, rather than working with categories supplied by the researcher. Kelly's approach favours neither cognition nor affect but ascribes actions and beliefs to mental constructs– the personal reference system through which individuals interpret the world (Kelly 1955; Fransella et al. 1989).

The nature of the procedure means that each construct is expressed as a dichotomy that describes the difference the participant understands to exist within the triad, for instance masculine/feminine or crisp/curvy. Once a construct was elicited, say "masculine/feminine", the participants then scored each of the 12 shapes on a 1-5 scale where 1 is masculine and 5 is feminine. They do this with each construct to produce a grid of rating data which can be analysed for correlations between the shapes. The correlations between the can shapes found in this data demonstrated that the participants rated similar shapes in a similar way, grouping similar cans together and distinguishing between groups of cans on the basis of their overall shapes as well as their details. For instance there was

significant negative correlation between the standard can (number 2) and a group of the shaped cans.

3. Results

Statistical analysis of the rating data means that the constructs provide insights into the relationships between the shapes. However, the elicited constructs are also in effect a body of linguistic data that can provide qualitative insights. Of the 104 constructs elicited, the majority, 64, were purely descriptive, consisting of words such as "curved", "grooved", "straight" or "ridged". The prevalence of such terms reflects perhaps the mundane nature of the subject matter–tin cans, even shaped ones, are not highly engaging in everyday life and the participants were probably confronting for the first time a requirement that they consider them in anything other than practical terms. A second group of 14 words were similes and described the shapes of the cans in terms of other objects such as a wineglass or a milk bottle. This confirms the impression that participants found it difficult to come up with *personal* constructs about the cans. However, a third group of 25 constructs included words that do have more richly inflected meanings. These refer simultaneously to the qualities of the can shapes and to cultural categories and values that these qualities may be associated with. This group of constructs included:

curves, slender (x2), elegant, sophisticated, thin, tall, feminine (x2), hourglass (x2), waist (x3), curvy, soft, smooth, angular, masculine (x2), hard, bulky, chunky (x2), dumpy, squat (x2), fat at bottom, fat.

They point very clearly to the fact that the participants thought about the shapes anthropomorphically, bringing ideas about gender and body shape to their evaluation of the can shapes. The group included words that have positive connotations in terms of body shapes such as "elegant" as well as ones that have clearly negative connotations such as "dumpy". This association between the shapes and cultural categories that are responsible for strong motivations in everyday life is interesting and relevant to an understanding of what consumers might feel about purchasing the product. However because the Kelly's Grid routine elicits only *labels* for constructs such as "femininity", or "curviness" it does not give access to the ways in which such constructs might result in attraction to or repulsion from the product. Referring only to this list of words, it is not possible to gain insights into the ways in which the cultural categories they represent might play a part in constructing emotional responses to the product. This issue is discussed further below.

Figure 6-2. Affect concept poles (Russell 1980).

To take into account the fact that the elicited constructs would give relatively superficial insights into the participants' relationship to the products, they also rated the cans against four pairs of terms supplied to them, using the same 1-5 scale. These "supplied construct" terms were derived from an emotion circumplex based on Russell (1980). Russell established that it is possible to map the relationship of emotions to each other by positioning them on two axes–"arousal" and "pleasantness" (Figure 6-2), which he calls a "layman's mental map" of emotion (1980). Russell notes that these terms are bipolar–they operate as dichotomies in the manner of Kelly's mental constructs. Therefore it seemed safe to use emotion terms of this sort to rate the can shapes in combination with the constructs elicited using Kelly's triadic technique.

Russell's circumplex and those proposed by others since (e.g., Watson et al. 1985; Desmet et al. 2000, 2001) have developed the basic emotion concepts expressed as nouns in Figure 6-2 into groups of emotion words that indicate subjective states. From these terms, four sets of polar opposites were selected for this study and the participants rated the can shapes against these. They were *active/passive; unsettling/serene; lively/sluggish; delightful/gloomy*. These terms were selected from the range of affect terms against two criteria: they were clear dichotomies and they seemed likely to relate to the can shapes. They also preserve much of the relationship they have in relation to Russell's two axes of arousal and

value. There was no expectation that it would be possible to derive telling inter-correlations between the cans from these rankings when they were analysed together, because the qualities they describe are designed to be distinct from each other. This turned out to be the case. Analysing the supplied construct rankings together produced no clear pattern in the correlations between the shapes and few correlations of extreme significance.

Analysing the ratings for each supplied construct on its own demonstrated that shapes with similar characteristics correlate with each other. However this analysis does not help to identify a relationship between the can shapes and the emotion circumplex because the same cans correlate with each other whichever supplied construct they were being ranked against–the relationships largely following the same pattern as for the elicited constructs with cans which shared a distinctive feature correlating with each other when ranked against the *active/passive* scale and also against the *lively/sluggish* scale. However analysing each can using a graphic representation of their ranking against these supplied construct scales, as presented in figure 3, makes it possible to position each shape in Russell's emotion space.

These graphics were generated by adopting another of Russell's principles (1980)–that the centre of the circle is the neutral point on each axis and the edge of the circle is the point where the emotion is at its greatest intensity. Average scores were calculated for each shape against each axis and plotted on the circumplex (see Figure 6-3). This indicated that some shapes have a distinct "character" in terms of the emotion words used.

The average ratings for cans 1 and 3 were towards the positive emotions, with can 3 being markedly *active*, *delightful* and *lively*. This sets it apart from all the others in this emotion rating, as it was set apart in the construct correlations. In contrast, the average ratings for can 2, as well as three other shapes in the set (not shown here) that were "bottom-heavy" are positioned towards the *sluggish*, *passive*, *gloomy* and *unsettling* poles, though to a smaller degree. The distinctiveness of these two groups of shapes is reinforced by the fact that the ratings for the remaining shapes clustered round the neutral point.

These results seem to reflect a genuine evaluation of the shapes. A family relationship was evident in the groups of shapes that correlated

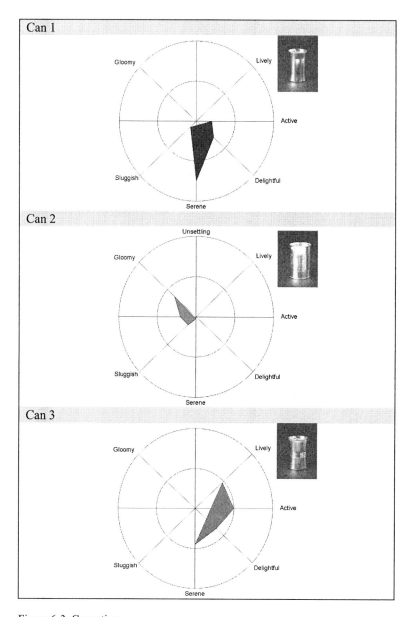

Figure 6-3. Can ratings.

with each other and the qualities these families shared matched the emotion words they tended towards on the circumplex. Shapes 1 and 3 do have a degree of formal "tension", whereas the regular can shape, number 2, along with others that it correlated with are relatively bottom-heavy and "planted" in appearance. However, because of the nature of this empirical work the extent to which these evaluations of the shapes genuinely relate to emotions that participants may feel spontaneously in everyday life and which may be implicated in decisions to purchase the product in question remains a matter of conjecture.

4. Discussion

It was not possible in the research just described to engage extensively with the "socio-cultural processes" that may be relevant to the discursive dimension of consumers' affective evaluations of canned slimming food. The timescale and the client's preference required a reductive approach that excluded obviously symbolic factors–labels, graphics, shelf placement etcetera and generated data that could be analysed statistically. However, despite this the results do strongly imply that the participants were drawing on familiar discourses of health and beauty in their evaluations of the cans–even though they were not directed towards these discourses in the process of the research. It seems safe to assume therefore that the participants read the shapes of the cans for such graphic/symbolic associations as they do have. Can 3 for instance does have a "waist" and reinforcing ribs that form a band round the shape add a "belt" motif that cinches in the shape. This reference was obvious to the designers who referred to the shape as the "Marilyn" can.

Recent research has suggested that women think about the shape and size of their bodies on average every fifteen minutes (Sayal 2006). Significant aspects of the goals, standards and attitudes' that the participants brought to the research are likely to derive from the very powerful values that western culture associates with body size and shape and these were therefore likely to have been highly salient to their evaluations of the can shapes (Desmet et al. 2001). Evidence for this exists in the body-related constructs that the participants provided such as "curvy", "thin" and "dumpy".[2] While this "concern" was probably similar

[2] An alternate interpretation of these constructs might be drawn from the use of less value-laden anthropomorphism that is encountered in other descriptions of

for all the participants it is not likely to have been uniform, given that women will come to their own accommodation with those values. The small number of participants as well as the nature of the exercise meant it was not possible to uncover these variations between the participants. It is safe to assume however, that the participants will have read the cans' symbolic content in terms of these concerns while making their evaluation of the shapes in terms of the emotion words.

One potentially confounding aspect of the method described here is that it required that the participants translate between the verbal representations of feelings and their impressions of the shapes–they had to work between the verbal and the visual. Desmet's emotion evaluation tool avoids this by adopting an entirely visual approach to evaluation, giving it potential cross cultural validity. However, it could be argued that where the emotions in question are positioned towards the discursive end of Lupton's spectrum a research tool that preserves the discursive relationship with felt responses to objects is of positive benefit. Many instances of product related emotions are likely to be constructed to a large extent in discourse–emotions about food being a good example. The case discussed above is an example where it is important to capture the linguistic dimension of the evaluation of objects in emotion terms because the discursive aspect of emotion *exists in language*. One shortcoming of the research process outlined above is that it could not capture the discursive element of the participants' evaluation of the objects with sufficient richness to meet the challenge indicated in the introduction.

Russell suggests that the same cognitive mechanism is at work when we are interpreting the emotions displayed by another person on their face, interpreting verbal or observed stimuli, or interpreting our own inner state. He also argues that the resulting interpretations all have the same relationship to each other on his circumplex.

> ...the cognitive structure that is utilized in interpreting the meaning of verbal messages or of facial expressions from others is the same structure utilized in the process of conceptualising one's own state, which precedes the affective experience (1980).

If this is so, our interpretation of our embodied experience of our own emotions and the idea of emotions that are communicated by other people

physical objects. Plumbers use "elbows", boat builders make "knees", cabinet makers talk about "cheeks".

or by objects relies on the same mechanism. It seems reasonable to suppose then that in the interpretation of the "expressions" of objects we use the same emotional "expertise" as we do when interpreting our own physical feelings or the expressions of others–expertise gained and defined through the socio-cultural processes that Lupton points to.

However, interpreting the indications of emotion in another person presumably differs from interpreting one's own state in that in the former physical feelings are absent, whereas in the latter one is interpreting ones own physical feelings. This means that some degree of "projection" is involved in interpreting states in others. To identify the relevant emotion we have to imagine what we would feel like if we looked as the other looks, if we made that face, adopted that posture, etcetera. It seems reasonable to assume that the same mechanism is behind the evaluation of objects in emotion terms. Given our tendency to read objects as expressive of human or animal qualities (Ingram et al. 2004), an anthropomorphic transformation might occur whereby the object is accorded active human properties that can be evaluated in terms that describe human emotions. In the example discussed above, the can is in effect given temporary human status to the extent that it matches the participant's understanding of the relationship between it and the human emotions implied by the supplied constructs.

In their anthropomorphized form, the cans would act as shape exemplars against the "expression" of which the participants measured the potential emotional content. However, given the importance of the normative socio-cultural element of emotions, the cans would not simply act as exemplars for physical feelings, but also for the values commonly attached to those feelings (Lupton 1997). So a participant would ask not just: "*What would I be feeling like if I was that shape?*", but also, perhaps, "*Would being that shape and feeling that feeling be desirable/acceptable?*" The arbiter of desirability/acceptability here, being the socio-cultural "feeling rules" that govern how we "do" emotions about our bodies.

The rules invoked would differ depending on the emotion axis in question and this would require the symbolic content of the shape to provide the "referent" for the emotion. So the "serenity" perceived in can 1 and the "liveliness" and "activeness" perceived in can 3 would perhaps be tied down by a directly anthropomorphic relationship between the can shapes and stereotypically feminine body shape–the shapes operate as

indexical signs of this body form. This circuit between shape, anthropomorphic identification with it and reading of it in terms that fit with the emotion terms used is completed by the "feeling rules" (Hochschild 1983) provided by discourses of femininity which were evident in the elicited constructs such as "slim", "feminine", "elegant" and "slender".

This in turn points up the significant shortcomings in an approach to product evaluation that is as reductive as the one described. For all that it did produce useful results it could not measure up to the challenge outlined in the introduction. The fact that the can shapes elicited these words indicates that the participants could relate the can shapes to discourse about body shapes. However, the nature of the data meant it was not possible to go much beyond stating that fact. Had the research process been able to capture richer evidence about the participants' relationship to discourses of femininity and body shape, say through interview, it might be possible to relate the elicited constructs to the emotion words. Such a procedure that integrated a rich qualitative element to capture the discursive aspect of the participants' emotional relationship to the can shapes is likely to have exposed the relationship between the shapes and the "socio-cultural processes" at work in the difficult, contested issue of femininity and body shape. This is potentially of more than academic relevance as it is in the socio-cultural domain that the consequences of human-object relationships may be challenged and reformed.

5. Conclusion

This paper has proposed that it is possible to gain insights into particular aspects of human relationships to objects by attending to the discursive aspect of emotions, offering an example of a research process that by its failure adequately to do so indicates clearly the shortcomings of reductive methods. It acknowledges both the opportunities that derive from investigating product details in these terms, and the desirability of attending to the social nature of emotions in this process. It discussed the strengths and weaknesses of research processes that take a reductive approach, acknowledging that such an approach can draw from well validated frameworks for emotion and can identify clear relationships between objects and emotions. However, to give full access to the discursive dimension of emotions elicited in human-object interactions would require that qualitative methods be used in combination with reductive ones.

As Desmet, Overbeeke and Tax admit, (2001) their work on emotion and design "begs, steals and borrows" methods from a range of disciplines. This paper adopts a similar (and in the author's opinion healthy) catholic approach. Even though it has attended to objects that were "reduced" in a sense–to shapes–it has demonstrated that it is possible to capture individuals' evaluations of elements of objects through a method that matches this reduction in its concentration on their emotional consequences. However, the specific case considered has a definite relationship to issues of femininity, which are inscribed in discourse and it therefore points strongly towards a method that can engage more thoroughly with this socio-cultural dimension of emotions.

Works Cited

Chapman, J. (2005). *Emotionally Durable Design: objects, experiences and empathy.* London: Earthscan

Cross, N. (2001). Design Cognition: Results from Protocol and other Empirical Studies of Design Activity. In Eastman, C., McCracken, M. and Newstetter, W. (Eds.),*Design Knowing and Learning: Cognition in Design Education.* Elsevier, Amsterdam

Desmet, P.M.A, Hekkert, P. and Jakobs, J.J. (2000). When a car makes you smile: development and application of an instrument to measure product emotions. *Advances in Consumer Research,* 27: 111-117.

Desmet, P.M.A., Overbeeke, K. and Tax, S. (2001). Designing Products with Added Emotional Value: Development and Application of an Approach for Research Through Design. *The Design Journal,* **4**(1): 32-47.

Desmet, P.M.A. (2002). *Designing Emotions.* Unpublished PhD thesis, ISBN 90-9015877-4.

Dewey, J. (1980 (1934)). *Art as Experience.* London: Penguin Books.

Fisher, Tom (2004). What We Touch, Touches Us: Materials, Affect and Emotion. *Design Issues,* **20**(4): 20.

Forlizzi, J., Disalvo, C. and Hanington, B. (2003). Emotion, experience and the design of new products. *The Design Journal,* **6**(3): 29-37.

Fransella, F. and Bannister, D. (1989). *Inquiring Man: The Psychology of Personal Constructs.* London: Routledge.

Green, W.S., Jordan, P.W. (2001). *Pleasure With Products: Beyond Usability.* Taylor and Francis.

Kelly, G.A. (1955). *A Theory of Personality: The Psychology of Personal Constructs.* Norton.

Hochschild, A. (1983). *The Managed Heart: commercialization of human feeling*. Berkely, University of California Press.

Ingram, J. and Annable, L. (2004). 'I See You Baby, Shakin' That Ass': User perceptions of unintentional anthropomorphism and zoomorphism in consumer products. *Proceedings of the Design and Emotion Conference,* 2004, Ankara, Turkey.

Kubberød, E. (2005). *Not Just a Matter of Taste: disgust in the food domain*. Norwegian School of Management, Unpublished PhD thesis.

Lupton, D. (1998). *The Emotional Self*. London: Sage.

McDonagh-Philp, D. and Lebbon, C. (2000). The Emotional Domain in Product Design. *The Design Journal*, 3(1): 31-43.

Miller, W. (1997). *The Anatomy of Disgust*. Cambridge Mass: Harvard University Press.

Norman, D. (2004). *Emotional Design: why we Love (or hate) everyday things*. New York: Basic Books.

Rittel, H.W.J. and Webber, M.M. (1973). Wicked Problems. In Cross, N., Elliott, D. and Roy, R. (Eds.), *Man-Made Futures: Readings in Society, Technology and Design*. Hutchinson Educational, in association with The Open University Press.

Russell, J.A (1980). A Circumplex Model of Affect. *Journal of Personality and Social Psychology*, **39**(6): 1161-1178.

Sayal, R. (2006). Women fret about their bodies every fifteen minutes. *The Times,* April 11th.

Van Hinte, E. (1997). *Eternally Yours: Visions on Product Design*. Uitgeverij 010 Publishers.

Watson, D. and Tellegen, A. (1985). Toward a consensual structure of mood. *Psychological Bulletin,* 98: 219-235.

The empirical work referred to in this paper was research carried out in 2005 for Crown Packaging Plc, and the authors are indebted to Crown for their permission to refer to its results.

Chapter Seven

Emotional Driving Experiences

Rafael Gomez, Vesna Popovic and Sam Bucolo

1. Introduction

The activity of driving requires the involvement of a variety of human resources. For instance, to drive a vehicle on a busy city road effectively and safely, divers must coordinate their cognitive, physical and emotional capabilities simultaneously (Groeger 2000). If one of these is affected, it will invariably influence the others, as a result affecting the entire driving experience. To complicate things further throughout the driving activity drivers simultaneously interact with the vehicle's interface including radio, air-condition and other on-board equipment. As such, it is essential that the interface is designed appropriately so as not to load the cognitive, physical or emotional resources of the driver.

Research into the physical aspects of the driving experience has been previously reported (Andreoni et al. 2002; Peacock et al. 1993; Regan et al. 2000) and is an established area of research. Typically, the research focuses on the physical ergonomics of the driving posture, vehicle interior relating to the layout and distance of buttons, controls, steering wheel and dashboard, and access into and out of the vehicle for the driver. Due to the type of data involved in this kind of research it is generally conducted in laboratory or virtual environments. Recent studies go as far as modelling the human driver as a computer graphic simulation in virtual environments (Porter et al. 1993; Reed et al. 2002).

Studies into the cognitive aspects of the driving experience have recently become an area of focus (Briem et al. 1995; Haigney et al. 2000; Lansdown et al. 2004; Schneider et al. 2005; Strayer et al. 2001; Stutts et al. 2005). This is due particularly to the advent of the mobile phone and

other on-board electronic interactive systems and their demands on the attention of the driver (Hahn et al. 2000). Typically this type of research involves observing drivers interacting with the vehicle and other equipment in laboratory, virtual or real-world environments.

In comparison, there is limited available literature studying the emotional experience of driving and interacting with the vehicle interface and how to approach the design of vehicle interfaces in order to support positive (and avoid negative) emotional experiences (Angulo 2007; Mesken 2001). This is an important area of research as the emotional state of the driver is a factor in the effectiveness, safety and overall satisfaction of the driving activity (Mesken 2001, 2003; Nasoz et al. 2002).

This chapter presents the findings from an experiment investigating the emotional component of the driving experience during interaction with the vehicle interface. Some of these findings are based on previous papers presented by the authors (Gomez et al. 2004a, 2004b). They report on an exploratory study focusing on the driver's experience during interaction with the vehicle interface in a real-world driving situation. The study was based on a data triangulation approach including interviews, observations, and think-aloud protocols. Participants were asked to perform specific tasks while driving. During the drive they were video and audio taped. Moreover, an interview was performed before and after driving. The aim was to identify aspects of the driving experience that affected their emotions in a positive or negative manner. These initial results identified the context and traffic situation as the critical aspects of the driving experience that enhanced and/or detracted from the overall experience. These aspects were found to have a dominant impact on the driving experience. They are so important that if incorrect tasks were performed in a high traffic context, any negative feelings associated with it appear to be magnified and remembered thus having a significant impact on the overall experience. The same did not apply when incorrect tasks were performed within low traffic context.

Further analysis (Gomez et al. 2004a) of the findings revealed that challenges with the interface under particular conditions in high traffic contexts could bring about positive emotional experiences for drivers. Interestingly it was found that if female drivers were feeling unhappy before driving, were faced with challenging interactions with the vehicle interface in high traffic contexts and could overcome them, they perceived the overall driving experience as positive. The same may apply for males,

however it is hypothesised that the testing method conducted did not allow for male participants to appropriately express their emotions. This suggested that interactions which are challenging or require a certain level of effort to accomplish may impact positively on the experience, depending on the emotional state of the driver prior to driving.

The current chapter expands on these findings and discusses how designers can utilise future technology such as context aware technologies, adaptive interfaces, digital screen technology and ubiquitous computing, within vehicle interface design to support positive emotional experiences in different traffic contexts.

2. The activity of driving

Driving requires the management of various human resources while focusing on the surrounding environment. As a result, to drive effectively people need to feel comfortable physically, mentally and emotionally. If drivers are at ease they can concentrate, make decisions and judgements successfully and enjoy a positive driving experience. The immediate driver-vehicle interface consisting of equipment like the radio, steering wheel or seats, is where the application of appropriate design can facilitate comfortable, relaxed, safe and enjoyable driving. The inclusion of existing and future technology in the design of the driver-vehicle interface should not only be ergonomically correct and useable in a physical and cognitive manner but also inspire confidence and make the driver feel emotionally at ease while driving, thus enhancing the overall experience.

2.1 Overall experience framework

Within the driving activity, developing an understanding of the interaction between driver, vehicle interface, and context is critical. There is evidence to suggest that studies relating to the human–artefact relationship have previously been based on cognitive psychology (Hoff et al. 2002). This approach has been criticised for being too systematic whereby the human aspect and the context of the interactivity is overlooked (Gay et al. 2004; Kaptelinin et al. 2006; Nardi 1996). As a result, it has been argued that to design appropriate interfaces for interactive products, consideration must be paid to broader issues of context, situation, moods, emotions, social communication and value systems (Frascara 1999).

To better understand interaction between user and artefact during use, activity theory has been considered. At a fundamental level, activity theory attempts to understand the relation between consciousness and activity. Consciousness refers to intention, a human aspect, while activities refer to the issue of interaction occurring between human and artefact over time. The focus is on *practice* and *doing* which concerns the development of activities through time (Nardi 1996). By concentrating on these issues interaction between driver and vehicle over time is understood in a more comprehensive manner, emphasising the overall experience of the driving activity.

To capture the driving activity an *overall experience* (Gomez et al. 2004a) framework was developed (Figure 7-1). It is based on the activity theory construct (Nardi 1996) which stands on the premise that objects are mediators of human experience (Kuutti 1996). The importance of emotion and context involved during interactions with artefacts or environments is also highlighted within activity theory.

An overall experience (Figure 7-1) is composed of the interaction between human and artefact in conjunction with the activity being performed within a particular environmental context. It is important to note that the surrounding environmental context, in which the human-artefact interaction is situated, forms a critical component of the overall experience.

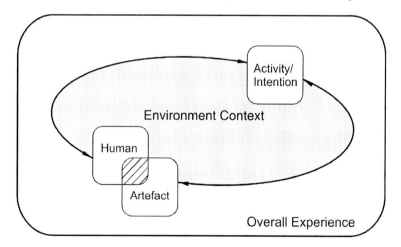

Figure 7-1. Human-Artefact-Activity within context forms an overall experience (Gomez et al. 2004b).

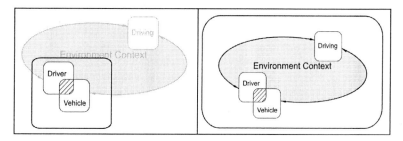

Figure 7-2. Micro (left) and macro (right) interaction levels for the overall driving experience.

If context is not considered within a framework of interaction the intention and meaning directing the activity can easily be misunderstood (Gay et al. 2004; Kaptelinin et al. 2006; McCarthy et al. 2004; Nardi 1996).

2.2 Framework for the driving activity

The driving activity can now be situated as an overall experience within the suggested framework. It consists of two interrelated interaction contexts; the micro-level context and macro-level context. The micro-level consists of interactions between driver and vehicle (Figure 7-2, left) and the macro-level consists of interaction between driver-vehicle and external environment (Figure 7-2, right).

To understand the overall driving experience, it is important to consider both interaction contexts in which the driver is simultaneously interacting with. Although the surrounding environment within the macro-level context (Figure 7-2, right) is in constant change while driving it is essential to recognise that the design of the vehicle interface needs to support these different driving conditions. In this way the physical design of the vehicle interface becomes a mediator for the overall experience attained by the driver.

2.3 Emotions and experiences

A positive state of mind while driving comes about when the driver is feeling content and relaxed. To achieve this, the driver must be physically, cognitively and emotionally comfortable while interacting with the vehicle interface. These capabilities needed for driving are intertwined and influence one another. As mentioned above research into the physical and

cognitive aspects of driving is abundant in the literature. For example, if drivers are using text messaging on their mobile phone as they drive their capacity to control their physical skills in an emergency decreases. However, there is little available research on the *emotional* aspects of interacting with the vehicle's interface and how this impacts the driving experience (Angulo 2007). There is a particularly gap in research on how to design for positive emotional experiences during human-vehicle interactions (Mesken 2001). Emotions are critical components that will impact on the overall experience attained by the driver, influencing all the aspects of the driving activity. They have been shown to directly affect concentration, judgements, decision-making and other critical cognitive and behavioural processes (Frijda 1986; Picard 1997; Plutchik 2003).

To identify emotions it was necessary to work with a basic construct that was easy, accessible and useful. Russell's (2003) model of Core Affect provides a basic model for articulating emotions. This model has previously been used as a foundation for emotions in studies that relate to emotional response to products (Desmet et al. 2002; Desmet et al. 2000), and emotional expression during mobile phone use (Fagerberg et al. 2004).

Russell suggests that a way to categorise emotions is to understand them as a blend of two dimensions. The first is a measure of feeling, ranging from contentment to discontentment (happy to unhappy) while the second is a measure of energy, ranging from excitement to calmness. The intensity of the emotion can be classified as neutral, moderate or extreme. The Core Affect model was used as a foundation to develop the Emotional Chart (Figure 7-3) (Gomez 2005).

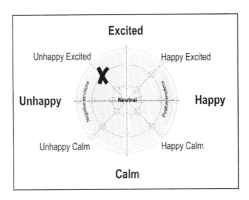

Figure 7-3. Emotional Chart (after Russell, 2003).

The Emotional Chart composes two hemispheres with "positive" emotions situated on the right and "negative" emotions on the left. To illustrate, the emotion *annoyed*, would be somewhere between "neutral" (midpoint) and "unhappy excited" as depicted on Figure 7-3. This Emotional Chart was used in the study and formed part of the questions asked during the initial and retrospective interviews. The labels were used in the coding system during the analysis stage.

3. Experiment: exploring the emotional driving experience

The research was conducted to investigate the driver's emotions with a vehicle interface in a natural driving situation. The aim was to investigate the emotional experience of driving as well as identify unique aspects that influence the overall experience.

3.1 Method

The study utilised a methodological triangulation approach (Denzin 1989) consisting of interviews, observation and think-aloud protocol. According to Robson (2002) triangulation techniques can help to counter particular threats to the validity of the experiment because it offers the researcher a variety of different channels to acquire and analyse data. The only foreseeable disadvantage of using this type of approach is that the information from the different sources may be conflicting; however this was not a problem given that during the analyses stage the data between interviews, observations and think-aloud protocols corresponded with each other. In addition, others researchers recommend utilising the approach of combining methodologies for measuring emotions in driving situations (Angulo 2007; Mesken 2001).

3.2 Participants

Fifteen participants (eight males and seven females), all full time staff members at Queensland University of Technology (QUT), were involved in the study. The participants represented a good cross-section of the driving population with ages ranging from 24 to 50. Every participant was screened to make sure they held a legal Australian driver's license.

Figure 7-4. Mini DV camera and tripod set-up (left) and Webcam and Laptop set-up (right) (Gomez et al. 2004a).

3.3 Equipment

The experiments were conducted using vehicles from Queensland University of Technology (Toyota Corolla–seven experiments; Toyota Camry–one experiment). This was due to the available time and availability of vehicles. Although one experiment used a different vehicle, the interface the driver interacted was very similar.

To record the experiment two video capturing devices were used. A mini DV camera and tripod located on the back seat recorded the participant's activities in the vehicle as well as recording audio (Figure 7-4, left). In addition, a web-cam was located on top of the dashboard attached to a laptop, which positioned on the passenger seat (Figure 7-4, right). This camera was used to videotape the participant's facial expressions during the drive.

Figure 7-5. Sample of two video sources into one file (Gomez et al. 2004a).

The image from the two videos were then mixed into one file (Figure 7-5) and used during the analysis of the experiment.

3.4 Procedure

The experiment focused on a daytime city-driving context. Each participant was required to drive a specified route around the central business district of Brisbane, Australia. The experiment was set-up in three basic steps. First, participants took part in an initial interview that was aimed at identifying their emotional state prior to driving. Second, they were required to drive a specified route while verbally expressing how they were feeling as they performed each task. Third, participants were asked to take part in a retrospective interview regarding their emotional state. Questions were also asked regarding their emotions about each of the activities performed while driving. A more detailed breakdown of the procedure is described below.

Step 1: Initial interview
Prior to driving participants were asked to undertake short interview. This was primarily set up to record their emotional state prior to the drive by noting their emotions on the Emotional Chart (Figure 8-3).

Step 2: Observation and think-aloud protocol
The participants were then asked to drive around a specified route in and around the central business district of Brisbane, which took them through a low-traffic area, a medium-traffic area and a high-traffic area. To keep the study as consistent as possible, the tests for all participants were performed between 11:00am and 2:00pm.

Participants were also asked to perform specific tasks during the drive so as to get detailed qualitative information relating to their interaction with the vehicle interface. These included operating the radio and tuning to a specific radio station, inserting a compact disc, playing a specific track on the compact disc, interacting with the air conditioning and washing the front and back water wipers. The reason for choosing these specific tasks was because they represent common, everyday activities that people perform in vehicles. Participants could perform these tasks in any order they liked and whenever they felt safe to execute them. Participants were also asked to think-aloud and verbally express what they were feeling about the tasks as they performed them. The drive took approximately twenty minutes to complete.

Step 3: Retrospective Interviews

Immediately following the drive a retrospective interview was conducted to gauge the participant's emotional state once more using the Emotional Chart (Figure 7-3). They were asked to provide an explanation about their feelings of the overall drive. Questions concerning how they felt regarding each of the activities they performed were also asked.

3.5 Coding system

The experiments were set up to measure the emotional response by analysing the participants' facial, vocal and bodily expressions in conjunction with their verbal descriptions of their feelings. Data was coded utilising a software program called Observer. This facilitated the coding of relevant elements of the driving experience. The coding system used was split into three categories called *Behavioural Classes* that comprised: *context*, *activities* and *emotions*. Each *Behavioural Class* was broken into *Behaviours*, used to define the categories into more detail (Table 7-1).

At any time throughout the analysis the researcher could code the *Behavioural Class* (context, activity and emotion) and its corresponding *Behaviour*. This resulted in information that was both detailed and comprehensive. With this type of information the software was able to construct a *time-event table* and *time-event plot*, which depicted the coded

Behavioural Class	Context	Activities	Emotions
Behaviour	Low Medium High	Correct Interaction Incorrect Interaction Visual Interaction Driving	Neutral Excited Happy Excited Happy Happy Calm Neutral Calm Unhappy Calm Unhappy Unhappy Excited

Table 7-1. Behavioural Classes and associated Behaviours.

Start Time (hh:mm:ss)	Behavioural Class	Behaviour	End Time (hh:mm:ss)	Duration (hh:mm:ss)
00:15:00	Context	High traffic	00:21:00	00:06:00
00:16:30	Activity	Visual interaction	00:16:33	00:00:03
00:16:31	Emotion	Neutral excited	00:16:35	00:00:04
00:16:33	Activity	Correct interaction	00:16:35	00:00:02
00:16:35	Emotion	Happy excited	00:16:40	00:00:05

Table 7-2. Portion of time-event table and corresponding portion of time-event plot.

information in a table and plot format (Table 7-2). For instance consider an instance where a driver is attempting to turn the radio on in high-traffic context. The driver looks at the interface for a few seconds attempting to find the "on" button. A few seconds later the driver finds the button expressing satisfaction as the radio is switched on. Table 7-2 depicts an example of this sequence.

The top portion of Table 7-2 illustrates (from left to right) the start time of a code, the behavioural class, its corresponding behaviour, the end time, and the overall time duration of the code. The corresponding image is a time-event plot of the same information. It illustrates the context (top

bar), activities (middle bar) and emotions (bottom bar) in different coloured segments along a timeline (in seconds). In each timeline different coloured bars were produced representing different behavioural classes of the corresponding behaviour. In activities, grey represents driving, light blue represent visual interaction and purple represents correct interaction. In the emotions timeline white represents neutral calm, red represents neutral excited and orange represents happy excited. The images represent an example of the corresponding video stills of the activities performed.

The time-event table and time-event plots were used to analyse how emotions during interactions in different contexts affected the overall driving experience (Gomez et al. 2004b).

4. Findings

The findings support the two levels of interaction relating to an emotional experience described in section 2.2. Figure 7.6 situates the experience framework within the driving activity.

Figure 7-6. Micro and macro levels of the driving activity.

On a micro level, issues relating to the specific interaction between the driver and the vehicle's interface were identified. In this case, the participant's emotions were a reflection of how they felt while driving but did not reflect the overall emotional experience. On a macro level, issues relating to specific interactions within specific contexts were identified. Situated within this broader context, the participant's emotions were an indication of how they felt about the overall driving experience.

Three main findings in respect to the emotional experience of driving are outlined. First, the emotional condition before driving had an impact on the overall emotional experience. Second traffic context was found to be of critical importance when exploring the overall emotional experience attained by the user. Third, analysis suggests that extensive visual interaction with the interface in high traffic context leads to negative emotions experienced within the driving situation. The first two findings will be briefly outlined as they are detailed in other previous presentations (Gomez et al. 2004a, 2004b), while the third finding will be discussed in more detail.

4.1 Effect of context on the driving experience

The most important finding of the entire study was the significance of context on the entire experience. It was found that the surrounding context completely dominated the emotional driving experience.

At the micro-level, emotions experienced within the driving situation fluctuated; however, the findings suggest that they did not determine their overall emotional experience. The *traffic context* in which the emotions were elicited however; had a critical impact on the overall emotional experience attained by the drivers (Gomez et al. 2004b). The context thus became the critical component in determining their overall emotional experience. In low-traffic contexts, emotions experienced while interacting with the interface did not influence the overall experience and were not remembered after the drive. In high-traffic context, emotions experienced appeared to be magnified and influenced the overall emotional experience. Participants particularly remembered any negative emotions experienced in high-traffic contexts.

4.2 Effect of emotional condition prior to driving

It was interesting to note that the emotional condition of the participant prior to driving influenced their overall emotional driving experience (Gomez et al. 2004a). The emotional condition before the drive served like a baseline value which would then influence the way they were to perceive positive and negative experiences later in the driving activity.

Drivers in a positive emotional condition before driving who experienced challenging interactions in a high-traffic context perceived the overall experience as negative. Drivers in a negative emotional condition before driving, able to overcome challenging interactions in high-traffic contexts, perceived the overall experience as positive. This finding suggests that in high-traffic contexts the emotions of achievement and accomplishment associated with overcoming challenging interactions help those in a negative emotional condition feel positive overall experiences.

4.3 Extended visual interaction with vehicle interface

An additional finding is that extensive visual interaction with the vehicle interface in high-traffic contexts often resulted in negative emotions expressed by the driver. It appears that when drivers focused too much attention away from the road in high traffic contexts they instinctively became anxious and displayed signs of stress and negativity; expressed by their facial expression and their verbal descriptions of their feelings.

Figures 7-7 and 7-8 show a consecutive set of still images of participants 13 and 14 respectively during interaction with the vehicle interface in high-traffic context. In each of the examples the participant is looking at the vehicle interface for an extended period of time trying to work out how to perform a particular task. As illustrated, the facial expression demonstrates the negative emotions experienced.

Figure 7-7 shows participant 13 trying to adjust the air-conditioning in high-traffic context. The left image shows the participant looking at the vehicle interface in high-traffic context experiencing concentration. Five seconds later (middle image), the participant is still looking at the vehicle interface but her emotions have become one of annoyance and irritation as

she tries to figure out how to perform the task. Four seconds after (right image), the participant has worked out how to perform the task but is still

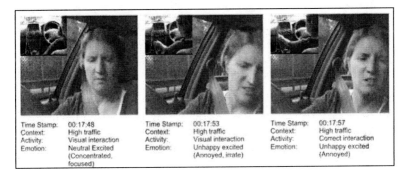

Time Stamp:	00:17:48	Time Stamp:	00:17:53	Time Stamp:	00:17:57
Context:	High traffic	Context:	High traffic	Context:	High traffic
Activity:	Visual interaction	Activity:	Visual interaction	Activity:	Correct interaction
Emotion:	Neutral Excited (Concentrated, focused)	Emotion:	Unhappy excited (Annoyed, irate)	Emotion:	Unhappy excited (Annoyed)

Figure 7-7. Still-images of participant 13 experiencing negative emotions after prolonged visual interaction with the air-conditioning system.

exhibiting negative emotions associated with the extended visual interaction. When asked about this particular task during the retrospective interview she commented on the problems encountered:

> ...Can't see marker on open-close control, did not realise the air-condition light was off until later... was not bright enough (referring to the air-condition light indicator).

Figure 7-8 illustrates participant 14 attempting to turn on the back windscreen wipers in high-traffic context. The first image (left image) shows the participant looking at the vehicle interface in high-traffic context. A few seconds after (middle image) the participant is still focusing on the vehicle interface expressing more intense emotion of confusion and irritation as she tries to figure out how to perform the task. Four seconds later (right image) the participant has not worked out how to perform the task and continues to express negative emotions associated with the extended visual interaction. The participant also commented on the problems experienced in the retrospective interview:

> ...Annoying cause it's hard to do. Did turn it [on] but only water came on, expected the wipers to come on as well except it didn't work like the front one (referring to front windscreen wipers).

The examples illustrate how extended visual interaction with vehicle interface can lead to negative emotions within the driving situation. This occurs most significantly in high-traffic contexts.

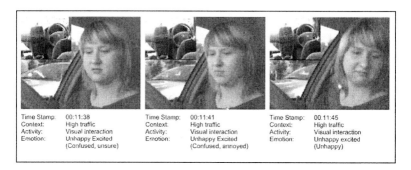

Time Stamp:	00:11:38	Time Stamp:	00:11:41	Time Stamp:	00:11:45
Context:	High traffic	Context:	High traffic	Context:	High traffic
Activity:	Visual interaction	Activity:	Visual interaction	Activity:	Visual interaction
Emotion:	Unhappy Excited	Emotion:	Unhappy Excited	Emotion:	Unhappy excited
	(Confused, unsure)		(Confused, annoyed)		(Unhappy)

Figure 7-8. Still-images of participant 14 experiencing negative emotions after prolonged visual interaction with the windscreen wiper controls.

5. Discussion and conclusion

To drive a vehicle safely and effectively and to create a sense of enjoyment within the driving activity, the driver needs to be physically, mentally and emotionally comfortable. This paper presented an experiment conducted which specifically focused on the emotional aspect of the driving activity within a daytime inner-city driving situation. It is important to note that the findings are indicative at this stage.

How do the results influence the design of vehicle interfaces, and how can current and future technologies support positive emotional experiences? To begin with, the main points identified from the findings were:

- Emotions experienced during interaction with vehicle interface in low-traffic context do not affect the overall emotional driving experience.
- Emotions experienced during interaction with vehicle interface in high-traffic context are critical in forming the overall emotional driving experience.
- The emotional condition before driving influences the overall emotional driving experience.
- Challenging interactions in high-traffic contexts, under certain conditions, appeared to result in positive emotional experiences.
- Extended visual interaction with the vehicle interface in high-traffic contexts seem to result in negative emotions within the driving situation.

A relevant question that arises from these findings is how can the traffic context overwhelm the overall emotional driving experience and why does the emotional condition before driving influence the overall experience? Cheng (2004) offers a theory to explain this by noting

> ...our total affective experience is larger than the sum of positive, negative and neutral moments [...] A positive experience which has little or no effect ordinarily would go a long way at hard times. On the contrary, when life is smooth, the effect of adding more positive experiences may just be marginal.

This suggests that people's perception of their overall emotional experience is not simply about the sum of individual experiences, but rather has to take into account the contrasting effects *between* individual experiences. Consequently there is a contrasting effect between positive and negative emotions on the overall emotional condition of an individual. For instance, if a negative experience is followed by a positive experience, the difference between the contrasting emotions creates a noticeably positive *overall* experience. If a positive experience is followed by a negative experience the difference between the contrasting emotions creates a noticeably negative *overall* experience.

The contrast theory helps to explain why participants in a negative emotional state before driving experienced overall positive experiences when overcoming challenges during interaction in high-traffic contexts. In this case, the positive emotions associated with overcoming the challenges were in stark contrast to the participant's negative emotions prior to driving. The same applies to participants in a positive emotional state prior to driving that experienced challenges in high-traffic contexts; the contrast between the two events resulted in an overall negative emotional experience.

Moreover, this theory also indicates that a positive experience followed by another positive experience creates only a marginal positive *overall* experience. This explains why participants in a positive state before driving that experienced no significant challenges with the interface in high-traffic contexts underwent neutral overall experiences. The positive emotions prior to driving followed by the positive emotions of completing tasks without difficulty produced minimal emotional change between the two events and thus the driver perceived the overall emotional experience as neutral.

5.1 Implications for vehicle interface design

These findings have implications for the design of vehicle interfaces. They also offer some directions for interaction between driver and vehicle interface that support positive emotional experiences and reduce negative emotional experiences in a variety of ways. Some directions include:

- Vehicle interfaces should allow for various kinds of interaction depending on the surrounding context.
- Vehicle interfaces may encourage interaction within a low traffic context, as the emotions experienced in this context will not critically affect overall emotional driving experience. Additionally, rather than being static, the element of fun could be introduced by presenting a variety of ways to interact with the interface.
- If the driver is in a positive mood prior to driving vehicle interfaces may discourage unnecessary interaction within a high-traffic situation. In this case any negative emotions elicited in a high traffic context will impact negatively on the overall emotional experience perceived by the driver.
- If the driver is in a negative mood before driving, vehicle interfaces may encourage certain interactions within a high traffic context. In this case positive emotions associated with overcoming challenging interactions will elicit positive overall emotional experiences.
- In high-traffic contexts, the interface may adapt and discourage unnecessary extended visual interaction. In doing so, it will decreases the chances of eliciting negative emotions from the driver.

Essentially this indicates that the design of vehicle interfaces should be able to adapt according to the context as well as take into account the emotional condition of drivers prior to driving. This may be achieved by designing vehicles with context-aware interfaces as well as vehicle interiors that are sensitive to the emotional state of the driver before and during driving. These technologies would allow the vehicle to adapt appropriately according to the surrounding environment in a dynamic style so as to enhance the overall driving experience; however there is always the need for the driver to be in control of these systems at any given time.

Ubiquitous, embedded or ambient technologies could be applied within interior vehicle designs to make interfaces aware of their surrounding context as well as interiors sensitive to the emotional condition of drivers.

Digital screens as well as smart materials could be used as adaptable interfaces between the driver and vehicle. Currently, digital screens are used in vehicle interiors. However, they could be designed in such a way so as to adapt to different surrounding context or user inputs. Navigation systems are a simple example of digital screen technology that responds to its changing surrounding. Within the context of this paper another way digital touch screens could be applied is in the design of the entire centre console (including radio and CD, air-condition, navigation, speedometer or fuel gauge) whereby the entire interface including colour, shape, sensitivity, sound, form of buttons and other features could change and adapt depending on the surrounding context. There is evidence to suggest that this type of technology is already being considered by major car manufacturers for implementation in future vehicles thus enhancing the safety and enjoyment for the driver (Walker et al. 2001). Essentially the benefit of digital screens is that they allow for customisation by the driver or other passengers in the vehicle, as well as permit the vehicle itself to utilise context-ware technologies to inform the digital screen how to adapt in different contexts.

Similarly smart materials are another type of technology that could be utilised within vehicle interiors. The term "smart" refers to materials such as thermochromic materials, shape memory alloys and polymers, and electro-rheological fluids (Friend et al. 1999). These materials have the ability to change and adapt dynamically to their environment. They offer versatility depending on the surrounding environment, as well as adaptability to the driver's wishes. For example, there are polymers that are able to change dynamically to respond to different stimuli, changing from a high level of stiffness to a low level of stiffness depending on the circumstances. Also, there is ongoing experimentation on conformable elastic materials that can change shape, adapting to the users grip or force applied (Friend et al. 2003). These materials could be utilised on steering wheels, buttons, control knobs, paddle shifts and other areas of the vehicle interface to enhance comfort as well as enjoyment in different situations.

Technology also exists to develop interiors that are sensitive to the emotional state of the driver (Nasoz et al. 2002; Teller 2004). Sensitivity to the driver's emotional condition does not imply that the interface can identify a specific emotion; nevertheless, identifying whether a driver is in a negative or a positive mood is possible. At this point in time however; the technology to achieve this is still at an early stage of development as is too intrusive to be implemented in a suitable manner.

5.2 Implications for design

The study has some implications for the Design fields, both research and practice. Principally, the methodology employed can be applied to develop new ways of understanding the human-artefact interaction in real-life contexts. Furthermore, the outcomes can help stimulate the design practice as they offer new ideas and directions for future product development.

The methodology used was driven by the interest to explore the human-artefact interaction over time, rather than a single interaction, and across contexts, rather than in a laboratory situation. Furthermore, the focus was on interaction in life-like situations, in an attempt to reflect as much as possible what would naturally occur for people in their everyday interactions.

This approach produces interesting outcomes, but also poses challenges. Perhaps the biggest challenge is in the difficulty to understand and measure emotional responses during human-user interaction without interfering with the episode itself. This is true for any experimental technique; nevertheless there are ways to mitigate this. One method is to try and use multiple techniques to attain the required data, in this case a triangulation methodology consisting of interviews, observations and think-aloud protocols. Furthermore, in the researcher's experience, it was important to help the participant relax before the actual study began. This was achieved by the use of some straightforward and simple questions during the initial interview, thus helping the participant feel comfortable.

In conclusion, this research is significant as it has opened up the area of emotional driving experiences for further study. The findings have identified ways in which vehicle interfaces can be designed to enhance and support positive emotions and reduce negative emotional within the driving experience. The appropriate application of technology will allow for the flexibility needed in vehicle interfaces to support positive emotional experiences in the driving activity. It is important to consider the application of these technologies into vehicle interface designs as the emotional condition of the driver will affect the overall performance, safety and enjoyment of the driving activity.

Acknowledgements

Thanks go to the Queensland University of Technology for providing time, support and funding for this research. Many thanks also go to the participants for their time and effort, without them the research would not be possible.

This chapter is based on a presentation given at the International Design and Emotion Conference 2006, Sweden. Some sections of this chapter are also based on conference papers presented at the International Design and Emotion Conference 2004, Turkey and Futureground International Design Conference 2004, Australia.

Works Cited

Andreoni, G., Santambrogio, G. C., Rabuffetti, M., and Pedotti, A. (2002). Method for the analysis of posture and interface pressure of car drivers. *Applied Ergonomics*, **33**(6), 511-522.

Angulo, J. (2007). The Emotional Driver: A study of the driving experience and the road context, Masters, Blekinge Institute of Technology, Ronneby.

Briem, V., Valdimer, and Hedman, L. (1995). Behavioural effects of mobile telephone use during simulated driving. *Ergonomics*, **38**(12), 2536-2562.

Cheng, S. (2004). Endowment and contrast: the role of positive and negative emotions on well-being appraisal. *Personality and Individual Differences*, **37**(5), 905-915.

Denzin, N. K. (1989). The research act : a theoretical introduction to sociological methods (3rd ed.) N.J.: Prentice-Hall.

Desmet, P. M. A., Hekkert, P. and Jacobs, J. (2000). When a car makes you smile: Development and application of an instrument to measure product emotions. *Advances in Consumer Research*, **27**, 111-117.

Desmet, P. M. A. and Hekkert, P. P. M. (2002). The Basis of Product Emotions. In P. W. Jordan and W. S. Green (Eds.), *Pleasure with products : beyond usability*. London: Taylor and Francis. 61-68.

Fagerberg, P., Stahl, A. and Hook, K. (2004). eMoto: Emotionally engaging interactions. *Personal and Ubiquitous Computing*, **8**(5), 377-381.

Frascara, J. (1999). Cognition, Emotion and Other Inescapable Dimensions of Human Experience. *Visible Language*, **33**(1), 74-87.

Friend, C. and Thorpe, C. (1999). Modelling Intelligent Electronic Consumer Products. *Journal of Intelligent Materials Systems and Structures*, **10**(7), 552-557.

Friend, C. and Thorpe, C. (2003). Smart consumer goods. Retrieved August 12, 2003, http://bookstore.spie.org/index.cfm?fuseaction=DetailVolumeandprod uctid=497187andCFID=3033066andCFTOKEN=67412257

Frijda, N. (1986). The emotions. Cambridge: Cambridge University Press.

Gay, G. and Hembrooke, H. (2004). Activity-centered design : an ecological approach to designing smart tools and usable systems Cambridge: MIT Press.

Gomez, R. (2005). Experience Design and Automotive Design, Masters Thesis, Queensland University of Technology, Brisbane.

Gomez, R., Popovic, V. and Bucolo, S. (2004a). Driving Experience and The Effect of Challenging Interactions in High Traffic Context. *Proceedings of the Futureground International Conference 2004*, Melbourne, Australia.

Gomez, R., Popovic, V. and Bucolo, S. (2004b). Driving: The Emotional Experience and Automotive Design. *Proceedings of the Fourth International Conference on Design and Emotion*, Ankara, Turkey.

Groeger, J. A. (2000). Understanding driving : applying cognitive psychology to a complex everyday task Hove England Philadelphia: Psychology Press.

Hahn, R., Tetlock, P. and Burnett, J. (2000). Should you be allowed to use your cellular phone while driving? *Regulation*, **23**(3), 46.

Haigney, D., Taylor, R. and Westerman, S. (2000). Concurrent mobile (cellular) phone use and driving performance: task demand characteristics and compensatory processes. Transportation research Part F, 3, 113-121.

Hoff, T., Øritsland, T. A. and Bjørkli, C. A. (2002). Exploring the embodied-mind approach to user experience. *Proceedings of the second Nordic conference on Human-computer interaction*, Denmark, 271-274.

Kaptelinin, V. and Nardi, B. A. (2006). Acting with technology : activity theory and interaction design Cambridge, Mass.: MIT Press.

Kuutti, K. (1996). A Framework for HCI Research. In B. A. Nardi (Ed.), *Context and Consciousness : Activity Theory and Human-Computer Interaction*. Cambridge, Mass: The MIT Press. 17-44.

Lansdown, T., Brook-Carter, N. and Kersloot, A. (2004). Distraction from multiple in-vehicle secondary tasks: vehicle performance and mental workload implications. *Ergonomics*, **47**(1), 91-104.

McCarthy, J. and Wright, P. (2004). Technology as experience Cambridge, Mass.: MIT Press.

Mesken, J. (2001). Measuring emotions in traffic. Retrieved December 12, 2004. URL: http://www.swov.nl/rapport/D-2002-03.pdf

—. (2003). The role of emotions and moods in traffic. Leidschendam, The Netherlands: SWOV Institute for Road Safety Research.

Nardi, B. A. (1996). Context and Consciousness : Activity Theory and Human-Computer Interaction. Cambridge, Mass: MIT Press.

Nasoz, F., Ozyer, O., Lisetti, C. and Finkelstein, N. (2002). Multimodal Affective Driver Interfaces for Future Cars. *Proceedings of the tenth ACM international conference on Multimedia*, France, 319-322.

Peacock, B. and Karwowski, W. (1993). Automotive ergonomics London Washington, DC: Taylor and Francis.

Picard, R. W. (1997). Affective Computing Massachusetts: The MIT Press.

Plutchik, R. (2003). Emotions and life : perspectives from psychology, biology, and evolution (1st ed.) Washington: American Psychological Association.

Porter, J., Case, K., Freer, M. and Bonney, M. (1993). Computer-aided ergonomics design of automobiles. In B. Peacock and W. Karwowski (Eds.), *Automotive Ergonomics*. London: Taylor and Francis.

Reed, M., Manary, M., Flannagan, C. and Schneider, L. (2002). A statistical method for predicting automobile driving posture. *Human Factors*, **44**(4), 557.

Regan, M., Oxley, J., Godley, S. and Tingvall, C. (2000). Intelligent Transportation Systems: Safety and Human Factors Issues. *Victoria: Monash University Accident Research Centre*.

Robson, C. (2002). Real world research : a resource for social scientists and practitioner-researchers (2nd ed.) Oxford: Blackwell Publishers.

Russell, J. (2003). Core Affect and the Psychological Construct of Emotion. *Psychological Review*, **110**(1), 145-172.

Schneider, M. and Kiesler, S. (2005). Calling While Driving: Effects of Providing Remote Traffic Context. Proceedings of Human Factors in Computing Systems, Portland, OR, USA.

Strayer, D. and Johnson, W. A. (2001). Driven to Distraction: Dual-Task Studies of Simulated Driving and Conversing on a Cellular Telephone. *Psychological Science*, **12**(6), 462-466.

Stutts, J., Feaganes, J., Reinfurt, D., Rodgman, E., Hamlett, C., Gish, K., et al. (2005). Driver's exposure to distractions in their natural driving environment. *Accident Analysis and Prevention*, **37**, 1093-1101.

Teller, A. (2004). A platform for wearable physiological computing. *Interacting with Computers*, **16**(5), 917-937.

Walker, G., Stanton, N. and Young, M. (2001). Where Is Computing Driving Cars? *International Journal of Human-Computer Interaction*, **13**(2), 203-229.

CHAPTER EIGHT

THE TA-DA SERIES - A TECHNIQUE FOR GENERATING SURPRISING DESIGNS BASED ON OPPOSITES AND GUT REACTIONS

SILVIA GRIMALDI

1. Introduction

Surprise is an emotion that is used very explicitly in personal interactions and in narrative media, yet it is not used in the same way within design. This case study presents a technique devised to apply the results of theoretical research on surprise to the creation of a series of surprising objects.

Figure 8-1. Surprise.

Most storytellers, whether they are working through speech, film writing, etcetera rely on surprise to make their story more interesting or funnier or scarier. The more obvious example of this use of surprise within narrative media is looking at horror or thriller films, in which suspense and unexpected events are often used to underline the fear. However, surprise is also used in other genres to make the story more interesting or funnier. Take a joke as an example; surprising elements are often created in jokes by playing with the timing of the narrative, or by setting up a recognisable context which carries certain expectations. The characters will then either break the repetition in the timing: take as example any very long repetitive joke and its punch line, or break the context that was set up: any joke in which the characters do not behave as they were expected. It is therefore through breaking a context, whether the context is created by the rhythm and repetition of the narrative, or whether the story unfolds differently than what was predicted from the context, that the surprise will be achieved. The final result is not surprise per se: in the case of a joke the final result will be to make people laugh, the surprise is there to underline the laugh; in the same way the final result of a horror film is fear or disgust, and the surprise accentuates these emotions.

In terms of products, many design objects use elements of surprise and work on the principles of displacement and recognition; taking elements from a certain context, particularly elements that signify a certain context, and then applying them to a different context with surprising results. A good example of this displacement can be seen in a lot of objects in the Droog collection: Hector Serrano's *Waterproof* lamp, or Marcel Wander's *Knotted Chair* both play with visual displacement and merging different contexts; other objects like Hella Jongerius' *Soft Vase* or Dick van Hoff's *Felt Washbasin* also displace the user but by changing the material, so that the surprise might not be apparent at first sight but it will be discovered when touching or interacting with the object.

Though many products use surprising elements to engage the user, the surprise is not usually the main focus of the object. This case study will analyse a technique used to create a series of objects, the "Ta-Da Series", to show how this emotional element of surprise can be incorporated into design pieces to have them function in a narrative sense and deliver a similar type of surprise. The method used was called the "Opposites Technique"; this paper will show how this is developed through analysing one of the pieces in the series and will then show how it was applied to create the other two objects.

2. Surprise and How it Works

The designs in this series are very different in the way they function as surprising objects, yet they are derived from the application of the same technique based on opposites, cultural expectations, gut reactions and pleasant surprise.

To begin with, considering surprise as one of the six primary emotions (Eckman 1984) the design process involved studying surprise to determine what type of situations can cause this emotion and what the benefits of using surprise in design would be. Darwin, in *The Expression of Emotion in Man and Animal*, defines it as the reaction to a sudden or unknown stimulus. The facial expressions and reaction of the whole body to the surprise indicates the function of this emotion in nature; the body puts itself on alert and prepares itself for action, the senses are heightened, for example the eyes are wide open, and we are more perceptive to visual but also auditory stimulus. The heart beats faster and the muscles tense, prepared to flee a possible danger. On the whole, a surprised person is paying more attention, is more aware of the surroundings and is more perceptive (Darwin 1934).

Figure 8-2. Peek-a-boo! Surprised Child.

This more perceptive state also heightens our reaction to other emotional stimuli; a pleasant surprise will have a stronger reaction than a

pleasant event which is not surprising. In recent neuropsychological studies, such as those by Antonio Damasio, there is a clear correlation between emotion and decision making. Several case studies show that people who have lost their emotional ability through brain damage but retain their rational ability are extremely impaired in decision-making, especially decisions affecting their own welfare (Damasio 1999). The clear benefit in terms of design is that this higher emotional impact will have repercussions when it is time to make a choice as to what product to purchase.

It is important to remember that what we learn to expect, and consequently what we deem unexpected, is acquired through our experience of the world, and the simpler and more common the object, the more expectations we will have about it. Because of this, it becomes clear that the technique would be most effective if applied to objects that we use every day, which we have expectations on, which in other words we trust.

This is why this project concentrated on designing domestic furniture: we use similar objects every day, we have grown up with them, we know everything there is to know about them. In addition, furniture carries a high emotional charge and emotional attachment: it is passed on from generation to generation, it is lived with. In Baudrillard's (1996) words:

> ...the primary function of furniture and objects here [in the family home] is to personify human relationships, to fill the space that they share between them, and to be inhabited by a soul.

The objects selected to undertake the technique are simple pieces of furniture: a lamp, a stool and a coffee-table; we can extract archetypical aspects from each of these objects.

3. The technique: opposites and gut reactions

The opposites technique is based on three consecutive steps that can help the designer to assess what surprises are possible, and what the final outcome of the surprising experience may be; in this way, the designer can steer the object to create specific reactions from the user. The first step is to assess which objects will be used and what their main characteristics are; the second step is to find the opposite of one characteristic and turn it into a design concept, and the third step is to incorporate additional reinforcing reactions which will unfold over time.

This opposites technique is necessary to make the final surprising piece relevant; there are an infinite number of surprises which could be applied to any object, but the design will have a stronger effect if the final aim of the designer is understandable, in other words if there is some sort of recognition of what the designer is trying to say. In a way, through understanding what the intent of the design is, it is like the user was being let in on a joke or a secret; it creates a sort of dialogue between the user and the designer, and it creates a narrative in which the user, by discovering the message himself, is the protagonist. (Dunne 1999)

3.1 Step 1: Assessing the qualities

To create a relevant and coherent surprise, and to avoid being gimmicky, the opposites technique centres on the essential qualities of the object that is being redesigned. Therefore, it is important in step one of the technique to assess what the main characteristics of the object are, which characteristics are essential to the object and which ones could be changed without losing the object completely. The characteristics that are looked at in this step could be physical, having to do with material, form, colour, etcetera, functional, having to do with the way the object works or the way the user physically interacts with the object, or cultural, having to do with what the object symbolises within a certain culture. The type of characteristics analysed will strongly influence the final outcome of the design, as subverting the different characteristics will create different types of surprises and different types of reactions from the user.

Taking the example of a lamp, the first quality of any lamp is that it makes light. This quality is essential for its "lampness": a lamp which does not make light is not only frustrating - it is simply not a lamp. Therefore this property in the lamp could not be subverted. On the other hand there are plenty of other qualities that are normally associated with lamps and which could be opposed without losing the essential "lampness"; these could be physical qualities, such as the shape of the lampshade as well as the fragile materials which are usually used in lamps; they could be functional qualities, such as the way the lamp is turned on and off as well as the type of light that will come out of a certain archetypal lamp shape; they could also be cultural qualities, such as the significance of a certain type of lamp or the connotations of certain lamp forms and the status associated with them.

Figure 8-3. Furniture Archetypes.

3.2 Step 2: Opposites

The concept for the design comes from opposing one or more of the analysed qualities; this can be done in different ways depending on which characteristics are chosen to be opposed and how this is then realised within a whole design concept. Of course the choice of which qualities to oppose will influence the way in which the design is read: physical qualities could be opposed in ways that are obvious at first sight, or in more subtle ways that need to be discovered, also the opposition could be based on what is normally associated with the object but is not necessarily part of the object, playing with what out pre-conceived notions are. When opposing a functional quality, the new object could gain added features, but it could also function in a quirky way that will establish a personality to the object, or it could lead the user in one direction pretending to function in one way, and then turn out to function in a different way. Cultural qualities are particularly apt for this type of opposition, because they immediately set us up questioning our set beliefs and expectations; the opposed quality then will be something that for example makes the object work differently as a status symbol or as a conversation piece, or it

may be something that gives a mixed message as to the meaning of the object within a certain setting.

The opposition of qualities is used to create the unexpected element that is essential in surprise, but the design process is not limited to just opposing one characteristic. It is not only the unexpected element that will create the surprising emotional impact, but also the way that the scene is set out, the way this element is discovered and the timing of the whole experience. In narrative media, a story usually starts from a position in which there is a "lack of closure"; we experience a sense of suspense when clues are given to let us know that something is going to happen in the story, and the surprise comes with the actual event (Abbott 2002). The designed object can be looked at in the same terms: the initial situation is the user's gained knowledge and beliefs about that type of object; the lack of closure or suspense comes with the first impression of the object and the surprise comes upon approaching the object, upon touching the object, or upon using the object over a longer or shorter time period; ideally, the surprise will then lead to the closure that is necessary at the end of a narrative.

It is therefore important to think of how the original scene is set up, how the user will first approach the object, and how the unexpected or surprising element will be discovered, and whether this sequence achieves the desired effect. Not only then is an unexpected opposing element introduced within the design, but it is important to look at how the user will first approach the object, what they will perceive at first sight, whether this will create a feeling of suspense, and whether this suspense can be resolved with a surprising event or discovery. All of these elements will inform the user's experience of the object and ultimately the user's emotional reaction.

Going back to our lamp, this particular design subverts one of the physical qualities of the lamp: the connotation of fragility. Lamps are usually quite fragile; we all know that if you drop a lamp on the floor it will break. This was chosen for something to oppose because though it is not a necessary quality, it is something commonly associated with the typology of the object.

The way the design plays with these expectations is by creating a lamp that at first sight has connotations of both a typical lamp and of fragility, but on second thought it contradicts the fragile aspect. It is therefore setting up the scene by giving hints to its fragile nature, and then creating a

sense of suspense before the user approaches the lamp. Of course some objects within this typology carry more outward signs of their expected qualities; certain lamps are and look more fragile than others. It was therefore necessary to find a type of lamp that would have the most visual clues as to its fragility, and the obvious choice was to choose a lamp entirely made out of glass. In order for this to be a recognizable feature the shape of the lamp itself had to reference the fact that the lamp is made out of glass; the archetype referenced had to be one of recognizable delicate and fragile nature. The choice fell on art deco glass lamps because they use a clear visual language, in other words they are often shaped "like a lamp" and they are often made entirely of glass. In particular, the type of lamp referred to as mushroom lamp seemed particularly suited for this project because it resembles a lamp shape and is often cast in clear or frosted glass.

The formal design features of the mushroom lamp then needed to be incorporated in a lamp design that did not break, and was indeed the opposite of breakable. The obvious choice at this point was rubber. Not only

Figure 8-4. Mushroom Lamp.

is a rubber lamp not breakable, but it is overtly so; once you know it is made of rubber you realise that the shape is softer and more rounded than the archetypal shape it refers to and it invites you to touch it and play with it.

3.3 Step 3: Gut reactions

To emphasize the surprise and create a rewarding experience which involves a realisation of the user's preconceptions and ingrained behaviour, an additional element is needed. Playing with the user's gut reactions and ingrained fears seems a useful addition because it brings the user to a realisation about herself and her own habits and preconceptions as well as about the object itself. "Gut reaction" is a term often used to describe an irrational and instinctive reaction to a sudden stimulus. In this way it is often based on surprise, but it implies a learnt physical reaction which can be used to catch the user off-guard. Closely related to this is the fact that we can play not only with what is unexpected of an object, but also with what is feared from that object. This will add some relevance to the surprising object, but it will also create a reward for the user in the end; by negating the fear, the end result of the user-object interaction is going to be a positive one, thus leading to a positive sense of closure. The surprise is turned into an inherently positive surprise because it goes against the initial fear.

To obtain a gut reaction from the user, it is necessary to look at the user's engrained behaviours, what is learned and what is instinctive, what clues lead users to react in a certain way. This is easier with everyday objects because they are ones that the user has come to trust, and that have the most learned reactions. We are all familiar with the sensation that something is not quite right; this could be a painting hanging slightly off, a glass placed close to the edge of a table, a feeling that, when using a chair, it is not quite stable. If the designer is able to simulate this situation, then they will be able to harness the user's gut-reaction to catch the user off-guard, to make the user unconsciously react in a certain way: the user will straighten the painting, move the glass, or brace for a fall. This is useful to simulate the surprise feeling that you would have with surprise in other media, such as the feeling when in a horror film the killer appears all of a sudden, making you jump out of the seat or scream. Similarly, this type of gut reaction is useful to set up a storyline, because it mimics the way a traditional narrative is set out: a somewhat negative initial situation, followed by an emotionally charged event, followed by a positive conclusion. In the same way, by using the gut reactions, the user's interaction with the object can follow all three of these stages, from an initial situation which induces a fear, which could be small or unconscious such as the crooked painting, the balancing glass or the non-solid chair, it will follow through some sort of action which is emotionally charged, such as straightening the painting, moving the glass or bracing for a fall, and it

will conclude with a positive conclusion, which could be that the painting is meant to be crooked, the glass is not made out of glass or the chair is actually solid.

Figure 8-5. On-edge lamp.

In the case of our lamp, what is feared of a lamp is that it will fall on the ground and break, and possibly be dangerous because of the glass and electricity involved. To reinforce this fear the lamp is only on when it is placed on the edge of the table. This creates a sense of suspense, by staging the future fall, and also tends to stimulate people's gut reaction to try to move it to the centre of the table. Anyone with children or pets will recognise the tendency to move fragile objects farther from the edge of the table. By moving the lamp onto the table the user is not only going to touch the lamp, and therefore feel the rubber and realise it will not break, but will also discover that the lamp can only be turned on when on the edge.

This process of discovery creates a narrative between the user, the object and the designer, by creating a difference between what the user thought or felt before the physical interaction, and what she felt after. The

sense of suspense of seeing the lamp on the edge adds to the narrative, the surprise creates the punch line, and the positive realisation of the lamp's unbreakable quality creates the happy ending.

In future interactions, once we are aware of the trick, the sense of suspense becomes playful; we understand that the lamp is toying with us, but we still can not help reacting in the same way when we see it out of the corner of the eye. This also reminds us of the surprise from the first encounter and of the story of the interaction. On the flip side, recalling the narrative will remind us of the object itself, creating more word of mouth and product recognition (Ludden 2004).

Figure 8-6. On-edge lamp explained.

4. Timing

Looking at the design process in terms of creating a narrative, it is important to remember that a narrative is not fixed in one moment but it changes and evolves through time. In the same way, the relationship between the user and the designed object is not based on a single moment in time, but it is based on a sequence of events. The user's idea of the object is not fixed in one moment but it is constantly evolving, changing

as the object is approached, used, lived with, etcetera. Because of this, it would be foolish of the designer to simplify the user-object relationship to fit within one moment in time; the relationship has to be analysed over a period of time, depending on how the object is meant to be approached or used. This creates the possibility for a whole sequence of events, each event informing the whole story of the interaction.

The designer will therefore have to look at the different key moments within this interaction sequence, and decide where to place the surprise, as well as looking at when in time all the other elements need to occur in order to make the interaction into a satisfying narrative. The surprise could be delivered immediately at first sight, as would be the case with objects that look surprising; it could be delivered at second glance or at first use, for example in an object which looks conventional but has a detail that is surprising, or an object that looks like it functions in a certain way, but actually functions in a different way, or an object which is different to the touch than it is to the sight; finally it could be delivered to the user over a longer period of time, for example with an object whose behaviour changes over time, or an object which develops as it is used, or something which normally behaves in a certain way but occasionally behaves differently. This will have a great influence over the final outcome of the design, because the way in which the surprise is discovered will not only change how the narrative is set up, but it will also change the user's opinion of the object and the emotional relationship with the object.

Taking the lamp as an example, the timing of the user's experience can be broken down into several different steps: the user sees the object on the edge of the table and assumes it is going to fall and break. Therefore the user will have the gut reaction of moving the object to the centre of the table, approaching and touching the object. The user then has the first "revelation" that the lamp is made of rubber, and therefore will not break when it falls. The lamp is then moved onto the table, where it shuts off. Following this, the user probably moves the lamp back and forth, discovering that it has to be on the edge in order to be on. After this, the user might get to the realisation that the switch feature was set in place to force the lamp onto the edge of the table, thus understanding the full design.

5. Applications of the technique

The same technique was applied to come up with the three designs in the Ta-Da series, the "On-Edge Lamp" which we have described at length, the "(Un-)Stable Stool", and the "Impolite Coffee Tables". However, the method is applied slightly differently to take into account functional differences and cultural expectations in the types of objects selected.

The (Un-)Stable Stool, like the On-Edge Lamp, is based on a tactile surprise, but as opposed to the lamp it is not something you discover with your hands but with your whole body. This design in particular uses the physical feeling to its full potential, while really playing with the fear ingrained in this type of object. The stool is an odd height, its seat is particularly small and its legs are set almost at ninety degrees to the seat. When the stool is sat on, its legs splay out, giving the user the impression that it is going to collapse. But after a split-second the legs settle into a locked position and it becomes fully functional and stable.

Figure 8-7. (Un-)stable stool.

Figure 8-8. (Un-)stable stool explained.

The idea was to incorporate the movement of splaying legs into some sort of seating, because it is something that is commonly feared when sitting on a chair, or at least a not very solid chair; you fear that its legs will come loose and the seat will collapse to the ground. In addition, this could create a type of surprise that is entirely physical and tactile, thus creating a strong gut reaction in the user, and also quite a fast timing, which will help to reinforce the strong gut reaction.

The question was what type of seating was most appropriate for this purpose. The first experiments and models were carried out with a traditional kitchen chair, but this type of object did not seem appropriate enough because it is usually fairly well built and reliable. Various types of seating were then analysed, and the most appropriate seemed to be the three-legged stool because, analysing its characteristics, it is clear that the essential one is that it should function as a seat. The additional connotation is its instability and liability to tip over or collapse.

This feeling of instability is reinforced at first sight with the proportions and the angles of the legs, reinforced again when someone sits on it as the stool starts to collapse, and then contradicted when the stool settles in a very stable position; the user is set out to expect something negative, and then this negative feeling is at first fully reinforced and then negated. What the user does not expect and will discover only through interaction is that the stool is actually usable and quite solid. In this way the surprise is delayed and it is turned into a pleasant surprise that adds an advantage to the object. Through the surprising element the object is transformed into something that functions better than the archetypal object.

The third object in the series and the one that is most different from the others is the Impolite Coffee Tables. These are three small square tables,

Figure 8-9. First chair model.

Figure 8-10. Windsor stool.

referencing the shape of nesting tables. They are smaller than each other, but the difference is not enough to make them nest, so they do not quite fit within one another. In addition, the surface of the tables has a pattern printed

Figure 8-11. Impolite coffee tables.

Figure 8-12. Nesting coffee tables.

on it in varnish, which is revealed when something is spilled on it and stains only the unvarnished wood. The pattern is different on the three tables but it connects at points when the tables are placed under each other at an angle.

The basis for this project is the contrast between the behaviour expected of people in situations where nesting coffee tables would be used and the behaviour of the tables themselves, as well as the behaviour that is forced on the user.

Nesting coffee tables are usually not used every day, but they are pulled out when receiving guests to have tea or coffee. They therefore belong in a situation which is particularly concerned with politeness, both on the part of the host and on the part of the guests. In this way, nesting coffee tables that refuse to go back to their place and nest are being very naughty, and the recognition of the contrast between these two behaviours is the first surprise.

If it were left at that however, the coffee tables would be fun the first time around but they would eventually become just an object that does not quite work. It becomes obvious that an extra step is required, later in time, which will create some sort of positive conclusion that negates the first surprise; it needs something that will indicate that the coffee tables do indeed go together, just in a different way.

The next step is to find a way in which the coffee tables will go together, which will only be discovered over time and through repeated use. In this sense, the pattern printed in varnish will allow bits of the table surface to get stained with the tea and coffee that will eventually get spilled on them. This action also reinforces the sense of impoliteness, since spilling coffee on a table is something that people usually excuse themselves for. In this way the abuse of the coffee table is turned into a positive addition, the spill is turned into the surface decoration.

The pattern that is revealed is based on a stylised floral pattern from Victorian lace doilies. This is because of the English nature of the situation and of the piece of furniture. Having people over for tea is a very traditional English activity, and the nesting coffee tables are also a local staple. In a sense, though, the nesting coffee tables represent a less desirable Englishness, since they are associated with lower-end shops; they are usually made of cheap materials and are badly assembled. The

fact that they are meant to be stored away inside each other also indicates
that they are not meant to be a decorative centrepiece in themselves.

Figure 8-13. Staining.

Figure 8-14. Impolite Coffee tables with pattern.

Figure 8-15. Impolite Coffee tables explained.

Once the pattern is revealed, it becomes clear that the pattern follows through from one table to the other when the tables are in certain positions. This creates a playful interaction between the user and the tables because it encourages the user to move the tables around and see if they connect in different ways. This is therefore the second surprise and the most effective one because it is something that users will discover on their own, and because it explains, after a long delay of use, the reason why the coffee tables do not nest and the way in which they actually go together. In this sense this second surprise is much more powerful because it has a longer build-up time, which makes the discovery more surprising and ultimately more satisfying.

Each one of the three designs therefore uses different types of surprises and different types of timing to create the story of the user's interaction. The (Un-)Stable Stool is an immediate physical surprise which demands a whole body gut reaction; the initial fear with the object (that the stool will not support your weight) is strongly reinforced, but within a moment also negated. This creates a fast, punchy, and highly physical and emotional surprise. The On-Edge Lamp uses a type of surprise based both on sense

and cultural expectations; it will not have as strong and as sudden a reaction from the user, but it plays with a more satisfying, longer narrative, which in the end reveals that the joke is about the user's learned reactions. The Impolite Coffee Tables have the longest timing, and also the surprise which is most based on reason and cultural convention; the surprise is not sudden at all, but it slowly builds up over time to a moment of realisation which may be well in the future of the first encounter, and which is fully based on the user's cultural expectations rather than senses and gut reactions.

6. Visual representations and testing

The designs were only tested at exhibitions, through informal observation of the public: how people approached the objects and how they reacted. This was done both by observing from a distance and noting the user's facial expressions and what they said to people that were with them, and by interacting with the public directly, encouraging them to use the objects. During one of the exhibitions, viewers were also encouraged to leave written feedback. This is by no means an exact way of testing the designs, but it achieves the goal of informing the designer about the success of the pieces, giving an idea about the way in which the pieces were received by the public as well as whether the designs had transmitted the intended emotions to the viewers and users.

The designs were presented in a gallery environment, so it was important to provide some context for the objects, which at first sight would not attract the viewer's attention enough to spend time interacting with them. Because of this, to describe the context for the designs and to explain the projects in an immediately understandable graphic way three characters were created, which represent the scenarios that the objects live in. These characters are meant to be stereotyped exaggerations to underline the type of feeling created by the objects. They are also meant to resemble comic book characters, sending a message that the images should be read as a sequence in time, a narrative, and also that the whole project should be read in a playful and humorous key.

Figure 8-16. On-edge lamp with housewife character.

Figure 8-17. (Un-) stable stool with engineer character.

Figure 8-18. Impolite coffee tables with English granny character.

These characters are useful to present the designs in a gallery environment, where it is necessary to quickly present the objects visually. Though they do work on stereotypes and might be seen to make the project shallow, they also help explain the playful mood of the series. When the objects were shown at three exhibitions, two within the University of the Arts and one during the London Design Week, people were usually drawn to the images first, since the objects themselves looked very common. From the images, the audience would then understand that they were meant to interact with the object, and that the object was intended to be approached in a light-hearted and humorous way. This was clear by the fact that most people would glance at the objects first, without really noticing them, then they would look up to the images, take a moment to take them in, and smile or exchange comments with people around them. Only after that, still smiling, would they approach the objects, usually touching the lamp lightly to check the material, and sometimes interacting more vigorously with all the pieces. When the exhibition space was supervised and the members of the public could speak to someone they would often enthusiastically ask if they could try the stool, but they would not usually attempt it without asking first. The visual representations were therefore at least partially successful in explaining

the project at first sight, and in interesting the audience in taking a second look or actually interacting with the pieces.

This visual representation probably helped with people's perceptions of the objects as well: with this series there is a risk that users will dismiss the objects as being annoying or not intuitive enough to use. If approached in a traditional functional design way, then users might say that the stool is dangerous, that really the tables take up too much room, and that the lamp is counterintuitive to use. The humorous setting helps explain the aims of the project while putting people in the right frame of mind to approach the objects. When the objects were shown in this setting, they did achieve the aim of producing a pleasant surprise with the users who were at the exhibitions. The first surprise would happen when they would look at the object first and then at the images: most people's expression would change from one of disinterest or minor interest into smiles of mild amusement; if they were in a group they would often talk animatedly about the objects or call the rest of the group over to show them the objects. The interactions with the object were mostly very timid when there was not anyone encouraging more interaction in person, but this is probably to attribute to the gallery setting more than anything else, since people are conditioned in galleries not to touch the work. When people did interact more directly and physically with the objects, their level of amusement/enjoyment seemed to be a lot higher than simply watching, for example people would often laugh when using the stool, as well as enthusiastically encourage their friends to try it. It was also possible to see when, within the course of the interaction, the users would display more signs of interest, peaked curiosity and amusement, and these moments seemed to coincide fairly well with the intended outcome: for example, people would experience two moments of peaked interest/amusement when interacting with the lamp, once when touching it for the first time, and once when trying to move it onto the table. This also provided anecdotal proof that even though the audience was pre-warned of the surprise by the images, they still reacted strongly to the interaction.

7. Conclusions

Timing is essential in storytelling and in all sorts of narrative media and it is integral in surprise. It is therefore essential to understand how this technique helps to create the timing of the surprising experience. To create the right sense of timing it is important that several things happen in sequence during the interaction with the objects and that the surprise is not

the one expected at first sight but one subsequent to that. The slightly odd shapes or details of the objects will attract the attention of the user and invite the user to interact with them. In this sense the objects do not necessarily set themselves out to look like they are perfect archetypes, but they set the user off track as to what is actually in store.

The lamp is sitting on the edge of the table, so the user will go up to it and touch it and discover that it is made of rubber. The user will then move it onto the table, causing the lamp to turn off, and they will eventually place it on the edge again. The surprise is therefore not in the discovery that the lamp is made of rubber, but in the understanding of the reason why the lamp is made of rubber. In this way the user is being surprised in a moment and in a way that she did not expect, and she will feel like she understood the object and she is the protagonists of this particular narrative.

In the same way the stool sets the user off in a direction that is not wrong, but lacks the conclusion. When first seeing the stool, because of its proportions and construction the user will fear that the stool will collapse. What the user does not expect and will discover only through interaction is that the stool is actually usable and quite solid. In this way the surprise is delayed and it is turned into a pleasant surprise that adds an advantage to the object.

The same type of three-step timing is applied to the coffee tables, though the experience is prolonged. The tables start as something quite plain and not really functional, but prolonged use reveals the pattern, which is surprising in itself but also helps make sense of the function of the whole object.

In addition to timing, the presented technique helps the designer to direct the object towards the specific type of surprise or reaction that is intended in the object: depending on what characteristics of the original archetype are chosen to be opposed, the designer can then control what type of emotional reactions are being generated in the user, whether these will be mainly based on physical qualities that require a physical discovery, sense qualities that require the user to explore the objects with different senses, or cultural qualities that require the user to question their own expectations about objects and how they have acquired such expectations. In this way the designer is not only in control of the fact that the user will be surprised by the object, but will be able to decide how and when the

user will be surprised, what type of emotions this surprise will reinforce, and how these will be remembered as a story by the user.

By studying how the user will interact with the object in terms of narrative and what the process of discovery will be, the designer places herself in the role of "director" of the user's own experience. We cannot control everything about the user's experience with our objects once they are out in the world, but studying the basics of emotions and narrative can help designers understand what clues can be used to trigger specific reactions, and therefore better direct the user's experience.

Works Cited

Abott, H.P. (2002). *The Cambridge Introduction to Narrative.* Cambridge University Press, Cambridge.

Baudrillard, J. (1996). *The System of Objects.* Verso, London.

Damasio, A. (1999). *The Feeling of What Happens: Body and Emotion in the Making of Consciousness.* Harvest Book, Harcourt, Inc., San Diego, New York, London.

Darwin, C. (1934). *The Expression of Emotions in Man and Animal.* Watts & co., London.

Dunne, A. (1999). *Hertzian Tales: Electronic Products, Aesthetic Experience and Critical Design.* RCA CRD Research Publications. London.

Ekman, P. (1984). Expression and the Nature of Emotion. In Ekman, P. and Scherer, K.R. (Eds.), *Approaches to Emotion.* Lawrence Erlbaum Associates, Hillsdale N.J., London.

Ludden, G.D.S. et al., (2004). Surprises Elicited by Products Incorporating Visual-Tactual Incongruities. *Fourth International Conference on Design and Emotion,* METU (Middle East Technical University), Istanbul, Turkey, 2004.

CHAPTER NINE

MAGIC AS A PHENOMENOLOGICAL TOOL FOR DESIGNING TECHNOLOGY

CRIS DE GROOT AND BENJAMIN HUGHES

1. Introduction

Magic as an encompassing worldview and cultural norm has been effectively combated or restrained by organized religion, industry and modernity, in almost every corner of the world. Yet it seems as if, in conjunction with the widespread of microelectronic information and communication devices, magical beliefs, perceptions and the subsequent behaviours and languaging of magic are forging a reappearance on the cultural and social stage of twenty first century life. Indeed, technological paradigms such as *augmented reality* and *ubiquitous computing* throw into sharp relief the potential for animating whole categories of artefacts that were once purely reactive and mechanical. This embedding of computing and information power into the fabric of everyday existence has the potential for incubating new experiential and behavioural norms. As George Dyson puts it, *"everywhere we look things are turning out to be more intelligent and more alive than they once seemed"*. (Dyson 1997)

We participate fully in this dramatically changing milieu of devices. The previous arguments from the canon of modernity which characterise the creep of technology into everyday life as "disenchanting" and "dehumanising" (Weber 1958) are countered by contemporary theorists such as Lash and Knorr Cetina, who instead promote the idea that human nature is adaptable enough to participate and survive, though the consequences are emergent. As Lash (2001) states:

> I cannot achieve sociality apart from my machine interface. I cannot achieve sociality in the absence of technological systems, apart from my interface with communication and transportation machines.

As products from the perspectives of modernity and technoscience, the advance of artefacts capable of enacting logic and simulating or conducting communication between and with humans should have had further sobering and becalming effect. From within the perspective of modernism, the reverse now seems to becoming the case. *"Every advance in technical rationality today is surpassed by a decline in common sense and a growing irrationality, the signs of which are everywhere"* (Stivers 2001). Such signs being a diversity of beliefs, behaviours, and a growing disconnect between the products of modern technology and the cultural forms that brought it about.

Discussions or dialogues that attempt to involve the concept of magic are beset by the problem of lacking a common or principle definition of the word and concept in question. In this study we refer to the eminent anthropologist Marcel Mauss (2001) and his observation that although the actions, aims and objects of magic differ widely–

> …they share one feature in that their immediate and essential effect is to modify a given state. The magician, therefore, knows full well that his magic is consequently the same. He is always conscious that magic is the art of changing–the Maya as the Hindus call it.

While the definition of magic as "the art of changing" seems too prosaic, too everyday for what feels like a special and spectacular word, we must attempt to engage with it without the cultural filters and assumptions that generate preconceptions and instead look at where it lives, what it does, what its effects are, and ultimately, how can design engage with this phenomenon purposefully and with clarity. As the interface design pioneer Bruce Tognazzini states, with regard to magicians, as designers *"we have much to learn from them"*. (Tognazzini 1993)

2. Imaginative participants and elusive objects

Contrary to popular opinion, when Arthur C. Clarke (1973) wrote the famous phrase (his third law), that *"any sufficiently advanced technology is indistinguishable from magic"*, he was commenting on the nature of predicting the future and how imagination was a critical ingredient, as opposed to the actual magicality of new technologies from the laboratory. However, in an era where devices are becoming increasingly miniaturised and complex, the popular intuition is holding more validity. The important point here is that Clarke's original intent behind the statement still resonates, in that imagination is required for consumers to overcome the

limitations of everyday knowledge in the face of a landscape of devices whose characteristics are an ever accelerating dematerialisation and are becoming increasingly responsive and "intelligent".

Historically, the elaboration of science and technology has succeeded best when the popular imagination has been invited to engage with the spectacle of entertaining public lectures and magic shows.

> Nineteenth-century popular science not only inherited its instruments from natural magic but also a tradition of public performance that subordinated the visual articulation of instruction and amusement to the intensification of aesthetic effect. Therein lay the secret to turning science into entertainment (Pierson 2002).

It is the authors proposition that design can utilise magic to turn consumers into "prosumers" or at least participants in the construction of technologically mediated meaning, as enhancing the process of "becoming" in a complex world. Design as supporting that process of a magically enriched "becoming" through the provision of appropriate props, tools, and routines (or rituals).

Technology makes its presence felt in the market and through marketing. As Bruce Sterling reminds us, technological effects and its corollary, effective intervention, occur in social relations and through the performance of those relations through technology. *"Effective intervention takes place not in the human, not in the object, but in the realm of the technosocial"* (Sterling 2005). It is therefore interesting to note that much of design research on the ethics and experiences of technological design is centred on the artefact and the design. The artefact is a site of "production" and performance.

Writing on sociology of technology, Knorr Cetina (1999) echoes Sterling:

> ...authors pay scant attention to the nature of knowledge processes and knowledge cultures, and they tend to see knowledge as an intellectual or technological product rather than as a production context in its own right.

This location of the production of meaning and of politics leaves research and analysis initially with the difficulty of identifying the object of its attention. People cannot speak easily or sensibly of their relations *through* things, particularly if the dimensions under enquiry are potentially

outside the conventions of what it is to be rational and of the mainstream culture or production and consumption.

Writing on the industry and culture of special effects in film, Michelle Pierson illuminates the active role played by enculturated and experienced cinema-goers.

> Within a discourse of effects connoisseurship, the experience of wonder depends on knowing enough to be surprised. Wonder, in this sense, is taking delight in having one's expectations met. Or, to turn this proposition around, connoisseurship expresses desire for the experience of wonder as a demand (Pierson 2002).

While not deflecting the immediate impasse of the invisible object of our research, Pierson is suggesting that consumers are active participants in the "spectacular", which is similar to how magic works on stage and in the everyday. You have to participate to be entertained and to derive meaning form the experience.

Rather than interrogate subjects as to their fetishisation of technology or their magically oriented imaginations in connection with devices and gizmos, this research has conducted itself through the methodology of phenomenology in order to uncover what is otherwise elusive to talk about. Lash expresses the potential of this method when he writes:

> …phenomenological inquiry makes sense of the world less though "intellection", but rather through what Husserl and Bergson called "intuition". We have knowledge, not through the abstraction of judgment, but through the immediacy of experience. Intuition is more bodily and organic than intellection; experience more life-like (Erlebnis in German) than judgment (Lash 2001).

It is at this level of intuition, of pre-rationality that we anticipate finding evidence of magic in twenty-first century human-device relationships.

3. Design as enabling 'showmanship'

The application of magic affords a process of *transformation* in one form or another. This might be the transmutation from one material into another, the translation from one place to another. This links it very closely to ideas of manufacture and commerce; the monetary gain through changing one thing into another. The judicious application of land, labour

and capital turns raw material into something to be traded at a price. In an age of over-abundance, mass-communication and market freedom, the end-product needs to squeeze as much out of the process as possible in order to turn a profit. This is where a touch of magic comes in handy. Judith Williamson in her book *Decoding Advertisements* tells us that *"Magic is the production of results disproportionate to the effort put in (a transformation of power–or of impotence into power)"*, but also that *"all consumer products offer magic, and all advertisements are spells"*. Design and marketing are clearly central to this transformation, and only in performing this magic are they useful to the system. Our magician is in his element as he describes the benefits of his patent cure to an enthralled audience, who gasp when his stooge makes a miraculous recovery. As the audience for these tricks becomes more and more sophisticated, so, too do the performers, but it reaches a limit at which each knows as much as each other.

In their book, *The Experience Economy*, Joseph Pine and James Gilmore (1999) argue that this is the point at which a mature market gives way to a more efficient model. In this case, it becomes related to experiences, rather than objects and the "thing" being consumed is the memory of the experience. In many cases these are unscrupulously augmented through the sale of signifiers of the experience, souvenirs. Whether glossy programmes, replica football shirts or Star Wars toys, these have long benefited from their status as the perfect product: they have a captive market at mass events, they can be marketed at gigantic mark-up, and they can be altered ad-infinitum to generate repeat sales. As the shift towards an economy based on experience takes place, it will have to be the experience itself that makes the money, not the merchandise.

In terms of the magician, our performer has now given up trying to sell us his snake oil or magic beans, he has ditched the product and is putting on a show for us. He even invites us up on stage to pick a card or help cut the assistant in half.

At some point, though, we grow tired of the monotony of the tricks being performed. This is when we take to the stage ourselves. Rather than being passive observers, we rise to the challenge of performance ourselves. In some areas of design practice, this phenomenon can be observed. Taking the notion that products are "props" for a lived experience, there are starting to emerge from some schools and consultancies props that challenge the user, rather than pander to stereotypical, and commonly

aspired to, lifestyles. The work of Tony Dunne, Fiona Raby and Noam Toran, for instance, is hard to relate to popular notions of commercial design. Dunne and Raby (2001) suggest the link between their work and the genre of film noir. Toran has gone as far as actually making the films, casting himself in the role of the protagonist and using of props he has designed along the way. All this work has had its imitators, and is becoming common currency in design criticism. There is nothing much that mirrors this in the marketplace however. Perhaps the idea of these products is too much. Certainly they do not work as one would expect. They are not "products" at all in the normal sense that you go out and buy them, take them home and "use" them. They are objects that take on an identity of their own and demand that the user interpret them. In terms of "use" value, they are more closely related to art, but they *look* like furniture.

Perhaps this is the realm in which we are beginning to witness a maturing of the economic value of these things–towards *transformation*. In the eyes of Pine and Gilmore, this manifests itself in educational and "improving" experiences, such as taking a class in martial arts, visiting a museum, or even eating Benecol (a cholesterol-reducing spread). In these cases, they argue, the "*customer becomes the product*". In this sense, the objects created by Dunne and Raby could be seen to fit the mould. The transformation, however, rather than being a commonly recognised goal, is toward an existentialist consideration and re-negotiation of the *use* of these objects. At the same time, the user is learning new modes of interaction with their surroundings, and, potentially, learning not to take them for granted. This is not an isolated practice. It seems to link with the prevalence of an ad-hoc approach to design that has gained popularity in recent years, particularly amongst emerging young designers. This reflects an increasing dissatisfaction with prevalent models of design which, despite a new-found freedom in terms of form, material and technology, do little to question or challenge the notion that serial consumption is good. In that sense, truly novel forms of design practice tend to emerge from outside conventions of the discipline.

4. An initial phenomenology of magic in designed devices

An initial analysis of existing contemporary technological devices and "gizmos" was conducted in both United Kingdom and New Zealand, of over

Figure 9-1. Selection of artefacts in initial phenomenological analyses.

one hundred and fifty artefacts, a selection of which are illustrated in Figure 9-1. These two phenomenological analyses of technological devices raised a variety of variant and invariant forms that, upon interpretation, were contributing factors to either or both the performer and the audience.

After contrasting the two studies, the eight factors that were agreed upon have been grouped under four basic headings:

1. **Presence**: (dis)appearance/(in)visibility.

 Appearance and disappearance refer here to the capacity of the device being manipulated by the performer to enter and exit the sensible field of the spectator. Visibility and invisibility on the other hand, refer to the persistence of the artefact and its field of effect in the sensible field of the audience.

2. **Control**: responsiveness to input/unique input.

 Control here is not about the ability to exert dominion over the physical artefact itself, rather the manner in which control over the device's function, capacity or power is negotiated by the performer. Therefore, a device's responsiveness to a users input can fall either side of "normal" responsiveness, i.e., being predictive or anticipatory on the one hand, and responding in a truculent or disobedient manner on the other.

3. **Causation**: action over time and distance/control of 3^{rd} objects.

 Action over distance is a familiar category of when discussing magical or enchanting technologies as it vividly extends human agency by non-physical means. Within the scope of this project, the extension of action, or more specifically causation, is over both time and space. In a similar manner to the experience of collapsing

and expanding space via the use of mobile phones and remote controls, time is also compressed or stretched out via the deployment of mediating technologies such as video recorders and answering services.

4. **Communication**: (in)constant/(in)comprehendability.

The type of communication referred to here is the sonic, visual, and kinetic produced by both the performer and the artefact in question during a performance. Whilst most performances are accompanied by a verbal narrative or "patter", it is particularly the non-linguistic information that interests the designer. The communication between the device and the user, and between the device or the user to the spectators.

The constancy and rhythm of the communication imparts the sense of conversationality, whether or not such a relationship is actually present. Such conversations are not in themselves necessarily entered into, rather they are the sensible features of awareness of one or more others, an alteric awareness that may or may not be welcome.

The comprehendability also contributes to the sense of an awareness and helps define the nature or character of the intelligence that is being aware. We do not necessarily need to understand the content of a communication to know that it directed, potentially, at us.

5. Design experiments

Following the phenomenological analysis of contemporary technological devices, the unfolding of experiential features of "magicality" in and through technology, the research turned toward stimulating possible magical experience through design experiment. That is to say that by stretching the designed reality of artefacts toward enabling magical performativity a set of "phenomenological probes" could be established to begin unfolding future potential. Not so much drawing parallels between *design* and *magic*, but more precisely using *design* to understand more fully the new form magic may be taking in daily life, and in turn how design can actively participate in this phenomena.

In order to begin unfolding the potential for magic through design, workshops have been conducted in the United Kingdom and New Zealand with a total of 41 undergraduate and postgraduate design students. These workshops were short, concept focussed affairs which employed the four-

Figure 9-2. Generated designs that could enable the "magical".

pair framework illustrated previously as the entry point. Working with the four-pairs relationship, students were encouraged to design objects as interfaces and imbue them with properties that could enable the "magical". The domains within which this phase of the work took place were fairly typical product arenas, such that departures or differences from normative practice could be easily identified, they were: "kitchen white ware" and "signage". The outputs were varied in their creative range, they were all however generating novel and atypical aspects of interaction with and through technology. Several of the designs are illustrated in Figure 9-2.

The designed outputs were taken to a second stage of analysis, whereby the artefacts themselves were phenomenologically described, reinforcing the four pairs of principles previously stated, and the performances that the designers enacted were recorded and analysed as participative scenarios in the manner described by Iacucci et al. (2000). The method used here was a derivative of role-playing based design scenarios, supported by the adoption of appropriate personae developed from a wide variety of first-hand and online data. The difference here being that the performance was conducted by the artefact's designer, aiming to "perform" in front of other designers who were participating as people in social circumstances do. This method certainly claims no high position under objective criteria, it does however bring out the embodied performer in the designer, externalising a role that in itself is often "masked" or suppressed.

6. Development of a methodological tool for magic through design

The data from both the second phenomenological analysis and the participative scenarios have been contrasted and combined with the writings and theoretical frameworks offered by Tognazzini (1993) and Mauss (2001). The resultant method is a set of three distinct categories of dimensions, which in turn host three principal characteristics which designers can pay consideration to when attempting to engage with and generate magical experiences and performances in and through technological devices. What follows are the three main dimensions and their constituent characteristics.

1. **Perception**: Illusion–Misdirection–Continuity.

 These are the basic psychological principles of performative magic, the primary techniques whereby magic is generated. This is where we find the transformative powers of magic used to deceive an audience, forcing them to witness the magical properties of mundane objects. More often than not these properties are stimulated into action, harnessed if you will, by the performer.

 Illusion is the single largest factor represented here. It encompasses simulation, dissimulation, disguise, metaphor, etcetera. The main purpose of illusion is to make something appear what it is not, to create a new reality and set of meanings for the user, often known in design as creating the "user-illusion" (Tognazzini 1993; Kay). Misdirection is where the recipient's attention is diverted from the "real action" or mechanism of magic so that the secret (spectacular or banal) is not revealed. Continuity is the principle of maintaining a fluid experience for the benefit of keeping the continued attention of the audience, that the actions, words and devices employed are aligned with the everyday and with the character of the performer.

2. **Magic**: Contiguity–Similarity–Opposition.

 Here the magic itself is the commodity. The performance and transformation is provided both for our diversion and entertainment, and contributes to a symbolic web of meanings that support or enable the act of believing the magic. This is difficult territory for industrial design as it is promoting an irrational and post-modern perspective on transparency and understanding.

 According to Mauss, examining the practice of magic into which the audience and the performer are participating with the beliefs (as well as their bodies), "*It is possible to extract three principal laws. They could in fact all come under the heading of laws of sympathy,*

if antipathy is also covered by the notion of sympathy. These are the laws of contiguity, similarity and opposition: things in contact are and remain the same–like produces like–opposites work on opposites" (Mauss 2001).

3. **Narrative**: Expectation–Surprise–Explanation.

 Here "time", the sequential narrative or schema or delivering *or* receiving magic.

 In this plane, the audience have taken over, co-opting the role of the magician in the interpretation and creation of their own narrative. This is hard to spot, but in some areas of society it is well ensconced. Pod-casting, modding (of automobiles), mass-customisation all fit this mould and see the consumer or the spectator in the place of the designer. The designer's role has now become filled by the owner/user/performer.

 Expectation refers to the anticipation the audience builds as the performances begin. Referring again to the work by Pierson (2002), the network of consumers or users is a network of connoisseurs, each holding a differing degree of prior knowledge, which in turn defines their level of expectation to be met and, possibly, exceeded. Surprise is the moment of catalysis in magically oriented performances and experiences. The audience is "won over" or seduced, it is in effect the punch-line or moment of revealing the dissonant outcome of the, previously ordinary sequence of events. Surprise here is a generic term that acts as a category for other sensations such as "shock", "delight", "disquiet" and notions connected to the uncanny or to humour.

 The final stage in this temporal narrative is that of explanation. Explanation occurs when the outcome of the performance that was initially dissonant or oblique to the cognitive model the spectator had held with regard to the logic of actions being performed is afterwards assimilated and a new mental model constructed, regardless of whether that model is correct or incorrect.

The three dimensional matrix presented in Figure 9-3 is the authors integration of the aforementioned three categories and their individual components into a single, practical tool.

Figure 9-3. The tool, integrating the three categories and their individual components.

7. Application

This model presents three contrastable domains, each with three components. It is possible to approach the application of this model in two basic ways. As an exploratory technique (whether exploring a new technology, or exploring the tool itself for the first time) the whole grid of the model can be systematically trailed, one square at a time. And since there are only 27 squares, this is not a Herculean task. The outcomes of this are typically an revealing of first order ideas, and the unfolding of preconceptions or recycled ideas that required articulation to be properly identified and avoided. The second way to utilize the model is to work through possible scenarios of use, thereby employing the narrative axis as the constant or driving dimension of the model. Against the different narrative phases in the context of a particular scenario, the purpose for manipulating perception can become manifestly clear, thereby enabling the domain of magic to be employed last of all. However, the magical axis is not to be thought of as a technical or tactical means. It too can drive experience design if tangible elements present themselves as available for

immediate deployment (e.g., polarized magnets/similarly styled or coloured switchgear/separate objects that work in a contiguous system).

The initial model (presence/control/causation/communication) is best used for the initial analysis or decomposition of existing artefacts and technologies. It is essentially a descriptive tool, a feature list of experiential forms (i.e., design tactics). This is also useful for supporting the ideation and designing of appropriate embodied and interactive details in the service of magical narrative and experience design.

8. Conclusion

The approach that this paper takes enables is exploratory in principle. The design experiments undertaken developed an initial methodology and proposed a second, more complex method or table by which to analyse and generate designs that engage with user experiences in the domain of special effects and showmanship. These methods begin to elaborate upon phenomena that fall outside of traditional, positivist forms of design technique, leading us into a space where design can acknowledge and authentically leverage the space between perception and comprehension.

This research is by no means exhaustive in either the range of artefacts explored and designed, or the variety of research perspectives taken up to view the phenomena through. It is an initial start into developing methods and practices by which designers may begin to consciously engage with the emerging landscape of networked, immaterial, and intelligent devices in ways that belong to a post-optimal and possibly post-rational future. Ultimately, if through using tools such as these designers can increase the felt sense of wonder in the world, to reconnect people with the affect of delight and curiosity, then these tools have positive outcomes.

Works Cited

Dunne, T. and Raby, F. (2001). *Design Noir, The Secret Life of Electronic Products*. London: August.

Dyson, G. (1997). *Darwin Among the Machines*. London: Penguin.

Iacucci, G., Kuutti, K. and Ranta, M. (2000). On the move with a magic thing: role-playing in concept design of mobile devices and services. In Boyarski, D. and Kellogg, W. (Eds.), *Proceedings of the conference on Designing interactive systems*. New York: ACM Press, (193-202).

Knorr Cetina, K. (1999). *Epistemic Cultures*. Cambridge, MA. Harvard University Press.

Lash, S. (2001). Technological forms of life. *Theory, Culture and Society* **18** (1): 105-120.

Mauss, M. (2001). *A General Theory of Magic.* London: Routledge.

Pierson, M. (2002). *Special Effects: still in search of wonder.* New York: Columbia University Press.

Pine, B.J. and Gilmore, J.H. (1999). *The Experience Economy–Work is Theatre and Every Business a Stage.* Boston: Harvard Business School Press.

Sterling, B. (2005). *Shaping Things, Mediawork.* Cambridge, Massachusetts: MIT Press.

Stivers, R. (2001). *Technology as Magic: the triumph of the irrational.* New York: Continuum.

Tognazzini, B. (1993). Principles, techniques, and ethics of stage magic and their application to human interface design. In Arnold, B., van de Veer, G. and White, T. (Eds.), *Proceedings of the SIGCHI conference on Human factors in computing systems.* New York: ACM Press.

Toran, N. (2001). ... In: Dunne, A. and Raby, F., *Design Noir: The Secret Life of Electronic Objects.* Berlin: Birkhäuser.

Weber, M. (1958). Science as a Vocation. In Gerth, H. and Mills, C.W. (Eds.), *From Max Weber.* New York: Oxford University Press.

Williamson, J. (1994). *Decoding Advertisements–Ideology and Meaning in Advertising.* London: Boyars.

CHAPTER TEN

DESIGN AND SCENT

BENJAMIN HUGHES AND JENNY TILLOTSON

1. Introduction

Scent provides an important, but poorly understood, component of our perception of our surroundings. It is clear that while many human scent responses to do with danger are universal, or instinctive, others, particularly pleasurable aromas, are linked to memories, which are highly specific and individual. What these responses have in common above all else is their *emotional* component. Along with every other living organism, our ability to detect chemical changes to our environment is extremely important. This may enable us to avoid poisonous, diseased or decaying sources of food, but equally may help us locate a genetically compatible mate (Vroon et al. 1997). The most easily identifiable and universally replicated responses are linked to survival, and have been shown to be "hard-wired" to some of the oldest (in evolutionary terms) parts of the brain, but this limbic system, or area, is also that most closely associated with the management of memory and emotion. Beyond this, the scientific understanding of human responses to scent stimulus remains extremely limited. Many studies have been undertaken, but the subjective nature of results makes the elimination of variation through control samples practically impossible.

There are specific areas in the brain where smell memories are received and stored. Smell information goes from the olfactory bulb to centres of the brain that handle strong emotions like aggression, fear and sexual arousal. This centre also plays a significant role in selecting and transmitting information between our short-and long-term memories, evoking memories from the past. Smells arouse emotions of sadness, loss, love, disgust, longing and passion, buried deep in our sub-conscious. Only a few molecules from an odour are required to convey a message to the

brain, creating a smell image. This can come from a flower, a memory or place, a person, or time, an olfactive evocation, or alternatively an aggression alarm or warning signal of danger. For artists and designers this powerful sense gives rise to an equally powerful medium of expression.

Whilst the incorporation of scent technology has suffered from numerous set-backs, from early gimmicks such as Smell-o-Vision of the early 1960s to the collapse of Digiscents in 2001, designers have started to take on the task of translating this technology for a consumer audience. Whilst Disney continues to "imagineer" additional sensory forms to its theme park rides, and supermarkets and shopping malls continue to pump out odours approximating to freshly-ground coffee or freshly-baked bread to its customers, there remains a question mark over the physical form, and mode of interaction this technology may take in the near future.

2. Uses of scent

The ways scent is used as a "tool", or "cue" in everyday life reflects this biological background. Scent is often added to harmful odour-free gases in order to warn users of leaks. We also use scent to repel insects such as mosquitoes and midges. Scent is used to mask the unpleasant odours present in cleaning products, and is intended to enhance the overall sense of "cleanliness" following a cleaning process. On our bodies and clothes, scent is used to mask malodour created by bacteria that linger even after washing, as well as enhancing the way we appear to others. In work, retail, entertainment and shopping environments, scent is used to elevate mood, increase concentration, or attract attention to particular products. Clearly these scents are not applied at random. They are concocted by experts in close consultation at every stage with potential consumers to determine their appeal. This is the extension of the perfumer's art in the age of marketing for mass-production, where scent is subject to changes in taste in the same way as fashion, interiors and all other areas of design.

3. Study of scent

The "serious" study of scent is a very recent phenomenon when compared to the practice of extracting, refining, mixing and selling scent products that is replicated across cultures and known civilizations since the Egyptians. These processes would be informed through an appreciation of aromatherapy, although this term was not coined until the 1920s (John et

al. 2003). It relates to the physical healing properties of essential oils, and their ability to relieve conditions such as headache, anxiety, bronchitis, indigestion and high blood pressure. There is some controversy surrounding the effectiveness of such therapies because of the inability to test in controlled environments–their mode of administration tends to include massage, breathing techniques and meditation, which might, on their own, be responsible for many of the effects. As such, and in common with other "alternative therapies" it has been difficult to assess their benefit using scientific tools. More recently, the area of aromachology has provided significant insight since its origins in the early 1990s (the term *aromachology* was coined in 1989 by the Sense of Smell Institute, formally the Olfactory Research Fund, a non-profit research arm of the fragrance industry). This area of research seeks to further the understanding of the role that fragrance plays in providing temporary, beneficial psychological mood enhancement. These studies employ metrics developed for psychological research to provide data that can help predict the emotional response to particular fragrances, both natural and synthetic. Studies have correlated links between autonomic nervous system responses (ANS), such as skin resistance, skin blood flow and instantaneous heart rate with an hedonic index of emotional responses, such as happiness, surprise, sadness, fear, disgust, anger (Vernet-Maury et al. 1999). Commercial organisations have developed their own tools to further aid in the process of developing new fragrances for particular applications (Warrenburg 1999).

4. Forms of delivery

As the means of measuring responses to individual scents becomes more sophisticated, so too are the means of administering, or dispensing the scent. New technology, in the form of novel materials, micro-fluidic delivery devices, nanotechnology and "lab-on-a-chip" style diagnostic and control electronics are allowing designers to completely re-interpret the way we experience and use scent in all areas of our lives. Since the 1960s innovations have paved the way for all sorts of experiments, but in general we still purchase perfume as a suspension in alcohol to be sprayed or dabbed on the skin, in the same way as every generation before us.

In fact, the most significant innovation in this area, the aerosol, is over 70 years old; this has allowed us to experience scent in deodorant and body sprays, hair sprays, air fresheners, breath fresheners, insect repellents and shaving foams, but their mode of operation and user-interaction has

changed very little. (It took a long time from the first patents filed by Norwegian Eric Andreas in the 1920s and 30s for the aerosol to be applied in the diverse forms we see today. The first commercial production was by the Oslo paint manufacturer Alf Bjerke. Later, during the war, aerosols were used in insect repellent and insecticide. It was not until 1950 that aerosols were used for air fresheners and in 1954 deodorants (which, along with body sprays, now account for the lion's share of production)). Much development has occurred in areas such as propellants, nozzle and cap design, canister shaping and printing, but the basic delivery method remains unpredictable, often wasteful, and occasionally harmful. Whilst other forms of scent delivery have appeared over the years, very little has penetrated the mainstream mass-market to compete with aerosols. This is largely due to considerable challenge of both capturing and then releasing the scent in appropriate concentrations, on demand. With a reliable, precise system for achieving this comes the possibility to employ scent in all sorts of novel applications.

Numerous promises were made in relation to products from the 1950s to the present day, but all suffered from one flaw or another. Many of these innovations were in relation to scent as part of an immersive entertainment experiences. The first of these dates back to the 1900s (the first use of scent at the movies was in 1906, when a cinema owner from Pennsylvania added the scent of roses to the Rose Bowl Football Team), but the first attempt to enter the mass-market came in the form of *Smell O Vision,* in 1960; *Scent Of Mystery,* starring Elizabeth Taylor was released in this medium. Cues to the identity of a murderer were given by aromas, relayed to each seat via a complex system of pipes. This had been preceded by *Aromarama* in 1959 and was followed by *Sensorama* (Rheingold 1991) in 1962. What these systems claimed to deliver, but which proved technically too demanding in each case, was the ability to reproduce olfactory stimulus at precise moments in sync with a film, or performance–in some cases, through the addition of a "smell-track", to sit alongside a soundtrack. This craze was ultimately damned as kitsch through films such as *Matinee* and John Waters' *Polyester*, the audience of which were provided with scratch'n'sniff cards to accompany on-screen cues. Sensory entertainment still endures in Disney and other theme parks around the world, but here the experience is more akin to a fairground ride than a cinema, and the films' content is more closely linked to the effects than any narrative. Whilst these developments have little to do with scent as it is understood in relation cosmetic or well-being applications, they clearly illustrate the complexity and pitfalls of working with novel control

mechanisms in this way. The form of delivery here generally relies on airbrush style technology, which is both complex and difficult to control.

Recent innovations which offer considerable improvements include solenoid-controlled perfume reservoirs, fan and/or heat assisted dispersal of scented wax/liquid/polymer, mechanized scratch and sniff elements, and inkjet micro-sprays. Numerous patents have been filed in each of these areas, and companies built upon their potential for development to market. Little has emerged, though, that might evolve into a credible standard, with the requisite versatility and robustness. This is due in part to the pace at which a reliable technology is being developed but may also have something to do with the way in which the technology has been interpreted from an interaction design perspective. It seems that design has not been considered as part of the development process, far less involved as a tool for developing worthwhile, compelling solutions. What the emergent technology offers is the ability to control scent in ways that are far more precise than previously imagined. This affords all sorts of possibilities in terms of application and interpretation and one that desperately needs the sensitivity of a design perspective to create appropriate solutions.

5. Design for scent

Several companies have created solutions for scent delivery, but with little success to date. Investors' hands were burned with the collapse of *Digiscents* in 2001 (Platt 1999; Abramson 2001), and despite a crowded field including Trisenx, Olfacom, Scentair, Procter and Gamble, Scent Communication, Aromajet and Aromasys, there are very few products on the horizon which seem to fully explore the emotional potential of the technology with an integrated approach to their design. What emerging technology has enabled is the complete re-interpretation of the mode of delivery and interaction with fragrances. Designers' work in this area has started to link the emotional component of the fragrance itself with the objects used to store and deliver it. Below are a number of projects that take a fresh look at how scent might be incorporated into products in the future. These involve individuals from several areas of practice including electronic engineering, fluid dynamics, aromachology, fashion, packaging and industrial design.

6. Scent Bubble

Figure 10-1. Scent Bubble by Dr Jenny Tillotson.

The Scent Bubble is an attempt to visualise how an individual might be able to fine-tune their immediate environment in order to achieve optimum benefit from a variety of scent stimuli. Precise delivery of tailored fragrances might be used throughout the day to, for instance: help one wake up in the morning; treat an allergy; concentrate at work; attract a potential partner; repel insects; or wind-down at the end of a day. This *Scentsory Design*® project presents a number of scenarios through which this might be achieved, including both wearable, functional accessories, and complete garments, which incorporate smart fabrics. These go beyond passive microencapsulated techniques by detecting physiological changes in the wearer's body via diagnostic transducers after which micro-fluidic pumps dispense beneficial chemicals in highly controlled doses. Research and collaboration with scientists working in the field has enabled the design and production of a number of devices that deal with extremely small volumes of liquid and can deliver very accurate fluid control, which might be described as "fragrances on a chip".

Figure 10-1 illustrates the concept of a garment that mimics the human body with its own "nervous system", allowing the user to effectively manage the functional "Scent Bubble" described. Embedded in the fabric is a network of micro-tubes resembling the body's own capillaries which pulse nano-litre size droplets of fragrance targeted to key points of the body, enabling the bubble to function with maximum accuracy and discretion. By linking a remote sensor with a fragrance-dispensing unit it is also possible to link items of clothing so that messages may be transmitted from one garment to the other, releasing scent in a localized area, enabling the user to act on visual cues or detect aromatic signals as "coded" messages. This affords immediate delivery of fragrance whose effects might be healing (e.g., lavender), protective (e.g., insect repellent) seductive (e.g., pheromones) or informative (e.g., burnt toast). In order to develop this concept further, and to visualise intermediate technologies that would afford some of the same effects, a number of accessories were designed and prototyped. The aim was to test not only the engineering principles involved, but also the potential of various modes of interaction with the technology from user perspective. This is where design becomes invaluable as a research tool to visualise, and interpret how technological objects might evolve. The first device, Figure 10-2, shows the electronics embedded in a shoulder bag. This allowed ample space for housing the batteries, control systems and fragrance, whilst dispensing the fragrance via a system of tubes, through the strap where it is needed to create the desired "scent bubble".

Figure 10-2. Fontenay Aux Roses 1 by Ben Hughes, demonstrated at Fashion in Motion show, CTIA Wireless Show, 2005.

This version incorporates three fragrance reservoirs, whose dispersal ratios could be adjusted in response to time, environmental or physiological changes. These principles were further refined and miniaturised to create a second device, "Fontenay aux Roses 2", Figure 10-3, a brooch with several

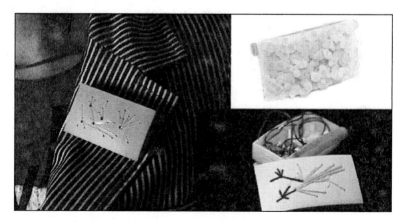

Figure 10-3. Fontenay Aux Roses 2 by Ben Hughes, 2005.

interchangeable covers to deliver fragrance at user-defined intervals, through an integrated button.

These devices explore and illustrate how the scent bubble might be achieved using inkjet micro-fluidic technology, and they give the chance for users and designers to test the process of interaction for real. In some ways, however, the design is compromised by the need to house the power supplies and delicate control circuitry. In reality, it is anticipated that these devices would deliver enhanced functionality in a smaller package so that their size could be reduced further.

7. NOKIA Scentsory phone concept

This project, by Kimberly Hu, a research student at Central Saint Martins, was undertaken as part of a collaboration with Nokia to look at future trends in mobile technologies from 2015 onwards. It is a novel mobile communication device that works through an integration of senses of smell, sight, hearing, and touch. It gives users the ability to experience remote communication on multi-sensory levels. In addition to including basic audio-visual features, it can detect, transmit and emit smells. It can also radiate colors, lighting, and temperature from the caller's environment. In addition, the device is described as having aromatherapy and owner-scent identification features. Not only does this provide a more comprehensive account of how fragrance might be incorporated into a communication device, but the design contains several subtle metaphorical cues relating to its function and mode of interaction. The phone has three modes of operation: the first, when the panels are flat, in portrait format, is for regular voice calls; the second, when the panels have been reconfigured so that the two LCD screens are alongside each other, is for text, email and video calls; the third mode, when the phone is folded between these two states, is for olfactory communication through interior scent detectors and

Figure 10-4. Three operational modes of Scentsory Phone by Kimberly Hu, 2006.

emitters. This form of "unfolding" and "layering" of technology develops the interface model, which has seen complex functions translated into physical configuration. This idea has been used extensively in the mobile phone sector to separate simple, common operations such as answering a call from sending a text message or taking a picture, by sliding, or folding the various elements of the handset. In this way, the phone styling and interaction becomes a clearer expression of its mode of use. This approach has been widely expressed in the branch of design known as *semantics* and came to the public's attention in the late 1980s through the "Phonebook Answering Machine" concept by Lisa Krohn, developed for her MFA at Cranbrook Design Academy. Kimberly Hu's mobile phone extends this metaphorical association into the universal "cupping" gesture that suggests holding a flower or glass of wine in order to magnify the scent sensation. This concept demonstrates that there is a role for the industrial designer in constructing meaningful interfaces and experiences with emerging technology such as this.

8. Sensaria and Ice Fizz

Figure 10-5. Sensaria perfume array by Nick Rhodes, 2002.

Figure 10-6. Ice Fizz perfume applicators by Nick Rhodes, 2002.

Nick Rhodes is a designer who has spent several years looking into the area of perfume brand and packaging both from a commercial and research perspective. His work has incorporated fragrance design and development commissions for brands including Puma, Mexx, Naomi Campbell, Strenesse, Chiemsee, Marc O'Polo, Cindy Crawford, Yardley and Bruno Banani. Through this work Rhodes is attempting to challenge what he regards as "*the narrow scope of expression permitted in the commercial realm which has stripped scent of its potency, its cultural and historical significance*". This interest led to the development of a series of speculative design work intended to provoke debate amongst both clients and the industry. "Sensaria" and "Ice-Fizz" are shown here as further examples of how designers are seeking to reinvigorate the objects used to package and apply scent. These are from a suite of projects initiated by Rhodes that interpret the process of application of scent in terms of a "ritual". In the first case (Sensaria), this relates to preparation rituals and the dressing table as domestic typology. The second example (Ice Fizz), is intended to explicitly link skin sensation and olfaction. The perfume is held in a water base as opposed to the conventional alcohol, which then melts, before evaporating, when coming into contact with the skin. Both examples make strong use of additional sensory cues in the application of the perfume and provoke a very different form of relationship between the user and the product. In each case it is desirable that the user makes and

spends time to savour the process, thereby creating space for novel forms of ritual.

This approach links the work to ideas that are held by many other packaging designers working at the forefront of the field; that to fully understand the relationship between users and packaging, one must develop an appreciation for enhanced experiential models of engagement. One consultancy that leads the way in "experiential branding" for packaging design is Tin Horse. Their aim to create *"big dreams for everyday things"*, has led to a sophisticated understanding of how people relate to products and packaging, and informs their phenomenological approach to design and innovation. Director Peter Booth describes how perceived product flaws, such as the viscosity and product flow of Guinness, have been turned into benefits, by linking the "delay" in product delivery, either in a glass or a can, to the completion of a process that enhances "quality". These ideas have also been employed by the company in relation to fragrance products both for commercial clients and for research. Booth describes the significance of ritual in this case in relation to activities which are either *sacred* and *profane.*

> If you consider the terminology for a moment, you start to realise that it is completely inappropriate. We talk about the "application" or "delivery" of perfume, which denies the potential to create beautiful objects. It leads, instead, to the design of "applicators" and "delivery systems", rather than something more poetic.

Current modes of engagement, therefore, are *profane* when mapped in relation to the *sacred* within the context of consumer culture (Belk et al. 1989). This suggests that a great deal can be gained through an understanding of anthropological readings of ritual. This is especially the case when looking at the marketing of fragrance products. These, more than any other, invite the designer to exploit their ephemeral, performative, personal and emotional characteristics.

9. Perfume Atomiser Fan

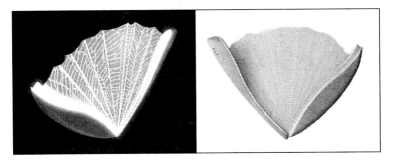

Figure 10-7. Perfume Atomiser Fan by Jason Morenikeji, 2004.

This project, by Jason Morenikeji, was undertaken in response to an invited brief to packaging innovation consultancies including PI3, a leader in this field. It was first shown at The Innovations Show at the Total Packaging exhibition at the NEC, Birmingham, where it won the Best in Show award. It is significant in relation to the other innovations shown, in that it is an extension of the gestural, and performative potential of perfume application, that is so little understood and explored in contemporary packaging design. The designer has taken insights from fields of research that deal with non-verbal communication, such as Kinesics in order to better understand the less-obvious psychological functions of perfume. This mode of interaction is reinforced throughout each part of the process: on opening, the device activates an electrostatic charge across its Power Paper "blade" and then, through a process of wafting back and forth, vaporization of the liquid perfume occurs. The intensity of the wafting action determines the strength, or localized concentration of the fragrance. Therefore, depending upon the users' intuitive control, the fan may be used to apply perfume to the body and clothing, or to create a soft aroma-therapeutic effect within the environment of, and to benefit, the user as a relaxation or mood-enhancing device. In addition, the fan may be used to create scent "messages" in the air as an aid to seduction rituals. This reinvention of the mode of interaction with fragrance was driven by the designer's observations of what he perceives to be a particularly stagnant market in terms of innovation:

> The industry demonstrates a breathtaking lack of innovative thinking. Given the number of blue chip companies who compete in this sector and the significant gross margins achievable, a clear opportunity exists for a

radical rethink of the product basics. Structural packaging can then move away from packs which are merely about the containment of a pleasant liquid which look great on a shop shelf and at home on a bathroom cabinet towards a total packaging solution which aims to deliver an engaging experience in terms of how, when, where and why it is applied. The scent industry needs to adopt a creative methodology which takes account of female rituals, experiences and the desire for self-expression, which are not being addressed with current perfume packaging.

How such methodologies might be introduced is hard to define. The whole business of marketing scent is based around a few very basic, but nevertheless successful formulae that manage to sustain consumer demand for over 9000 varieties at any one time. Although apparently every variation of vessel form has been employed by different brands in order to differentiate and enhance their product, there is little or no variation in the application method for each scent. To find anything out of the ordinary, we need to go to one of the most experimental perfume houses, Comme Des Garçons.

10. Comme des Garçons 2

"Comme des Garçons" has earned a reputation for challenging conventions in perfume design through the launch of a series of "Anti-Perfume" collections starting with *Odeur 53* in 1998. The *Synthetic* range from 2004 includes individual titles such as *"Garage"*, *"Dry Clean"* and *"Tar"*, which have proved surprisingly popular with scent connoisseurs. Whilst competing in a market dominated by floral, fruit and herbal scent descriptions, titles in their range garner such evocative descriptions as "electricity," "dust on a hot light bulb," "photocopier toner," "taste of a battery," "flash of metal," and "burnt rubber." The rest of the notoriously traditional perfume industry has been slow to catch on, though, and these perfumes have become collectible in their novelty and scarcity.

When they wanted to translate this avant-garde approach to perfume design to the whole experience of application, "Comme des Garçons" went to Spanish industrial designer, Ana Mir. Mir's work has always had close connections with the body and the senses, so this was an ideal partnership. She chose to create a *Visual Perfume* experience by mixing the scent with ink, which can then be applied with a special stamp. The result is a perfume that you can not only smell, but see. It is particularly fitting for this particular fragrance, "CDG2", one of whose variants was

designed with a strong note of ink (unusual in perfume design). Mir describes CDG 2 as:

> a very erotic perfume, but also intense, complex, sophisticated, very ambiguous and mysterious. For me the icon of the eye connects perfectly with those concepts related to the perfume.

The eye graphic is depicted inside the iconic bottle outline, which is then packaged like a conventional rubber stamp, with a twist-top. Unusually, given the amount of technical innovation involved in developing this product, it will only ever exist as a promotion, and no doubt highly sought-after. As to the way the user is supposed to interact with the product, the designer refuses to be prescriptive:

> I think you can play with it! and it could be either seen or unseen. The body has many parts, some very visible, other more hidden and intimate...I hope people will find unpredictable and interesting uses of the stamp...

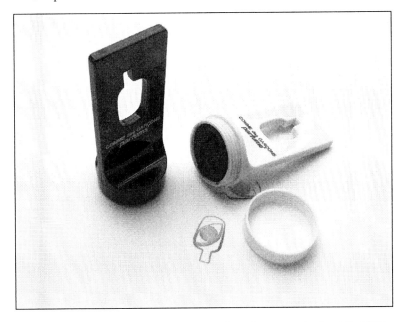

Figure 10-8. Comme Des Garçons *Visual Perfume Experience,* by Ana Mir, 2007.

11. Conclusions

Design for fragrance is an area where fashion, industrial and packaging designers can provide a great deal of insight and stimulus for market innovation. "Ritualised" evocative and "branded" modes of interaction with FMCG products are well established and understood by those at the forefront of packaging design, but these ideas have been very slow to emerge in the fragrance industry. This is partly due to the slow delivery of long-promised revolutionary technologies, but also through the lack of an outlet or impetus to develop the more challenging concepts. A combination of an increasingly experimental approach by perfume houses such as Comme des Garçons, together with a number of relevant technologies starting see the light of day means that we are starting to see the emergence of some exciting design proposals. Through these, we can see that the intelligent integration of these technologies into appropriate devices has the potential to completely re-invent users' relationship with their favourite scent. Deodorant and body sprays, which currently account for the most ubiquitous form of consumption of fragrance could become just part of a vast array of smart scent devices that will serve not only mask unpleasant odours, but may also repel insects, treat allergies, administer medicine, aid communication, augment entertainment experiences, aid concentration, enhance mood and help to manage emotional states.

Acknowledgements

The authors would like to thank Peter Booth, Ann Chui, Dr Gareth Jenkins, Kimberly Hu, Steve Kelsey, Prof. Andreas Manz, Ana Mir, Jason Morenikeji, Murray Tidmarsh, Nick Rhodes, Peter Wiktor.

Works Cited

Abramson, R. (2001). *Sniff-Company DigiScents is a scratch.* The Register 11 April 2001.

Belk, R.W., Wallendorf, M., and Sherry, J.F. (1989). The Sacred and Profane in Consumer Behavior: Theodicy on the Odyssey. *The Journal of Consumer Research*, Vol. 16.

John, T.V., Christensen, C. and Boyden, J. (2003). The Benefits of Fragrance Material. *Perfumer and Flavorist*, Vol. 28: 30-41.

Platt, C. (1999). You've Got Smell. *WIRED*.

Warrenburg, S. (1999). The Consumer Fragrance Thesaurus: Putting Consumer Insights into the Perfumer's Hands. *The Aroma-Chology Review*, Vol. **8**(2).

Vernet-Maury, E., Alaoui-Ismali, O., Dittmar, A., Delhomme, G., Chanel, J. (1999). Basic Emotions Induced by Odorants: A New Approach Based on Autonomic Pattern Results. *Journal of the Autonomic Nervous System*, 75: 176-183.

Vroon, P., van Amerongen, A. and de Vries, H.; translated from the Dutch by Vincent, P. (1997). *Smell–The Secret Seducer*. Farrar, Straus and Giroux, New York, New York.

CHAPTER ELEVEN

MATERIALS AFFECT–
THE ROLE OF MATERIALS
IN PRODUCT EXPERIENCE

ELVIN KARANA AND ILSE VAN KESTEREN

1. Introduction

A number of factors (such as form and function of the product, cultural background of the user, to name a few) can be influential on the experience of products. Several studies consider the effects of one or more of these aspects on product experience (e.g., Desmet 2002; Govers 2004; Van Rompay 2005). Unrelated to the other parameters of design–such as form, function and use–materials can be used by designers to establish the intended meanings and experiences. Hodgson and Harper (2004) state that materials considerations are pervasive in design as the substance through which designers' intentions are embodied. Likewise, Gant (2005) emphasizes that the strategic use of materials is one of the most influential ways through which designers can engender deeper, more emotive connections between their products and their users. Hence, an effective materials selection process can help to embody the desired emotions in a product. Many scholars in the field agree on the significant role of materials in creating meanings and values (Arabe 2004; Conran 2005; Cupchik 1999; Ferrante et al. 2000; Gant 2005; Karana 2006; Karana et al. 2007; Lefteri 2001, 2005; Ljungberg et al. 2003; Macdonald 2001; Mcdonagh et al. 2002; Rognoli et al. 2004; Zuo et al. 2005).

Several studies and examples can be found that investigate the relationship between materials and users of products and how materials are used to evoke particular meanings and emotions. For instance, studies have tried to classify the visual and tactile characteristics of different textiles and how people describe them (Giboreau et al. 2001), or the sound

characteristics of materials (Ui et al. 2002). In another example, Zuo et al. (2001, 2004) focus on the relationships between texture and emotions of materials. They found a link between the smoothness of a material and positive emotions such as lively and comfortable. Roughness evoked negative emotional responses such as depressing and uncomfortable. To sum up, with their different physical and sensorial properties, materials play an important role in creating meanings and eliciting emotions in product experience.

The experiences with products are defined as the entire set of effects that are elicited by the interaction between the user and a product (Hekkert 2006). Hekkert (2006) describes the three experiential components in product experience as: (1) *aesthetic experience* (gratification of the senses), (2) *experience of meaning* (attribution of meanings to products) and (3) *emotional experience* (the elicitation of feelings and emotions). When a user is asked to describe a material after an interaction, besides the physical characteristics of the material, he/she can talk about its colour, transparency and softness (sensorial properties of materials). He/she can also mention the material's utility for hygienic environments and its appropriateness for several kinds of applications (use of materials) or its modernity, sobriety, robustness, prettiness (perceived characteristics of materials). Furthermore, the user can tell how a material can evoke memories of grandparents, high technology, or foods (associations of materials), or how materials make him/her happy or bored (emotions evoked by materials). Based on these examples, we assume that materials can also be appraised with the characteristics of experience.

This assumption was verified in a previous study. Three main experiential components of product experience–namely *sensorial experience, experience of meaning* and *emotional experience* - were found in people's material descriptions (Karana et al. 2008). On the basis of the found experiential components, materials experience was defined as "*the whole series of effects elicited by the interactions between people and materials in a particular context*" (Karana et al. 2008). Accordingly, six descriptive categories in experience with materials are classified in this study as (Figure 11-1):

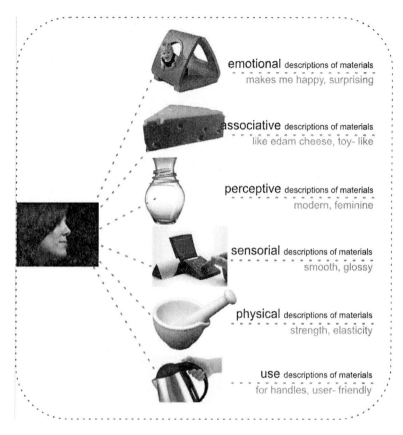

Figure 11-1. Six descriptive categories in materials experience used in this study.

1. Emotional descriptions of materials

We define the emotional descriptions of materials as the feelings of people towards the materials, or how a material makes them feel. The emotional responses, delineated also as the reactions to meanings, are not triggered by situations or events as such, but by our thoughts, beliefs and attitudes about the situations or events (Demirbilek and Sener 2003). Thus, an emotion is a result of a cognitive process, which comes out often unconsciously and automatically (Desmet 2002). Desmet assembled a set of emotions often elicited by product appearance. We took these emotions as a basis for grouping together emotional descriptions of materials in this research. *"This material is boring"* or *"this material surprises*

me" are two examples of *emotional* descriptions of materials (Karana et al. 2008).

2. **Associative descriptions of materials**

 Associations are defined by Ashby and Johnson (2003) as the things a product reminds you of, the things a product suggests. The *associative* descriptions of materials require retrieval from memory and past experiences, and finding the things a particular material brings to mind; such as the association of holey polyurethane foam with a piece of cheese, or associating a colourful, transparent, elastic plastic with childhood jellybeans.

3. **Perceptive descriptions of materials**

 Bonapace (2002) defines perception as how much the individual takes in after the signal has passed through the person's psycho-sensorial filters and the meaning the person attributes to it. The *perceptive* characteristics of materials in this study elucidate what we think about materials, what kind of meanings we attribute after the initial sensorial input, and what qualities a specific material expresses, e.g., modern, sexy, masculine, sober, aggressive, etcetera.

4. **Sensorial descriptions of materials**

 The descriptive items clarifying the interaction between the materials and the users through the five senses–sight, touch, smell, taste and hearing–were defined as the *sensorial* descriptions; tactile aspects such as smooth, cold, flowing, or visual aspects such as matt, translucent and glossy.

5. **Use descriptions of materials**

 People frequently correlate a material to some use circumstances and give descriptive items related to the appropriateness of this material in the context of these particular circumstances (Karana et al. 2008). A product often has some visual or tactile clues in order to help an end-user discover how to activate a functionality of the product. Van Kesteren (2008) explains that when more functions are present, these clues can indicate the various activators. A simple example is a remote control. Different flexibility properties are used for the materials of the casing and the buttons; and different colours indicate the different functions that can be activated with a button. Even in the simplest products, for example a cup, sensorial properties influence the interaction. A cup made of flexible materials makes it a challenge to hold the cup without spilling fluids. "*This material makes this product user-friendly*" or "*the material of this product is easy to use with wet hands*" are two examples from our study explaining the *use* descriptions.

6. **Physical descriptions of materials**

The physical properties are categorized as mechanical, electrical, thermal, chemical and optical properties (Ashby. 1999). These properties are largely numeric; that is, they are quantifiable. Each material can be thought of as having a set of physical properties, which can mostly be directly derived from the chemical structure of the material. All quantifiable characteristics of materials, such as strength, weight, conductivity, as well as descriptions related to the manufacturing techniques are deemed to be *physical* descriptions in this study.

2. Development of two descriptive models

2.1 Background

When users interact with products, their senses are in contact with the materials that make up those products. Users see the colours of materials, feel the texture and the weight and hear the sounds materials make when moving the object (van Kesteren 2008). Fenech & Borg (2006) emphasize that during interaction with the material world, senses serve as media that give rise to perceived sensations, which then act as stimuli for emotions. Furthermore, visual and tactile properties of products strongly contribute to the first overall quality judgement of a consumer (Giboreau et al. 2001; Sonneveld 2004). Hence, the sensorial aspects of materials highly influence the user-product interaction. MacDonald (1999) and Manzini (1989) also explain the relationship between the weight of a product and the perception of quality. People associate a certain weight with a certain product and when this is different, the sense of quality changes.

The studies referred to above were aimed at identifying relationships between material properties of products and the experiences of people who use the product. These experiments were designed to gain understanding of the mechanism of materials experience. The question that remained unanswered, however, is which of the material characteristics are consciously perceived by the users of a product. Insight into the end user's view of materials of a product can help product designers to select appropriate materials, taking into account meanings and emotions alongside physical aspects to create balanced products that function well, are nice to use and evoke the intended perceptions, associations and emotions.

2.2 Research aim and questions

The study presented below provides insight into how product users experience the materials a product is made of. The material experiences are studied by comparing a person's descriptions about selected products with the six descriptive categories identified above of experiences with materials (emotional, associative, perceptive, sensorial, use and physical). The results are used to propose two models representing the characteristics used in product descriptions and material descriptions: (1) the Product Description model (PDM), and (2) the Material Description Models (MDM).

Many factors, such as user characteristics, product type, context of use, can influence how users describe a material, or what kind of descriptive categories they mention (Margolin 1997; Rognoli et al. 2004-2; Suri 2002; Williams 2007; Karana et al. 2008; van Kesteren 2008). In this study, we focus on how a product type, which is a group of products categorized as explained in section 2.3, affects the users' product and material descriptions. Our two main research questions were: (1) to what extent do people take materials into consideration when they describe a product within a certain product type? And, (2) which of the six identified characteristics in a material description do they use to describe materials those products are made from.

2.3 Selected product types

We expected that users would interact differently with different kinds of products and that this would influence the way people describe the materials those products are made from. For example, people might not take materials into consideration for a product that is used mainly because of its function, and, people might emphasise the materials of products they have an emotional bonding with. Other examples are the difference in perception of materials in products that are mainly touched during use, and those that are mainly looked at during use or the differences between products that are liked or not. To be able to explore the assumption that people use different material descriptions, we selected six product types based on the following three distinctions:

- A functional product–an emotional product:
 product 1: a product with a distinct function;
 product 2: a favourite product.
- A product mainly touched during use–a product mainly looked at during use:

product 3: a small electronic product;
product 4: a big electronic product.
* A product that is liked–a product that is disliked:
product 5: a product made of a liked material;
product 6: a product made of a disliked material.

The first aim was to collect data about the differences between a functional product and an emotional product; we did not want to influence the participants' descriptions by making this distinction clear to them, however. We therefore did not use any definite words related to "function" or "emotion" for these two groups of products. Instead, we defined four functions of products, namely an object used for sitting, storing, eating or writing on (such as a table or a coffee table), and for lighting. The product type chosen to explore the material descriptions of the products people have an emotional bonding with was their *favourite* product.

The second distinction required two product types that are similar, but different in terms of usage. We selected the overall category of electronic products, in which we made a distinction between small electronics and big electronics. The product type *small electronics* contains products that can be carried easily by people. This type allowed us to assess the participants' approach to the materials of the electronic objects which they touch frequently every day. The product type *big electronics* cannot be carried easily by users, and is mainly looked at during use.

To explore the distinction between material descriptions of products that are liked and of those that are disliked, we specifically mentioned this as a product type. To be able to study the topic at hand, materials, we added this element to this category. The aim was to be able to assess which of the material characteristics dominate people's descriptions of products. We asked participants to describe two products with materials they like and dislike, and therefore within the selected product types: *liked materials* and *disliked materials*.

2.4 Procedure

A field study was conducted with people who have the ability to create their private environment with their preferred products. We asked them to select products from the collection of products they use in their daily lives and that fit within the product categories described above. We expected them to have a bond with these products and therefore be able to describe them in an interview session. The participants were informed by letter about the product types, from which they were asked to select a product

they own or use beforehand. The interview sessions took place at the participants' living environments. They were not paid for participating and the sessions took approximately one hour per participant.

A total of 16 respondents (11 male, 5 female) participated: seven students at a technical university (three in architecture, two in industrial design engineering, one in aerospace engineering, one in civil engineering), and one student at a medical university. Eight participants were employed, as programmer, advisor, policeman, researchers (four) and entrepreneur/DJ. The participants' ages ranged from 21 to 31, with a mean of 25.5 years.

The interview sessions consisted of two phases: a product phase and a material phase. In the product phase participants were asked to describe the products they selected one by one. The first assignment was to describe the product in the participant's own words, followed by a summarizing question of describing the product in keywords. For every product, we additionally asked the participants to compare the selected product to a product with a similar functionality or similar materials. The material phase started just after the participants had described their selected six products. This involved asking the participants to describe the materials of the products by answering questions similar to the questions in the product phase (in their own words, using keywords, comparing). All the answers were set down on answer sheets by the moderators. Dutch answers were translated into English in the analysis phase.

2.5 Analysis

The answer sheets that were filled in during the interview sessions formed the basis for the analysis. All terms and fragments were written down on two datasheets and categorized based on the description categories referred to above as explained in the introduction. One datasheet contained the descriptions used in the first part of the interview session (product descriptions) and one datasheet related to the second part of the interview (materials descriptions). The categories used were (both for products and materials):

- emotional descriptions;
- associative descriptions;
- perceptive descriptions;
- sensorial descriptions;
- use descriptions.

Two description categories were used, that were different for the product descriptions and material descriptions. These were:

- **Materials** (product descriptions) and material labels (material descriptions).

Descriptions categorized as materials in the product part specifically mentioned the term "material", for example: "The material is soft". When the term "material" was not used, it was categorized as a sensorial description. When describing materials of products, people frequently used words like plastics, polypropylene, wood or glass. These words are the type name of a material and are categorized as material labels when used in the material descriptions.

- **Function** (product descriptions) and physical (material descriptions)

The descriptions relating to the function of the product, such as "This product is a musical instrument" were categorized as *function*. As explained in the introduction, the *physical* descriptions of materials are related to the material properties that were selected for the functioning of the product, e.g., weight, waterproof, isolating, transparent.

The terms which were used to describe components of products, such as LEDs or screens, were categorised as *others*.

The number of terms was counted for each category. For example participant x used three *sensorial* characteristics - blue, transparent and soft - to describe his favourite product. The authors each categorized half of the sessions and together all the data entries were discussed in terms of obtaining a uniform categorization and minimizing the number of wrongly categorized terms.

3. Results of the field study

The 16 participants selected a total of 96 products from the defined product types (Table 11-1). The number of terms used to describe the products and the materials of the products, and their distributions among the descriptive categories can be found in the charts in Table 11-2.

The overview of characteristics used in the descriptions of all the products is explained in section 3.1. Section 3.2 looks at how the differences in the descriptions of products and materials are evaluated based on the product types. In the final section (3.3), we explain how we selected the most-used categories per product type for profiling our models.

Small electronic	Liked materials	Disliked materials	Function of...	Big electronic	Favorite
phone	iPod mini	mp3 cd player	Billy closet	washing machine	power ball
watch	closet	raincoat	pillow	television	guitar
Gameboy	bed	chair	closet	coffee machine	sunglasses
digital camera	electric toothbrush	remote control	desk	TFT screen	calculator
mobile phone	jacket	kitchen knife	laundry basket	laptop	coffee table
remote control	watch	dryer	pen	refriger-ator	computer
mp3 player	cap	sunglasses	poker suitcase	printer	super Nintendo
mobile phone	coat	quilt	chairs	television	computer
mobile phone	hard disk	tea towel	lamp	television	computer
iPod	coat	ghetto blaster	storage box	computer	camera
iPod shuffle	reflector	garlic press	breadbox as closets	DVD player	wallet
palm pc	power drill	coffee machine	Ikea sofa	micro-wave	laptop
mobile phone	mp3 player	plate	Ikea sofa	stereo	laptop

iPod	hand bag	office chair	bookshelf	computer	digital camera
mobile phone	clock	refriger-ator	closet	television	DVD player
iPod	coffee pot	table	lamp	television	Senseo coffee machine

Table 11-1. Products that were selected by the participants.

3.1 Overall evaluation

Looking at the number of terms derived from all product descriptions in Table 11-2, we found that participants were more descriptive about products (694 terms) than materials (510 terms). This is true for all product categories, including the "liked materials" and "disliked materials" in which participants selected products based on the materials of these products. For each product type, the total number of descriptive terms was approximately the same (about 120), except for the big electronic products (101 terms). The number of terms found in the materials descriptions ranged from 77 to 98 terms.

Looking at the descriptions of products, the terms related to *perception* and *function* categories were used most frequently (164 terms and 150 terms respectively), followed by the *use* and *sensorial* terms. In describing the materials of the products, *material labels*, such as plastics, glass or metals, were frequently used in most cases (235 terms). The second largest category was the *sensorial* descriptions of materials and they were used approximately 50% less often (115) than the material labels.

Overall, the main differences between product and material descriptions can be found in the *use*, *function* and *emotions* categories. These categories scored low in the material descriptions compared to the product descriptions. In relative terms, participants used more terms categorized as *sensorial* and *associative* in descriptions of materials than in the descriptions of products. When describing products, participants used a wider range of characteristics than when they were describing the materials. In the last condition, participants hardly used any terms related to the *use* and *emotions* categories. In Table 11-2, the categories used most frequently were are shaded dark grey. *Material labels* were found most frequently in the descriptions of materials for all product types. Material

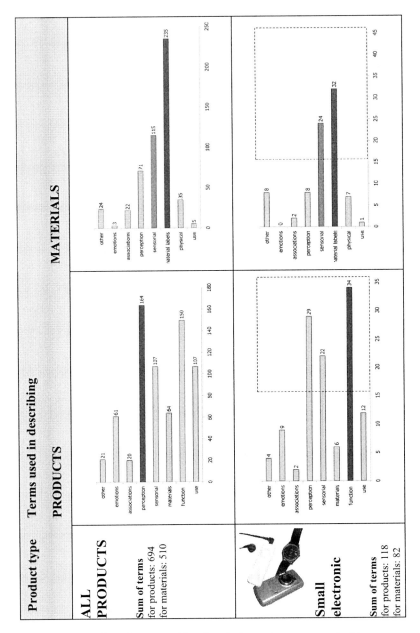

Table 11-2. Number of terms used in a descriptions category per product type.

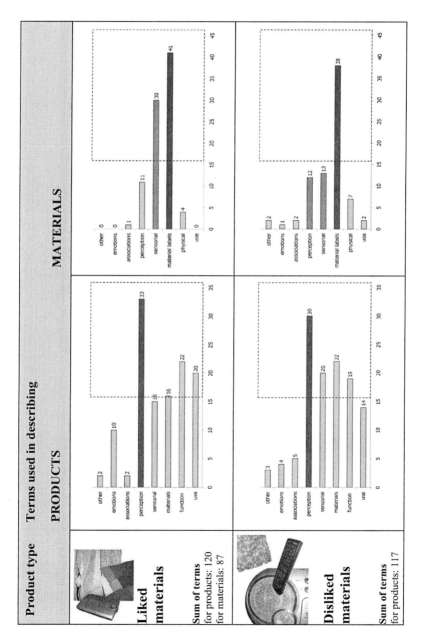

Table 11-2. (continued).

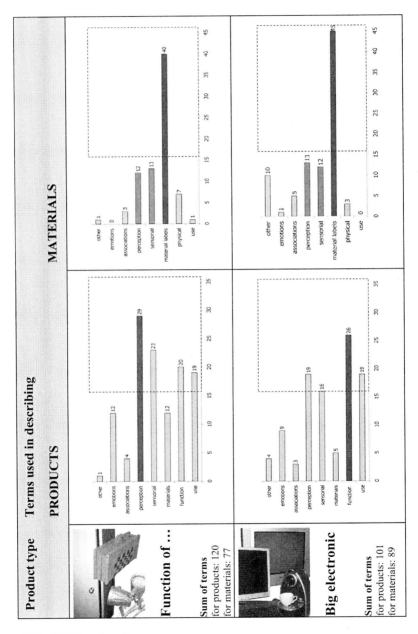

Table 11-2. (continued).

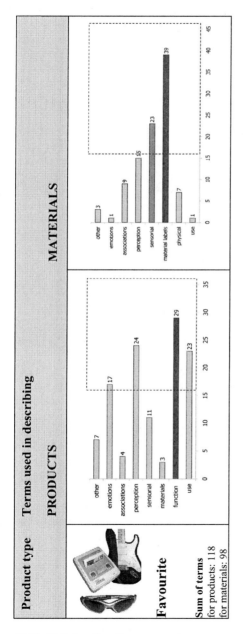

Table 11-2. (continued).

labels are not a characteristic of material experiences. *Material labels* were therefore not used for further comparison of the materials descriptions for the different types of products.

3.2 Evaluation of the results based on the product types

In describing the materials used in *small electronics*, the *sensorial* descriptions (24) were used most frequently and were mentioned at least four times more often than the rest of the descriptive categories. When describing small electronics products, *sensorial* terms were also frequently used (22) but not as frequently as *perceptive* (34) and *function* terms (29). The number of terms in the *sensorial* category for the *big electronic* products was only half of the number (12) used for *small electronic* products. Overall, the participants used fewer terms to describe the materials of the big electronics (except for materials labels) than for small electronics.

There is a major difference between the terms used for describing products and the materials of the products for the products with *liked materials*. Most of the terms for material descriptions were categorized as *sensorial* characteristics (30), followed by *perception* (11). This was the other way around for the product descriptions: most terms were found in *perception* (33) and a fewer number in *sensorial* (15). Other descriptive categories were hardly used in this context in material descriptions, although *emotions* (10), *function* (22) and *use* (20) terms were frequently found in the product descriptions. Most of the terms in the material descriptions for the *disliked materials* were *perceptive* (11) or *sensorial* (12). Few terms were found, however. The distribution of the terms used in the product descriptions of the *liked materials* and *disliked materials* was similar.

Products in the *function of...* were mostly described in *perceptive* terms (29). *Function* characteristics (20) were frequently used for these products. The number of terms related to function was comparable with the number of *sensorial* (23) and *use* (19) terms. In the *function of...* products not many terms were found. Most terms from the materials description were classified under the *perception* (12) or *sensorial* (13) categories. Remarkably, most of the terms used for the *favourite* products were in the *function* category (29). The *use* (23), *perception* (24) and *emotion* (17) terms were also used frequently in the descriptions of favourite products. Most of the terms from the materials descriptions were used in the

favourite category (98). These terms were categorized mostly as *sensorial* (23) and *perception* (15) descriptions.

3.3 Selection of the frequently used descriptive categories

A category was deemed to be "frequently used" when the number of terms found in 16 sessions exceeded 16. This number indicates that on average every participant mentioned a term in this category at least once. Based on this, a category was found acceptable to be included in the Products and Materials Descriptions Models. The characteristics included were shown by the "dotted border lines" in Table 11-2.

The *perceptive* and *functional* descriptions were used more than 16 times in the product descriptions in each product type. The *associative* descriptions and *others* were never found more than 16 times. For the *small electronic* products the *sensorial* descriptions were included in the model. For the product category *liked materials* this were the *use* and *materials* descriptions and for the *disliked materials* the *sensorial* and *materials* descriptions. For the products of *function of...* we included the *sensorial* and *use* descriptions in the model, and for the *big electronic* products this were the *use* and *sensorial* descriptions. Lastly, in the *favourite* products the *use* and *emotion* descriptions were included. In the people's descriptions about the materials of a product, only *sensorial* terms were used more frequently than 16 times, but only for three product types. These were the *small electronics*, *liked materials* and *favourite* products, which were included in the materials descriptions profile.

4. Product and Material Descriptions Models

Two models were created for explaining people's descriptions of six types of products and their materials, based on the six descriptive categories defined in the introduction. The first model summarizes the distribution of the frequently used descriptive categories in product experience for each product type (the Product Descriptions Model in Figure 11-2). The second model elaborates on the types of descriptive categories which were often used for describing the materials of the products for each product type (the Material Descriptions Model in Figure 11-3).

Both models are built up from three elements: (1) the six product types, (2) the six characteristics of the descriptions and (3) connecting lines. A description characteristic found within the "border box" of a product type

(as explained in the previous section) was connected to that specific product type in the models. Some characteristics were connected to more product types (e.g., the functional characteristics in the product descriptions). Starting from a product type, the reader can now see which were the most frequently used characteristics in the participant's product and material descriptions.

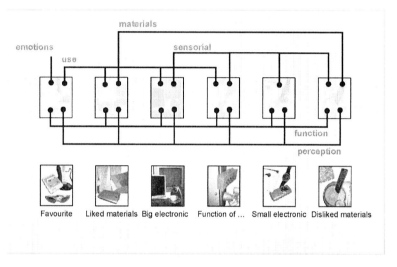

Figure 11-2. Product Descriptions Model (PDM).

4.1 Product Descriptions Model (PDM)

According to the PDM, the most descriptions about the materials of products were found in the *disliked materials* and *liked materials* categories. The *functional* and *perceptive* descriptions were the two most used descriptions in all product types. The usage frequency of the descriptions belonging to a particular category changed based on the product types. For some product types, the function of the product is clearer than in others. Therefore, people tended to be more expressive about the other characteristics of these products rather than the function. For example, the s*ensorial* descriptions category was only included in *small electronic, big electronic, function of...*, and the *disliked materials*.

The emotional descriptions of products can only be deemed a characteristic worthy of consideration for *favourite* products. This can be explained by the participants' emotional attachment to their favourite

products. However, it is surprising that we hardly found any emotional descriptions for big electronic (such as laptops), or small electronic (such as iPod mini) products. In the overall evaluation, the participants were most expansive when describing their favourite products. Another interesting point about the *favourite* products was that participants were very descriptive about the function of these products.

Looking at the differences between product types that we expected, we see that people do indeed use more emotional descriptions for products selected for their emotional bonding, compared to functional products. Based on the results of this study, no difference in product descriptions between products that are mostly touched and mostly looked at during usage could be found. It was clear that specifically asking to talk about a product selected for its materials elicited material descriptions. Regarding the difference between products that are liked and that are disliked we found that, with regard to the liked products, people tend to describe the usage aspects. And with regard to the disliked type, people tend to describe the sensorial aspects.

Figure 11-3. Materials Description Model (MDM).

4.2 Materials Descriptions Model

People described the materials mostly with the *sensorial* properties of materials, especially for the *favourite, liked materials* and *small electronic* products. Other characteristics were not used to a significant extent. The common aspect of these three product types is that the interaction with these products is more tactile; that is, they are used frequently and they are easy to hold. Accordingly, the sensorial properties of materials play a crucial role in people's evaluations of materials and can influence their preferences, such as in their favourite products.

Participants used more terms to describe the materials of the *big electronic* products compared to *small electronic* products, mainly describing material labels. The large number of materials labels can be

explained by the fact that these products are bigger and contain more materials, but also have bigger surfaces showing the materials. Apart from the material labels, the participants were less talkative about other descriptive categories for the *big electronic* products. Daily interaction with *big electronic* products does not usually provide tactile interaction, holding or grasping. The low tactile contact with these products might therefore have made the participants less descriptive about sensorial aspects of the materials. However, the materials descriptions about the *disliked materials* and the *liked materials* in the MDM were quite nominal. We explain this result by the eagerness of the participants to explain their selection in the first part of the questionnaire, in which they describe the products. When we specifically asked about the materials of these products in the second part of the interviews, they had already given answers to this question, and may not have wanted to repeat their explanations.

Looking at the differences between product types that we expected, we see that people use sensorial descriptions for products selected for their emotional bonding, compared to merely material labels in the functional products. We see a clear difference in product descriptions between small products and larger products. The small products elicited more sensorial descriptions than the larger ones. Unlike in the product descriptions, people use more sensorial materials descriptions for the products of the *liked materials* type than of the *disliked materials* type.

4.3 General discussion

The participants did not give a considerable amount of descriptions directly related to materials in their product descriptions. We included most of the sensorial properties, such as colour and texture in the *sensorial* category in our categorisation of terms, although these can also be considered aspects of *materials*. For the assessment of the product descriptions part, we only counted the descriptions as *material descriptions* if the participants particularly mentioned the materials of these products. The way we categorized the terms can therefore explain why very few descriptions directly related to materials were found in the product descriptions section.

This study was performed with a limited number of participants. For further studies and for more reliable results, we strongly recommend working with a greater number of participants. Moreover, some of the descriptions had ambiguous meanings, which made them difficult to classify; such as, *cold, warm* and *firm,* which can be evaluated as both

sensorial and perceptive descriptions. We assessed them individually in their particular contexts. Furthermore, although people try to describe the materials of the products as individual substances, it is difficult to evaluate them without any context. For instance, even though the emotional descriptions of materials were defined as an individual category in materials experience, it was found hardly effective in people's material descriptions. The reason of this result can be that most of the time people form emotional bonds with the products rather than with the materials. An attachment or an emotional bond therefore cannot easily be designed by only the materials of products. In other words, material experiences are formed based on the context of use, or products they are incorporated into.

It was remarkable that people use so many material labels in their materials descriptions, compared to the other description categories. Sonneveld (2007) found, in a blindfolded test, that people try to identify the materials a product is made of first when asked to describe the tactile experiences with a product. Picard et al. (2003) found similar results about the vocabulary that people use to describe tactile aspects of the materials of a car seat. Hence, people are able to recognize the materials from which a product is made, but do not use that fact to explain its user-interaction qualities. Furthermore, Klatzky and Lederman (1995) found that tactile aspects of a product enable people to recognize products even at a haptic glance. Hence, it seems that people need to perceive the materials in order to form a judgement about the user-product interaction, but evaluate it as a combination of product characteristics in relation to its functioning and how it is experienced. Wastiels et al. (2007) found a similar result with architects who do not think in terms of materials, but rather in terms of the experience they want to create and the attributes needed for that. The words that architects use for describing materials and spaces are similar, such as "friendly materials" and "friendly rooms".

In general, the results of the study show that the type of a product influences the frequency of the descriptive terms used by participants for describing the product and its materials. This implies that other types of products, which were not included in this study, may generate different frequencies. The method used in this study, therefore, can be used for generating other models including other types of products.

5. Conclusions

The aim of this study was to answer two main questions: (1) to what extent do people take materials into consideration in product experience? And (2) which descriptive categories of materials experience do they use

for describing materials? The results show that users often describe materials when they are asked to select a product particularly for its materials. While describing the materials of products, they not only focus on the physical characteristics of materials but also non-physical ones, such as the sensorial and perceptive characteristics of materials, or the emotions elicited by materials. According to this study, the sensorial characteristics of materials appear to be the most important descriptive category in the experiences of materials.

Works Cited

Arabe, K.C. (2004). Materials' central role in product personality, Thomas Net Industrial News Room (March). URL:
 http://news.thomasnet.com/IMT/archives/2004/03/materials_centr.html.
Ashby M.F. (1999). Materials selection in mechanical design, second edition. Oxford: Butterworth-Heinemann.
Ashby, M. and Johnson, K. (2003). The Art of Materials Selection. *Materials Today* (December): 24-35.
Bonapace, L. (2002). *Linking Product Properties to Pleasure: The Sensorial Quality Assessment Method–SEQUEM, Pleasure with Products beyond Usability*. Edited by William S. Green and Patrick Jordan, Taylor & Francis, London and New York: Chapter 15.
Conran, S. (2005). Creating Value. *International Conference on the Art of Plastics Design*, Berlin, Germany (18-19 October) paper 1.
Crilly, N., Moultrie, J. and Clarkson, P.J. (2004). Seeing things: consumer response to the visual domain in product design. *Design Studies* 25: 547-577.
Cupchik, G.C. (1999). Emotion and industrial design: reconciling meanings and feelings. *First International Conference on Design and Emotion*, Delft, the Netherlands: 75- 82.
Demirbilek, O. and Sener, B. (2003). Product design, semantics and emotional response. *Ergonomics* **46**(13), pp: 1346- 1360.
Desmet, P.M.A. (2002). *Designing Emotions*. Delft: Delft University of Technology, dissertation .
—. (2003). A multilayered model of product emotions. *The Design Journal* **6**(2): 4-13.
Fenech, O.C. and Borg, J.C. (2006). A sensation based model of product elicited emotions. *Proceedings from the 5th Conference on Design and Emotion 2006*.

Ferrante, M., Santos, S. F. and de Castro, J.F.R. (2000). Materials selection as an interdisciplinary technical activity: basic methodology and case studies. *Materials Research* **3**(2): 1- 9.

Gant, N. (2005). Plastics design–the unlikely pioneer of product relationships. *International Conference on the Art of Plastics Design*, Berlin, Germany (18-19 October) paper 6.

Giboreau, A., Navarro, S., Faye, P. and Dumortier, J. (2001). Sensory evaluation of automotive fabrics–the contribution of categorization tasks and non verbal information to set-up a descriptive method of tactile properties. *Food Quality and Preference* **12**(5):311-322.

Govers, P.C.M. (2004). *Product Personality*. Delft: Delft University of Technology, dissertation.

Hekkert, P. (2006). Design Aesthetics: Principles of Pleasure in Design. *Psychology Science*, **48**(2):157-172.

Hodgson, S.N.B. and Harper, J.F. (2004). Effective use of materials in the design process–more than a selection problem. *International engineering and product design education conference*, Delft (2-3 September).

Karana, E. (2006). Intangible characteristics of materials in industrial design. *5ᵗʰ International Conference on Design and Emotion*, Sweden.

Karana, E., Hekkert, P., Kandachar, P.V. (2008). Material considerations in product design: a survey on crucial material aspects used by product designers. *Materials and Design*, **29**: 1081-1089.

Karana, E., Hekkert, P., Kanddachar, P.V. (2008). Materials experience: descriptive categories in material appraisals. *International Conference on Tools and Methods in Competitive Engineering 2008*, Izmir, Turkey.

Karlsson, M.A., Desmet, P. and van Erp, J. (Eds) (2006). *Design & Emotion*, Chalmers University of Technology, 27-29 September, Göteborg, Sweden.

Klatzky, R.L. and Lederman, S.J. (1995). Identifying objects from a haptic glance. *Perceptions and Psychophysics* **57**(8):1111-1123.

Lefteri, C. (2001). Materials for inspirational design: Plastics, Roto Vision, SA, 2001.

—. (2005). The branding of plastics–how important is the branding of a material and how far do plastics go in helping to define brands. *International Conference on the Art of Plastics Design*, Berlin, Germany (18-19 October) paper 7.

Ljungberg, L.Y. and Edwards, K.L. (2003). Design, materials selection and marketing of successful products. *Materials and Design* 24: 519-529.

Lovatt, A.M. and Shercliff, H.R. (1998). Manufacturing process selection in engineering design. Part 1: the role of process selection. *Materials and Design* 19: 205- 215.

MacDonald, A.S. (1999). Developing aesthetic intelligence as a cultural tool for engineering designers. In Lindema, U., Birkhofer, H., Meerkamm, M., Vajna, S. (Eds.), *Proceedings of the International Conference on Engineering Design (ICED)*, Munich, 297–300.

MacDonald, A.S. (2001). Aesthetic intelligence: optimizing user-centered design. *Journal of Engineering Design* **12**(1): 37- 45.

Manzini, E. (1989). *The material of invention*. London: Design Council.

Margolin, V. (1997). Getting to know the user. *Design Studies* 18, 227- 236.

McDonagh, D., Bruseberg, A. and Haslam, C. (2002). Visual product evaluation: exploring users' emotional relationship with products. *Applied Ergonomics* 33: 231-240.

Nagamachi, M. (1995). Kansei Engineering: A new ergonomics consumer-oriented technology for product development. *International Journal of Industrial Ergonomics* 15: 3- 11.

Norman, D.A. (2002). Emotion & Design: Attractive things work better. *Interaction* (July- August): 36-42.

Picard, D., Dacremont, C., Valentin, D. and Giboreau, A. (2003). Perceptual dimensions of tactile textures. *Acta Psychologica* **114**(2):165-84.

Rognoli, V. and Levi, M. (2004). How, what and where is possible to learn design materials? *International engineering and product design education conference*, Delft (2-3 September).

Sonneveld, M. (2004). Dreamy hands: exploring tactile aesthetics in design. In McDonagh, D., Hekkert, P., van Erp, J., Gyi, D. (Eds.), *Design and emotion, the experience of everyday things*. Taylor & Francis.

Sonneveld, M.H. (2007). *Aesthetics of tactile experiences*. Delft: Delft University of Technology, dissertation.

Suri, J. F. (2002). Design expression and human experience: evolving design practice. In *Proceedings of Design and Emotion*, Ankara, Turkey.

Ui, E., Cho, G., Na, Y. and Casali, J.G. (2002). A fabric sound evaluation structure for totally auditory-sensible textiles. *Textile Research Journal*, Jul 2002.

Van Kesteren, I. (2008). *Selecting materials in product design*. Delft University of Technology, dissertation.

Van Rompay, T. (2005). *Expressions: Embodiment in the Experience of Design.* Delft University of Technology, dissertation.

Wastiels, L., Wouters, I. and Lindekens, J. (2007). Material Knowledge for Design: The architect's vocabulary. *IASDR 2007 International Association of Societies of Design Research*, Emerging Trends in Design Research, Hong Kong, November 12-15, 2007.

Williams, L. (2007). *The Ipod and the bathtub: managing perceptions through design language.* URL: http://www.frogdesign.com/design-mind/articles/early-articles/the-ipod-and-the-bathtub.html.

Zuo, H., Hope, T., Castle, P. and Jones, M. (2001). An investigation into the sensory properties of materials. *Proceedings of the international conference on affective human factors design.* Singapore, 27-29, June. London: Asean Academic Press p500-507.

Zuo, H., Hope, T., Jones, M. and Castle, P. (2004). Sensory interaction with materials. In McDonagh, D., Hekkert, P., van Erp, J., Gyi, D. (Eds)., *Design and emotion, the experience of everyday things.* Taylor & Francis.

Zuo, H., Jones, M. and Hope, T. (2005). Material texture perception in product design. *International Conference on the Art of Plastics Design*, Berlin, Germany (18-19 October) paper 5.

CHAPTER TWELVE

DESIGNING FOR CONTROL – FINDING ROLES FOR SMART HOMES

MIN KYUNG LEE, SCOTT DAVIDOFF, JOHN ZIMMERMAN AND ANIND K. DEY

1. Introduction

For many years technology researchers have promised a smart home that, through an awareness of people's activities and intentions, will provide the appropriate assistance to improve human experience. However, before people will accept intelligent technology into their homes and their lives, they must feel they have control over it (Norman 1994). To address this issue, social researchers have been conducting ethnographic research on families, looking for opportunities where technology can best provide assistance. At the same time, technology researchers studying "end user programming" have focused on how people can control devices in their homes. We observe an interesting disconnect between the two approaches–the ethnographic work reveals that families desire to feel in control of their lives, more than in control of their devices. Our work attempts to bridge the divide between these two research communities by exploring the role a smart home can play in the life of a dual-income family. If we first understand the roles a smart home can play, we can then more appropriately choose how to provide families with the control they desire, extending the control of devices to incorporate the control of their lives families say they need.

Our research takes a human-centered design approach to explore the needs, goals, and desires of families. This approach includes contextual interviews, cultural probes, the generation of concepts based on the needs discovered, and needs validation that evaluates the overlap between the needs we observed and the needs families perceive in their own lives. This

work has resulted in two main insights into the role of the smart home. First, a smart home can play an important role in transitioning families from feeling out of control to feeling in control. The smart home can provide this service by helping families avoid breakdowns caused by deviations in daily routines. Second, a smart home can help make dual-income families feel they have mastered the complexity of their lives. Here, the smart home can provide opportunities for family members to give "gifts of time and attention" to one another around activities that support the construction of a family identity. These gifts make family members feel better about themselves and the roles they play, and potentially increase the emotional connection between family members. We review our design process and provide reflections on how the focus on emotional experiences helped us identify opportunities for a smart home. Finally, we discuss issues around automation that were revealed in our study and suggest how designers can tackle these problems.

2. Related work

The large number of studies of the family (Beech et al. 2004; Darrah et al. 2001) has produced a substantial corpus of knowledge. Some studies have focused on communication patterns in the home (Crabtree et al. 2003), the use of refrigerator magnets (Taylor et al. 2005), the adoption of communication technology (Frissen 2000), or the general use of domestic technology (Venkatesh et al. 2000). Field studies have covered a broad spectrum of families, including families with both stay-at-home moms (Crabtree et al. 2003), and, like our study, dual-income families (Beech et al. 2004; Darrah et al. 2000; Davidoff et al. 2006).

The dual-income family is of particular interest to us. Dual-income families currently comprise 43% of the population of the United States (Hayghe 1989). They represent both a significant marketing opportunity and a population in need of serious support. As dual-income families move away from the stay-at-home mom model, they are exposed to a surprising amount of stress. Also, their aggressive adoption of communication technology (Frissen 2000), we believe, indicates that they will be early adopters of smart home services that they see can enhance their lives.

The demands of work (Beech et al. 2004; Darrah et al. 2000), home life (Darrah et al. 2001; Elliot et al. 2005) and enrichment activities (Davidoff et al. 2006) drive dual-income families to lead highly-structured lives, with almost no unscheduled time. Families often compensate for this

complexity by establishing routines (Tolmie et al. 2002), offloading some of the responsibility for remembering every event-related detail. But despite detailed routines, breakdowns are inevitable. Children get sick, things get forgotten, and traffic causes delays. During these breakdowns in routines, parents feel particularly out of control, and victim to their environment and circumstances. This loss of control stresses families both physically and emotionally. During these situations, families report that their goal is just to make it through the day (Davidoff et al. 2006).

Demands on time also force parents to compromise the quality of activities that contribute to their sense of identity–to how they see themselves as parents. Activities such as cooking provide a chance for dual-income parents to feel they have made something for their children and provide an example of what good parenting is. However, in dual-income families, parents often feel like poor or inadequate parents because they do not have time to cook and often must "heat and serve" quick dinners (Beech et al. 2004). The demands of their day constrain parents' ability to achieve their sense of who they are and who they would like to be. In this sense, too, parents find it difficult to achieve a sense of control over their lives.

Control, from the perspective of smart home research, tends to focus not on life control, but on control of devices. Smart home systems often enable the home to automatically turn on lights (Mozer 1998), control a thermostat (McCalley et al. 2005), close the blinds (Jahnke et al. 2002), or provide a single user interface for control over all home appliances (Ducheneaut et al. 2006).

Even systems that recognize that families will desire unique services and individual ways of implementing them, approach the problem in terms of devices. Using such metaphors as puzzle pieces (Humble et al. 2002), or magnetic refrigerator poetry (Truong et al. 2004), these end user programming systems allow individuals to combine different artifacts into newly-derived services.

3. Design process

We followed a user-centered design process to explore the needs of dual-income families around the activities of *waking up* and *arriving home*. We chose these time windows because pilot fieldwork revealed that these

were often the busiest moments of the day, involving significant coordination amongst all family members.

Our design process included:
1. Contextual interviews with dual-income families in their homes.
2. Cultural probes exploring family emotions, including their most and least favored experiences.
3. Concept generation based on our data gathered, and other ethnographies of dual-income families.
4. Needs validation sessions where families provided feedback on our application concepts.

3.1 Contextual interviews and cultural probes

We conducted three-hour contextual interviews with 12 dual-income families. All participants were recruited via bulletin board flyers and postings on community sites in the area near Pittsburgh, Pennsylvania in the U.S. Each participant family had an average of 1.9 children, and the average age of the children was 12 years (see Table 12-1 for detailed information of participants). The interviews included directed storytelling, artifact walkthrough, and role-playing activities. All family members were asked to participate. We focused questions on their routine activities, use of artifacts during these activities, and their strategies for dealing with breakdowns in routine.

Following the interview, we left families with cultural probe packages for one week, hoping to gain insight into the emotions associated with waking up and arriving home. The packages included a camera, a book of stimuli questions, and a journal to log their responses. We also left families with an activity log. The log asked families to comment on their level of stress, principal activities, immediate needs, preoccupations, and on how rushed they felt.

To analyze our data, we coded our interview notes and photos, and clustered them into emerging categories. We created maps of homes that detailed families' activities and the artifacts they used based on the interview notes and the activity logs. For each family we created three distinct timeline types: the typical day (e.g., week days), the day when non-routine activities are scheduled (e.g., child's picnic), and the deviation day when the scheduled activities cannot be executed due to unexpected

events (e.g., sick child, snow day). These models helped us see the detailed patterns of families' routines.

Family	Mother	Father	Children
A	Not provided, Administrative assistant	Not provided, Carpenter	15, son 18, son
B	47, Department manager	48, Art gallery director	9, daughter 15, daughter
C	41, Professor	39, Teacher	1, son 5, daughter
D	38, Business manager	41, Marketing manager	5, son 8, daughter 10, son
E	Not provided, Professor	Not provided, Carpenter	15, son
F	45, Secretary	46, Truck driver	15, daughter
G	32, Surgeon	31, Graduate student	5, son
H	36, Project manager	34, Graduate student	1, daughter 5, daughter
I	52, Nurse	53, Steam fitter	15, son 19, daughter
J	49, Administrative assistant	50, Manager	15, daughter 20, son
K	54, Events coordinator	55, Salesman	21, son
L	43, Legal secretary	46, Landscaper	11, daughter 15, daughter 17, daughter 19, daughter

Table 12-1. Demographic information on participating families.

The cultural probes allowed us to understand emotional experiences that people have with their family members and their homes. (For definition of emotional experiences, please see Desmet et al. 2007). We grouped these as negative experiences (e.g., stress from managing multiple activities, anxiety caused by the fear of potential breakdowns, frustration from messy, cluttered house) and positive experiences (e.g., pleasure of seeing family after work, calmness of morning coffee ritual). These two categories guided us to focus on both reducing negative experiences and enhancing positive ones. (For more examples, please refer to Figure 12-1 to 12-6).

Figure 12-1. A cultural probe photo of Family C's kid's shoes on a table, an unusual location for shoes. The mother reported that "*The kids' shoes are often the last thing we attend to on work/school days, and it sometimes requires a full-house search to find them.*" She also expressed that "*I don't like cranky children, lost shoes, squabbles over hair-brushes and clothes, no available food for making breakfasts and lunches, and being pressed for time in the morning. These make me anxious and irritable; get me off to a bad start. This stresses me out and make me rue the day that I decided to have kids.*"

Figure 12-2. A cultural probe photo of Family L's four lunch boxes. The mother indicated that she feels rushed when packing individual lunches for her four children during her busy morning routine. She stated; "*It is very time consuming. Everyone likes something different, so I want to make sure everyone gets what they want.*"

Figure 12-3. A cultural probe photo of Family B's pendulum clock is emblematic of the feeling of being in a hurry. The mother explained that "*the loud tick-tock is a constant reminder that time is rushing forward...It makes me glance at the time over and over again. It's a weird mix of comfort and stress. I grew up with pendulum clocks, so it has a homey sound, but I also associate it with rushing in the morning.*"

Figure 12-4. A cultural probe photo of Family H reveals parents' conflicted feelings from the tension between doing jobs as parents and doing them for themselves. The father reported that "*I often have to make the girls' breakfast and lunch the same time I make coffee, so it's often a struggle to get things done but I try to get the coffee started before I make their breakfasts, which I feel kind a selfish a bit.*"

Figure 12-5. A cultural probe photo of Family F's daughter and dog. The mother expressed the happiness and relief she experiences when she returns from her work and is greeted by her daughter and dog in the window.

Figure 12-6. A cultural probe photo of Family H's table next to a front door, where every family member places and organizes things to bring to work or school. The father revealed that the state of the table is like a barometer for their lives, in which a chaotic and disordered table meant the family was out of control.

3.2 Concept generation and needs validation

We generated smart home concept applications that addressed the needs we identified in our fieldwork and other ethnographic research performed with dual-income families. In a brainstorming session focused on this fieldwork and research, we produced one hundred and one concepts, which we clustered into seventeen themes including activity monitoring and scheduling, home security, and enhancing family relationships. We then further abstracted this list into five high-level application areas: activity management, logistical backup, opportunistic reminders, health and meal support, and family awareness. (For more about the fieldwork and cultural probes, please see Davidoff et al. 2006.)

To gain some perspective on our concepts, we conducted a needs validation session. In this method, designers document their concepts as storyboards showing situations that users recognize and technology interventions that address the underlying need. Following the presentation of each storyboard, a facilitator begins a discussion around the underlying need. The goal of this method is to see if there is an overlap between the observed needs from the fieldwork and the needs participants perceive in

" I feel so helpless." The smart home senses The neighbor's not far The tow truck that comes
 that Dad's going to miss from Annie. She agrees for Dad tells him that
 Annie, and pings the to get her. Annie is safe and sound.
 people the Millers count
 on in a pinch.

Figure 12-7. A storyboard taken from our needs validation depicting a family in need, and how a smart home might help them.

their own lives. (For more details on needs validation, please see Davidoff et al. 2007.)

In preparing materials for our needs validation sessions, we encapsulated forty application concepts from the five different concept areas within twenty-two storyboards. Each storyboard documented a specific situation where the smart home might intervene in families' lives to provide them with assistance (see Figure 12-7). Our storyboards deliberately obscured a clear technical implementation, obliging participants to focus more on the service delivered than on any particular method of its delivery. We presented the storyboards and asked families to estimate the previous impact of the proposed situations on their lives. In addition to probing the underlying need, we also probed families' receptivity to our proposed solutions.

3.3 Design implications

The outcome of the fieldwork, concept generation, and needs validation helped us form a conceptual model of how desires, "busyness," and feelings of control interact. In addition, it revealed two main opportunities for the smart home to improve the quality of people's lives: (1) helping families avoid breakdowns caused by *deviations* in the daily routine, and (2) providing opportunities for family members to give their time and attention to each other, especially for activities that support the construction of a family identity.

Our conceptual model illustrates how parents desire to feel in control of their lives and to effortlessly demonstrate for their children a mastery of

the busyness that comes with participation in many activities (Figure 12-8). Following this model, parents attempt to be good parents by enrolling their children in enrichment activities such as soccer, piano, Chinese lessons, or Sunday School to help them gain the skills they will need to compete and the knowledge to continue the family culture and traditions. The addition of new activities leads to increased busyness: more responsibilities to transport children and equipment and to address conflicting activities and commitments. The increase in busyness makes parents feel completely controlled by their schedules that allow for very little free time. Parents find themselves constantly scrambling to stay on top of things, but when deviations in the normal routine occur, they experience a cascading set of failures, and feel their lives have become out of control. The very action they have taken to feel like a good parent–enrolling their children in activities–has now become the source of their feeling like a bad parent.

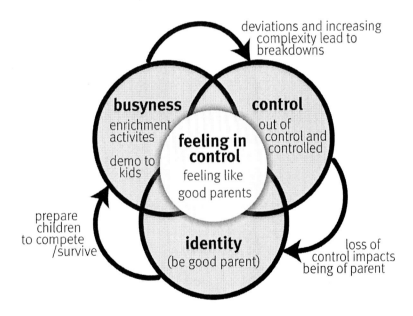

Figure 12-8. A conceptual model that illustrates how parents desire to feel in control.

3.4 Help families avoid breakdowns in routines

Both our research and the findings from the other ethnographies reveal that breakdowns caused by the need to deviate from daily routines are one of the major stressors that make families feel a loss of control. It is the routines that allow families to carry on the synchronous choreography of their lives without having to constantly invent and agree on a plan (Tolmie et al. 2002). Deviations from routine cause stress by making family members both improvise in response to deviations and potentially miss the timing of their responsibilities. Deviations can be planned, such as a spouse away on a business trip, requiring the other parent to assume duties that are not normally their own. Or deviations can be unscheduled, such as a sick child who cannot go to school. All these planned and unscheduled deviations could potentially lead to breakdowns and almost certainly lead to stress. The following story from our fieldwork helps illustrate a breakdown and its consequences on families.

> Little Billy has a soccer game every Wednesday evening. Usually Dad takes Billy and watches him play. But today it is a little bit different. It is Billy's turn to bring oranges for the whole soccer team. Even though Billy put a note on the fridge an entire week earlier, Dad misses the note because it is not in his routine to check for note before a game, and he goes to the soccer field without oranges. After the first half of the game, everybody gathers for snacks and wonders why there are no snacks prepared. The coach asks Billy why he did not bring oranges. Billy is so upset with his Dad. He feels sorry for disappointing his friends and is embarrassed of his family. He also feels that his friends will think his family is not "organized" and does not care about him. To get the oranges, Dad goes to the grocery store and misses the second half of the game. But he doesn't recover from the feeling that he let his son down.

As illustrated in this story, a seemingly small deviation caused by a predictable event can lead to breakdowns in daily routines and cause an emotional disturbance to families. Even the possibility of a breakdown can cause families a great deal of anxiety. Thus, dual-income families would benefit from both functional support to cope with potential breakdowns, and emotional support to be relieved from fear of breakdowns. Our work shows that a smart home could address these needs by providing important reminders and alerts during critical family activities. We describe these individually below.

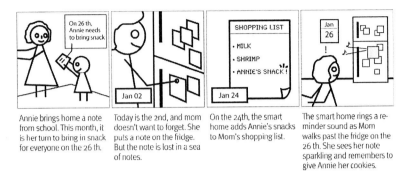

Annie brings home a note from school. This month, it is her turn to bring in snack for everyone on the 26 th.

Today is the 2nd, and mom doesn't want to forget. She puts a note on the fridge. But the note is lost in a sea of notes.

On the 24th, the smart home adds Annie's snacks to Mom's shopping list.

The smart home rings a reminder sound as Mom walks past the fridge on the 26 th. She sees her note sparkling and remembers to give Annie her cookies.

Figure 12-9. A storyboard that illustrates how a smart home may provide a reminder for deviation.

Reminders for deviations

During our needs validation sessions, participants really favored our concepts around smart home reminders, especially when they helped them cope with changes to the daily routine. One concept particularly resonated–reminding a mom to purchase food for her child's school snack day while she was shopping for groceries (Figure 12-9). In this case, it was not just a reminder of the unusual responsibility, but the match between this unusual event and the opportunity to take action at the appropriate time. These types of reminders can function in a wide range of circumstances, from small deviations, such as not knowing where needed ballet slippers are, to more critical deviations, such as remembering to pick a child up at an event that is not typically a parents' responsibility. Providing this service helps parents feel they are regaining control of their lives both by reducing the chance of breakdowns and by lowering their stress level about the possibility of breakdowns.

Alerts of unscheduled deviations

Even when families have carefully planned their days, external forces can cause unexpected deviations. Occurrences like changes in weather, unplanned meetings, traffic, or a sick child can cause families to begin to improvise workarounds on the fly. A smart home can play a role in reducing the stress from fear of these events by monitoring routines and alerting families to sensed deviations.

Our needs validation sessions showed that families were positive and receptive to the concept of a smart home as safety net. In the scenario (Figure 12-7), Dad is supposed to pick up his child. But he has a flat tire

and cannot contact anybody. The smart home provides an alert to family members noting that Dad's whereabouts are unknown, and he cannot pick up a child. While this extreme case may not happen often in real life, the presence of a smart home that takes actions in emergency situations alleviates some of the feelings of fear and stress of breakdowns that families feel. In addition, participants also valued the support that a smart home could provide with coordination activities and the ability to coordinate alternative schedules. In another scenario, for example, when neither parent could stay home to watch their sick child, a smart home proactively displayed how many times other families have helped out, enabling the parent to be sure to evenly spread their last-minute favor requests.

3.5 Providing opportunity for the gift of time and attention

Even successfully managing their routines was not sufficient for families to have a feeling of control over their lives. They desire to carry out their routines in the way they want to and to achieve an expected quality of life through that action. Let us say, for example, that a parent manages to leave the house on time in the morning, but ends up rushing their children, or even yelling at them in the process. This results in making them feel like poor parents because they have started both their children's and their own day on the wrong foot. The required end is achieved, but the manner of its completion contributes to a feeling of lack of control. Here, a smart home could provide families with opportunities to regain that control over these circumstances by providing them with more time to enhance the things that they value–their identity, their time, and their relationships. We describe this in more detail.

Make parents feel like good parents

Parents in dual-income families often find it hard to spend time with their children and complete all the tasks they have assigned themselves. This imbalance between family and work often makes parents feel like bad parents. A smart home might help parents accomplish their myriad of chores so that they might be able to better focus during their time interacting with their children. But our needs validation sessions revealed a careful line that automation needs to consider. Participants indicated that activities such as waking up their children, choosing outfits, dressing small children, and cooking were a lot of work, and stressful, but also make parents feel like good parents. These activities provided opportunities to have quality interactions with their children, and to teach children skills

necessary for succeeding in life. Thus smart home designers need to be wary of simple automation as a universal answer to all possible problems. It is important to understand which activities make parents feel good about themselves as parents and which just feel like work.

We found parents really want more time for doing activities that are important to them–that are closer to their sense of identity. To create more time for parents and enhance the qualities of parenting activities as a result, a smart home could assist with mundane tasks. For example, while automating cooking might remove the opportunity to feel like good parents from parents, an automated shopping list could cut preparation time and prevent mistakes such as forgetting to buy essential ingredients. This "gift of time" could create new opportunities for parents to perform parenting activities in the way they desire.

In our needs validation, parents also expressed they would like to have more information that could enrich their activities as parents–recipes, school information, etcetera. One scenario involving educational support provides a good example of this need (Figure 12-10). In the scenario, a smart home notifies parents about subjects that their children are studying, and suggests possible ways to participate in their education such as aiding with simple scientific experiments that could complement what children are learning in school. This allows parents to naturally initiate dialogue with children and engage in their education in a constructive way, and provides an opportunity for parents to engage children and bring learning out of the classroom and into the world.

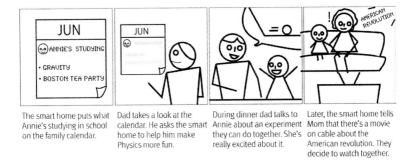

The smart home puts what Annie's studying in school on the family calendar.

Dad takes a look at the calendar. He asks the smart home to help him make Physics more fun.

During dinner dad talks to Annie about an experiment they can do together. She's really excited about it.

Later, the smart home tells Mom that there's a movie on cable about the American revolution. They decide to watch together.

Figure 12-10. A storyboard that illustrates how a smart home may provide an educational opportunity for parents.

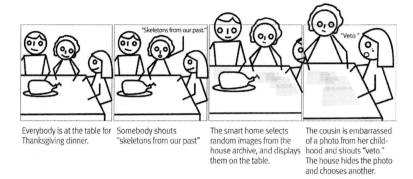

Everybody is at the table for Thanksgiving dinner.

Somebody shouts "skeletons from our past"

The smart home selects random images from the house archive, and displays them on the table.

The cousin is embarrassed of a photo from her childhood and shouts "veto." The house hides the photo and chooses another.

Figure 12-11. A storyboard that illustrates how a smart home may reinforce family bonds by supporting easy creation and retrieval of memories.

Increase emotional connectedness

Emotional bonds are a central driving force that ties all family members together. These emotional bonds are reinforced by "family activities," such as Sunday dinner or vacations together (Darrah et al. 2001). During our needs validation, our families welcomed a smart home service that could facilitate and enrich these activities. For example, a smart home could enable easy creation and retrieval of memories. This could ultimately reinforce the emotional bonds among family members (Figure 12-11).

4. Discussion

In this section, we review our design process and provide reflections on how the focus on emotional experiences helped us identify opportunities for a smart home. We also elaborate on issues of automation that were revealed in our study and suggest how designers can tackle these problems.

4.1 Emotion

The focus on emotional experiences allowed us to expand our design scope beyond the traditional pursuit of improving productivity. By taking into consideration both negative and positive experiences of families, we generated smart home concepts that addressed not only problems in their daily routines, but also concepts that provided more opportunities for pleasure from things that families enjoy.

In particular, our contribution is that we explicitly identified the overlap between parents' core concerns and their emotional experiences from daily activities. Desmet et al. suggests that people get greater emotional satisfaction from cars with appearances that match people's values than from ones with non-matching appearances (Desmet et al. 2004). Similar to this study, we sought to address activities that contribute to parents' positive self-images to maximize the positive effects that a smart home can have. This focus helped us prioritize the myriad of families' emotional experiences observed in our fieldwork and address experiences that people really value.

4.2 Automation

Automation has lessened some of the burden of human labor and made human tasks more efficient (e.g., washing machine); yet automation cannot be an answer to all the problems that people have. Some tasks would simply resist automation. People desire to perform tasks that they enjoy or tasks that are important in constructing their positive self-images. For example, our needs validation sessions revealed that parents do not want to automate activities that are meaningful to them as parents, such as selecting children's clothes in the morning, even though they are time-consuming and stressful. Thus, it is critical for designers to understand the lines that distinguish tasks that people want to automate from the ones that people do not.

Designing an automated system requires more than just a distinction between tasks. To design a system that assists tasks where people desire the convenience from automation, designers need to carefully consider what is an appropriate level of automation to employ. Some tasks require more involvement of human control than the other tasks. For example, people may want to have options to choose what route to take to go to a destination rather than following the one route that their automatic navigation system recommends However, in other circumstances, people may just want to give full control to the system like a central air conditioning system and not bother with the details of interaction. This may be also affected by people's context such as busyness. People may want an automated service when they are busy, but want to perform tasks by themselves when they have some free time and place an important personal value on that task.

As a design method to help designers understand the right level of automation and the influence of contexts, we propose a user test with hypothetical scenarios, each representing a different level of automation for the same task (Table 12-2). By a different level of automation, we mean how much involvement the system requires from people. For example, low automation can be a system that offers a complete set of decisions about how to complete a task, medium automation represents a

Automation	Scenarios of smart home intervention		
	Last-minute meeting and a parent cannot pick up his/her child.	Parents need to bring snacks to school for his/her child's school activity.	All the family members gather for a holiday.
High level	A smart home arranges a ride and informs the parent.	A smart home adds snacks to a shopping list and schedules shopping.	All the family members gather for a holiday.
Middle level	A smart home contacts friends and neighbors, and relays their responses to the parent.	A smart home adds snacks to a shopping list and prompts the parents to schedule shopping.	A smart home takes photos of the family during the gathering.
Low level	A smart home provides the parent with the list of people and their schedules.	A smart home displays that the parents need to add snacks to a shopping list.	A smart home asks the family whether to take photos of them when it judges that there is an active event.

Table 12-2. Exemplary scenarios that describe different levels of automation offered by a smart home system.

system that executes a particular task completion upon human approval, and high automation is for a system that automatically performs some task-related action and informs the human of this action only if asked (Sheridan 2002). Testing these scenarios with people will allow designers to learn whether people want assistance, and if so, what levels of automation people desire (Davidoff et al. 2007).

5. Conclusion

In this paper, we have presented two roles that we believe a smart home could play in family life: helping to regain control over their lives and providing opportunities to improve family life. These two roles represent different ways that a smart home could help families regain more control over their lives. We derived these roles from an ethnographic study of dual-income families and needs validation sessions, where we evaluated concepts developed based on the findings of our ethnographic study. Most of the research on smart homes and end-user programming focuses on the control of devices. However, what dual-income families really want is control over their lives–being relieved from the stress of breakdowns in the daily routines, and getting emotional satisfaction through the things they value. We believe a smart home can help families regain their control over their lives by helping families avoid breakdowns caused by deviations in their daily routine, and providing opportunities for family members to give their time and attention to each other, especially for activities that support the construction of a family identity. In the future, we plan to build a smart home that plays these two roles. We also plan to evaluate how well it is incorporated in family lives and how much it helps families feel in control over their lives.

Works Cited

Beech, S., Geelhoed, E., Murphy, R., Parker, J., Sellen, A. and Shaw, K. (2004). *Lifestyles of working parents: Implications and opportunities for new technologies.* HP Tech report HPL-2003-88 (R.1).

Cowan, R.S. (1989). *More Work for Mother.* London: Free Association Books.

Crabtree, A., Rodden, T., Hemmings, T. and Benford, S. (2003). Finding a place for ubicomp in the home. In *Proceedings of Ubicomp 2003*, 208-226.

Darrah, C.N. and English-Lueck, J.A. (2000). Living in the eye of the storm: controlling the maelstrom in Silicon Valley. In *Proceedings of the 2000 Work and Family: Expanding the Horizons Conference.*

Darrah, C.N., English-Lueck, J. and Freeman, J. (2001). *Families at work: An ethnography of dual career families.* Report for the Sloane Foundation (Grant Number 98-6-21).

Davidoff, S., Lee, M.K., Yiu, C., Zimmernan, J., and Dey, A.K. (2006). Principles of smart home control. In *Proceedings of Ubicomp 2006*, 19-34.

Davidoff, S., Lee, M.K., Dey, A.K., and Zimmernan, J. (2007). Rapidly exploring application design through speed dating. In *Proceedings of Ubicomp 2007*, 429-446.

Desmet, P.M.A. (2002). *Designing emotions.* Delft, Delft University of Technology.

Desmet, P.M.A., Hekkert, P., and Hillen, M.G. (2004). Values and emotions: an empirical investigation in the relationship between emotional responses to products and human values. In *Proceedings of Techne: Design Wisdom 5th European Academy of Design conference*, Barcelona, Spain.

Desmet, P.M.A. and Hekkert, P. (2007). Framework of product experience. *International Journal of Design*, **1**(1), 57-66.

Ducheneaut, N., Smith, T.F., Begole, J.B. and Newman, M.W. (2006). The orbital browser: Composing ubicomp services using only rotation and selection. In *Proceedings of CHI 2006, 321-326.*

Elliot, K., Neustaedter, C. and Greenberg, S. (2005). Time, ownership and awareness: The value of contextual locations in the home. In *Proceedings of Ubicomp 2005*, 251-268.

Frissen, V.A.J. (2000). ICTs in the rush hour of life. *The Information Society*, 16: 65-75.

Hayghe, H.V. (1989). Children in 2 worker families and real family income. In *Bureau of Labor and Statistics' Monthly Labor Review*, **112**(12), 48-52.

Humble, J., Crabtree, A., Hemmings, T., Åkesson, K., Koleva, B., Rodden, T. and Hansson, P. (2003). "Playing with the bits": User-configuration of ubiquitous domestic environments. In *Proceedings of Ubicomp 2003*, 256–263.

Jahnke, J.H., d'Entremont, M. and Stier, J. (2002). Facilitating the programming of the smart home. *IEEE Wireless Communications*, **9**(6): 70-76.

McCalley, L. T., Midden, C. J. H. and Haagdorens, K. (2005). Computing systems for household energy conservation: Consumer response and

social ecological considerations. In *Proceedings of CHI 2005 Workshop on Social Implications of Ubiquitous Computing.*

Mozer, M. (1998). The neural network house. In *Proceedings of AAAI Symposium on Intelligent Environments*, 110-114.

Norman, D.A. (1994). How might people interact with agents. *Communications of the ACM*, **37**(7): 68-71.

Sheridan, T.B. (2002). *Humans and automation: system design and research issues.* Wiley-Interscience.

Taylor, A. and Swan, L. (2005). Artful systems in the home. In *Proceedings of CHI 2005*, 641-650.

Tolmie, P., Pycock, J., Diggins, T., MacLean, A. and Karsenty, A. (2002). Unremarkable computing. In *Proceedings of CHI 2002*, 399-406.

Truong, K.N., Huang, E.M. and Abowd, G.D. (2004). CAMP: A magnetic poetry interface for end-user programming of capture applications for the home. In *Proceedings of Ubicomp 2004*, 143-160.

Venkatesh, A., Chuan-Fong, E.S. and Stolzoff, N.C. (2000). A Longitudinal analysis of computing in the home based on census data 1984-1997. In *Proceedings of HOIT 2000*, 205-215.

CHAPTER THIRTEEN

THE LYON PARC AUTO CASE STUDY: A POLYSENSORIAL APPROACH?

FABIENNE MARTIN-JUCHAT AND MARC MARYNOWER

1. Introduction

Innovative practices require that we, researchers, question ourselves as to our ability to analyse and understand them. The main objective of this article is to give an account of an exchange between a communication professional and a researcher in Information and Communication Science, in order to analyse the reasons behind the success of a communication project which integrates environmental design.

The redefinition of the identity of multi-storey car parks in the city of Lyon (semi-public company Lyon Parc Auto: LPA) through design enabled the transformation of the type of relationship that is usually established between users and this type of place. Traditionally, car parks are considered throughout the world to be a source of anxiety and not very appealing, ordinary but unsightly. The objective of LPA's project, by rethinking these spaces, was to not only transform the emotions evoked by them, but also and as a result, transform the very image of this urban function incarnated by the LPA company.

An analysis of the environmental design and of the signposting of the LPA car parks will be carried out, by crossing the main theories stemming from the sociology of users with the methodological tools used in sociosemiotics. In this way, we will be able to clearly measure the changes which have taken place in the relationship with car parks, thanks to work on the visual identity and the design of the LPA environment. It should be noted that this work on the physical aspects of the car parks was

accompanied by training measures for the staff in customer relations and regular information to the press, to inhabitants of the area and to opinion leaders.

1.1 Case study

At the beginning of the 90s, the city of Lyon decided to entrust LPA with the construction of new car park buildings. The Communiquez group (specialised in public communication, identity and design) was commissioned to carry out an ethnographic field survey to observe the way in which motorists felt about the existing car parks, and to understand "the reasons" behind the car parks' mediocre image. The results of this study were used to help develop a guiding document setting out the requirements for the design of a new generation of car parks (treatment of spaces for pedestrian and vehicle circulation, signposting, light, welcome and security....), for which Georges Verney-Carron (President of Art/Entreprise, a company within Communiquez group) would be in charge of the artistic leadership.

The principle of the work was to form multi-disciplinary teams, bringing together, alongside structural architects, an interior architect–Jean-Michel Wilmotte–and a graphic designer-signpost specialist–Yan D. Pennor's–who together would design the graphic charter outlining the common identity for all the car parks, and a guest artist invited to work on a car park by car park basis, for "in situ" work (such as Daniel Buren, Joseph Kosuth, Mat Mullican, François Morellet, Marin Kasimir, etcetera).

As this team worked together on the interior scenography from the earliest stages of each project, the design and artistic dimensions of these car parks were not simply a fleeting lick of polish on the surface but, on the contrary, totally interwoven into the durable work of the structural architects.

With this work bringing together art, architecture and design, LPA opened the way for the car parks to be experienced in a different way, designed as real entrance ways in a human-sized city.

In the context of this communication, we are going to focus our analysis on the elements of LPA's design (integrating artistic contributions) and signposting so as to highlight their roles in the redefinition of the representations that individuals might have concerning:

- car park buildings;
- their use (which is to say the thoughts and emotions resulting from immersion in a car park or, more precisely, the various actions and interactions taking place in a car park.);
- the image that LPA receives in return, or in other terms, the image of the user according to LPA.

2. The basis of LPA identity through design: Wilmotte's interior architecture, Pennor's' signposting, artistic works

Jean Michel Wilmotte, architect, town planner and designer, is internationally renowned and works all over the world. His agency has developed the concept of "interior architecture within cities", a new approach to the treatment of urban spaces which involves surface coating (floors, walls and facades), planting, lighting, urban furniture and transport. According to Jean-Michel Wilmotte,

People, the city, the movement in the streets, the swaying of a tree, the space explored to the rhythm of walking: this is the first task, the work site to discover, whether it be New York, Paris, Le Puy-en-Velay, Beyrouth, Tokyo, Seoul. For an architect it's always the same essential frame: the space to decipher (http://www.wilmotte.com/pge/homepage).

For LPA,

Jean-Michel Wilmotte's scenography deliberately played the harmony and softness card, without being completely free of a certain rigorousness. The indirect lighting, the transparency of the walls are accentuated by the geometry of the structures treated in black and by the dull grey of the dividing walls. Here, the glass, the metal, the bare concrete come together to carry the image of modernity of Lyon Parc Auto through their own contemporary resonance. He brings back the memory of these places, by drawing for example the arches of the interior helix of the Celestins echoing Italian style theatre.
http://www.lyon-parc-auto.com/fr/sensible/sb.html).

Figure 13-1. Purpose: changing the global image of car parks. Manner: car parks as historical monuments with Daniel Buren's contribution.

Different artists duly signed the works of art integrated into the parks :
- Daniel Buren in Célestins park: "Sens dessus dessous " (Figure 13-1);
- Dror Endeweld in Berthelot park: "Innommable, Innombrable";
- Matt Mullican in Terreaux park: "Sans titre";
- François Morellet in République park: " Les hasards de la République";
- Michel Verjux in Croix-Rousse park: "De plain-pied et en sous-sol";
- Marin Kasimir in Saint Georges park: "three panoramic photographs".

Figure 13-2. Purpose: transforming the communicational identity of LPA. Manner: choosing Yan D. Pennor's, an internationally-known typographer.

These works designed "in situ" answer the architecture of the place and give a reading associating the park with the history of the district, supporting a better "inside/outside" bond.

F. Dagonet rightly reminds us of the lexical closeness of the term "design" with the French term "dessein", which means "project" or "programme". Design is indeed at the service of a company project the mission of which is to propose a new scenario of use to its clients. Furthermore, the term "design" also refers to "dessin" [drawing] which, according to Dagonet, *"gives importance to the reshaping and the distribution of elements"* (Dagonet 2005). Moreover, the visual identity of LPA (which is essentially expressed through signposting applications) was reworked by the graphic designer Yan D. Pennor's.

Yan D. Pennor's claims to be a meticulous craftsman. He became internationally known as a typographer for renowned companies and institutions such as Sofitel and Larousse. He also designs objects, furniture and luxury product lines. He has worked for Laguiole, Pierre Hermé, Fauchon and many others.

Yan D. Pennor's reshapes and redistributes elements which carry meaning, the meaning which will be attributed to the company. In this respect, it is indeed *"the combination of invented and retrieved signs, born from a stroke and/or colour which best characterise the work of Pennor's"* (Heilbrunn, 2005: 86).

For LPA, ...deliberately minimal, the sign markings designed by Yan D. Pennor's is free of all superfluous signs. It is content to accompany a path which is already coherent by its design. Carriers of image for Lyon Parc

Auto, elegance and rigorousness mark the signs and the typography. Information is presented in two ways: in yellow on a black background for motorists, in black on a yellow background for pedestrians. (http://www.lyon-parc-auto.com/fr/sensible/sb.html)

3. Theoretical issues

The values for use are the fruit of an immersion in a multi-semiotic space, which will generate emotions then representations (Blandin, 2002). The sense attributed to a place, arising from an activity, in this case that of parking, is deeply embodied in a practice. This type of acknowledgement is rich in theoretical consequences as it deconstructs the cybernetics notion of the interpretation process. Representations are the fruit of an activity which not only involves cognition but also the emotions and physical actions produced in an environment.

As an extension of cybernetics, such as is developed by cognitivism, representations are abstract and logical units that it is possible to extract from their context of production. Representations are made up of symbols, defined as formal elements, which refer to the real world by a relationship of equivalence. Cognition amounts to an activity of treating these symbols. Interpretation is the activity of finding the middle ground between the representations of objects in the world and their references. Cognition is an activity of treating the information from the representations. Cognition is a mental activity involving the reason. Finally, reception can be reduced to a simple activity of treating a space of symbolic representation.

Indeed, recent research in neurosciences (Petit 1999; Petitot 2003; Berthoz 1997) and in semiotics (Landowski 2004; Fontanille 2004) integrated into the sociology of usability and practice (Blandin 2002) allows us to revisit these post-cybernetic notions of the way in which things make sense to us. Any symbolic interpretation activity of a space or multi-semiotic action is fundamentally embodied in a practice, which appeals to emotions. Any activity of appropriating artefacts (machines, instruments, etcetera) is carried out in and by their use. Any activity of receiving a place, a space, is immersive in the sense where it involves a user in his/her entirety (physical and mental).

Meaning, as a system of values attributed by a place, is the product of a real-life experience, which is both cognitive (thoughts), physical (the movement generated by the use) and above all emotional (all the positive and negative emotions which result from this use). These emotions give

meaning to a theatrical space, giving it value. Moreover, the emotions experienced during the visit generate an overall feeling of identity, which will be attributed to the place.

More precisely, from the entrance to the exit of a car park, the user will repeat scenarios of action which will appeal to him/her in a polysensorial manner (look, move, smell, listen, etcetera). Each action which makes up the use of the car park and its artefacts (take the ticket at the entrance, find a space for the vehicle, park, continue on foot, look for the lift, go up the stairs, go out, then, later on, pay the car park attendants or at an automatic machine, find the car, drive to the exit, go out) will thus generate thoughts and emotions which either will or will not add to the image of the car parks, those of LPA as a company, and especially the image that the user has according to LPA.

It is therefore a matter of understanding how, by reworking the design of a place, it is possible to change the values and the emotions generally attributed to this type of place. From a semiotic point of view, it is a question of developing a semiotic of the mark. The places touch the users, leaving impressions which are mental, emotional and sensorial This process constructs the meaning which will be attributed to the place. From a methodological point of view, this implies describing in detail the characteristics at an expression level of the theatrical measure and of the signposting (see tables) in order to understand in a heuristic manner what they can generate at a content level (in the form of thoughts or emotions).

4. Methodology

4.1 Methodology of analysing the signposting

The visual identity of an institution or of a brand is usually structured on three levels[1] :

- The level of discursive expression, where the manner in which the visual identity presents itself in a certain form to the client/user shows itself and will be analysed. This level takes into consideration the visual codes of the time, the production techniques of the image and the constraints or advantages of the

[1] We will use, in this article, a simplified version of the analysis model of visual identity, put together from the writing of semioticiens such as R. Barthes, U. Eco, J.M. Floch, L. Hjemslev, F. Saint-Martin, reappropriated by Heilbrunn and Hetzel in Sciences de Gestion/Marketing.

representation supports. Colours, shapes, their topology and their vectorialisation make up this level of expression.

- The content level, where the meaning that will be attributed to the institution by the means of the expression of its visual identity is thought out. This meaning will be reconstructed by the receiver by the act of reception, including the emotions which will be associated. By interpreting the expression, the receiver builds him/herself a representation of the institution and above all of the manner that it conceives relationships. The visual identity thus implies a conception of the client, a model of the user: his/her personality, cognitive and in particular emotional structure, the style of relationships with the institution and its services.
- The axiological level, where the values of the institution in a system of opposites and complementarities (often represented as a semiotic square) can be revealed. This level allows the main principles, which feed the institution's action towards its clients via the act of buying services, to be highlighted. This level can be summarised in the form of promises of added value, values promising to be acquired through the act of consuming (Baudrillard, 1968).

This three-level model only has a heuristic and explicative value. It does not claim to describe the path of elaboration followed by the designers, nor the real interpretative path of the users/clients.

4.2 Methodology of analysing the environmental design (integrating art)

As far as the theatrical design or environment design are concerned, it is the different actions or interactions (manipulate, see, hear, move, find bearings, smell, etcetera) with or without a car, in the LPA car parks which will provide the user with a new image of a car park building, of its use, of LPA and above all of the image that LPA has of its clients. Moreover, the environment design provides an embodied identity, an identity in relation, in action and in emotion for LPA.

Beyond the design conceived to facilitate the different processes of action and interaction carried out in a car park building, the scenography work for these car parks clearly had the objective of transforming the representations and especially the emotions usually associated with this type of place and its practices (Thomas, 2006). Leaving behind the not

very reassuring, anxiety-inducing, unsightly dimension , the new car parks would have to generate feelings of attractiveness, well-being, confidence, and harmony so as to render their use more pleasant and efficient.

Indeed, the postulate is that the energy lost in difficult manoeuvres or complicated actions (during the different phases which characterise the use of a car park building), in the negative emotions resulting from an anxiety-inducing atmosphere, disturb the use of a car park and as a consequence negatively affect the image of the company which manages it.

The objective was thus for the designers to facilitate and to improve the various actions and interactions taking place in the car park (circulate, find bearings, walk, park) but also the emotions generated from the sensorial appeals in this place (odours, sounds, lights, etcetera) and thus to not only make this activity ergonomic but also more harmonious, giving the image of a place which is respected by the users.

Better still, the feeling of well-being and of harmony is the product of the balance between thoughts, emotions and actions generated by the use of the place, of an artefact, of an instrument (Berthoz, 1997). If there are too many emotions, the thoughts and actions risk being disturbed. If there is too much physical effort (to park) or intellectual effort (for example orientation or memorisation) required, the action will be hindered. The purpose of a car park's use is to allow the user to free his/her thoughts so that (s)he can dedicate his/her time to the reasons why (s)he came to park in this area (shopping or business for example). All actions will be more efficient if they are made "routine" by an accompaniment throughout the client's course (the role of signposting), and if his/her thoughts are not disturbed by negative emotions (the role of lighting and the attractiveness of the place) or too complex manoeuvres (the role of ergonomics). The objective of the design of the car parks is to avoid losing energy in the manoeuvres and long and difficult actions, which are time consuming and likely to trigger stress and annoyance: take a ticket, find a lift, park the car, find it again, etcetera.

5. Analysis

In this last section, our intention is to analyse the graphic and environmental identity of the new LPA car parks. It is a matter of artificially deconstructing the interpretation process as it was thought out by the project team, while resorting to a methodology stemming from the semiotics of impression (Fontanille, Landowski) and of the sociology of

uses. In other words, our aim is to understand the reasons for which the signposting combined with the design of the Lyon car park buildings allowed the image of LPA to be transformed through work on modifying the thoughts, emotions and actions which are normally generated in this type of place.

5.1 Yann D Pennor's' signposting

Level of discursive expression	Highway code	Pennor's signposting
Colours	Blue, red and white Chromatic opposition	Golden yellow and black Chromatic opposition
Shapes	Basic geometrical shapes, standard typography and icons	Streamlined (oval) and re-dimensioned geometrical shapes, redesigned typography and icons
Topology	Logic of overlapping shapes of balanced proportions	Logic of overlapping shapes to reinvent a new balance
Vectorialisation	Static shapes	Dynamic shapes
The content level		
Colours	Universe of the law and the State's authority	Universe of elegance, sobriety and luminosity
Shapes and combinations	Reason, coldness and authority	Creativity, passion and relationship Sensitivity, attractiveness and humanity
Emotions	Few emotions suggested	Attractive feelings suggested

The axiological level		
Principles / Mission of public service	The Ministry at the service of equipment	LPA at the service of the user, central preoccupation not the building but its use
Commercial Promise		Facilitate and make the use of the car park appealing again

Table 13-1. Comparing Yann D. Pennor's signposting propositions with classic highway code examples.

To analyse the added value of Yann D Pennor's' signposting, we have compared his propositions with classic examples from the highway code. We are going to successively analyse the expression level (colours, shapes, topology, vectorialisation) then the content level (the guiding principles of which–the main values–define LPA's identity).

5.2. Jean-Michel Wilmotte's environmental design

In order to analyse the work of Jean-Michel Wilmotte, we have compared a classic "car park" building with a car park conceived by a designer. While looking at the various actions which characterise the use of such a place, we will highlight how the work of a designer allowed the modification of the emotions usually generated by the different actions carried out in the car park (from the entrance to the exit of the car park in a car).

Sensorial functions	Classic "car park"	Wilmotte's environmental design (integrating art)
See	Cheerless concrete walls and numerous pillars which impede the view, disrupt the act of parking and cause you to imagine a hidden stranger	Alternation and complementarity between rough, concrete and slabs of concrete, reduced number of pillars Transparent doors, wide pedestrian walkways

	Opaque lift doors, narrow stairs Direct and uniform lighting	Indirect light (less shadow) and adjusted light (intuitive signposting at pedestrian exits)
Hear	The car parks are often "screechy" and resonant	Acoustic soundproofing work through ground paint and music
Smell	Bad odours	Deodorising then reodorising
Orientate, circulate	To park: spaces at a right angle to the circulation To find the space again: several criteria to memorise To move on foot: signposting necessary	To park: spaces at an angle facilitating the manoeuvres and dictating, when leaving, the direction of the circulation To find the space again: one single criterion to memorise To move on foot: minimal signposting, intuitive orientation
Suggested emotions		
See	Unappealing and anxiety-inducing concreteplace for storage Pillars: impede view, fear of a hidden person, fear of scratching the car Opaque doors: anxiety-inducing Direct light: aggressive	The car park is a pleasant place where it is possible to experience aesthetic emotions Few pillars: reassuring Transparent doors: reassuring Indirect light: comfort, softness, intimate
Hear	Disagreeable and stressful noise	Reduced noise and music: reassuring
Smell	Bad odours: disagreeable and repulsive	Neutral odours

Orientate, circulate	Difficult and distressing	Facilitated by the light and ground markings: natural and reassuring

Table 13-2. Comparing a classic "car park" with a car park conceived by a designer.

5.3 Examples

Circulation to park: spaces at an angle facilitating the manoeuvres and dictating, when leaving, the direction of the circulation`
To find the car again: a single criteria to memorise
Orientation facilitated by the light and ground markings: natural and reassuring

Figure 13-3. Example "orientate/circulate"

Transparent doors: reassuring	Indirect light: comfort, softness, intimate

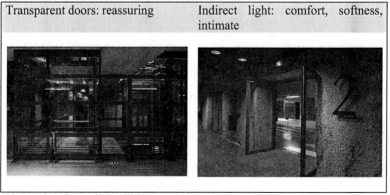

Figure 13-4. Example "see" (1)

Artistic lighting by Michel Verjux, in Croix-Rousse park, Lyon	The car park is a pleasant place where it is possible to experience aesthetic emotions

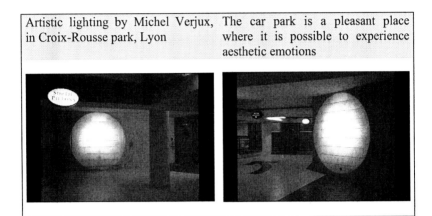

Figure 13-5. Example "see" (2)

6. Conclusion

"In situ", we cannot separate the signposting, the artistic and design work for analysis, although the three elements were intended to be completely interconnected. In all these car parks, LPA combines comfort, meaning and beauty so that inside as outside, the car park is integrated by again providing directions into each district of the city.

In a slightly artificial manner, we separated the signposting and design work for analysis, even though the two elements were originally conceived as being completely interconnected. The design is at the service of the signposting, indeed *is* even, at times, signposting, in the sense that it indicates a direction, a path, or even a drawing, a life project within the car park. For example, the accentuated lighting at the pedestrian exits compared to that at the parking spaces naturally orientates the user towards the exits, without cognitive overloading or anxiety. The angled parking spaces intrinsically dictate the direction of the circulation and reduce the amount of signposting.

A conception methodology placing the user and his/her parking practices at the heart of preoccupations was applied upstream with success by the actors of a project of rethinking of Lyon's car parks. The design work combined with the signposting made the latter less visible, lighter but more intuitive. This considerably modified the emotions and representations usually associated with this type of urban function. Freeing thoughts by facilitating the actions carried out in a car park building;

generating a feeling of balance and harmony by combining more pleasant auditory, olfactory, visual and corporal sensations than in a classic "car park", participate in a feeling of respect for the user. LPA, by expressing this respect, induces an ethic model of the user, which could only have direct consequences on its own company image. In this way, by combining ethics and aesthetics, LPA built an identity, that of an institution, which places human values at the heart of its preoccupations. Emotions and aesthetic feelings, considered in most projects to be pointless and not very profitable, have fully found their place here, showing that profitability can also occur through clients' physical, psychological and emotional comfort.

Works Cited

Berthoz, A. (1997). *Le sens du mouvement*. Paris: Odile Jacob.

Blandin, B. (2002). *La construction du social par les objets*. Paris : PUF, 2002.

Dagonet, F. (2005) Et si on changeait de valeurs. *D. Day : le design aujourd'hui*. Paris: Centre Pompidou editions, 46-49.

Damasio, A.R. (2002). *Le sentiment même de soi: corps, émotions, conscience*. Paris: Odile Jacob, 2002, 1ère ed. 1999.

Fontanille, J. (2004). *Soma et Séma*. Paris, Maisonneuve & Larose.

Heilbrunn, B. (2001). *Le logo*. Paris: PUF.

—. (2005). L'empreinte de la marque. *D. Day : le design aujourd'hui*, Paris, Centre Pompidou editions. 82-87.

Hetzel, P. (2002). *Planet Conso: Marketing Expérientiel et nouveaux univers de consommation*. Paris: Ed. des Org.

Landowski, E. (2004). *Passions sans nom*. Paris: PUF.

Petit, J.L. (1999). La constitution par le mouvement : Hurssel à la lumière des données neurobiologiques récentes / Constitution by movement : Hurssel in light of recent neurobiological findings. In Petitot, J. (Ed.), *Naturalizing Phenomenology: Issues in Contemporary Phenomenology and Cognitive science*. Standford, Stanford University Press, 220-244.

—. (2003). *Introduction du numéro d'Intellectica : repenser le corps, l'action et la cognition avec les neurosciences*. n°36-37.

Petitot, J.J., Varela, F., Pachoud, J., Roy, B. and Roy, J.-M. (1999). *Naturalizing phenomenology : issues in contemporary phenomenology and cognitive sciences*. Stanford: Standford University Press.

Thomas, R. (2006). Environmental Design–*An Introduction for Architects and Engineers*. London: Taylor & Francis Book.

CHAPTER FOURTEEN

CREATING ATMOSPHERES–
THE EFFECTS OF AMBIENT SCENT
AND COLOURED LIGHTING
ON ENVIRONMENTAL ASSESSMENT

ELLY P.H. ZWARTKRUIS-PELGRIM,
JETTIE H.C.M. HOONHOUT,
TATIANA A. LASHINA,
YVONNE A.W. DE KORT
AND WIJNAND A. IJSSELSTEIJN

1. Introduction

To most people home means far more than a place that provides shelter, something which is reflected in the old adage *my home is my castle*. People spend substantial amounts of effort and money on making it their own special place. Although most of the time we are not consciously aware of it, two factors have a large impact on how we assess homes and other places: lighting and odour. Scents of coffee and freshly baked pie can give even the most formal living room a "homely" feeling, and different lighting conditions can make us feel comfortable and relaxed or tense and uneasy. But even though lighting and scents are considered to be important atmosphere creators, little knowledge appears to exist into how the combination of these factors affect an individual's experience of an environment. Even less data is available about the combined effects of *coloured* lighting and fragrances.

Perhaps surprisingly, the scientific literature contains only few studies that indicate that either ambient scent or (coloured) lighting directly affects

people's moods. For example, in her meta study Dalton (2002) reports little evidence of the effectiveness of either pleasant or unpleasant odours to modulate worker's mood or performance. The same appears to apply for lighting. For example, in their review of studies on full-spectrum fluorescent lighting, McColl and Veitch (2001) conclude that in general the evidence does not show dramatic effects of lamp type on arousal, stress, performance and depression. On the other hand, a number of studies demonstrated that fragrance or lighting (not necessarily tested in combination), did affect the assessment, or evaluation of places such as shops, lobbies or offices (e.g., Clifford 1985; Spangenberg et al. 1996). Environmental assessment comprises both affective (how people appreciate, or feel about a place), and descriptive reactions (e.g., whether a place appears cleaner, larger, more spacious).

Literature reporting on the effect that (coloured) lighting and scents have on people's judgement of an atmosphere is already scarce, even less is published on how combinations of these factors affect individuals' experience of environments. Yet lighting and scents, and their combinations, provide potentially powerful means for influencing the appearance and appreciation of spaces. Such applications would be interesting for public spaces which aim to project an image of quality or hospitality, e.g., hotel rooms, lobbies, and waiting rooms. However, as said, the combined effects of fragrance and lighting on environmental assessments have not been studied to date and theory is still lacking to be able to predict specific behavioural and/or affective effects of fragrance and lighting on people. In addition, several practical problems arise in the application of scents, such as the variability between individuals in their sensitivity and their liking for certain scents, scent neutralization and maintaining a constant scent concentration. These problems might have well contributed to the fact that fragrances are not commonly used as behavioural modifiers in commercial environments.

Given that still little is understood about the combined effects of fragrance and lighting on environmental assessments, predicting specific behavioural and/or affective effects of specific combinations, or even determining the optimal combination for a particular situation, is virtually impossible. For this reason, a series of tests were conducted, in which we explored how combinations of scents and lighting settings might help to establish a more positive assessment of a location with which one is not familiar, but where one is going to spend some time, and where one would like to feel comfortable–such as a hotel room.

2. Effects of fragrance and lighting on environmental assessment

In contrast to reports of only modest effects on mood, or an emotional state, several studies demonstrated significant effects of ambient scent and lighting on environmental assessment. Spangenberg, Crowley and Henderson (1996) studied the effects of scents in a retail environment. They found that evaluations of the store overall, of the store environment and of the merchandise were more positive when the store was scented than when it was not scented. Little difference was found among evaluations of the store when it was scented with affectively pleasing scents (for which the researchers choose spearmint and orange) versus affectively neutral scents (for which the researchers selected lavender and ginger). The authors concluded that the specific scent used does not matter as much as the presence of a scent. In a comparison of otherwise identical rooms by Clifford (1985), respondents indicated that the room containing a (very modest) level of fragrance was judged to be brighter, cleaner and fresher (none of the participants noted the scents). Hellema (1994) found similar results in a study, in which participants perceived a scented room as larger than an unscented one. Vroon (1989) even claims that it is possible to have an ugly interior judged as tasteful by adding a pleasant odour.

Apart from studying the effect of the mere presence of fragrances on people's assessment of the environment, other researchers have made a distinction between the effects of congruent (i.e., matching the theme/connotation of the setting), versus incongruent scents (i.e., not matching, as in the case of, for example, a tropical scent in a room with a pine forest theme). Some odours, although generally perceived as pleasant, may be viewed as inappropriate in a particular context (Bone et al. 1999), which might affect people's judgments.

Schifferstein and Blok (2002) studied the effects of congruent and incongruent ambient scents in a retail setting. They found that the presence of a pleasant ambient scent did not affect sales in general. In addition, ambient scent did not increase sales for a thematically congruent product, nor did it decrease sales for a thematically incongruent product. That is, the sales of soccer and gardening magazines were not increased when a grass scent was released in the store, nor did these scents decrease the sales of women and personal care magazines. However, measuring sales might not have been the most appropriate dependent measurement to study

the effect of ambient scent, since other studies have demonstrated that scents have little direct effects on consumers' spending (Chebat et al. 2003).

Mattila and Wirtz (2001) studied the effects of congruency of two stimuli, music and scent, on consumer experience (pleasure, approach, perceived store environment, impulse buying and satisfaction). However, in contrast to the study of Schifferstein and Blok, Mattila and Wirtz focused on congruency in arousal (slow tempo music with relaxing scent and fast beat music with arousing scent) instead of in semantics (thematic congruence of stimuli). Their findings support the belief that when stimuli in the environment act together to provide a coherent atmosphere, the individual in the environment will react more positively (that is for approach behaviours, impulse buying and satisfaction). Still, a mismatch between the stimuli seemed to provide more pleasure than no stimuli at all. However, the authors note that beauty is in the eye of the beholder and similarly, the appropriateness of the stimuli. Also the novelty can wear off quickly, which might reduce pleasure after a while.

In conclusion, it seems that scents can positively influence environmental assessments, at least of store environments. In addition, the few studies available on this aspect suggest that scents do not need to match the environment semantically, as long as the scent matches other stimuli in the environment in terms of level of arousal.

Most studies investigating the effects of lighting on environmental assessment to date, focused on the effects of white lighting. In one study, Flynn (1992) examined how the location and illuminance of white light affected people's impressions of a room. He found that low-level overhead lighting makes a space feel confined. Low lighting levels in the region of the occupant and higher levels in the peripheral area reinforced privacy. Pleasantness seemed to be enhanced by a moderate illuminance level with non-uniform wall lighting.

Investigating the effects of coloured lighting, Mikellides (1996) found consistent evidence for the notion that red light or red paint induced visual warmth in comparison to blue but only on the cognitive level, not on the physiological level. That is, a room with red light or red paint gives the impression of being warmer, but people do not actually feel warmer. There is merely the suggestion of warmth in response to red.

Although a respectable amount of research has been performed on the effects of colours, apart from the study of Mikellides (1996) no other study was found that focused on the effects of coloured *lighting* on environmental assessment.

From the research outlined above it is clear that both scent and coloured lighting indeed have a potential impact on the experience of an environment. By implementing the right combinations of scent and coloured light in the design of a space, user assessments could be shaped in the direction of higher perceived luxury, newness, comfort or trust. However, determining the right combinations is still a matter of speculation.

The current study aimed to clarify the independent effects of ambient scent and coloured lighting on the user experience and environmental assessment. In addition, the potential interaction effects between coloured light and scent were investigated, both in congruent and incongruent atmospheres. That is, do scents and coloured lighting strengthen or hamper each other in creating a particular assessment of an environment? And what are the effects of congruency of the stimuli on this assessment?

3. Method

3.1 Pre-test

In order to answer the research questions, an experiment was carried out in which three scent conditions were combined with three lighting conditions, resulting in nine conditions (see Table 14-1). Both scent and coloured lighting were manipulated independently on three levels, namely neutral vs. refreshing vs. relaxing. These specific scents and lighting colours were selected on the basis of a pre-test, in which 20 participants (10 male; 10 female) were asked to rate 4 fragrances and 5 coloured lighting settings (red, orange, yellow, violet and blue-green) by means of 7-point Likert scales, determining subjective intensity, pleasure and stimulating/relaxing association. Based on the results, two scents (one refreshing and one relaxing) and two coloured lighting ambiences (one refreshing and one relaxing) were selected as independent variables. These stimuli differed in terms of their relaxing and stimulating associations, but were perceived as equally pleasant. For the refreshing condition a citrus scent and the yellow coloured lighting were selected, whereas for the relaxing

Scent / Lighting	Neutral	Refreshing scent: citrus	Relaxing scent: white laurel
Neutral			
Refreshing light: yellow		Congruent	Incongruent
Relaxing light: violet		Incongruent	Congruent

Table 14-1. Conditions in the main experiment.

condition a white laurel scent (consisting of a mix of, among others, lavender and cinnamon) with the violet coloured lighting were selected. This resulted in two congruent (refreshing-refreshing and relaxing-relaxing) and two incongruent (refreshing-relaxing and relaxing-refreshing) combinations of scent and colour (Table 14-1).

3.2 Main experiment

During the main experiment scents were tested between groups, meaning that each participant evaluated only one scent condition. Coloured lighting was tested within groups, i.e., each participant evaluated all lighting conditions. Thus, participants were assigned to one scent condition and successively experienced all three lighting conditions within that scent condition. Testing scents within groups would involve a time-consuming process of ventilating the room to remove the scents after each measurement. Another disadvantage of a fully within groups design is that participants would experience the same coloured light settings three times (in each scent condition). We feared that this could lead to unwanted accustomization to one lighting condition during the test. Also the participants might become aware of the scent manipulation, of which they were deliberately not told.

3.3 Measurements

During the main experiment the user assessment of the environment was investigated by measuring the subjective affective reaction and evaluation of the environment. This was done by means of three questionnaires. One questionnaire measured the participants' internal affective state and consisted of the "scales of the affective quality

attributed to places" by Russell and Pratt (1981), measuring pleasure and arousal, on a scale ranging from 1 (very inaccurate) to 7 (very accurate). The other two sub-questionnaires measured the evaluation of the environment. The scale of Bell, Holbrook and Solomon (1991) measured perceived unity, aesthetic response, social impression, general liking and intention to own on a scale from 1 (very high) to 7 (very low). The scale of Flynn, Hendrick, Spencer and Martyniuk (1979) measured evaluative response, perceptual clarity and spaciousness on a scale from 1 (very high) to 7 (very low). In addition, questions were added to measure innovativity, comfortable temperature, tidiness and feeling comfortable, also measured on a scale ranging from 1 (very high) to 7 (very low).

3.4 Environmental setting

The experiment was performed in the HomeLab at the Philips Research laboratories in Eindhoven, the Netherlands. HomeLab is a test facility for evaluating product concepts and new technologies in realistic settings (Aarts et al. 2006). HomeLab contains various rooms, among others a kitchen, a living room, and two bedrooms. All rooms are equipped with recording facilities. For this study, the master bedroom was decorated in such a way that it could be presented as a hotel room to the participants. The hotel room scenario was chosen as an interesting setting for people to try out new means to create an atmosphere with coloured lighting-fragrance combinations.

During the pre-test it became clear that the citrus scent was perceived as more intense than the white laurel scent. However, for the main experiment it was essential to ensure equal perception of intensity to avoid bias in the results. Therefore, it was decided to spray the citrus scent less often than the white laurel scent. Based on concentration measurements, it was decided that the citrus scent was sprayed every 7 minutes, while the white laurel scent was sprayed every 4 minutes. During these periods the ventilator was running at the lowest speed to maintain a steady airflow. Spraying was done with an automatic sprayer, containing a piezo element, causing vibration of a needle, which thereby released a drop of a scent. A small fan behind the needle caused the drop to evaporate into the air. The frequency of spraying could be adjusted, from spraying every 2 minutes to every 15 minutes. The scents were sprayed at predefined intervals to create a slightly above threshold perceptual effect and to avoid adaptation.

	Yellow	Neutral	Violet
On the bed	21	15	15
In front of the window	14	12	12
In front of the wall	12	8	9
On the hassock	19	14	14

Table 14-2. Light intensity in lux.

Also the intensity of the lighting conditions was controlled, providing similar, low lighting intensities across the three conditions (see Table 14-2).

3.5 Participants

Ninety individuals between 18-60 years old participated in the study (46 male; 44 female). The average age was 35. Participants with colour blindness were excluded from the study. Smelling problems could not be controlled for since participants were not told beforehand about the presence of scents.

3.6 Procedure

Each lighting condition (atmosphere) was experienced for 15 minutes. In order to become accustomed to the environmental condition, participants were first asked to perform a small assignment before filling in the questionnaire. An example of such an assignment was:

Imagine you have just arrived in this hotel room. Suddenly you are thinking about all the nice places that you've visited in the past. Can you list these places?

After completing this assignment, the participants filled in the questionnaires.

The order of the lighting and scent conditions were balanced to avoid order effects and bias caused by time of the day. Participants were not told

about the presence of the fragrances and coloured lighting before or during the experiment to avoid demand bias.

4. Results

Before testing the hypotheses, factor analyses and scale analyses were performed to construct robust and meaningful dependent variables. Subsequently, the data were analysed employing repeated measures analysis of variance (REMANOVA).

4.1 Scale construction

After recoding, the 10 items measuring experienced arousal in the room (Russell & Pratt, 1981) were combined into one variable by computing the mean for each experimental group (all Cronbach's alphas of the experimental groups were >.8), and labelled "arousal". Similarly the 10 items measuring valence were combined into one variable labeled "pleasantness" (all Cronbach's alphas >.9).

Principal Component Analyses (PCA) were performed on the items from the scales of Bell, Holbrook and Solomon (1991) and Flynn, Hendrick, Spencer and Martyniuk (1979). Subsequently, two variables were constructed:

- Liking (consisting of the items measuring aesthetic response, social impression, general liking, evaluative response, inviting impression, intention to own and feeling comfortable)
- Spaciousness (consisting of the items measuring spaciousness, innovativity, comfortable temperature and tidiness).

The internal consistencies of these scales were acceptable for all experimental groups, with Cronbach's alphas ranging between .94 and .97 for liking, and between .65 and .77 for spaciousness.

REMANOVAs of these four dependent variables are reported below. All analyses were performed employing the full model: 3 (lighting colour, within) x 3 (scent, between).

4.2 Assessment of arousal

The mean scores on arousal for each of the experimental groups and conditions are reported in Table 14-3. Both coloured lighting conditions resulted in higher scores than the white light condition, representing more

arousal. This main effect was significant (F(2,174)=18.44, p<.001). Scores for the violet and yellow light did not differ significantly. There were no remaining significant effects.

	Scent / Lighting	Citrus	Neutral	White laurel	Overall
Arousal	Yellow	4.11	4.15	4.39	4.22a
	Neutral	3.16	3.28	3.41	3.28a,b
	Violet	4.06	3.93	3.85	3.94b
	Overall	3.78	3.79	3.88	
Pleasantness	Yellow	4.99	4.89	5.51	5.13a
	Neutral	4.50	3.86	4.30	4.22a
	Violet	4.71	4.19	4.90	4.60a
	Overall	4.73a	4.31a,b	4.90b	
Liking	Yellow	3.44	3.42	2.85	3.23a
	Neutral	3.81	4.38	3.63	3.93a,b
	Violet	3.52	4.01	3.50	3.67b
	Overall	3.59a	3.94a,b	3.33b	
Spaciousness	Yellow	2.55	3.00	2.44	2.66a
	Neutral	2.94	3.16	2.92	3.01a,b
	Violet	2.69	2.73	2.73	2.72b
	Overall	2.73	2.96	2.70	

Note: (1) For arousal and pleasantness higher scores indicate more positive assessments, for liking and spaciousness lower scores indicate more positive assessments. (2) Identical subscripts within a row or column indicate significantly different group contrasts (p<.05).

Table 14-3. Assessment of arousal, pleasantness, evaluation and spaciousness.

4.3 Assessment of pleasantness

Again, the mean scores are reported in Table 14-3, with higher scores representing more pleasant assessments. Both coloured lighting conditions generated significantly higher scores $(F(2,174)=12.89, p<.001)$ than the white lighting. Yellow was rated as more pleasant than violet. The main effect of Scent was also significant $(F(2,87)=3,76, p=.027)$, with both scented conditions generating more pleasant assessments than the neutral one. No significant interaction effect was found.

4.4 Assessment of liking

Again, the mean scores are reported in Table 14-3, but now higher scores represent less positive assessments. Lighting colour again rendered significant main effects, $(F(2,174)=10.58, p<.001)$. The coloured lighting conditions were rated more positively than the white lighting condition, but no differences were found between the yellow and violet light. The main effect of Scent was also significant, $(F(2,85)=3,95, p=.02)$, indicating more positive evaluations for the scented conditions than non-scented ones. The interaction between Lighting colour and Scent was not significant.

4.5 Assessment of spaciousness

Again, the mean scores are reported in Table 14-3, with higher scores representing less positive assessments (indicating less spaciousness). Also here, Lighting colour generated significant main effects, $(F(2,174)=7.51, p=.001)$. The coloured lighting conditions were rated more positively than the white lighting condition. The main effect of Scent was not significant $(F(2,87)=1,11, p=.34)$, nor was the interaction $(F(4,174)=1.50, p=.20)$.

4.6 Interviews

The evaluations were concluded with a short interview, in which participants were asked whether they had noticed a scent, whether they liked the scent, what their preference for the lighting conditions was and whether they would like to have scent and/or coloured lighting in their own bedroom or hotel room. Out of the 60 scented conditions in the experiment, 47 participants (78%) noticed the scent, of whom 75% thought it was pleasant or acceptable. Most participants preferred the yellow lighting condition (55% compared to 31% for the violet and 15% for the neutral conditions). Participants appeared to be somewhat hesitant

in having scents in their own bedrooms, although they were more willing to try it out in a hotel room. The most important reasons were concerns about the intensity of the scents and participants' health.

5. Discussion and conclusions

The results reported in the literature showed that scents can influence the evaluation of a store environment. The study reported here has demonstrated that scents can also influence the assessment of other types of environment, in this case a hotel bedroom. In general, the room was judged to be more pleasant and was evaluated more positively in both scented conditions than in the unscented condition. There were no significant differences between the two scents employed (which were in fact both meant to be pleasant). In line with earlier studies, the two scent conditions failed to evoke clear differences in arousal (Mattila et al. 2001; Knasko 1992; Fiore et al. 2000), or perceived spaciousness.

The effects of the lighting manipulations were stronger than those of the scents, which is perhaps also partly due to the fact that this was the within groups manipulation. Consistent with the literature, this study demonstrated that lighting positively affected the assessment of an environment. More specifically, both coloured light settings elicited more positive evaluations of the room than white lighting. The room with the yellow lighting was experienced as more pleasurable than the room with the violet lighting. As with the scents, the two coloured lighting settings also failed to generate a clear difference in arousal. Surprisingly however, both colours did result in higher scores on arousal than white lighting, even though the violet lighting itself was associated with a relaxing, i.e., unarousing atmosphere in the pre-test. During the experiments some participants remarked that they were amazed by the experience they had in the violet lighting condition, because it made them feel very relaxed and sometimes even sleepy. These participants expressed this feeling on items of the arousal scale, which was actually intended to measure the opposite of feeling relaxed. Thus although participants informally reported that the violet condition was much more relaxing than the other two lighting conditions, this was not reflected in the data. Potentially violet light in itself is perceived as relaxing, but violet room lighting is not very common and perhaps for this reason perceived as more arousing than white light.

The present experiment did not demonstrate congruency effects between lighting colour and scent. Although the yellow light and citrus

scent were rated "refreshing" and the violet light and white laurel scent were rated "relaxing" in the pre-test, combinations of these did not result in significant interaction effects for any of the four dependent variables. These findings are in accordance with Spangenberg, Crowley and Henderson (1996), Clifford (1985) and Hellema (1994), who all report positive effects of neutral or pleasant scents on evaluative assessments, irrespective of their appropriateness. We conclude that both coloured lighting and pleasant fragrances influence people's evaluative assessments and, in addition, that congruency between coloured light and scent is of minor importance.

The present study focused on relatively short-term effects of coloured lighting and scent on the assessment of an environment. In future studies it would be interesting to investigate whether these effects can be validated over longer periods of time. Such longitudinal studies are especially relevant for environments where people typically spend longer periods of time, such as hotel rooms. Berlyne (1970) argues that when stimuli are new, people engage in specific exploratory behaviour where the novelty of a stimulus is its dominant property. As a person becomes more familiar with the stimulus a diversified exploratory behaviour is employed in which other stimulus properties, such as arousal potential and (perceived) complexity become more important. A longitudinal design with a more naturalistic procedure could also increase the ecological validity of the current findings. Of course, the physical setting was purposefully selected because it presents a naturalistic physical setting, yet the task given to the participants was definitely not typical for a hotel setting. As was argued by for instance David Canter (1991), our evaluation and assessment of places is partly shaped by the purpose of our visit. In other words, our assessment of a hotel room we have actually paid for and plan to spend the night in may well differ from the assessment of the same room as a research participant. However, for practical reasons we decided to design the test in such a way that we would be able to attribute the effects to the experimental manipulation of scents and lighting.

Still, based on the comments of the participants in the interviews, selecting the hotel room scenario as a setting for experiencing enhanced atmospheres, using coloured lighting and fragrance combinations–seems to have been a realistic choice. Enhancing an environment through coloured lighting and fragrances seems to be a feature that people find interesting, to try and play with, albeit not immediately in their own homes. This seems to be particularly the case for the use of fragrances.

The present study aimed to investigate the effect of lighting and fragrances as well as the interplay of these different sensory modalities on the formation of evaluative judgements of environments. At present, existing scientific literature on effects of fragrances on evaluations is scarce, and the potential of olfactory stimulation is yet to be explored. The present study illustrates both the feasibility and relevance of this type of research. And more studies are needed to further improve our understanding of this domain, aiming to discover the psychological processes behind these effects as well as their potential to enhance our enjoyment of environments and places.

Development of products, services and systems is more and more about how to create an alluring, engaging and enjoyable experience on top of offering the required basic functionalities and features (Norman 2004; Hoonhout 2008). This leads to increased attention for the (multi)sensorial experience that can be evoked by the design of products and systems. Despite this attention for multisensorial aspects of design it should be realized that as yet little is known about the interaction of modalities addressing different senses, so it is imperative that we improve our understanding of multisensory perception. This study forms one step towards a better understanding of this domain. Such insights will enable designers to create user experiences with the particular emotional impact they envision in their conceptual designs.

Acknowledgements

The authors thank Antoine de Riedmatten, Lyse Tranzeat, Wessel Jan Kos, Yann Le Gauffey and other colleagues from Firmenich SA, Geneva for their valuable input during project discussions, the creation of the scents and providing the scent dispenser, and Jan Engel from CQM in Eindhoven for his contribution to the data analysis.

Works Cited

Aarts, E., Diederiks, E. (Eds.) (2006). *Ambient Lifestyle. From concept to Experience.* Amsterdam: BIS Publishers.
Baron, R.A. (1991). Perfume as a tactic of impression management in social and organizational settings. In Van Toller, S., and Dodd, G.H. (Eds.), *Perfumery: the psychology and biology of fragrance.* London: Chapman & Hall, 91-104.

Bell, P., Holbrook, M. and Solomon, M. (1991). Combining esthetic and social value to explain preferences for product styles with the incorporation of personality and ensemble effects. *Journal of Social Behavior and Personality,* 6:243-273.

Berlyne, D.E. (1970). Novelty, complexity and hedonic value. *Perception and Psychophysics,* 8: 279-286.

Bone, P.F. and Ellen, P.S. (1999). Scents in the marketplace: Explaining a fraction of olfaction. *Journal of Retailing,* 75: 243-262.

Byrne-Quinn, J. (1991). Perfume, people, perception and products. In Van Toller, S., and Dodd, G.H. (Eds.), *Perfumery: the psychology and biology of fragrance.* London: Chapman & Hall, 205-216.

Canter, D. (1991). Understanding, assessing, and acting in places: Is an integrative framework possible? In Gärling, T. and Evans, G.W. (Eds.), *Environmental cognition and action: An integrated approach.* Oxford: Oxford University Press, pp. 191-209.

Chebat, J.C. and Michon, R. (2003). Impact of ambient odors on mall shopper's emotions, cognition, and spending. A test of competitive causal theories. *Journal of Business Research,* 56: 529-539.

Clifford, C. (1985). New scent waves. *Self,* December: 115-117.

Dalton, P. (2002). Olfaction. In Pashler, H. and Yantis, S. (Eds.), *Stevens' handbook of experimental psychology (3rd ed), vol. 1: Sensation and Perception.* New York: John Wiley & Sons, Inc, 691-746.

Fiore, A.M., Yah, X. and Yoh, E. (2000). Effects of a product display and environmental fragrancing on approach responses and pleasurable experiences. *Psychology & Marketing,* 17: 27-54.

Flynn, J.E. (1992). Lighting-design decisions as interventions in human visual space. In Nasar, J.L. (Ed.) *Environmental aesthetics: theory, research & applications.* New York: Cambridge University Press, 156-170.

Flynn, J.E., Hendrick, C., Spencer, T.J. and Martyniuk, O. (1979). A Guide to the methodology procedures for measuring subjective impressions in lighting. *Journal of the Illuminating Engineering Society,* 9: 95-110.

Hellema, H. (1994). *Geur en gedrag.* Amsterdam: de Brink.

Hoonhout, H.C.M. (2008). How was the experience for you just now? Inquiring about people's affective product judgements. In Westerink, J.H.D.M., Ouwerkerk, M., Overbeek, T.J.M., Pasveer, W.F., de Ruyter, B. (Eds.), *Probing Experience. From Assessment of User Emotions and Behaviour to Development of Products.* Dordrecht: Springer.

Knasko, S.C. (1992). Ambient odor's effect on creativity, mood, and perceived health. *Chemical Senses,* 17: 27-35.

Knez, I. (1995). Effects of indoor lighting on mood and cognition. *Journal of Environmental Psychology,* 15: 39-51.

Mattila, A.S. and Wirtz, J. (2001). Congruency of scent and music as a driver of in-store evaluations and behavior. *Journal of Retailing,* 77: 273-289.

McColl, S.L. and Veitch, J.A. (2001). Full-spectrum fluorescent lighting: a review of its effects on physiology and health. *Psychological Medicine,* 31: 949-964.

Mikellides, B. (1996). Emotional and behavioural reactions to colour. In Sivik, L. (Ed.) *Colour report: Colour and psychology.* From AIC Interim Meeting in Göteborg, Sweden, 86-92.

Norman, D.A. (2004). *Emotional design. Why we Love (or Hate) Everyday Things.* New York: Basic Books.

Pine, J. and Gilmore, J. (1999). *The experience economy.* Boston: Harvard Business School Press.

Russell, J.A. and Pratt, G. (1981). A description of the affective quality attributed to environments. *Journal of Personality and Social Psychology,* 38: 311-322.

Schifferstein, H.N.J. and Blok, S.T. (2002). The signal function of thematically (in)congruent ambient scents in a retail environment. *Chemical Senses,* 27: 539-549.

Spangenberg, E.R., Crowley, A.E. and Henderson, P.W. (1996). Improving the store environment: Do olfactory cues affect evaluations and behaviours? *Journal of Marketing,* 60: 67-80.

Vroon, P. (1989) *Tranen van de krokodil.* Baarn: Ambo.

Chapter Fifteen

The Effects of Perceived Web-Store Design Characteristics on Consumers' Affective States and Attitudes Towards the Store

Talya Porat and Noam Tractinsky

1. Introduction

A key issue in e-retail is the multi-disciplinary and complex nature of Web-store design. It includes the application of knowledge from diverse areas such as marketing, information technology, and human-computer interaction (HCI). The intriguing point about such an endeavour is that traditionally those fields have been occupied with a different set of goals and success criteria. Thus, for example, the field of marketing has been intensively involved in attempts to influence consumers' emotions through advertisements, and product and store design (e.g., Bloch 1995; Kotler et al. 1984; Whitney 1988). Considerations of efficient and accurate information processing, navigation, and task execution by customers are not of major concern here. On the contrary, some marketing techniques attempt to make the information processing or the shopping process even less efficient for various reasons (e.g., Russo 1977; Levy et al. 1998; Hoyer et al. 2001; Schroeder 2002).

The field of HCI, on the other hand, has traditionally been dedicated to the study and the practice of effective task performance while refraining from dealing with the affective aspects of the interaction in general and specifically with aesthetic issues (Norman 2002; Tractinsky 2004). Thus, the marriage of these contrasting disciplines in a new business model is challenging for both research and practice (Wind et al. 2002). Currently, there is only scarce research on merging marketing and HCI (Barwise et al. 2002; Vergo et al. 2003) and insufficient explanations regarding how

Web-site design affect consumers' emotions, beliefs, attitudes and behaviour *vis a vis* a particular vendor. Most of the existing attempts to study the design aspects of retail Web-sites are not theory driven, and there is no robust theory to explain how Web-site design affects emotions, consumers' beliefs, attitudes and willingness to purchase from a particular vendor.

This study has two primary objectives. Firstly, we propose a research model that integrates theoretical concepts and frameworks from both the field of Marketing and the field of HCI.

The second objective is to understand the role of HCI design dimensions–usability and aesthetic, in establishing the atmospherics of online retail stores. Atmospherics has been defined as

> the conscious designing of space to create certain buyer effects, specifically, the designing of buying environments to produce specific emotional effects in the buyer that enhance purchase probability (Kotler 1973-1974).

There is a large body of literature on factors that contribute to the atmospherics of traditional stores. However, only recently have researchers begun studying what influences the atmospherics of online stores (e.g., Eroglu et al. 2001; Richard 2005). This study posits that the atmospherics of a Web-based store can be captured by HCI design factors, and that key emotional reactions and attitudes towards the store can be captured by an environmental psychology model (Mehrabian et al. 1974).

In the next section, we discuss the role of aesthetics and emotions in HCI and Web design, and the importance of emotion in retail. The research model and hypotheses are presented in section 3. Section 4 describes the research method. Section 5 presents the results, which are discussed in section 6.

2. Background

2.1 Aesthetics and emotion in HCI

HCI researchers and practitioners have traditionally emphasized objective performance criteria, such as time to learn, error rate and time to complete a task (Butler 1996). Consequently, the HCI literature expressed only passing interest in the aesthetic aspects of the interaction (Tractinsky

1997; Norman 2002). However, evidence in support of the importance of aesthetics in various aspects of computing has also emerged recently (Schenkman et al. 2000; Tractinsky et al. 2000; Postrel 2001; Kim et al. 2002; Hassenzahl 2003; van der Heijden 2003; Lindgaard et al. 2003).

Emotions are considered a main cause of choice and action (Frijda 2000; Norman 2004), as has been demonstrated in a variety of contexts (Zajonc et al. 1982; Rafaeli et al. 2003, 2004). Recently, the case has been made for the importance of emotion in HCI as well (Cockton 2002; Brave et al. 2003; Zhang et al. 2005; Sun et al. 2006). Thus, the claim that aesthetic design influences people's emotions (Postrel 2002; Coates 2003; Norman 2004) has many implications.

Recent research into the potential effects of emotions generated by artefacts has yielded several theoretical frameworks (e.g., Desmet 2002; Rafaeli et al. 2003; Norman 2004). There are some interesting parallels to these framework (cf. Tractinsky 2004; 2006), but most notably–and in line with Postrel (2002) and Coates (2003)–they all view aesthetics as a major determinant of affect. There are several reasons for that, but perhaps the most obvious is that first aesthetic impressions are formed immediately (e.g., Berlyne 1971; Lindgaard et al. 2006; Tractinsky et al. 2006). Those first impressions may linger and colour subsequent evaluations of objects. Thus, to a large extent, aesthetics sets the tone for the rest of the interaction.

2.2 Emotion and retail

Practitioners and researchers alike have long recognized the importance of affect in consumer behaviour. In comprehensive reviews of the role of emotions in marketing, Bagozzi et al. (1999) and Isen (2001) enumerate various effects of emotional states in the retail environment. For example, emotions influence cognitive processes and evaluation and decision making; positive affect is positively correlated with customer satisfaction, which in turn increases the probability of repeat purchase.

Marketing has also realized the importance of the shopping environment and product design in influencing the consumer's affective states (Martineau 1958; Kotler 1973-4; Donovan et al. 1982; Bloch 1995; Nagamachi 2002; Michon et al. 2005; Guiry et al. 2006). Atmospheric cues may include store layout and design, employee appearance, and musical and olfactory stimuli (Baker et al. 1992; Bitner 1992; Darden et al.

1994, Spangenberg et al. 2005). Studies demonstrated that emotions experienced in the store environment trigger buying responses (e.g., Gardner 1985; Gardner et al. 1987; Baker et al. 1992). They influence price and value perceptions (Grewal et al. 1994; Babin et al. 2000), shoppers' satisfaction and future shopping intentions (Dawson et al. 1990; Swinyard 1993; Yoo et al. 1998), and perceptions of the quality service (Kluger et al. 2000). For example, pleasure was found to be a significant predictor of extra time spent in the store and actual incremental spending (Donovan et al. 1994) and positive affect induced by store atmospherics increased perceptions of both hedonic and utilitarian value whereas negative affect decreased those perceptions (Babin et al. 2000).

Tractinsky and Rao (2001) suggest that to create a desired store atmosphere, e-retailers have to invest more in visual design in order to compensate for the medium's shortcomings: lack of olfactory and tactile information, limited auditory channel, and the lack of opportunity to use physical space to affect atmospherics. Reviews of the e-retail literature (Barwise et al. 2002; Vergo et al. 2003; Sun et al. 2006) show only few studies that have looked into the role of aesthetics or emotion in e-retail. Recently, studies have begun to explore various aspects of the affective qualities of e-retail environments. Eroglu et al. (2001) proposed that similar to traditional in-store stimuli, online atmospheric cues (e.g., colours, graphics, layout, and design) can provide information about the retailer (e.g., the quality or type of retailer, the target audience of the retailer). They can also influence shoppers' responses during the site visit. However, the questions of which design factors affect the atmosphere of online stores and how these effects translate to consumers' emotions and behaviour remain open. Zhang and von Dran (2001) examined user perceptions of using Web-sites. They suggest that designers have to concentrate on identifying exciting features that address consumers' unstated emotional and affective needs in order to provide companies a competitive advantage. Kim and Yoo (2000) show that representational delight (such as relevance of screen layout, user's location interface and customisation of interface) is more important than structural firmness in three of four Internet business domains that were studied.

Richard (2005) examined the impact of Internet atmospheric cues on surfer behaviour. One of the key findings was that entertainment cues (escapism, diversion, aesthetic enjoyment and emotional release) affected site involvement and site attitudes. Fiore et al. (2005) tested linkages between emotion, hedonic value, consumer characteristics, and responses

toward an online store. They found that trying image interactivity as a stimulating experience, predicted emotional arousal and emotional pleasure. Both arousal and pleasure enhanced willingness to patronize the on-line store.

3. Theoretical framework

Prior research on emotional responses in the retail context has mirrored various approaches to the study of emotions in general. The discrete emotions perspective, proposes that emotions can be conceptualised as a set of discrete and distinct affective states (e.g., Izard 1977). In line with this approach, Dawson et al. (1990) measured seven types of emotions (relaxed, content, satisfied, happy, surprised, excited, rewarded) in their study of the effects of emotions in the retail environment. A dimensional perspective of emotions, on the other hand, suggest that more basic understanding of the impact of emotions can be derived from reducing the various emotion types into a set of underlying dimensions. For example, Yoo et al. (1998) show that a two-dimensional model (pleasure vs. displeasure; arousal vs. sleepiness) can be used to convey various emotions (cf. Yoo et. al. 1998).

Research into consumer online behaviour examined also the nature and consequence of staging compelling Web experiences that were capable of inducing the optimal mental state known "flow" (Csikszentmihalyi 1990; Mathwick et al. 2004). Flow denotes a state of experience in which a person's skills are optimally matched to the challenges of a focal task, ultimately producing an enjoyable state of complete immersion and absorption in that task (Sautter et al. 2004).

However, despite the appeal of flow theory as a basis for research into compelling Web experiences, the usefulness of the concept when applied to the full range of online consumer behaviour has been questioned. For example, flow and other experiential outcomes were considered less relevant to goal-directed tasks such as many online purchase contexts (Novak et al. 2000; Mathwick et al. 2004).

3.1 Environmental psychology model - PAD

The environmental psychology model of Mehrabian and Russell (M-R) is based on the dimensional perspective to the study of emotion. It is depicted in Figure 15-1. The model suggests that stimuli are perceived in

terms of their affective qualities. Mehrabian and Russell (1974) proposed three emotional dimensions, abbreviated PAD, along which emotions vary. (1) *Pleasure* refers to the degree to which a person feels happy or satisfied in a place; (2) *Arousal* is the degree of stimulation caused by an atmosphere; and (3) *Dominance* indicates the degree to which a person feels that he or she has control of the situation. Subsequently, the person's emotional state influences her tendency to approach or avoid the environment.

The PAD model and its derivatives have been used extensively in the study of physical retail environments (e.g., Donovan et al. 1982; Bellizzi et al. 1992; Donovan et al. 1994; Sherman et al. 1997; Babin et al. 2000; Turley et al. 2000). Recent empirical research has demonstrated that online shopping environments can also evoke emotional responses in consumers (Machleit et al. 2000; Eroglu et al. 2005, Mummalaneni 2005). Yet, the relations between design attributes of online stores and consumers' affective states remain largely unexplored.

4. Proposed model

Based on the M-R model, we propose a model that builds on the relation between perceived design qualities of the Web-store (i.e., e-store atmospherics), the emotions induced by those qualities, and consumer attitudes (see Figure 15-2). The perceived aspects of the e-store environment are based on two key construct of web-site design: aesthetics (e.g., Lavie et al. 2004) and usability (e.g., Nielsen 2000).

Figure 15-1. The M-R model of environmental influence.

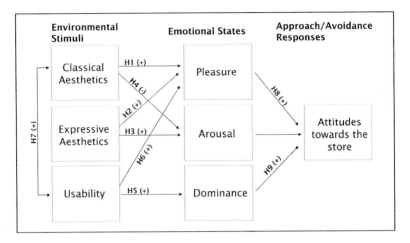

Figure 15-2. Research Model.

4.1 The environment–Web-site design characteristics

Clearly, aesthetics and usability are not the only components of the e-store environment. We chose to concentrate on these aspects because they are the most directly related to the field (both practice and research) of HCI; and because they are the most salient to the consumers when they interact with the e-store, and hence the most likely to influence the perceived atmosphere of the retail outlet and consumers' emotional states.

Usability captures the original essence of the HCI field by striving to focus the design and evaluation activities around users' ability to accomplish their tasks efficiently (Butler 1996). It concentrates on reducing task completion times, minimizing errors, and increasing the learnability of the system. Design recommendations for e-retail stress the paramount importance of adhering to usability guidelines (Nielsen 2000, Nah et al. 2002). While the usability of systems can be captured both objectively and subjectively (i.e., by self reports), the latter method appears more viable in practical settings. As such, usability can be viewed as the equivalence of the ease of use construct in the technology acceptance model (TAM, cf. Davis, 1989)–a subjective measure that reflects users' perceptions of the degree to which the system facilitates easy interaction.

Recent HCI research suggests that hedonic and aesthetic design aspects also play a major role in affecting users' perceptions of, and attitudes towards information technology (Hassenzahl 2003; Tractinsky et al. 2000; De Angeli et al. 2006). Lavie and Tractinsky (2004) further divided the aesthetic evaluations of Web pages into two dimensions: classical aesthetics and expressive aesthetics. This allows for a finer-grain analysis of aesthetics' influence on users' perceptions, attitudes and emotions.

4.2 Emotional States

The environmental psychology model proposes that all stimuli are perceived in terms of their affective qualities. Originally, Mehrabian and Russell (1974) considered three affective dimensions: *pleasure, arousal* and *dominance* (PAD). The original conceptualisation underwent several modifications. Today it is more common for applications of the PAD model to include only the first two dimensions (*pleasure* and *arousal*). Use of the third dimension, *dominance* (or perceived control), has been decreased over the years. The reasons for this may have been the fact that it represents a more cognitive reaction and less of an affective state (Feldman et al. 1999) and that studies often failed to demonstrate its independence of the other two dimensions (Brengman et al. 2003) or its effects on approach/avoidance variables (Babin et al. 2000). Still, we include it in our model for two reasons. First, its lack of independence of the other two emotions in M-R model may have been merely an artefact of limited stimulus sets in many studies (Mehrabian 1995; Mehrabian et al. 1997; Brengman et al. 2003). Secondly, this dimension appears particularly relevant to situations such as e-retail where the consumer's interaction with the system is not as intuitive as in the physical world but rather mediated by a computerized system. In such environments, perceptions of control (or lack thereof) are very important (Brown 1986; Shneiderman 1998; Huang 2003).

4.3 Response: approach or avoidance

According to the original PAD model, the environment influences the person's affective states, which in turn influence his or her approach/avoidance behaviour. In a retail context, approach responses may include the desire to stay longer in the store, to explore it, to be willing to return, and to communicate with salespeople (Donovan et al. 1982; Bitner 1992). Likewise, in e-retail context an approach response would mean greater tendency to browse, search and interact with a store site for a

longer period of time, greater willingness to buy from the store, and a better chance of actual purchase and loyalty. An avoidance response would mean just the opposite.

5. Hypotheses

The relationships among the model's variables are depicted in Figure 15-2. These relationships are explained below together with our formal hypotheses.

We expect both aesthetic dimensions to correlate positively with pleasure, since pleasure is regarded as a prominent emotion accompanying the aesthetic experience (e.g., Sheppard 1987; Coates 2003). This premise is based not only on philosophical, linguistic, or theoretical grounds, but also on empirical evidence (e.g., Lavie et al. 2004; Gannon 2005).

Thus, we hypothesize:

H1: Sites perceived by users as having higher levels of classical aesthetics induce higher levels of pleasure.

H2: Sites perceived by users as having higher levels of expressive aesthetics induce higher levels of pleasure.

Due to its emphasis on novel and creative stimuli, we expect expressive aesthetics to correlate positively with arousal (e.g., Berlyne 1971). Classical aesthetics, on the other hand, reflect typical notions of design, and is expected to have a calming effect on the senses. Hence, not only is it not expected to increase arousal–it may even reduce it.

H3: Sites perceived by users as having higher levels of expressive aesthetics induce higher levels of arousal.

H4: Sites perceived by users as having higher levels of classical aesthetics induce lower levels of arousal.

Based on usability's role in supporting the users' feeling of control over the interaction (e.g., Shneiderman 1998; Brave et al. 2003), we expect it to correlate positively with perceived dominance. In addition, smoother interactions facilitated by better usability are likely to increase pleasure, whereas flawed usability increase frustration (Brave et al. 2003) and thus reduce pleasure.

H5: Sites perceived by users as more usable will increase feelings of dominance.

H6: Sites perceived by users as more usable will induce higher levels of pleasure.

Previous studies have found that perceptions of usability and aesthetics might be related (Tractinsky et al. 2000; Lindgaard et al. 2003; Hartmann et al. 2007). This is especially the case concerning the relations between usability and classical aesthetics (Lavie et al. 2004).

H7: There will be positive association between users' perceptions of sites' perceived usability and classical aesthetics

Finally, we expect that consumers who are more pleased and who feel more in control of their environment will have more favorable attitudes towards the e-retail environment. For example, Koufaris et al. (2002) show that perceived control and shopping enjoyment can increase the intention of new Web customers to return. The relations between arousal and approach/avoidance may be more complicated because they may reflect the inverted U-shaped relations often observed between arousal and other attitudinal or behavioral measures (e.g., Berlyne 1971) and because they may be contingent upon the nature of the shopping sites and products. Testing such relations is beyond the scope of our study.

H8: Higher levels of pleasure will increase users' approach response.

H9: Higher levels of dominance will increase users' approach response.

6. Method

6.1 Preliminary Qualitative Study

A preliminary qualitative study was conducted to gauge the adequacy of the theoretical framework constructs and to examine if the model's environmental constructs can influence emotional states.

Participants
Three participants (a 26-year-old student, a 33-year-old working married woman, and a 37-year-old working married man) voluntarily participated in this study.

Data collection

The participants were told that the experiment is about e-commerce sites, but did not receive additional information prior to the experiment. A semi-structured interview was conducted individually with each participant while he or she was browsing web-sites. While browsing each site, the participants were asked regarding their initial thoughts about the site. Following that, they were asked to elaborate their respond.

Three sites, in the flowers category, were displayed one after the other. Each interview lasted on average one hour, and was tape recorded and transcribed.

Data analysis

The thematic analysis (Tutty et al. 1996) began using inductive process with a theoretical framework that recognized aesthetics and usability as atmospherics cues in e-retail, which consequently influence, through emotions, the approach/avoidance response. Initially, we scanned the data in search of dominant themes; more than thirty themes were identified, such as *"it's a horrible site, very ugly"*, *"the site is not reliable, it seems amateurish"*, *"the site is very friendly"*, *"I can't see the general picture, I'm confused"*.

In support of our initial theoretical model, these themes could clearly be organized into two main categories: *aesthetics* (*"very ugly site"*) and *usability* (*"Its a very confusing site, its not divided to categories and its not clear at all"*). The first author and a research assistant independently categorized the themes into the two categories. Only minimal disagreements were noted. Although our data collection tools did not ask the participants to express their emotions, the data contained numerous emotional reactions. In addition, the link between aesthetics and usability to emotions appeared to be direct and almost immediate (e.g., *"This site looks ugly, I don't like it"*; *"I like the colours and the picture, I'm satisfied, I feel I know what I'm getting"*; *"It's a very confusing site, I feel lost"*, *"This site is very easy and intuitive, I feel I know this site"*).

Main results

Our data comprised reactions, thoughts and opinions regarding three e-commerce sites, and included distinct references to two aspects of the sites as well as a rich set of emotions. Aesthetic and usability aspects of the site are suggested by the data to produce emotion through a non-mediated, direct impact on the senses. The aesthetic artefact itself is sensed as

pleasant, arousing, boring, or annoying, with no mediation involved (results that correspond to Rafaeli et al. 2004). The usability artefact induce emotions such as pleasure and in-control. Thus, albeit initial and limited, the findings supported the notion of usability and aesthetic as design dimensions of e-commerce sites that induce atmospheric perceptions that can be mapped directly to users' emotional states.

6.2 Main Study

Following the preliminary study, the main study was conducted to test the model, including the relations between the aesthetics and usability of a site, the emotions it evolves and the approach/avoidance response it produces.

Participants
Sixty-one undergraduate engineering students (45 males and 16 females) participated in this study for class credit. The average age of the participants was 25.4 years old (between 20 to 31). Eighty-four percent of the participants had purchased at least one item in an online store; more than half of them purchased at least three items. All of the participants were expert Web users.

Measures
Participants filled a questionnaire that included multiple-item scales for measuring the model's variables: the environment's variables, which include *classical aesthetics*, *expressive aesthetics*, and *usability*; the emotional states variables: *pleasure*, *arousal* and *dominance*; and *approach/avoidance response*, which was operationalized as attitudes towards the sites. The items for the aesthetics and the usability scales were adopted from Lavie and Tractinsky (2004). Items for the emotional states scales were adopted from Mehrabian and Russell (1974) and were slightly modified to fit the e-retail context. The items for the approach-avoidance scale were adopted from Donovan and Rossiter (1982). All scales were presented as 7-point statements, with the end points marked as "fully agree" and "fully disagree" (see the Appendix for the study's items).

Procedure
Participants were randomly assigned to one of the five retail domains (flowers, music CDs, cars, furniture or house painting). In the assigned domain, participants visited three different sites. The participants were instructed to perform a task of ostensibly purchasing an item via each of

the three e-stores. The instructions did not specify which item to purchase but displayed a scenario that inspired the participants to select and ostensibly purchase at least one item at each e-store. The purpose of the instructions was to encourage the participants to browse the e-stores, to form some impression and simulate a true process of e-purchasing. After visiting each site, the participants completed a questionnaire, based upon their impression of that site. The experiment lasted about 45 minutes.

7. Analysis and results

7.1 Analysis

An exploratory factor analysis was conducted to assess the discriminant validity of the model's variables. Following the literature's recommendations for conducting such studies (e.g., Fabrigar et al. 1999; Conway et al. 2003), a common factor model (maximum likelihood) was used as the factor extraction method and an oblique factor rotation method. The number of factors for extraction was predetermined to seven based on the number of the constructs in the model.

7.2 Results

In essence, all items were loaded on their respective factors with two exceptions. Firstly, the *arousal* items were loaded on two distinct factors–negative and positive–instead of on one bipolar factor. This result reflects the ambiguity of the *arousal* construct, which has been noted before in the marketing domain (Donovan et al. 1994), including its potential bi-dimensionality (Brengman et al. 2003; Smith et al. 1975). Secondly, two of the *dominance* items were loaded on the *usability* factor. Consequently, the factor analysis was rerun without these two items, and eight factors were specified for extraction instead of seven factors in order to account for the emergence of two *arousal* factors. The Appendix displays the rotated pattern matrix of the revised factor analysis. As can be seen from this table and from the reliabilities reported in Table 15-1, all variables are distinct, one-dimensional and reliable.

Descriptive statistics, reliabilities and inter-correlations of the model's variables are provided in Table 15-1. The table indicates that, on average, the sites were perceived as about average in terms of their aesthetics qualities and above average in terms of usability. Emotional states ranged from low arousal (both negative and positive), somewhat below average pleasure and above average feelings of dominance. Overall attitudes towards

Variable	Mean	SD	Correlations							
			1	2	3	4	5	6	7	8
Classical Aesthetics	4.43	1.36	.90							
Expressive Aesthetics	3.52	1.51	.69**	.94						
Pleasure	3.68	1.40	.63**	.67**	.92					
Arousal_N	2.68	1.35	-.32**	-.24**	-.15*	.87				
Arousal_P	2.58	1.28	.19	.46**	.45**	.00	.82			
Dominance	5.24	1.26	.10	.02	-.11	-.36**	-.15*	.81		
Usability	4.45	1.44	.35**	.32**	.30**	-.25**	.20**	.51**	.91	
Attitudes	3.47	1.64	.47**	.55**	.54**	-.36**	.40**	.24**	.68*	.93

Note: All scales are measured on a 1 (low) to 7 (high) scale.

Table 15-1. Descriptive Statistics, Cronback Alpha Coefficients (on the diagonal) and Correlations of model's variables.

the sites were below average, indicating a slight tendency to avoid, rather than approach them.

The correlations table indicates moderate relationships between the aesthetics variables and usability, thus partially supporting H7. To test the rest of the research hypotheses a multiple regression analyses was conducted. First, each of the emotional states variables were regressed on all of the environmental variables (*usability* and *classical and expressive aesthetics*). In the second stage, Attitudes were regressed on all of the emotional states variables (*pleasure, dominance,* and *negative and positive arousal*). The regression analyses allowed to examine both if the hypothesized relationships between variables in the model indeed exist and whether there are relationships which exist despite not being hypothesized. The results are shown in Table 15-2 and Figure 15-3.

In general, the data supported the relationships posited by the model. All of the research hypotheses were supported with the exception of lack of significant impact of the site's usability on pleasure (H4). It is interesting to note that higher levels of classical aesthetics were associated with lower levels of both positive and negative arousal. Finally, approach/avoidance

Regression tests	β	Hypothesis
1. Pleasure (Adj. $R^2 = 0.50$) Classical aesthetics Expressive aesthetics Usability	0.31** 0.44** 0.04	H1: supported H2: supported H6: not supported
2. Arousal positive (Adj. $R^2 = 0.23$) Classical aesthetics Expressive aesthetics Usability	-0.26* 0.60** 0.10	H4: supported H3: supported
3. Arousal negative (Adj. $R^2 = 0.11$) Classical aesthetics Expressive aesthetics Usability	-0.27* 0.00 -0.15	H4: supported
4. Dominance (Adj. $R^2 = 0.27$) Classical aesthetics Expressive aesthetics Usability	0.02 -0.17 0.56**	H5: supported
5. Approach attitudes ($R^2 = 0.51$) Pleasure Arousal negative Arousal positive Dominance	0.40** -0.18** 0.24** 0.35**	H8: supported H9: supported

$** \, p < 0.01; \; *** \, p < 0.001.$

Table 15-2. Results of regression tests. Each test reports dependent variable first, followed by the list of independent variables.

reactions in the context of this study were predominantly influenced by feelings of pleasure and dominance and less by arousal.

8. Discussion and conclusion

Atmospherics is recognized as an important aspect of the shopping experience in traditional retail stores and a major element in the design of such stores. This study demonstrated the viability of the retail atmospherics to the e-retail context. The concept of atmospherics received more attention in traditional retailing. It is now time to consider the role of e-atmospherics in virtual retail environments as well. Tractinsky and Rao

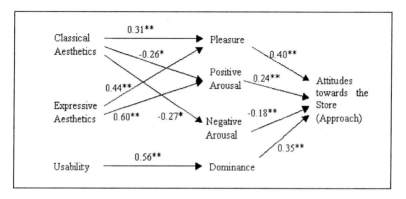

Figure 15-3. Model of the impact of e-store atmospherics on customer emotions and attitudes. Only significant regression coefficients are shown.

(2001) suggest that e-retailers have to invest in visual design even more than their brick-and-mortar counterparts in order to compensate for the sensory shortcomings of the medium. The ability of the traditional store designer to appeal to all of the shopper's senses through an infinitely complex combination of ambient, structural, social, and aesthetic elements has now been constrained to a predominantly visual appeal via a computer display (Eroglu et al. 2001).

The study reported here has several limitations. The results are based on a relatively small sample. This had precluded the use of more powerful statistical techniques to test the research model. It also limits the generalisability of the results. In addition, the results may reflect the nature of the stores that were used in this study. Thus, additional tests of the model with different sets of domains and stores, using larger and different samples, are required.

Still, this study augments existing descriptions of the designed virtual shopping environments in several respects. Firstly, the model offers a systematic and theoretically driven treatment of e-store atmospherics and its relationship to HCI design elements. Then, it shows how these atmospherics elements affect e-shoppers' emotions, which in turn influence approach/avoidance responses (conceptualised here as attitudes towards the Web-store). Related contributions are the systematic introduction of perceived aesthetics into the study of online retail environments and the inclusion of all three aspects of the original PAD model's affective states, as opposed to recent tendencies in the marketing

literature to ignore the *dominance* aspect. The results indicate that feeling of dominance are strongly related to perceptions of the site's usability and to attitudes towards the store. Perhaps due to the lack of standard practices of physical retail environments and lack of real-world visual cues about how to navigate within the store and how to complete the shopping process, dominance appears to be a viable and pertinent emotion in the e-retail context. Finally, the results indicate that among the PAD dimensions, pleasure plays the major role in determining users' attitudes towards Web-based stores. This finding is in line with previous studies, which found that pleasure was the most significant predictor of approach/avoidance in retail environments (Donovan et al. 1982; Donovan et al. 1994).

The major empirical deviation from our model was the bi-dimensionality of the arousal construct. While this problem has been noted in previous research (e.g., Donovan et al. 1994), this issue should be addressed by future research. Still, it is interesting to note that despite splitting the arousal construct into two, the hypothesized relation between the environmental variables and arousal were supported. That is, classical aesthetics was associated with reduces levels of arousal–both positive and negative.

Thus, the study's implications are both theoretical and practical. Theoretically, it contributes to our understanding of virtual environments in general and in the e-retail domain in particular, and of the associations between design, emotion, and attitudes. Practically, the proposal can help e-retailers and Web-site designers in general to focus their efforts on design objectives based on better understanding of the relations between design attributes and consumer behaviour.

Works Cited

Babin, B. J., & Attaway, J. S. (2000). Atmospheric Affect as a Tool for Creating Value and Gaining Share of Customer. *Journal of Business Research*, 49: 91-99.

Bagozzi, R.P., Gopinath, M., and Nyer, P.U. (1999). The Role of Emotions in Marketing. *Journal of the Academy of Marketing Science*, **27**(2): 184-206.

Baker, J., Grewal, D., and Levy, M. (1992) An Experimental Approach to Making Retail Store Environmental Decisions. *Journal of Retailing* 68: 445–460.

Barwise, P., Elberse, A., and Hammond, K. (2002). Marketing and the Internet. In Weitz, B. and Wensley, R. (Eds.) *Handbook of Marketing*, London: Sage Publishing (2002).

Bellizzi J.A. and Hite R.E. (1992). Environmental Color, Consumer Feelings, and Purchase Likelihood. *Psychology & Marketing*, **9**(5): 347.

Berlyne, D. E. (1971). *Aesthetics and Psychobiology.* New York, Appleton-Century-Crofts .

Bitner, M.J. (1992). Servicecapes: The impact of the physical surroundings on customers and employees. *Journal of Marketing*, 56: 57-71.

Bloch, P. H. (1995). Seeking the ideal form: product design and consumer response. *Journal of Marketing*, **59**(3): 16-29.

Brave, S. and Nass, C. (2003). Emotion in human-computer interaction. pp. 251-271 In Jacko, J. and Sears, A. (Eds.), *Handbook of human-computer interaction*. Lawrence Erlbaum Associates.

Brengman, M. and Geuens, M.(2003). *The four dimensional impact of color on shoppers' emotions*. Ghent University, Belgium, working paper.

Brown, J.S. (1986). From cognitive to social ergonomics and beyond. In Norman, D.A. and Draper, S.W. (Eds.), *User Centered System Design*. Lawrence Erlbaum, London.

Butler, K.A. (1996). Usability engineering turns 10. *Interactions*, **3**(1): 59-75.

Coates, D. (2003). *Watches Tell More than Time.* New York: McGraw-Hill (2003).

Cockton, G. (2002). From doing to being: Bringing emotion into interaction. *Interacting with computers*, 14: 89-92.

Conway, J.M. and Huffcutt, A.I. (2003). A review and evaluation of exploratory factor analysis practices in organizational research. *Organizational Research Methods*, **6**(2): 147-168.

Csikszentmihalyi, M. (1990). *Flow: The Psychology of Optimal Experience*. New York: Harper and Row.

Darden, W.R. and Babin, B.J. (1994). Exploring the concept of affective quality: Expanding the concept of retail personality. *Journal of Business Research*, 29: 101-109.

Davis, F.D. (1989). Perceived usefulness, perceived ease-of-use, and user acceptance of information technology. *MIS Quarterly* (September): 319-340.

Dawson, S, Bloch, P.H., and Ridgway, N.M. (1990). Shopping Motives, Emotional States and Retail Outcomes. *Journal of Retailing* 60: 408-427.

De Angeli, A., Sutcliffe, A. and Hartmann, J. (2006). Interaction, Usability and Aesthetics: What Influences Users' Preferences? In *DIS 2006*, June 26-28 2006, University Park, Pennsylvania, USA: 271-280.

Desmet, P.M.A. (2002). Designing Emotions. Doctoral Dissertation. TU Delft, Netherlands. Taylor and Francis.

Donovan, R.J. and Rossiter J.R. (1982). Store Atmosphere: An Environmental Psychology Approach. *Journal of Retailing*, 58: 34-57.

Donovan, R..J., Rossiter, J.R., Marcoolyn, G. and Nesdale, A. (1994). Store Atmosphere and Purchasing Behavior, *Journal of Retailing*, **70**(3): 283-294.

Eroglu, S.A., Machleit, K.A. and Davis, L.M. (2001). Atmospheric qualities of online retailing a conceptual model and implications. *Journal of Business Research* 54: 177-184.

Eroglu, S.A., Machleit, K.A. and Chebat, J. (2005). The interaction of retail density and music tempo: effects on shopper responses. *Psychology & Marketing* **22**(7): 577-589.

Fabrigar, L.R., Wegener, D.T., MacCallum, R.C., Strahan, E.J. (1999). Evaluating the use of exploratory factor analysis in psychological research. *Psychological Methods*, **4**(3): 272-299.

Feldman Barrett, L. and Russell, J.A. (1999). Structure of current affect. Current Directions. *Psychological Science*, 8: 10-14.

Fiore A.N., Jin H-J., and Kim, J. (2005). For fun and profit: Hedonic value from image interactivity and responses toward an online store. *Psychology and Marketing*, **22**(8): 669-694.

Frijda, N. (2000). Emotions. In Pawlik, K. and Rosenzwieg, M.R. (Eds.) *The International Handbook of Psychology*, Sages Publications.

Gannon, A.J. (2005). The effects of flightdeck display interface aesthetics on pilot performance and workload. Unpublished doctoral dissertation, Arizona State University.

Gardner, M.P. (1985). Does Attitude Toward the Ad Affect Brand Attitude Under a Brand Evaluation Set? *Journal of Marketing Research*, 22 (May): 192-198.

Gardner, M.P. and Hill, R. (1987). The Buying Process: Effects Of and On Consumer Mood States. In M. Wallendorf and P. Anderson (Eds.), *Advances in Consumer Research*, 14, Ann Arbor.

Grewal, D. and Baker, J. (1994). Do retail store environmental factors affect consumers' price acceptability? An empirical examination. *International Journal of Research in Marketing*, 11: 107-115

Guiry, M., Magi A.W. and Lutz R.J. (2006). Defining and measuring recreational shopper identity. *Journal of academy of Marketing Science*, 34: 74-83.

Hartmann, J., Sutcliffe, A., and DeAngeli, A. (2007). Investigating attractiveness in web user interfaces. In *Proceedings of ACM CHI 2007 Conference on Human Factors in Computing Systems 2007,* 387-396.

Hassenzahl, M. (2003). The Thing and I: Understanding the Relationship Between User and Product. In Blythe C., Overbeeke, C., Monk, A. and Wright, P.C. (Eds.), *Funology: From Usability to Enjoyment*: 31-42.

van der Heijden, H. (2003). Factors influencing the usage of Websites: the case of a generic portal in the Netherlands. *Information and Management*, 40, 541-549.

Hoyer, W.D. and MacInnis, D.J. (2001). *Consumer Behavior* (2nd Ed.). Boston: Houghton Mifflin.

Huang M-H. (2003). Modeling virtual exploratory and shopping dynamics: an environmental psychology approach. *Information & Management*, 41: 39-47.

Isen, A.M. (2001). An influence of positive affect on decision making in complex situations: theoretical issues with practical implications. *Journal of Consumer Psychology*, 11(2): 75–85.

Izard, C.E. (1977). *Human Emotions*. New York: Plenum.

Kim, J and Yoo, B. (2000). Toward the optimal link structure of the cyber shopping mall. *International Journal of Human-Computer Studies*, 52: 531-551.

Kim, J., Lee, J., Han, K., and Lee, M. (2002). Businesses as Buildings: Metrics for the Architectural Quality of Internet Businesses. *Information Systems Research* 13(3): 239-254.

Kluger, A.N., and Rafaeli, A. (2000). Affective Reactions to Physical Appearance. In Ashkanasy, N., Hartel, C.E.J. and Zerbe, W.J. (Eds.). *Emotions and organizational life.* Greenwood Publishing Group: Westport, CT.

Kotler, P. (1974). Atmospherics as a marketing tool. *Journal of Retailing*, 49: 48-61.

Kotler, P. and Rath A.G. (1984). Design a powerful but neglected strategic tool. *Journal of Business Strategy*, 5: 16-21.

Koufaris, M., Kambil, A. and LaBarbera, P.A. (2002). Consumer behavior in Web-based commerce: an empirical study. *International Journal of Electronic Commerce*, 6(2): 115-138.

Lavie, T. and Tractinsky, N. (2004). Assessing Dimensions of Perceived Visual Aesthetics of Web Sites. *International Journal of Human-Computer Studies,* 60(3): 269-298.

Levy, M., Weitz, B.A. (1998). *Retailing Management* (3rd Ed.). Boston: Irwin/McGraw-Hill.

Lindgaard G. and Dudek C. (2003). What is The Evasive Beast We Call User Satisfaction? *Interacting with Computers*, **15**(3): 429-452.

Lindgaard, G., Fernandes, G., Dudek, C. and Brown, J. (2006). Attention web designers: You have 50 milliseconds to make a good first impression! *Behaviour and Information Technology*, 25: 115-126.

Machleit, K.A. and Eroglu, S.A. (2000). Describing and measuring emotional response to shopping experience. *Journal of Business Research*, 49: 101-111.

Mathwick C. and Ridgon, E. (2004). Play, flow, and the online search experience. *Journal of Consumer Research*, 13: 324-332.

Martineau, P. (1958). The personality of the retail store. *Harvard Business Review*, 36 (January/February): 47-55.

Mehrabian, A. (1995). Framework for a Comprehensive Description and Measurement of Emotional States. *Genetic, Social, and General Psychology Monographs*, 121: 339-361.

Mehrabian, A. and Russell J. A. (1974). *An approach to Environmental Psychology*. Cambridge, MA: MIT Press.

Mehrabian, A., Wihardja, C. and Ljunggren, E. (1997). Emotional correlates of preferences for situation-activity combinations in everyday life. *Genetic, Social, and General Psychology Monographs*, 123, 461-477.

Michon R., Chebat J-C. and Turley, L.W. (2005). Mall Atmospherics: the Interaction Effects of the Mall Environment on Shopping Behavior. *Journal of Business Research*, 58: 576-583.

Mummalaneni, V. (2005). An empirical investigation of Web site characteristics, consumer emotional states and on-line shopping behaviors. *Journal of Business Research* 58: 526-532.

Nagamachi, M. (2002). Kansei engineering as a powerful consumer-oriented technology for product development. *Applied Ergonomics*, **33**(3): 289-294.

Nah, F. and Davis, S.A. (2002). HCI Research Issues in Electronic Commerce. *Journal of Electronic Commerce Research* **3**(3): 98-113.

Nielsen, J. (2000) *Designing Web Usability: The Practice of Simplicity*. New Riders Publishing.

Norman, D.A. (2002). Emotion and design: attractive things work better. *Interactions*, July-Aug: 36-42.

—. (2004). *Emotional Design: Why We Love (or Hate) Everyday Things*. New York: Basic Books.

Novak, T.P., Hoffman, D.L. and Yung Y-F. (2000). Measuring the customer experience in online environments: a structural modeling approach. *Marketing Science* **19**(1): 22-42.

Postrel, V. (2002). *The Substance of Style.* Harper Collins.

—. (2001). *Can good looks guarantee a product's success?* The New York Times, July 12.

Rafaeli, A. and Vilnai-Yavetz I. (2003). Discerning organizational boundaries through physical artifacts. In Paulsen, N. and Hernes, T. (Ed.), *Managing Boundaries in Organizations: Multiple Perspectives,* Palgrave (Macmillan), Basingstoke, Hampshire, UK.

Rafaeli, A. and Vilnai-Yavetz, I. (2004). Emotion as a connection of physical artifacts and organizations. *Organization Science,* **15**(6): 671-686.

Richard, M-O. (2005). Modeling the impact of internet atmospherics on surfer behavior. *Journal of Business Research,* 58: 1632-1642.

Russell, J.A. and Pratt, G. (1980). A description of the affective quality attributed to environments. *Journal of Personality and Social Psychology,* **38**(2): 311-322.

Russo, J.E. (1977). The Value of Unit Price Information. *Journal of Marketing Research,* 14: 193-201.

Sautter, P., Hyman, M.R. and Lukošius V. (2004). E-tail atmospherics: a critique of the literature and model extension. *Journal of Electronic Commerce Research,* **5**(1): 14-24.

Schenkman, B.O. and Jonsson, F. (2000). Aesthetics and Preferences of Web Pages. *Behaviour & Information Technology,* **19**(5): 367-377.

Schroeder, J.E. (2002). *Visual Consumption.* London: Routledge.

Sheppard, A. (1987). *Aesthetics: An Introduction to the Philosophy of Art.* Oxford University Press, Oxford.

Sherman, E., Mathur, A. and Smith, R.B. (1997). Store environment and consumer purchase behavior: mediating role of consumer emotions. *Psychology & Marketing,* **14**(4): 361-378.

Shneiderman, B. (1998). *Designing the User Interface: Strategies for Effective Human-Computer Interaction,* (3rd Edition). Addison Wesley Longman Inc..

Smith, K.C.P. and Apter M.J. (1975). *A Theory of Psychological Reversals.* Chippenham, UK: Picton.

Spangenberg, E.R., Grohmann, B. and Sprott, D.E. (2005). It's beginning to smell (and sound) a lot like Christmas: the interactive effects of ambient scent and music in a retail setting. *Journal of Business Research,* 58: 1583-1589.

Sun, H. and Zhang, P. (2006). The Role of Affect in IS Research: A Critical Survey and a Research Model In *Human-Computer Interaction and Management Information Systems*: Foundations, Zhang, P. and Galletta, D. (Eds.), M.E. Sharpe, Armonk, NY.

Swinyard, W.R. (1993). The Effects of Mood, Involvement, and Quality of Store Experience on Shopping Intensions. *Journal of Consumer Research*, 20: 271-280.

Tractinsky, N. (1997). Aesthetics and apparent usability: empirically assessing cultural and methodological issues. *ACM CHI Conference Proceedings on Human Factors in Computing Systems* (CHI 97): 115-122.

—. (2004). Towards the Study of Aesthetics in Information Technology. *Proceedings of the 25th Annual International Conference on Information Systems (ICIS)*, Washington, DC, December 12-15: 771-780.

—. (2006). Aesthetics in Information Technology: Motivation and Future Research Directions. In Zhang, P. and Galletta, D. (Eds), MIS (I): *Foundations, Series of Advances in Management Information Systems*, Zwass, V. (editor-in-chief), M.E. Sharpe.

Tractinsky, N., Shoval-Katz, A. and Ikar, D. (2000). What is beautiful is usable. *Interacting with Computers*, 13: 127-145.

Tractinsky, N., Cokhavi, A., Kirschenbaum, M. and Sharfi, T. (2006). Evaluating the Consistency of Immediate Aesthetic Perceptions of Web Pages. *International Journal of Human-Computer Studies*, **64**(11): 1071-1083.

Tractinsky, N. and Rao, V.S. (2001). Social Dimensions of Internet Shopping: Theory-Based Arguments for Web-Store Design. *Human Systems Management*, 20: 105-121.

Turley L.W. and Milliman, R.E. (2000). Atmospherics effects on shopping behavior: a review of the experimental evidence. *Journal of Business Research*, 49: 193-211.

Tutty, L.M., Rothery, M.A. and Grinnell, R.M. (1996). *Qualitative research for social workers*. Boston: Allen and Bacon.

Vergo, J., Noronha, S., Kramer, J., Lechner, J. and Cofino, T. (2003). E-Commerce Interface Design. In Jacko, J.A. and Sears, A. (Eds.), *The Human-Computer Interaction Handbook*. New Jersey, Lawrence Erlbaum Associates.

Whitney, D.E. (1988). *Manufacturing by design*. Harvard Business Review (July- August): 83-90.

Wind Y. and Mahajan V. (2002). Convergence Marketing. *Journal of Interactive Marketing*, **16**(2): 64-79.

Yoo, C., Park, J. and MacInnis, D.J. (1998). Effects of Store Characteristics and In-Store Emotional Experiences on Store Attitude. *Journal of Business Research* 42: 253-263.

Zajonc, R.B. and Markus, H. (1982). Affective and Cognitive Factors in Preferences. *Journal of Consumer Research*, 9, September: 123-131.

Zhang, P. and Li, N. (2005). The importance of affective quality. *Communications of the ACM*, **48**(9): 105-108.

Zhang , P. and von Dran, G. (2001). User Expectations and Ranks of Quality Factors in Different Website Domains. *International Journal of Electronic Commerce*, **6**(3): 9-34.

Appendix

Factor	Items	Factors							
		1	2	3	4	5	6	7	8
CA1	Clean	.787							
CA2	Pleasant	.593							
CA3	Symmetrical	.666							
CA4	Aesthetic	.771							
EA1	Original		.663						
EA2	Sophisticated		.836						
EA3	Fascinating		.789						
EA4	Creative		.876						
US1	Easy to navigate			-.636					
US2	Convenient buying process			-.749					
US3	Easy to use			-.911					
US4	Easy orientation			-.672					
PL1	Comfortable				.749				
PL2	Pleased				.859				
PL3	Relaxed				.862				
PL4	Satisfied				.612				
PL5	Contented				.560				
ARN1	Sluggish					.802			
ARN2	Sleepy					.885			
ARN3	Unaroused					.678			
ARN4	Dull					.765			
ARP1	Frenzied						.680		

ARP2	Aroused						.757			
ARP3	Excited						.851			
DM1	Helpless							.925		
DM2	Needy							.721		
DM3	Dragged							.471		
AT1	Enjoyed being in the store									-.671
AT2	Would like to return to the store									-.817
AT3	Will recommend store to others									-.728
AT4	Made me feel like buying									-.740

Note: Loadings under 0.4 are not displayed.

Legend: CA = perceived classical aesthetics; EA = perceived expressive aesthetics; US = perceived usability; PL = pleasure; ARN = negative arousal; ARP = positive arousal; DM = dominance; AT = Attitude (approach/avoidance) towards the site.

Table 15-3. Pattern Matrix of the model's variables.

WHAT MAKES YOU TICK–AN INVESTIGATION OF THE PLEASURE NEEDS OF DIFFERENT POPULATION SEGMENTS

SAMANTHA PORTER, SHAYAL CHHIBBER AND MARK PORTER

1. Introduction

In recent years there has been a transformation in the global market place (of developed countries) that can be termed as a shift towards an "experience economy" (Pine et al. 1999). Company success has become increasingly dependent upon meeting the improved quality expectations of the consumer. Young, Van der Veen, Illman, and Rowley (2000) propose that in the domain of product design and manufacture, this shift in consumer needs has seen the contextual issues of products (their social/ideological context) become increasingly more important than the physical ones e.g., styling. They also argue that the physical issues have evolved to include a more emotional relevance, e.g., the semantic cues that particular physical properties may imply. As Westcott, Rutchik, and Crosby (1999) state:

> In exchange for their loyalty, customers are demanding more than good service and product satisfaction; they are seeking experiences that are educational, entertaining and motivational.

To satisfy these evolving consumer needs, the consideration of emotional satisfaction has to be integrated into the design process. Young et al. (2000) highlight three key drivers that are accelerating the necessity for this change:

- Societal change; consumers are more knowledgeable and demanding and this places a greater pressure upon retailers and manufacturers.

The designer is well placed to balance the consumer demand and the manufacturing budget.

- Technology driven by human pull; consumer preference, human factors, and satisfaction will reshape the product creation process, and override the current efficiency driven system.
- Emotional bonds; it is the contextual meaning of a product that creates a higher level of interaction and strategies have to change to meet this future demand.

There is strong evidence to suggest that consumers now seek products that engage on an emotional level, products that induce delight and pleasure, rather than products that are simply usable, or merely fulfil a role (Jordan et al. 1995; Jordan 2000; Hummels 1999). As Hartmut Esslinger, the founder of Frog Design concludes (in Demirbilek and Sener, 2001): "*... no matter how elegant and functional a design, it will not win a place in our lives unless it can appeal at a deeper level, to our emotions.*"

Jordan has adapted Maslow's hierarchy of human needs (1970) to form a "hierarchy of consumer needs" (1997) that visually demonstrates this paradigm shift. As with Maslow's model, the hierarchy follows the principle that once one level of needs have been met, then the consumer will seek the next, higher, level. Furthermore, the top level of the hierarchy can only be attained for a short time as other needs surface that require satisfying.

Figure 16-1. Jordan's hierarchy of consumer needs (1997).

In Jordan's hierarchy (Figure 16-1) it is proposed that the primary user need is *functionality*; the product must fulfil the task for which it is intended. Once this has been attained, the user then seeks a product with an appropriate level of usability. Once the product has achieved the desired level of *usability*, the user will then demand more from the product. This leads them to the top level; *pleasure*. Jordan's hierarchy provides a useful starting point from which to view this growing trend in consumer behaviour. However, a hierarchical approach may be too simplistic. The hierarchical structure of the model implies (at least to the layman, particularly those familiar with Maslow's hierarchy) that one can only proceed further up the hierarchy once the present level has been fully achieved. This notion is particularly true for those familiar with Maslow's original hierarchy where this concept does hold true. However, it has been shown that consumers can choose products based on pleasure, while compromising functionality and usability (Porter et al. 2002). Despite this, the conclusion that can be drawn from Jordan's model is clear; consumers are now demanding more from the products that they buy than just adequate functionality and usability.

Jordan (1997) developed his model further by taking Tiger's conceptual framework of "four pleasures" (1992) and adapting it to relate to product design.

1. **Physio-pleasure**

 These are pleasures derived from the sensory organs such as touch and smell as well as sensual/sexual pleasure e.g., the tactile sensation from using controls or the olfactory sensation from the smell of a new car.

2. **Socio-pleasure**

 This is concerned with pleasure gained from interaction with others. This may be a "talking point" product e.g., a special ornament or painting. Alternatively, the product may be the focus of a social gathering e.g., a vending machine or coffee machine. This pleasure can also be a product that represents a social grouping e.g., a particular style of clothing that gives a person a social identity.

3. **Psycho-pleasure**

 This pleasure is closely related to product usability, and is the feeling of satisfaction formed when a task is successfully completed and the extent to which the product makes that task more pleasurable e.g., the interface of an ATM that is quicker and simpler to use.

4. **Ideo-pleasure**
This is the most abstract pleasure and refers to the pleasure derived from entities such as books, art and music. In terms of products, it is the values that a product embodies e.g., a product that is made of eco-friendly materials and processes that conveys a sense of environmental responsibility to the user or brand loyalty.

2. Designer needs from a resource

Clearly, the context in which designers are now designing has changed and they need the appropriate tools and resources to support their designing activity. Traditionally, designers have satisfied the emotional and aspirational needs of the consumer through intuitive techniques, with no formal methodologies. However, research has shown that providing designers with data that assists them in their awareness of the emotional needs of a target market is something that is much sought after (Chhibber et al. 2004). To ensure that the information collected is accessible to designers it was necessary to consider carefully the design of the resource itself. The input of ergonomics information into the design process is immensely valuable (Feeney et al. 2000). However, there has traditionally been a communication "gap" between the two disciplines. Porter and Porter (1999) suggest that the differences between the two (and other related disciplines) may be due to the consequences of innate ability, education, and the real world practices of the different disciplines. Most human factors methods are quantitative or qualitative, and are essentially analytical tools; the data they provide concern people's capabilities and reactions to design variables, but do not generally lead directly to design solutions, leaving the designer frustrated (Fulton-Suri et al. 2000). The data are often produced in a scientific non-prescriptive form that designers find hard to interpret (Feeney et al. 2000). This leads to human factors information frequently being left out of the design process (Burns et al. 2000) or being used in an inappropriate way (Burns et al. 2004).

Porter and Porter (1999) highlight three factors that contribute to the communication "gap".
- Communication of ergonomics information at an inappropriate point in the design process;
- Communication difficulties between ergonomists and designers/ engineering designers caused mainly by educational and practice differences;

- Communication of ergonomics information and data in an inappropriate fashion by ergonomists.

Clearly the format of ergonomics information and its point of input into the design process are critical. Whilst methods do exist that enable the classification and evaluation of user 'pleasure' (http://www.designandemotion.org/society/knowledge_base/tools_method s.html), but little is known about what methods designers are aware of or are currently using. There was also a need to understand what types of information designers would like in a "pleasure" resource and, crucially, how they would like to access it. Fourteen practising designers were interviewed concerning their practices and views on a "resource" for designers (Chhibber et al. 2004) and the following conclusions were drawn.

User pleasure is of growing importance to designers but they are unaware of any tools/methods/resources that are available to them. They tend to incorporate only physio-pleasure and are less aware of other ways that they are able to bring pleasure to the user. The pleasure resource must be representative of all pleasure types and raise awareness in the designer population.

Designers are increasingly employing user centred design research methods to develop a more holistic view of the user, but methods are often "quick and dirty" with an intuitive evaluation of data. Time is an issue for designers who are often working to very tight time constraints so tools must be quick and easy to use.

Designers would find a pleasure resource very useful but there were concerns of it being misused e.g., focusing on particular users. The resource must be designed in such a way that accessing all users is encouraged/facilitated.

The information in the resource must immerse the designer in people's lifestyles in a highly visual and engaging way. As much lifestyle information as is practical would be appreciated. Designers also require very flexible and intuitive access to information in such a resource. They also emphasised the need for visual presentation as a means of communicating ideas in the design process.

Whilst it is crucial to satisfy designers' needs, it is also important to develop mechanisms in the resource that promote inclusive design decisions, and reinforce the principle that the resource is a reference database aimed at inspiring and guiding design direction and research. It is not a replacement for user centred design and research, but a resource that can be used to identify the key pleasure issues of their target demographic, earlier in the design process.

These findings were used, in conjunction with the results of a focus group (six design students and academics), to understand more about designers' preferences in web-design to inform the development of a design resource, to guide the development of the resource in terms of its functionality, the manner in which it would operate and the type of content. A performance specification was developed (see Table 16-1).

Component	Specification	Additional comment/question
Data content	The resource must contain a set of statistically valid data that shows general trends for a population.	Must consider sample size required, scale of data collection i.e., where is it sourced and how it is collected. Consider ethical issues and logistics of large data collection.
	The resource must contain data about specific individuals and the pleasure they gain from products that they own.	Must consider sample size, location of sample and how data will be collected. Consider ethical issues.
	The resource must contain data that immerses the designer in peoples' lifestyles.	Must consider ethical issues and the information designers would find useful.
	The resource must capture the aspirational needs of consumers e.g., brands they aspire to.	What questions will help designers understand peoples' aspirations for the future?

Data format	The resource must be "hosted" in a way that does not hinder its functionality or usability.	Issues arose concerning running a resource over the internet; stand alone DVD or CD ROM format may be less restrictive. Investigate further during technical development.
	The statistical data in the resource must be presented in a way that designers find useful and engaging.	Desire for this to be represented in an original way – suggestions such as icons, graphics and schematics as opposed to bar charts.
	The resource must use a limited amount of text.	A visual approach requires a limited use of text. Where text is used, it must be legible. Structuring the information in the resource into "layers" may be a way of reducing the amount of text that is displayed at any one time, but maintaining the content level.
	The resource must present data collected about individuals in a visual manner.	Utilisation of video clips and images were clearly sought after by designers in the interviews.
		Video clips must be of a high quality and of a reasonable size. They must be edited to be as concise as possible and play in the "browser" as opposed to an independent media player.
		Images must be of a consistently high quality and show the interesting features of products in the resource.

Resource interface	The resource must have an interface that operates in an obvious manner.	The interface must be simple and easy to use.
		The interface should where possible use conventional icons/symbols.
	The resource must be quick to use.	Assess technical constraints that may limit speed.
		Interface layout must be consistent and logical.
		The resource must provide the designer with a sense of location as to where they are in the resource at any one time.
		Speed of navigation may be improved by the use of keyboard shortcuts and controls such as "forwards", "backwards" and "home" as found on most internet browsers.
		The information must be structured into "layers" to make navigation easier and the mass of data less daunting.
		Consider variable navigation styles to suit the way that the designer works, investigate whether this may compromise usability.
	The resource must be flexible in the way that designers can access information.	There was a clear desire to filter information by the characteristics of different market groups e.g., gender, as well as the ability to search for different product types.

		Searching and filtering data should be done through the use of icons and graphics wherever possible.
	The resource must be "pleasurable" for designers to use.	Consideration of aesthetic appeal, use of icons and the use of standard navigation features.
		Speed and ease of use are of paramount importance to the appeal of the resource.
		Consider the inclusion of "wow" factors in a subtle way.
		Consider the balance between interactive features and sticking to more conventional methods of control e.g., method of saving search information.
		Avoid the use of "pop-up" displays, use scrolling where there is too much information for a standard screen size.
	The resource should encourage inclusive design.	Any interface mechanism that encourages inclusive design should be considered.
Additional features	The resource must provide a way of saving search results and reviewing data that has been collected.	Assessment of technical needs that would enable this functionality. Interface for such a feature must be quick and simple to use.
		Consider ways of annotating or manipulating saved data e.g., portfolio toolbox.

Table 16-1. Resource performance specification.

3. Tools/resources to support designers

Methods have been developed that allow designers to formally address the pleasurable aspects of products in the design process e.g., Kansei Engineering (Nagamachi 1995), a method for translating feelings and impressions into product parameters. It facilitates the "measuring" of feelings and reveals the relationship with certain product properties. Consequently, products can be designed to provoke a specified emotion. However these methods are statistically cumbersome, and implemented late in the design process, often after critical design decisions have already been made. More recently, methods have been developed that can be used at an earlier stage in the design process e.g., User Compass Chart (Sperling 2005), which involves users selecting materials/colours that match desired attributes of a product. Such methods, however, can be quite time consuming and there is the risk that less technical designers may be reluctant to use them without appropriate support (Porter et al. 1999).

The RealPeople project differs in several ways. The majority of designing for emotion resources tools available to the designer are product focused, assessing variations in product design and the resulting human reaction. The RealPeople resource has been developed from a human-centred perspective, looking at the products that specific people find pleasurable and also general trends across a population in terms of attitudes towards product relationship, and at specific people and their lifestyles. The resource was developed with designers' needs in mind (Chhibber et al. 2004), and is suitable for use at the beginning of the design process, to guide and focus the design direction.

4. Collecting RealPeople data

There was clear evidence from the interviews that two different sets of data were required to satisfy the needs of designers; more intimate data about people, their lifestyles, and the products that they find pleasurable and data that shows general trends across a wider population. These data were collected in two research strands that ran concurrently during the project. Both sets of data used a quota sampling method to ensure an even spread across gender and age.

4.1 Intimate data

The first activity involved the collection of richer, more intimate data from 100 people. Each participant took part in an in-depth interview in which they discussed their three most pleasurable products. Each interview took place in the participant's home or a personalised work space; showing their chosen products in, as far as practicably possible, their natural environment. It also allowed the interview session to be conducted in as relaxed and informal a manner as possible, to facilitate the collection of such intimate data.

As well as an in-depth interview where they discuss each of their three most pleasurable products, participants completed a number of other questionnaire; the first concerned their attitudes towards product pleasure. The questionnaire was developed through several pilot studies and its content was strongly influenced by the views of practising designers (Chhibber et al. 2004). It was subdivided into several sections, and was filled in, in part by the interviewer, and in part by the participant, allowing the process to feel more informal and relaxed. It was an attitude questionnaire where they were asked to select from a number of statements the ones which best described their feelings towards a particular aspect of product functionality, usability and each of the four pleasures; the statements are summarised in Table 16-2.

Additionally, a number of other areas were explored; these are described below:

- Lifestyle; a series of open-ended questions regarding different aspects of a person's life e.g., leisure activities, favourite music and career aspirations. The aim of including this information was to facilitate in immersing the designer in each individual's lifestyle.
- Brand choice; participants list several brands that they like, aspire to, or feel reflect their personality. These data are included to satisfy the need, specified by designers, to understand the aspirations of different individuals.
- Style choice; participants were presented with images showing a sample of products from four product categories: mobile phones, chairs, fonts, and wristwatches. Each category had five examples selected through a focus group with designers, to represent the style possibilities in that category i.e., 5 mobile phones that were chosen because they reflected the full breadth of the mobile phone market

Product characteristic	Attitude statement
Functionality	I like products that (select one from four)… - have exactly the functionality I know I will use - have exactly the functionality I know I will use, plus some other functions that I am interested to explore and evaluate whether they will be useful - have more functionality than I will probably use - have the maximum available functionality, despite the fact that I will not use many of these functions
Usability	I like products that (select one from four)… - are simple and easy to use first time - are challenging to learn, but once learned they are easy to use - that are challenging to use even after I have owned them for a while e.g., a computer game with increasingly more challenging levels - have "secrets" and hidden features that I have to discover over time, whilst learning to use the product
Physio-pleasure	I like products that (select as many as you like)… - the colour(s) of a product are important to me - the touch and feel of a product when I interact with it are important to me - the "right" sound of a product in use is important to me e.g., the clunk of a car door - the way materials are used in a product is important to me - the shape and form of a product is important to me
Socio-pleasure	I like products that (select as many as you like)… - demonstrate I have a discerning taste to other people - demonstrate to other people that I am successful - tell other people something about me e.g., sports watch, ethnic clothing - are a talking point amongst my friends and/or my

	family.
	- are a talking point amongst any group of people
	- allow me to socialise
	- that fit into any social context e.g., a wristwatch that can suit a formal or casual situation
	- that are understated
Psycho-pleasure	I like products that (select as many as you like)…
	- express an aspect of my personality
	- allow me to complete tasks easily
	- operate in a meaningful way to me e.g., desktop metaphor on a computer
	- have some level of personal significance to me e.g., a gift from a loved one
Ideo-pleasure	I like products that (select as many as you like)…
	- represent an ideology that I believe in e.g., eco-friendly, fair trade, materialism
	- where the overall aesthetics (the combination of form, textures, colour, etc. that create the aesthetic) of a product are important to me
	- from a particular brand
	- by a particular designer

Table 16-2. Standardised interview questions.

at that time. The participants selected which one of the five samples in each category they liked the most, and briefly explained why; this should enhance the designer's understanding of particular users and their aesthetic preferences.

• Personality assessment; each participant completed a short personality assessment. The test is based on the Big Five personality locator (Glietman et al. 2000).

4.2 General trend data

The data collection of general trend data; a street survey was conducted in 11 UK locations, including the north and the south of England. A total of 582 people were interviewed and filled in the Pleasure attitude

questionnaire filled in by the 100 "intimate" data participants, described in the section above.

5. Analysis and results of RealPeople data collection

Each interview was then edited into three, 2-3 minute film clip (one for each product) that encapsulates the most pertinent reasons why each product brings pleasure to the individual. These reasons are also summarised in short text bullet points with the "four pleasures" used as a framework.

5.1 The RealPeople DVD resource

The "intimate" data is what forms the core of the RealPeople "resource". It is a stand alone DVD based resource (both Mac and PC compatible) with an interactive graphic "front end" developed in Macromedia Director MX and the collected data being stored in a database accessed via the scripting language "lingo". The "look" and "feel" of the resource have been developed through an iterative design process using team members, other colleagues and designers for evaluation.

The principal page of interaction is the "search page" (see Figure 16-2). The designer is able to search the database in a flexible and intuitive way. Selecting different icons allows the designer to filter the individuals in the database by criterion such as age, gender, or income; conversely, they can filter the data by specifying different product types. For example, selecting "mobile phones" filters out everyone except those who chose their mobile phone as one of their most pleasurable products. As the designer defines the search parameters, the array of 100 individuals (grid at bottom of Figure 16-2) updates in "real time" and fades out those individuals that have been eliminated. This highly visual feedback during the search process gives the designer a greater sense of which individuals they may be "designing out" during each search. The images of those that remain form the link that directs the designer to that individual's data set.

Figure 16-2. Search page showing selection categories and photographs of 100 individuals in the database.

Figures 16-3 to 16-7 illustrate the different subsets of information available for each of the participants. Each person has in essence, their own individual homepage that remains consistent on the left hand side of the screen (aiding navigation). Access to each different data set for that individual is done through interacting with this homepage, the right window updating to show that data set in full.

As a default, each individual's page appears with the three product video clips on display in the right window (as these are part of the search criterion). Each video clip is highly immersive, thought provoking, and is selected to encourage empathy between the designer and each individual in the database. In addition to this, a table of bullet points of the most pertinent reasons why the product brings them pleasure, analysed and presented with respect to the four pleasure framework, is provided as a quick reference for the designer.

Figure 16-3. Individual "home" page and product videos.

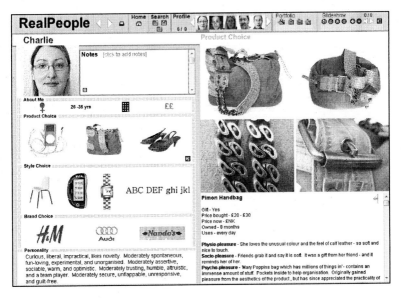

Figure 16-4. Individual "home" page and more product information.

Figure 16-5. Individual "home" page and lifestyle information.

Figure 16-6. "Home" page and style choice data.

Figure 16-7. "Home" page and brand choice data.

5.2 Population wide trends

The χ^2 was used as a test of fit; showing a number of significant trends across the entire sample population. The data provided by the 100 "intimate" data participants were combined with the data from the 582 respondents to the trend data survey; they were entered into the statistics package SPSS and analysed to identify any trends. A non-parametric χ^2 test was employed in two ways as a test of fit and as a test of independence, to identify trends across the entire sample population and trends across gender and age. A number of trends were identified at $p<0.05$ but only those that reached a significance of $p<0.01$ are presented. A more complete discussion of the trends can be found in Chhibber (2007).

5.2.1 Consumer attitudes towards product functionality

A number of significant trends are shown in Table 16-3. Participants were required to choose from four statements concerning functionality (see Table 16-2). The sample showed a significant preference towards products that have either the exact functionality required (39%), or slightly higher levels of functionality that can be explored (44%). There was a low appreciation of products with more functionality than will be used (9%), or

Functionality attitude	χ2 across whole sample	χ2 across gender	χ2 across age
Preference for one of four levels of functionality	306.75**	5.45	63.83**

Table 16-3. Chi-square results for functionality (* indicates significance of p<0.05, ** indicates significance of p<0.01).

maximum functionality (8%). The literature indicates that functionality is now seen as a prerequisite for products; Jordan's (1997) adaptation of Maslow's hierarchy of needs shows functionality as the base level of consumer satisfaction. However, the pleasure capacity of functionality should not be underestimated and as the results show, the level of functionality that brings pleasure must not be misjudged. The work of Burns and Evans (2000) focuses on automotive interiors and proves an interesting case in point; they found that interior functions fell into three categories: expected features, wanted features and unexpected features. In essence, customer delight was found to be at its highest when features (regardless of how much the customer wanted them) were "executed" to a high level. It is interesting to note that "expected" functionality when well executed, was a source of pleasure to the consumers in their study, indicating that apparently basic functionality can also bring pleasure to consumers.

Increasingly older age groups prefer products that display exact functionality (36-45 yrs, 48.3%; 46-55 yrs, 48.1%; and 56+ yrs, 53%). This finding is mirrored by a higher proportion of younger age groups preferring products, with more functionality, which they are able to explore (18-25 yrs, 57.3%; 26-35 yrs, 51.1%). This is probably explained by the fact that younger age groups tend to expect more from the products they buy and are essentially more comfortable with technology and exploring the functionality of products. The opposite is true for older users, who appear to seek products that are fit to the task and do not have additional functionality. This may indicate that in order to design more "pleasurable" and acceptable technology for the elder user, a better understanding of their attitudes and understanding of technology is needed.

Whilst the survey results indicate lower levels of technology acceptance with an increase in consumer age, it is important to note that

the stereotype of the techno-phobic older consumer may be in decline. Quigley and Tweed (2000) cite a survey performed by computer manufacturer Packard Bell in the 1990s as evidence of older generations becoming more comfortable with technology. Between 1995 and 1998, the percentage of elderly users of home PCs in the US rose from 29% to 40%. Older users may be becoming more comfortable with new technology; Quigley and Tweed (2000) also propose that a person's level of education, favourability to new technology and income, affected their acceptance of PCs. It is also fair to predict that as current "technology aware" younger generations age they will carry with them their more open attitudes towards technology and its uses, potentially leading to a shift in time towards an appreciation of more functionality in products across all age ranges.

5.2.2 Consumer attitudes towards product usability

Participants were required to choose from four statements concerning usability (see Table 16-2). Table 16-4 shows a number of significant trends. Further examination of the data showed that there was a preference across the sample population for products that are simple and easy to use (60%). 27% of the sample population preferred products that are initially challenging to use but then easy, with the remaining 13% of the sample split across the remaining two categories. It is natural to assume that people want products to be simple and easy to use. Jordan (2000) proposes that adequate usability is now inherent in consumer products and that it is no longer a consumer satisfier, i.e., usability is a pre-requisite and if it is poor the consumer is dissatisfied. It is thus possible to conclude that the majority of the sample population will prefer products that are simple and easy to use, as it has become a central tenet to that which consumers perceive as good design.

There is an age effect concerning consumer attitudes towards usability. The results for the entire sample indicated that 60% of the participants

Usability attitude	χ^2 across whole sample	χ^2 across gender	χ^2 across age
Preference for one of four levels of usability	512.19**	7.61	56.21**

Table 16-4. Chi-square results for usability (**indicates significance of $p<0.01$).

preferred products that are simple and easy to use; a high proportion of
these are from the older age groups e.g., 78% of the 56+ age group,
compared to a much lower percentage in the younger age groups e.g.,
41.3% of the 18-25 year old age group, 51.9% of the 26-35 year old age
group. 27% of the entire sample preferred products that were initially
challenging to use, but after some ownership were easy to use. A relatively
higher proportion of that 27% are from the younger age groups e.g., 18-25
yrs, 33.5%, 26-35 yrs, 34.5%, indicating that younger age groups were
more willing to use products that require a level of learning or are a
challenge to use. The percentage of the 56+ yrs age range seeking a
similar level of usability was markedly less; 18.9%. This adds weight to
the premise that younger age ranges tend to be more comfortable with
technology and with learning how to use it.

The desire from older age groups to have usable and simple products is
highlighted by the low percentage selecting either one of the final
categories of usability; only 6.1% of 46-55 year olds and 2.3% of 56+ year
olds wanted products that were always a challenge to use. This pattern is
repeated for the final category of products with hidden features that need
to be discovered over time; 5.3% of 46-55 year olds and 0.8% of 56+ year
olds selecting this level of usability. Usability testing of products has often
showed marked differences in performance and user age (Freudenthal et al.
2003) and it is evident from the results gained here that there is a link
between the two. Freudenthal and Mook (2003) account for the disparity
in usability results between generations, by the technology that they
encounter in their "formative years"; noting that older users are less
familiar with iconic displays and the use of metaphor in interaction with
products when compared to younger users. As these results also draw
parallels with the findings reported for consumer attitudes towards product
functionality. As current generations age, it is logical to propose that the
more technologically able younger generations will carry this greater
desire for challenging and engaging products into their older age.

5.2.3 Consumer attitudes towards physio-pleasure

Table 16-5 shows a number of significant trends. The colour of a
product is significantly important to the sample, with 61.6% stating that
they valued this product characteristic, There is no doubt that colour is an
important component of the emotional appeal of products, as Baker (2004)
states: "... *colour is a fast track to emotion: a hotline to instinct. It is
powerful, evocative and mood changing*..."

Q	Statement	χ2 across whole sample	χ2 across gender	χ2 across age
A	The colour(s) of a product is important to me	36.60**	26.03**	123.20**
B	The touch and feel of a product when I interact with it are important to me	47.51**	0.69	9.58*
C	The "right" sound of a product in use is important to me e.g., the clunk of a car door	26.33**	10.40 **	4.21
D	The way materials are used in a product is important to me	0.29	0.81	10.28*
E	The shape and form of a product is important to me	90.18**	2.17	7.55

Table 16-5. Chi-square results for physio-pleasure (* indicates significance of p<0.05, ** indicates significance of p<0.01).

Baker suggests that the field of product semantics includes aspects such as texture, scale, form and line, but it is often colour that makes the first, most memorable and lasting impact upon the consumer. Much work has been done on defining colour and related emotional responses, especially in the field of psychology (Sato et al. 2000). However, there are problems with the current state of research in this area; the vast majority of work has focused on emotional responses to single colours; something that we rarely encounter in day to day life and something that a designer is rarely going to use; much less work has been conducted into emotional responses to colour combinations (Ou et al. 2004). More often, designers utilise combinations of colours, whose relationship will evoke emotional reactions.

63.2% of the sample population valued the tactile characteristics of products, significant to p<0.01. There has been some research into emotional reactions to differing materials and textures and the findings that the emotional response to the texture of a shampoo bottle may elicit

another response when placed on a coffee jar (Sedgwick et al. 2003). The development of techniques such as Skin 2.0 (Saakes. 2005) do provide the designer with a means of beginning to present and understand tactile properties within the context of the form and styling of the product. Such methods and techniques are clearly beneficial to designers, as the findings reported here clearly indicate that an appealing "touch and feel" to a product is something that consumers often find pleasurable.

The auditory qualities of a product were valued by 40.18% of the sample population, significant to $p<0.01$; this would appear to indicate that the "right" sound of a product in use is not as important to the sample population as other physio-pleasure qualities. The question used in the standardised interview provided the example of the sound of a car door when closing; the characteristics of this sound have implications upon the consumer's perception of the car, perhaps its build quality or the sense of safety that it gives. In contrast to this, there may be situations where a well designed product needs to emit very little sound at all, for example, a person may find pleasure in the quietness of a computer printer. In this instance the "right" sound that the question refers to no sound at all; however, it is also plausible that it may be reassuring to the consumer that a printer does emit some sound, so they know their printing is occurring.

The shape and form of a product was also important to 68.2% of the sample population, which was significant to $p<0.01$. It was also the most valued of all of the physio-pleasure characteristics.

The form of a product may contribute to its success in several ways; to differentiate the product in a cluttered market place, to communicate product attributes to the consumer and to develop corporate and brand identities (Bloch 1995).

Each of the physio-pleasure attributes has been evaluated individually in order to highlight trends specific to that characteristic. However, it is important to remember that the physical properties of a product interact with each other; we perceive products as complete entities, rather than as a group of individual characteristics. Research by McLoone (2003) highlights the inter-relationships that exist between the physical characteristics of products; he highlighted a number the close inter-relationships that the physio-pleasure properties of a product can have.

There were two physio-pleasure characteristics that had a significant gender effect. There was a significant gender effect present (to $p<0.01$)

regarding the importance of colour, with 70.7% of the female sample valuing this characteristic compared to just 51.7% of the male population. This would appear to show that females place a greater emphasis on the colour of products than males. Research by Hetzel (1999) concurs; he found that females tended to be more sensitive to the subjective aspects of cars, such as colour. It is plausible that this greater sensitivity to colour is applicable to females' preferences in other products.

There was also a significant gender effect (to p<0.01) related to the "right" sound of a product. Although this characteristic was not valued particularly highly across the entire population (40.2% stated that this was an important feature to them), the data does display a gender effect. 46.5% of the males in the sample population valued this characteristic compared to just 34.4% of the females. It is possible that the close association between sound and perceived performance may be more important to males, as they are often value products from a goal and performance orientated perspective (Csikszentmihalyi et al. 1981).

There is an age effect in relation to pleasure gained from product colour, significant to p<0.01; younger age groups valued the colour of products to a greater extent than older age groups, e.g., 74.8 % of 18-25 year olds compared to just 47.7% of the 56+ category. It may be the case that this age trend is related to the markets within which each of the different generations has developed. It is only in recent times that products have begun to be produced in such a vast array of colours and it is perhaps only recently, that colour has become a major differentiator to the consumer; hence older generations may place less emphasis on it than the younger generations, as they grew up in a market where colour choice was more restricted.

There is also an age effect regarding pleasure gained from the touch and feel of a product, which was significant to p<0.05; with younger age groups valuing the tactile sensations of product use more than the older age groups e.g., 73.7% of 26-35 year olds compared to 56.1% of 56+ year olds. This trend may also be related to the generational issue outlined for the previous trend. Again this is likely to be because the older generations formed the purchasing ideas at a time when finish and materials choice was more restricted. As the younger generations grow older things are likely to be different.

5.2.4 Consumer attitudes towards socio-pleasure

Q	Statement	χ2 across whole sample	χ2 across gender	χ2 across age
A	I like products that demonstrate I have a discerning taste to other people	80.29 **	9.21**	12.95*
B	I like products that demonstrate to other people that I am successful	291.67 **	0.48	13.52**
C	I like products that tell other people something about me e.g., sports watch, ethnic clothing	190.03 **	1.51	36.99**
D	I like products that are a talking point amongst my friends and/or family	81.67**	2.12	32.08 **
E	I like products that are a talking point amongst any group of people	236.96 **	0.86	30.12**
F	I like products that allow me to socialise e.g., picnic hamper	27.12**	9.69 **	21.40**
G	I like products that can fit into any social context e.g., a wristwatch that can suit a formal or casual situation	47.51 **	6.19*	9.97
H	I like products that are understated	13.51**	1.34	13.95 **

Table 16-6. Chi-square results for socio-pleasure (* indicates significance of $p<0.05$, ** indicates significance of $p<0.01$).

It is clear from Table 16-6 that all of the socio-pleasure characteristics showed a significant trend when viewed across the entire sample population; there were a number of statistically valid trends (to $p<0.01$) that indicate several socio-pleasure attributes are not of great value to the sample population as a whole. In particular, statements B ("*I like products that demonstrate that I am successful*") and E ("*I like products that are a talking point amongst any group of people*") received a very low rating; B, 17% and E, 21%. There was also a low appreciation of products that demonstrate a discerning taste to other people (33%), are a talking point amongst friends and family (33%) and that tell people something about the owner (24%).

However, each of these statements perhaps needs reflection; are these characteristics that participants would be readily willing to admit about themselves to an interviewer? These five socio-pleasure characteristics all relate to products that may be a status symbol of sorts, or attract attention to the owner. It may be possible that the low positive response rate to these questions is due to "social desirability bias". In certain situations, a participant may be tempted to give the socially desirable response rather than describe what they actually think, believe or do. Typically, this has been associated with the person's general strength of need for approval and the demands of the situation they are in (Phillips et al. 1972). The question has to be raised as to whether a participant would have been comfortable admitting that they liked products that demonstrated success or discerning taste, or drew attention from others.

57% of the sample liked products that were understated; both of these trends were significant to $p<0.01$. The positive response to statement H is the corollary of statements A to F, as these concern products that are designed or purchased to attract attention. Furthermore, it is possible that products that fit any social context (statement G) have similar attributes to those that are understated, as they are neutral enough to fit a number of different contexts.

It is evident that males (38.5%) showed a greater preference for products that demonstrate a discerning taste, than females did (27.6%). Across the whole sample this product characteristic did not provide a great deal of pleasure (33% of sample population responded positively), but gender did have a significant effect ($p<0.01$).

A substantially greater percentage of females (47%) found pleasure from products that facilitate social interaction, in contrast to males (33.9%); this was significant to $p<0.01$. It is apparent that female consumers place a greater emphasis on the social aspects of products and the way in which they can develop or maintain relationships.

The final significant trend showed that females had a greater appreciation for products that can fit into any social context (65.6%) as compared to males (58.9%), which was significant to $p<0.05$. It was suggested earlier that this characteristic was essentially the opposite of a number of the other socio-pleasure characteristics that related to products as status symbols or as a means of attracting attention.

These trends are all supported by the work of Hetzel (1999), of Csikszentmihalyi and Rochberg-Halton (1981) and Dittmar (1992) who note that males place a greater emphasis on the appearance and often see products as symbols of personal achievement and representing a goal that they aimed to achieve. Equally, females favour the values of sharing and friendliness; causing increased feminisation in the automotive industry in terms of styling and design, and they tend to treasure possessions that are associated more with inter-personal relationships and representative of their social lives.

There were a number of age trends. The first was significant to $p<0.05$; the younger age showed a slight preference for products demonstrating a discerning taste to other people over the older age groups in the sample e.g., 34.3% of 18-25 yr olds and 43.6% of 26-35 yr olds, compared to 27.3% of 36-45 yr olds, 34.4% of 46-55 yr olds and only 25% of the 56+ yr olds. They also showed a preference for products that demonstrate success to other people, significant to $p<0.01$ e.g., 18-25 yr olds, 25.2%; 26-35 yr olds, 20.3%; 36-45 yr olds, 17.5%; 46-55 yr olds, 10.7%; and 56+ yr olds, 12.1%. It is also clear that younger age groups found pleasure from products that tell people something about the owner, e.g., 39.9% of the 18-25 yr olds compared to only 12.9% of the 56+ yr olds; significant to $p<0.01$.

These trends all illustrate how younger age groups appear to be more image conscious and more aware of how the products that they buy and use, can reflect them as a person and can demonstrate status to others. It also highlights how younger age groups can view products as showing an identity e.g., product shows them as part of a particular social group,

whereas older age groups value this attribute less; it also shows clear evidence of a preference in younger age groups for products that are a talking point amongst the owner's friends and family. Additionally, there was also an age effect regarding pleasure gained from products that are a talking point amongst any group of people; younger age groups found this aspect more appealing than older ones, e.g., 18-25 yr olds, 35.7%; 26-35 yr olds, 21.8%; compared to 46-55 yr olds, 14.5%; 56+yr olds,

All of these age trends relate to the use of products to reflect status to other people and to give the owner a sense of identity, discussed above.

There was also an age effect concerning products that facilitated social interaction, with younger age groups showing a greater affinity for this characteristic than older age groups, e.g., 18-25 yr olds, 51%; 26-35 yr olds, 45.1%; compared to 46-55 yr olds, 40.5%; 56+ yr olds, 25%. Again these results are reflected in the work of Csikszentmihalyi and Rochberg-Halton (1981), Dittmar (1992) and Kamptner's (1991).

There is also an age effect concerning pleasure gained from a product being understated, with the middle age groups showing a preference for this characteristic over the old or young age groups e.g., 36-45 year olds, 65.7%; compared to 18-25 year old, 48.3%; 56+ year olds, 49.2%. This may again relate to products being used to reflect personality or identity by younger consumers, understated products may appeal more to older age groups as they already have an established identity (Dittmar 1992) and do not seek to use products in this way. The reason for a low level of interest in this characteristic for the eldest age group however remains unclear.

5.2.5 Consumer attitudes towards psycho-pleasure

Table 16-7 shows a number of significant trends. It is clear from an examination of the results for statement B ("*I like products that allow me to complete tasks easily*") that these correspond closely with the results for the level of usability consumers sought; however this psycho-pleasure attribute relates more to the sense of satisfaction from task completion and the ability to achieve this easily. It is evident that there was a marked preference towards products that display this characteristic; 84% of the sample. These results correspond with evidence in the literature that usability and ease of task completion is still a valued commodity by the consumer and can bring pleasure (Jordan 2000).

Q	Statement	χ2 across whole sample	χ2 across gender	χ2 across age
A	I like products that express an aspect of my personality	1.32	8.78**	74.53**
B	I like products that allow me to complete tasks easily	315.68 **	1.99	16.11**
C	I like products that operate in a meaningful way to me e.g., desktop metaphor on a computer	3.97*	3.42	7.01
D	I like products that have some level of personal significance to me e.g., gift from a loved one	140.91**	10.49 **	10.76*

Table 16-7. Chi-square results for psycho-pleasure (* indicates significance of $p<0.05$, ** indicates significance of $p<0.01$).

There is also a slight trend evident of pleasure gained from products operating in a meaningful way to the consumer; 54% of the sample found this appealing, which is significant to $p<0.05$. This characteristic relates closely to the ease of use of a product or interface; specifically, the product operating in an intuitive manner that the consumer finds logical and easy to understand. The positive result for this characteristic matches those for usability and for the previous psycho-pleasure characteristic.

The sample population found products with personal significance to them to be appealing; 73% responding positively. There is however some ambiguity concerning how each participant interpreted the idea of "personal significance". The question that was used in the survey offered the example of a "gift from a loved one" and in this context the results would seem logical. Dittmar (1992) provides anecdotal examples of how people view photographs as "reminders of relationships with family members or friends" and how "sentimental knickknacks" can be used as good luck charms, as evidence of the manner in which products can have personal significance to the owner.

There are two significant gender effects present for the psycho-pleasure characteristics that were assessed. The first concerned pleasure gained from products representing an aspect of the consumer's personality. 53.2% of females liked this product characteristic compared to 41.9% of males. These results are supported by the work of Hetzel, who found that 33% of females, compared to 24% of males felt that their car expressed their personality.

The second significant gender effect relates to products that have a level of personal significance to the consumer e.g., a gift from a loved one. 78% of females valued this characteristic, compared to only 67% of males. These findings again draw a parallel with Dittmar's (1992) views on females' greater concern with the symbolic and relational aspect of products, as opposed to the male focus upon the functional, activity related and self-orientated aspects. Csikszentmihalyi and Rochberg-Halton (1981) also found that females were more attached to products that symbolised relationships; favoured products amongst women in one of their studies included photos, sculptures and textiles. This is in stark contrast to the more egocentric and goal orientated reasons given for the choice of televisions, stereos and sports equipment by males.

A number of significant age effects were present. It appears that younger age groups tend to find greater pleasure from products that express their personality than older age groups e.g., 18-25 year olds, 74.8%; 26-35 year olds, 55.6%; 36-45 year olds, 39.2%; 46-55 year olds, 40.5%; 56+ year olds, 27.3%. Again, this is in line with the work of Dittmar (1992) and Kamptner (1989, 1991a) as discussed previously. And it is clear that younger designers need an understanding of the different concerns that the different age demographics have, to facilitate successful design.

5.2.6 Consumer attitudes towards ideo-pleasure
As Table 16-8 shows, all of the characteristics proved to have a significant trend when viewed across the entire sample population and there were also a number of significant gender and age effects present. Products that represent an ideology that a consumer believes in was an important factor to the sample population; 61% responding positively. Dittmar (1992) suggests that products have a self-expressive function for the individual and can be used to express "*their attitudes, values and personal qualities*"; these results indicate that this is of value to consumers with 75% responding positively. Bloch (1995) proposes that:

Q	Statement	χ2 across whole sample	χ2 across gender	χ2 across age
A	I like products that represent an ideology that I believe in e.g., eco-friendly, fair trade, materialism	35.68**	11.89 **	9.25
B	The overall aesthetics (the overall look of a product, the combination of form, textures, colour, etc. that combine to form the aesthetic) of a product are important to me	175.54 **	3.46	14.63**
C	I like products by a particular brand	55.19**	2.56	5.91
D	I like products by a particular designer	271.11 **	0.45	25.10**

Table 16-8. Chi-square results for ideo-pleasure (* indicates significance of p<0.05, ** indicates significance of p<0.01).

> In modern societies, aesthetic sensibilities (aesthetics being used to mean the combination of all of the factors that form the overall character of the product) are relevant to all products, regardless of their function

and that the use of "beautifully designed" products brings pleasure and improves the quality of our lives. Bloch's beliefs support the positive response for this characteristic that products by particular brands do not seem to be a great source of pleasure for the sample population, only 36% of the sample stated it was important to them.

Additionally, products designed by a particular designer do not appear to elicit a great deal of pleasure for the sample population; 18% found this characteristic to be pleasurable. The results for "designer" and "branded" products are surprising; brands have been shown to play a pivotal role in a consumer's expression of self (Belk 1988) or of certain specific dimensions of themselves (Kleine et al. 1993) and people often form quite

strong relationships with particular brands (Fournier 1998). The low appreciation of such characteristics may again be due to social desirability bias, as participants may not have wanted to admit to placing emphasis on an attribute that is so closely linked to other factors such as status and taste. Conversely, some consumers genuinely may not care about branded or designer products and may in fact deliberately seek products that do not display these characteristics.

There is one significant gender effect concerning products that represent an ideology that the consumer believes in; it shows that 67.6% of females liked this characteristic compared to 54.7% of males.

In the study by Dittmar (1992) found that females often related more to the symbolic properties of the products that they own, compared to the more activity and functional related perspective of males. Hence, females' greater emphasis on the symbolism that may be inherent to a product may be reflected in this trend as they seek to express their beliefs and attitudes through the products that they own. This is not to say that beliefs and attitudes are not relevant to males, but that they seek to express them through the products they buy to a lesser extent.

There are two significant age trends in relation to the ideo-pleasure characteristics of products. The first concerns appreciation of the overall aesthetics of a product; there is a steadily reducing appreciation of this characteristic as the age groups get older e.g., 18-25 year olds, 84.6%; 26-35 year olds, 77.4%; 36-45 year olds, 75.5%; 46-55 year olds, 73.3%; 56+ year olds, 65.2%. This greater emphasis on aesthetics in the younger generations may, again, be a consequence of the different "markets" in which the age groups developed their purchasing preferences; the greater diversity of today's market means that the consumer can more easily express aesthetic tastes, and as such, younger consumers are more focused on the aesthetic qualities of products than the older generations.

The other significant age effect concerning pleasure gained from products that have been designed by a particular designer. Younger age groups seem to gain more pleasure from products by a particular designer than older age groups, for example, 28% of 18-25 year olds compared to 9.1% of 56+ year olds. The reasons for this trend are unclear: however, it could be argued that particular designers carry a certain level of status and portray a certain image. It is almost certain that "designer" clothing and products and the status of certain designers and brands plays a critical role

in the sense of identity consumers wish to portray; the younger consumer appear to place more value in such commodities.

What is clear from all of the trends that are described above is that the relationship with product is complex and varies tremendously across gender and age groups. The more the designer understands of these variations the more likely they are to be able to successfully design for a demographic. It is also important to acknowledge those consumers' views and attitudes are "fixed" in their formative years and evidence suggests that they remain with them throughout their purchasing life.

5.2.7 Data representation

In keeping with the desire of the designers, for the resource to be visually driven, the trend data is represented in a visual manner as shown below in Figure 16-8. The detail of the significant trend is given i.e., "the shape and form of a product are important to the sample population". This is then illustrated using photographs of some of the products where participants highlighted the pleasure that was elicited by the shape and form.

Figure 16-8. RealPeople page showing gender trends.

6. Functionality

The RealPeople resource also has several functional features that are intended to enable them to use the resource more effectively, allowing it to fit in with the manner in which designers work. These are outlined below:

- Notes–each database individual has a text window in which designers can add and save notes about that person, either for personal use, or to be viewed by subsequent users.
- Slideshow–the designer can create basic slideshows containing information from the database. These can be saved and then shown as a presentation.
- View all videos–the designer can enter search criteria, then activate a "play all video" function. This automatically plays all of the video clips relevant to that search, consecutively, allowing the designer to take a more passive role and absorb the information at leisure.
- Portfolio–the designer can save relevant search results in individual project portfolios; these will be editable and also be able to be shown as slideshows. It is envisaged that the designer may develop multiple portfolios as several projects may be running consecutively, each with its own relevant search criterion.
- History–allows the designer to view previous searches, similar to contemporary web browsers.
- Export–the ability to export notes and portfolios for use on other machines that have the RealPeople database installed, potentially allowing sharing of information across global design teams.

7. Feedback and future work

Once enough data were available, a fully functioning prototype was developed and evaluations conducted by fourteen designers in the first instance to ensure the robustness of the basic functionality and a second time, once all of the functionality was working.

Testing involved a brief demonstration of the resource and its functionality. Each designer then carried out several tasks (e.g., searching, creating a portfolio) that allowed them to fully experience the method of interaction and the functionality that was on offer. They were then asked to comment on different aspects of the resource, ranging from the quality of the data and its format, to the overall visual appeal.

The feedback from designers was very positive. The evaluation assessed a number of different aspects of the resource and the main conclusions were:

- The designers liked the aesthetic style of the resource.
- The designers liked the level of functionality that was on offer; in particular the feedback from the search interface was seen as valuable.
- The designers found the resource easy to use and speculated that it would not take long to become familiar with the full functionality on offer.
- The designers were happy with the type of data that was available in the resource and the manner in which they were presented.
- The designers felt that the data was of a high quality, with the video clips, brand data, style choice and lifestyle information, in particular appealing to them.
- The designers felt that the resource would be of great value to designers, particularly in the opening stages of a project to inspire and guide concept generation and initiate research. They also suggested that other disciplines, e.g., marketing, might be interested in using it.
- The designers all felt that the resource would promote a greater sense of empathy with the consumers.

The informal task analysis that was conducted highlighted a number of minor issues that were addressed during further refinement of the resource, as the final data sets were added. Crucially, there were no major issues that required restructuring of the resource or major re-development. The resource is currently in the final stages of production.

Acknowledgements

This research was supported by the Arts and Humanities Research Council, and Procter and Gamble. Many thanks go to Ben Neal for his help in the technical development of the RealPeople DVD.

Works Cited

Baker, S. (2004). Colour and emotion in design. In McDonagh, D., Hekkert, P., van Erp, J. and Gyi, D. (Eds), *Proceedings of the 3rd International Conference on Design and Emotion: Design and*

Emotion, the experience of everyday things. Loughborough, 2002, Taylor and Francis, London.

Belk, R.W. (1988). Possessions and the extended self. *Journal of consumer research,* 15, 139-16.

Bloch, P.H. (1995). Seeking the ideal form: product design and consumer response. *Journal of marketing, 59 (3), 16-29.*

Burns, C.M., and Vincente K.J. (1994). Designer evaluation of human factors reference information. In *Proceedings of the 12th triennial congress of the IEA, Toronto, 259-297.*

Burns, C.M., and Vincente K.J. (2000). A participant study of ergonomics in engineering design; how constraints drive the design process. *Applied ergonomics, 31(1), 73-82.*

Burns, A.D. and Evans, S. (2000). Insights into customer delight. In Scrivener, S.A.R., Ball, L.J. and Woodcock, A. (Eds), *Co-designing conference proceedings, 'Collaborative design'.* Springer-Verlaag.

Chhibber, S. (2007). *Towards an understanding of pleasure.* Unpublished PhD thesis, Loughborough University.

Chhibber, S., Porter, C.S., Porter, J.M. and Healey, L. (2004). Designing Pleasure; Designers' Needs. In Kurtgozu, A. (Ed), *Proceedings of the Fourth International Conference on Design and Emotion*, Middle East Technical University, Ankara, July 2004 [CD-ROM].

Csikszentmihalyi, M. and Rochberg-Halton, E. (1981). *The meaning of things: domestic symbols and the self.* Cambridge, Cambridge University Press.

Demirbilek, O. and Sener, B. (2001). A design language for products; designing for happiness. In Helander, M.G., Khalid, H.M. and Tham, M.P. (Eds), *Proceedings of the International Conference on Affective Human Factors Design.* Asean Academic Press, London.

Dittmar, H. (1992). The social psychology of material possessions: to have is to be, *Hemel Hempstead, Harvester Wheatsheaf and New York.* St. Martin's Press, 19-24.

Feeney, R. and Bobjer, O. (2000). Communicating ergonomics data and principles to other professions. In *Proceedings of IEA 2000/HFES 2000 congress,* Tampere, Finland.

Fournier, S. (1998). Consumers and their brands; developing relationship theory in consumer research. *Journal of Consumer Research*, 24.

Freudenthal, A. and Mook H.J. (2003). The evaluation of an innovative intelligent thermostat interface: universal usability and age differences. In *Cognitive Technical Work 2003, 5,* 55-66, Springer-Verlag.

Fulton Suri, J. and Marsh, M. (2000). Scenario building as an ergonomics method in consumer product design. *Applied ergonomics 31, 151-157.*

Glietman, H., Friedlund, A.J. and Reisberg, D. (2000). *Basic Psychology,*
 5ᵗʰ Edition, WW Norton & Co. New York.

Green, W.S. (2002). Pleasure with products; beyond usability. In Jordan,
 P.W. and Green, W.S. (Eds), Taylor and Francis, London.

Hetzel, P. (1999). Stereotyping gender differentiation in marketing and
 product design: the 'construction' of 'female' customers in
 contemporary French automotive industry. In *Proceedings, Third*
 International Conference European Academy of Design, Sheffield
 Hallam, 30ᵗʰ March - 1st April, 1999.

Hummels, C.C.M. (1999). Engaging contexts to evoke experiences. In
 Overbeeke, C.J. and Hekkert, P. (Eds), *Proceedings of the*
 international conference on Design and Emotion, 3-5 November, Delft,
 The Netherlands.

Jordan, P.W. (1997). Products as personalities. In Robertson, S.A. (Ed),
 Contemporary ergonomics, Taylor and Francis, London.

—. (1999). Pleasure with products: human factors for body, mind, and
 soul. In Jordan, P.W. and Green, W.S. (Eds), *Human Factors in*
 Product Design, Taylor and Francis, London.

—. (2000). *Designing pleasurable products*, Taylor and Francis, London.

Jordan, P.W. and Servaes, M. (1995). Pleasure in product use: beyond
 usability. In Robertson, S.A. (Ed), *Contemporary ergonomics,* Taylor
 and Francis, London.

Kamptner, N.L. (1991). Personal possessions and their meaning in
 childhood and adolescence. In *Proceedings of the joint conference of*
 the Society for the Advancement of Socio-economics and the
 International Association for Research in Economic Psychology on
 nterdisciplinary approaches to economic problems, 16-19 June,
 Stockholm, Sweden.

Kleine, R.E., Kleine, S.S. and Kernan, J.B. (1993). Mundane consumption
 and the self; a social identity perspective. *Journal of Consumer*
 Psychology, 2(3), 209-235.

Maslow, A. (1970). *Motivation and personality (2nd Edition).* Harper and
 Row, New York.

McLoone, H. E. (2003). Touchable objects: attributes applied to the design
 of computer input devices. *Ergonomics,* 46(13/14), 1320-1331.

Nagamachi, M. (1995). *The Story of Kensai Engineering.* Kaibundo
 Publishing, Tokyo.

Ou, L.-C. and Luo, M.R. (2004). Colour preference and colour emotion. In
 McDonagh, D., Hekkert, P., van Erp, J. and Gyi, D. (Eds), *Proceedings*
 of the 3ʳᵈ International Conference on Design and Emotion: Design

and Emotion, the experience of everyday things, Loughborough, 2002, Taylor and Francis, London.

Phillips, D.L. and Clancy, K.J. (1972) Some Effects of 'Social Desirability. *Survey Studies', American Journal of Sociology,* **77**(5), 921-938.

Pine, B.J. and Gilmore J.H. (1998). Welcome to the experience economy, *Harvard Business Review,* July-August. URL: http://www.iterations.com/protected/dwnload_files/experience_econo my.pdf [01.11.02].

Porter, C.S., Chhibber, S. and Porter, J.M. (2002). *Towards an understanding of pleasure in product design.* In McDonagh, D., Hekkert, P., van Erp, J. and Gyi, D. (Eds), *Proceedings of the 3rd International Conference on Design and Emotion: Design and Emotion, the experience of everyday things.* Loughborough, 2002, Taylor and Francis, London.

Porter, C.S. and Porter, J.M. (1999). Designing for usability; input of ergonomics information at an appropriate point, in an appropriate form, in the design process. In Jordan, P.W. and Green, W.S. (Eds), *Human Factors in Product Design,* Taylor and Francis, London.

Quigley, G. and Tweed, C. (2000). *Added-value services from the installation of assistive technologies for the elderly.* Queen's University of Belfast, Research report EPSRC GR/M05171. URL: http://www.qub.ac.uk/arc/research/projects/papers/AddedValue.pdf [21.02.05].

Saakes, D.P. and Keller, A.I. (2005). Beam me down Scotty: to the virtual and back!. In Wensveen, S., Diederiks, E., Djajadiningrat, T., Guenand, A., Klooster, S., Stienstra, M., Vink, P. and Overbeeke, K. (Eds.), *Proceedings of the conference Designing Pleasurable Products and Interfaces (482-483).* Eindhoven: Technische Universiteit.

Sato, T., Kajiwara K., Hoshino, H. and Nakamura, T. (2000). Quantitative evaluation and categorisation of human emotion induced by colour. *Advances in colour science and technology, 3(3).*

Sperling, L. (2005). Ergonomics in user-oriented design. In Holmér, I., Kuklane, K. and Gao, C. (Eds), *Environmental Ergonomics, XI.*

Westcott, M., Rutchik, J. and Crosby, B. (1999). From brand image to brand experience, *Innovation,* Summer 1999.

Young, R.A., Van der Veen G.J., Illman M.E. and Rowley F.J.B. (2000). Creating enhanced user experiences: the designer as a co-operator by facilitating communication. In Scrivener, S.A.R., Ball, L.J. and Woodcock, A. (Eds), *Co-designing conference proceedings, 'Collaborative design',* Springer-Verlaag.

CHAPTER SEVENTEEN

USING NARRATION TO RECALL AND ANALYSE USER EXPERIENCES AND EMOTIONS EVOKED BY TODAY'S TECHNOLOGY

JOHANN SCHRAMMEL, ARJAN GEVEN, MICHAEL LEITNER AND MANFRED TSCHELIGI

1. Introduction

User experience as a relatively new concept has attracted a lot of attention in the field of Human Computer Interaction (HCI). The main driving factor for the vivid interest in user experience is the increasing introduction of technological devices into application areas besides the office domain that brings along new priorities. A common assumption is that "technology as a tool" becomes "technology to play with". A central question when studying these experiences with regard to HCI is whether emotions are constitutional parts in the users' interactions with technology and if so which are of central relevance.

So far, several helpful models and frameworks on user experience have been developed with the goal to better understand the user's experience and to identify and systemize the factors influencing it (Arhippainen & Tähti, 2003; Forlizzi & Ford, 2000; Jääskö & Mattelmäki, 2003). Besides these theoretical approaches several empirically based studies with the aim to better understand and/or evaluate user experience have been conducted (Kidd, 2002; Steen, et al., 2003). Central to these models is the term of experience, which, according to Dewey (1980), embraces the totality of the whole lived experience but also can be broken up into a variety of separate "experiences" or situations. These situations are set off as self-contained wholes by virtue of an immediate "quality" that pervades each situation. These qualities are not mere feelings, but they are characteristics of situations themselves, which include natural events, human affairs,

feelings, etcetera. Examples of such qualities are satisfying, problematic, exciting, surprising, etcetera.

Likewise, there are several existing frameworks dealing with classifications of emotions (e.g. Cacioppo & Gardner, 1999). Ortony, et al. (1988) provide a structured approach to elaborate on different emotions such as (among others) hope, fear, desire, distress, admiration, reproach, satisfaction, and disappointment. The inclusion of certain emotions and the omission of others are however subject to heavy debate. Many researchers have proposed models of basic and peripheral emotions, but no theory has been widely agreed on (Ortony & Turner, 1990).

2. Goals

We address two key questions in this study. First, we want to find out if emotions are a constitutional part of technology use and if yes which ones are dominant? We further want to better understand today's experiences that appear in a real context when user play, work and interact with technology. Our aim is to identify characteristics of current experiences, to classify the involved emotions and compare these with existing conceptualisations of user experience. That findings on experience-related emotions can provide useful insights in designing-for-experience. We want to trace the content, generation and progression of these experiences and to derive implications and recommendations for designers based on these findings.

Secondly, we want to explore if "Narrations" proves to be a useful method for HCI to reveal emotions and experiences associated with everyday technology. We report on the applicability of the method and its potential to extract experiences and related emotions.

3. Method

User experience research has triggered the development of several new methodological approaches such as cultural probes (Gaver, et al., 1999) and perspective sorting (Forlizzi, et al., 2003). The development of such new methods reflects the difficulties in making the user's experience accessible to the researcher. Due to our focus on widespread and real-life experiences with technology we were also limited in the choice of applicable methods. Our answer was found in narrative interviews. The focus on eliciting narrations allowed us to make use of the structural

peculiarities story-telling follows e.g. the need to make meaningful selections, the need to provide sufficient details for the listener or the need to close a once started narrative figure (Kallmeyer & Schütze, 1976). The emotional content of the story is re-enacted during the narration therefore stories provide a more direct access to the experience than evaluative questions (Schütze, 1976). Beside these, we believe that respondent's intrinsic motivation to tell particular stories and experiences and the active involvement during the interviews leverage the exploration of experiences. Moreover, with stories as base material, the analysis can also consider structural elements of the narrations and characteristics of the used language. Latter is possible as narrations do not impose given phrases, wordings or mental-models (like in questionnaires) but allow respondents to express experiences in their own modality. Such considerations we believe as being utterly important for the given task as classifications are made afterwards as a result of responses and not vice versa by filtering answers and cutting off meanings using pre-given clusters and wordings.

3.1 Procedure

The interviews started with a short briefing of the interviewees. They were informed about the general goal of the study: to better understand the experiences of the interaction with systems of all kinds, e.g. mobile devices, robots, personal computers, personal digital assistants (PDAs) and consumer electronics.

Each interview started with open questions about "emotional encounters with technology" which introduce the interviewee to the focus of the interview and creates the right mindset for follow-up questions. Users were asked to remember any situation with technology in which they experienced emotions. They were asked to recount these memories in detail and to narrate stories as complete as possible.

After these relatively unfocused questions, we asked participants for negative and positive experiences, and then focused on specific experiences mentioned by the interviewees.

Then, the interview focused on special emotional and user experience factors that were selected based on the user experience work mentioned in the introduction. Questions on these factors included (1) *general experiences*, both positive (fun, pleasure) and negative (frustration, anger), as well as (2) *social experiences*, connectedness to other people and

sharing experiences with others, and (3) *personal experiences*, feeling intimate with a system, trust in a system and flow, the latter can be described as the positive experience of being totally immerged in something (Csikszentmihalyi, 1990). For each factor, participants were asked to narrate stories about situations in which they experienced it and elaborate on the precise circumstances under which the situation occurred.

Each interview took between 90 and 120 minutes and was audio taped. The audio data then was transcribed in detail. Analysis was based on the transcriptions, but the audio files were used during analysis as an additional source in the case where text based interpretation was not unambiguous. The interviews were conducted in German. Samples used below are translated into English by the authors.

3.2 Participants

Due to the time-consuming character of in-depth qualitative analysis and the explorative character of the study the number of interviews was limited to eight interviews. The eight participants were recruited from our database, which contains about 2000 persons who are interested in participating in usability tests and studies. The criteria for invitation were that users can be characterized as heavy users of new technologies and have wide experience with different kind of systems such as office computers, games, internet chats, mobile devices, etcetera. The average age of the participants was 24.1, with the youngest being 19 and the oldest being 30 (5 males, 3 females). All users use the internet at least 10-20 hours per week, and all use a mobile phone extensively. Additionally, all but one participant used a PDA. The target was to find people that have had a chance to encounter different situations with advanced interfaces that are used for everyday purposes. The drawback of inviting these specific users is that it introduces a certain early-adopter bias in the study. This drawback is compensated by the effect that more experiences with various new technologies can be addressed.

3.3 Analysis

The analysis was conducted in three steps. First, we summarized the qualitative interview data, next compared our data with existing conceptual classifications of emotions and last we analysed characteristics and differences of narrated experiences. Each step is detailed below:

The first step in the analysis of the interviews was to summarize the content of the narrations, classify them and see what type of experiences are actually mentioned and to which devices and situations they relate.

In a second step the emotions contained in the experiences were analysed based on a bottom-up approach that applies an ex post interpretation of users' experiences. After this initial processing, the findings of this analysis were compared with emotions in existing theoretical frameworks to find out whether all theoretical emotions are useful to analyse technology-related user experiences or if relevant subsets of emotions can be identified that are of particular importance in user experience research. As mentioned there are different existing approaches to classify emotions. In their structured approach, Ortony, et al. (1988) mention a number of emotions: prospect-based emotions for the self (confirmed and disconfirmed hope and fear) and for others (gloating, happy for, pity, resentment), well-being (joy, distress), attraction (love, hate) and attribution (pride, shame, admiration, reproach, relief), as well as compound emotions related to well-being and attribution (gratification, gratitude, remorse and anger). Ekman mentions a total of fifteen groups of emotions as a basic set, partly similar to the ones from Ortony, et al., but also including contempt, disgust, embarrassment, and sadness, as well as amusement, contentment, excitement, and sensory pleasure.

The third step of analysis concerned the common structural aspects of the different experiences and their implications for design. For analysing this aspect we followed the classical "grounded theory" approach as suggested by Glaser and Strauss (1967). We first approached the data without specific hypotheses in mind and developed analytical conceptualisations based on the data (so-called "codes"), searched for contrasting occurrences and cases for the identified codes and then integrated the results. Additionally knowledge from the field of structural analysis of oral narrations was used to enhance this approach (Schütze, 1976; Kallmayer & Schütze, 1976). Two researchers worked independently on the texts to ensure inter-subjectivity of the interpretations.

4. Results

Step 1: Interview analysis
 Users were first asked to narrate stories containing *general experiences* with technology. The experiences they mentioned were grouped together into experiences with positive and negative emotions and attributed a label

by both interpreters. The following two parts of the interview focused on primary aspects of user experience: *social experiences*–connectedness and sharing experiences–and *personal experiences*–feeling intimate, trust and flow. These bottom-up narrated experiences were summarized, grouped and labelled by the two interpreters and are reflected in Figure 17-1.

Challenge	Anger	Companionship	Support	Compassion	Autonomy	Excitement
Completion	Annoyance	Completion	Feedback	Respect	Control	Fun
Competence	Deception	Connection	Involvement		Fear	Learning
Delight	Disappointment	Curiosity	Love		Vigilance	Sharing
Discovery	Disrespect	Involvement			Risk	Guilt
Fun	Distress	Surprise			Trust	
Novelty	Frustration					
Pride	Panic					
Safety	Restraint					
Support	Shame					
Surprise	Surprise					

Figure 17-1. Labelled experiences described in the interviews.

The kind of system the stories are about can be summarized as follows: the majority of narrations dealt with experiences with personal computers (67,7%; 21 mentions). Typically these were stories about interactions with software programs or a system crash. The next frequent categories were stories containing cell phones and consumer electronics (both 9,6%; 3). Only rarely users told stories related to cars/bikes (6,4%; 2), games (3,2%; 1) or other things (3,2%; 1).

Step 2: Analysis of emotions contained in the experiences

The narrations were further analysed in detail to gain an overview of the emotions central in the experiences. When we compare the above mentioned experience-related emotions to emotions from theoretical approaches such as those from Ortony, et al. (1988) and from Ekman (1999), this leads to interesting results. A comparison shows that many existing emotions mentioned by Ortony, et al. and those mentioned by Ekman are found in the list of experiences from our interviewees: *joy, fun, pride, anger, disappointment, distress, panic, shame, love, fear, excitement and guilt*. Some examples are the following:

Fun:

> The computer program does not have to tell jokes. Nevertheless, I like to notice that designers put some effort on nice features. For instance there is an absolutely useless function that supports handwritten notes in MS Messenger – but it is fun exploring it and see how it works.

Anger:

> I made an software-update on my computer that I expected to improve some functionalities. But the system did not work well afterwards. I was not sure what caused the malfunction. I was really annoyed.

In addition, some compound emotions might identify the additional factors *hope* (from discovery and novelty), *satisfaction* (from challenge and completion) and *gratitude* (from safety, support and feedback). Although many emotions mentioned in emotion theory also were described in the interviews, a number of emotions are not reflected in the interviews: *desirable and undesirable emotions regarding others* (happy-for, resentment, gloating and pity from Ortony, et al.) were not mentioned at all, nor were *remorse, admiration, reproach* or *hate* mentioned in any form.

One experience, *surprise*, occurred in a positive setting where the system is doing something unexpectedly good, as well as in a negative setting, where the system is doing something unexpectedly in a negative way. The following two citations should illustrate the ambivalent occurrence of surprise:

Positive surprise:

> Once my home computer crashed and I tried out a function that promised to repair the system automatically. Unless I didn't believe it to work I executed it. As it finally worked out I was really disabused and positively convinced.

Negative Surprise:

> My mobile internet browser (on the respondents cellular) was said to support JAVA. I tried it out but it did not work, I had no idea why, so I had to install different browsers to get it running. I did not really expect that...

Surprise is a difficult experience to relate to specific emotions. Some researchers have categorised surprise itself to be an emotion, but this approach is not undisputed (e.g. Derbaix & Vanhamme, 2003; Ekman, 1999). All emotions are valenced, that is, are either positive or negative, whereas surprise can be both. The findings from the interviews underline this non-valence of surprise on a theoretical level, implications of the presence of surprise in both positive and negative experiences can be seen on a practical level regardless of the theoretical discussion.

Step 3: Interesting characteristics from a design-for-user-experience point of view

The detailed analysis of the structure and the content of the narrations based on suggestions from the "grounded theory" as well as the work of Schütze give us an overview of striking characteristics that recur in multiple situations. These observations are described in detail below.

1) Positive Experiences

The first important observation based on the interviews is that we can identify three important key factors for positive experiences, *exploration*, *challenge* and *autonomy*. Almost all of the narrated positive experiences are strongly related to one or more of these three aspects.

- **Exploration**–Narrations about positive experiences contained as key element the exploration of "new territories" with the potential to discover novel and interesting possibilities. An interesting structural aspect of these exploration activities was that the outcome–i.e. if the user actually discovered something helpful–was only of secondary nature. Exploration was experienced as a satisfying activity in its own right. The perceived possibilities of a

device are powerful determinants for the exploration possibilities and the resulting positive or negative experiences. Users report negative surprises when advertisements introduced unrealistic expectations and positive surprises when they discover more possibilities than expected.

- **Challenge**–Another frequent starting point for positive experiences is a challenge that matches the ability of the user. Participants mentioned difficult situations that they could solve with the help of a system as example. An interesting aspect here is that the difficulty typically was not introduced by the system but by factors outside the user-system-interaction, e.g. a deadline is coming up and a lot of work still has to be performed, in this challenging setting a computer program has to be used. Computer-games are an exception to this outside influence; here the challenge comes from the game itself. The following example refers to the challenge of learning a software program (and increasing the ability of working with it):

 > Using Adobe Photoshop is really challenging as there are so many buttons and functions. And you know nothing at the beginning… in a positive sense… exploring the instruction manual is really a challenge…

- **Autonomy**–Positive experiences included the increase of the perceived autonomy of the person. The system allowed the users to do things they were not able to do before e.g. they could chat to friends far away at low cost. But this relationship can be inverted dramatically if the system does not function well–the autonomy switches into dependence.

An example for a positive experience containing all three aspects is to learn to use a system auto-didactically–a situation mentioned strikingly frequent as example for positive experiences. To learn a new system you have to explore it. This is not always easy, it is a challenge. But when you succeed it increases your autonomy.

2) Negative Experiences

A general trend within the interviews was that *negative experiences dominated* both in terms of frequency and in terms of intensity. Negative experiences, e.g. frustration, anger or annoyance, were mentioned far more often than positive ones. Negative experiences were told using more emotionally loaded terms and the structural organization of the narrations

showed stronger patterns indicating emotional activation. Typically for positive experiences were terms like "*quite good*", "*nice*". For negative experiences similar terms were used, like "*bad*" but also much more expressive phrases like "*hit rock bottom*" or "*I would have liked it the most to throw the cell phone against the wall*".

3) Social Experiences

With respect to the social experiences participants mainly mentioned experiences where technology helped them stay in contact with distant friends and relatives via chat, e-mail and telephone conversations and share not only information with each other, but also "connect" and share experiences with each other. This corresponds with Battarbee's (2005) "co-experience", which mentions that social interaction is very important to many kinds of experience and technology needs to be designed to support this social interaction. To demonstrate such a social experience reported the following statement is mentioned:

> Using my Messenger I like to see whether some of my friends are online even though I do not talk to them immediately. I know that they are online so that I'm able to talk to them later. From time to time I turn on the "do not disturb-sign" in order to work patiently...

4) Personal Experiences

Regarding personal experiences with technology and relationships with technology itself, we found a number of interesting results. The personal experiences mainly revolve around four aspects: reliability, frustration, intelligence and goals which are described below.

- **I can count on you**–Regarding the perceived and expressed (implicitly or explicitly) relationship between the user and the system the most outstanding result is that reliability is the core value users appreciate in their relationship to technology. This we think is not only related to the above mentioned importance of functionality but also has to be understood in comparison to human-human relationships. It is especially what is different in technology that makes it appealing. Typical statements by our interviewees expressing this were e.g. "*It doesn't disappoint me*" or "*I can count on it*". This also can explain the importance of functionality as problems with it interfere with this model of relationship. This aspect is especially relevant for advanced systems, as with the emerging new interaction styles this model of relationship might be challenged.

- **Person-system relationships are coloured by usage goals**–What people use the devices for seems to be much more relevant for users' attitudes towards the device than what it is capable of. For example, if they use a system to communicate with friends the mobile phone becomes also kind of a friend, if the system is always running it becomes a companion, if the device is used in work it becomes a tool. The emotional characteristics of the usage situation–independent of the devices capabilities–are colouring the overall impression of and relationship with the device. There is no intrinsic property of the device that defines the relationships; there are just potentials and possibilities which are ignited by the way the device is used to reach other goals.
- **"It frustrates me" and "I frustrate me"**–Users report two ways in which they deal with frustration and anger in relation to technology. When a system reacts unexpectedly and leads to errors or data loss, the terms describing these experiences for all interviewees are either frustration or anger, or both. Interestingly, these are either a) targeted at the technology or the developers of the technology for some users, or b) targeted at themselves. These differences in blame attribution provide an interesting dichotomy in which both styles of blame attribution have different design implications.
- **Immergence leads to wasted time, not flow**–Although all interviewees reported that it occurred at least occasionally to them that they were so occupied with technology that they completely forgot everything around them and lost track of time (attributes of flow), the experiences reported by the participants were associated with wasted time and feelings of guilt or shame for not doing something productive. These negative emotions are quite different from the positive experience of flow. Interestingly, not one experience mentioned by any of the participants could be considered to be a real flow experience, even though they were directly asked to recall an experience in which they felt completely immerged in an activity including technology.

5. Discussion of results

Many experiences that were described could not be directly related to specific emotions. This could be related to the structure of the interview, as we asked for experiences and asked participants to give as many details as possible, and not asked for specific emotions. This bottom-up

processing of experiences led to situations that contain more than only a single emotion, giving also antecedents and results of emotional encounters. This allows a more *integrative approach to emotions in user experience research*, and provides us with interesting findings regarding the relative importance of negative emotions such as anger and its antecedents, and more generally, positive and negative surprises in encounters with technology. We believe that when designing for emotions "surprises" are a potent medium to convey particular experiences if sensibly applied. Hence, in a way "exploring a system" turns to be an important fact in order to generate such positive astonishments.

We also noticed that some experiences were dominated by certain emotions to such a degree that the experience was labelled after the dominant emotion (e.g. fun, pride, anger, excitement). Other experiences that were described by our participants were more abstract from their emotional content, and could not be directly related to emotions. These include challenge, completion, discovery, feedback, novelty, safety and support. Other positive experiences that were mentioned are curiosity, autonomy, control, vigilance, and trust, most of which were mentioned in describing "trust"-experiences. These abstract experiences could not be directly related to emotions, as they describe other appraisal processes and are not as emotion-rich as the above-mentioned experiences.

A comparison between the emotions mentioned in the narrations and emotion theory revealed us that *a very large part of general emotion theory is transferable* to emotions in users' experiences with using everyday technology. This makes emotions not only an integral part of user experience, but also one of its important parts. However, *designing for user experience comprises other factors as well*: we also need to take care about issues like trust, control, autonomy, challenge, and discovery to guide user experience, which do not have the same physiological and psychological characteristics as emotions, but are also important in good design. For instance, trusting a system goes hand in hand with reactions the user expects the system to perform. Users may only trust a system if they now how it reacts and if they are able to control and anticipate the systems' reactions. However, the system needs to address such circumstances being able to "tailor" one's experiences and emotions (e.g. identifying and identifying the source of error and provide proper feedback, etcetera). In any case, designing for positive experiences the system has to convey a feeling of control and give the user the possibility to understand the situation (even if an error occurs).

We can also see that, when we look at the emotions mentioned by Ortony, et al. (1988), that the emotions that are related to the "self" are all reflected in the interviews, but the ones that are all related to specific parts of emotions that are related to others, to agents and to objects are partly missing. This shows a particular focus on the self in respect to everyday technology. Partly, this can be attributed to the interview style that focused on personal experiences, but some questions were directed at interactions with other users, and users were often asked whether they experienced a situation with other people. This implies that, in dealing with technology, *the most salient emotions are the ones that are related to the self.*

The fact that both the amount and the intensity of negative experiences dominate, can be traced back to the notion of "negativity bias" as reported by Cacioppo & Gardner (1990), who explain this behaviour from an evolutionary point of view: a missed opportunity for exploration is not as dangerous as an overly positive assessment that can end in being eaten by a predator. This evolutionary footprint apparently also determines our experiences in relation to technology: this is the user's reality and interaction designers should consider this.

6. Reflections on using the method

The method proved to be a potent instrument to extract self-experienced feelings and emotions related to everyday technology. However, the key challenge proves to be extracting meaningful narration in place of evaluation. In our experience during the interviews respondent tend to continuously switch between narrations and evaluations that forces the interviewer to be sensitive in balancing the interview and holding the track. In such situations the interviewer needs to confront the respondent positively and empathically. He/She respond to the "narration-style" of his/her opponent without forcing the narration towards particular directions. Hence, a good introductory briefing, which may pre-eliminate such problems, should be part of any interview session. In social-theoretical literature good examples for valuable guidelines for the conduction of narrative interviews exist (e.g. see Schütze (1976)).

A limitation of the method is its incapability of generating narrations about systems that people do not know or have not worked with (it is obvious that respondents are not able to tell stories about something they do not know). The method is able to extract experiences and emotions of existing systems but is not able to pre-evaluate such issues. This fact limits

the method to be used in post-evaluations (or prototype evaluation). From the actual point of view we only see restricted possibilities to adopt the method in early design phases. However, in our experiences narration as well could help designers and research in creating ideas for new designs and solutions for particular problems (see for instance implications for the design of positive surprise).

We conducted interviews with 8 respondents. The qualitative material we gathered provided a satisfactory level of detail unless we recommend researchers to strive for a higher number of respondents. With session about 90 and 120 minutes respondents were able to finish about 3 to 5 stories. We believe shorter session to be unsatisfactory, as narrative interviews need time to develop over time during the session.

7. Conclusions and implications for design

This paper discussed the everyday experiences and emotions evoked by today's technology. We were able to identify interesting phenomena, e.g. the overlap between emotion theory and technology practise as well as the differences between them, the dominance of negative experiences and the influence of usage on the user-system relationship. Our results strengthen the position that designers cannot evoke positive experiences directly but the results also show that there are several things designers can do to make positive experiences possible. Based on these considerations we want to provide a number of recommendations for practitioners concerned with designing for experiences:

- Support approaches that invite the user to *explore* the system and provide possibilities for playful interaction without dead ends while not placing excessive demands on him/her.
- Create a realistic image of your product, or even omit certain features in your advertising. Users will be positively *surprised* by your features (of course, be careful not to omit too many features in your advertisements). This also means that negative surprise can be avoided which results in anger and frustration.
- When performance is different than expected by the user and the system is able to recognize such an exception, it should be designed to provide meaningful error messages. Try by all means to rescue data: deleting is easy, recovery difficult. Apologize for your imperfection and ask for feedback, show that you care, to reduce possible user frustration and retain trust.

- Unexpected behaviour is very tricky, especially in more or less autonomous systems. When analysing the sequential organization of experiences it became clear that untimely actions by the system can flip a formerly positive perceived process into an offending experience. In contrast, an unexpected but helpful intervention by the system can trigger positive experiences as for example thankfulness. To enable positive experience actions initiated by the system must match with the users' needs and expectations.
- It is important whom the user is blaming for occurring difficulties and errors. Think about proper mechanisms of blame attribution and how to channel this process. Users might blame the software, "take it" and do something with this emotion. Or users might blame themselves, which is a very negative experience for the users. Instead, try to redirect this blame towards the original target: the developers, who can do something against it.

As we could see in the analysis of the interviews, exploration, challenge and autonomy play a crucial role for positive experiences. The above recommendations, based on direct user experiences with everyday technology, can help provide the necessary preconditions for these concepts and to construct a positive user experience.

Acknowledgements

This work was supported by the Austrian Science Foundation (FWF, project S9107-N04). We would like to thank Stephanie Deutsch for helping with practical details of the work.

Works Cited

Arhippainen, L. and Tähti, M. (2003). Empirical Evaluation of User Experience in Two Adaptive Mobile Application Prototypes. *Proceedings MUM 2003*: 27-34.
Battarbee, K. (2005). *Co-Experience: Understanding User Experiences in Social Interaction*. University of Art and Design, Helsinki, dissertation.
Cacioppo, J.T. and Gardner, W.L. (1999). Emotion, Annual. Review. *Psychology*, 50:191-214.
Csikszentmihalyi, M. (1990). *Flow: The Psychology of Optimal Experience*. New York: Harper and Row.

Derbaix, C. and Vanhamme, J. (2003). Inducing Word-of-Mouth by Eliciting Surprise–A Pilot Investigation. *Journal of Economic Psychology*, **24**(1): 99-116.

Dewey, J. (1980). *Art as Experience.* New York: Perigee, (reprint).

Ekman, P. (1999). Basic Emotions. In Dalgleish, T. and Power, M. (Eds.) *Handbook of Cognition and Emotion.* Sussex, U.K.: John Wiley & Sons, Ltd.

Forlizzi, J. and Ford, S. (2000). The building blocks of experience: an early framework for interaction designers. *Proceedings DIS 2000*, ACM Press: 419-423.

Forlizzi, J., Gemperle, F. and DiSalvo, C. (2003). Perceptive sorting: a method for understanding responses to products. *Proceedings DIS 2003*, ACM Press: 103-108.

Gaver, B., Dunne, T. and Pacenti, E. (1999). Design: Cultural probes. *Interactions* **6**(1): 21-29.

Glaser, B.G. and Strauss, A.L. (1967). *The Discovery of Grounded Theory: Strategies for Qualitative Research.* Chicago: Aldine Pub. Co.

Jääskö, V. and Mattelmäki, T. (2003). Observing and probing. *Proceedings DPPI 2003*, ACM Press: 126-131.

Kallmeyer, W. and Schütze, F. (1976). Konversationsanalyse (Transl: Conversation Analysis). *Studium Linguistik.* Heft 1: 1-28.

Kidd, A. (2002). *Technology Experiences: What makes them Compelling?* Bristol: HP Laboratories, HPL-2002-338. URL: http://www.hpl.hp.com/techreports/2002/HPL-2002-338.pdf.

Ortony, A., Clore, G.L. and Collins, A. (1988). *The Cognitive Structure of Emotions.* Cambridge, UK: Cambridge University Press.

Ortony, A. & Turner, T.J. (1990). What's basic about basic emotions? *Psychological Review*, 97: 315-331.

Schütze, F. (1976). Zur soziologischen und linguistischen Analyse von Erzählungen (Transl: on the sociological and linguistic analysis of narrations). *Internationales Jahrbuch für Wissens- und Religionssoziologie* 10: 7-41.

Steen, M., Koning, N.D. and Hoyng, L. (2003). The 'Wow' Experience– Conceptual Model and Tools for Creating and Measuring the Emotional Added Value of ICT. *Proceedings COST269 Conference 2003.*

CONTRIBUTORS

Marcus Abbott
Body & Trim Engineering, Bentley Motors Limited, Crewe, United Kingdom

Rodney Adank
The Center for Affective Design Research, Massey University, Wellington, New Zealand

Sam Bucolo
School of Design, Queensland University of Technology, Brisbane, Australia

Jonathan Chapman
School of Architecture & Design, University of Brighton, Brighton, United Kingdom

Shayal Chhibber
PDD Group Ltd, London, United Kingdom

Scott Davidoff
Human-Computer Interaction Institute, Carnegie Mellon University, Pittsburgh, United States

Erdem Demir
Department of Industrial Design, Delft University of Technology, Delft, The Netherlands

Pieter M.A. Desmet
Department of Industrial Design, Delft University of Technology, Delft, The Netherlands

Anind K. Dey
Human-Computer Interaction Institute, Carnegie Mellon University, Pittsburgh, United States

Çiğdem Erbuğ
Department of Industrial Design, Middle East Technical University, Ankara, Turkey

Jeroen van Erp
Fabrique Communications and Design, Delft, The Netherlands

Tom Fisher
School of Art and Design, Nottingham Trent University, Nottingham, United Kingdom

Arjan Geven
Center for Usability Research & Engineering (CURE), Wien, Austria

Rafael Gomez
School of Design, Queensland University of Technology, Brisbane, Australia

Silvia Grimaldi
Central Saint Martins College of Art and Design, London, United Kingdom and Anglia Ruskin University, Chelmsford, Essex, United Kingdom

Cris de Groot
School of Design, Unitec New Zealand, Auckland, New Zealand

Peter Guest
Body and Trim Engineering, Bentley Motors Limited, Crewe, United Kingdom

Ray Holland
School of Engineering & Design, Brunel University, London, United Kingdom

Jettie H.C.M. Hoonhout
Philips Research, Royal Philips Electronics N.V., Eindhoven, The Netherlands

Benjamin Hughes
MA Industrial Design, Central Saint Martins College of Art and Design, London, United Kingdom

Wijnand A. IJsselsteijn
Technology Management, Eindhoven University of Technology, Eindhoven, The Netherlands

Melinda-June Jenkins
Colour and Trim, Bentley Motors Limited, Crewe, United Kingdom

Elvin Karana
Department of Design Engineering, Delft University of Technology, Delft, The Netherlands

MariAnne Karlsson
Department of Product and Production Development, Chalmers University of Technology, Chalmers, Sweden

Ilse van Kesteren
PPG Architectural Coatings EMEA, Uithoorn, The Netherlands

Yvonne A.W. de Kort
Technology Management, Eindhoven University of Technology, Eindhoven, The Netherlands

Tatiana A. Lashina
Philips Research, Royal Philips Electronics N.V., Eindhoven, The Netherlands

Min Kyung Lee
Human-Computer Interaction Institute, Carnegie Mellon University, Pittsburgh, United States

Michael Leitner
Center for Usability Research & Engineering (CURE), Wien, Austria

Fabienne Martin-Juchat
Groupe de Recherche sur les Enjeux de la Communication (GRESEC), Université de Grenoble 3, Echirolles, France

Marc Marynower
Groupe Communiquez, Lyon, France

Hilde Nordli
Independent researcher, Norway

Elly P.H. Zwartkruis-Pelgrim
Philips Research, Royal Philips Electronics N.V., Eindhoven, The Netherlands

Vesna Popovic
School of Design, Queensland University of Technology, Brisbane, Australia

Talya Porat
Department of Industrial Engineering and Management, Ben-Gurion University of the Negev, Beer Sheva, Israel

Mark Porter
Department of Design & Technology, Loughborough University, Leicestershire, United Kingdom.

Samantha Porter
Department of Design & Technology, Loughborough University, Leicestershire, United Kingdom.

Johann Schrammel
Center for Usability Research & Engineering (CURE), Wien, Austria

John P. Shackleton
Institute of Technology and Engineering, Massey University, Albany, New Zealand

Noam Tractinsky
Department of Information Systems Engineering, Ben-Gurion University of the Negev, Beer Sheva, Israel

Jenny Tillotson
Central Saint Martins College of Art and Design, London, United Kingdom

Manfred Tscheligi
Center for Usability Research & Engineering (CURE), Wien, Austria

Anders Warell
The Centre of Affective Design Research, Massey University, Wellington,
New Zealand

John Zimmerman
Human-Computer Interaction Institute and School of Design, Carnegie
Mellon University, Pittsburgh, United States

INDEX